INSIDE HAVANA

imprint

To stay informed about upcoming TASCHEN titles, please request our magazine at www.taschen.com/magazine or write to TASCHEN, Hohenzollernring 53, D–50672 Cologne, Germany; contact@taschen.com; Fax: +49-221-254919. We will be happy to send you a free copy of our magazine, which is filled with information about all of our books.

© 2011 TASCHEN GmbH
Hohenzollernring 53
D–50672 Köln
www.taschen.com

Original edition: © 2006 TASCHEN GmbH

CONCEPT, EDITING AND LAYOUT
Angelika Taschen, Berlin

DESIGN
Sense/Net Art Direction, Andy Disl and Birgit Eichwede, Cologne
www.sense-net.net

GENERAL PROJECT MANAGEMENT
Stephanie Bischoff, Cologne

ENGLISH TEXT EDITING
Deborah Irmas, Los Angeles

GERMAN TRANSLATION
Simone Ott Caduff, Pasadena
André Höchemer for LocTeam, S. L., Barcelona

FRENCH TRANSLATION
Philippe Safavi, Paris

ENGLISH TRANSLATION
Mary Black for LocTeam, S.L., Barcelona

LITHOGRAPHY MANAGEMENT
Horst Neuzner, Cologne

Printed in China
ISBN 978-3-8365-3177-1

PHOTOS BY Gianni Basso / Vega MG
TEXT BY Julio César Pérez Hernández
ED. Angelika Taschen

inside Havana

TASCHEN

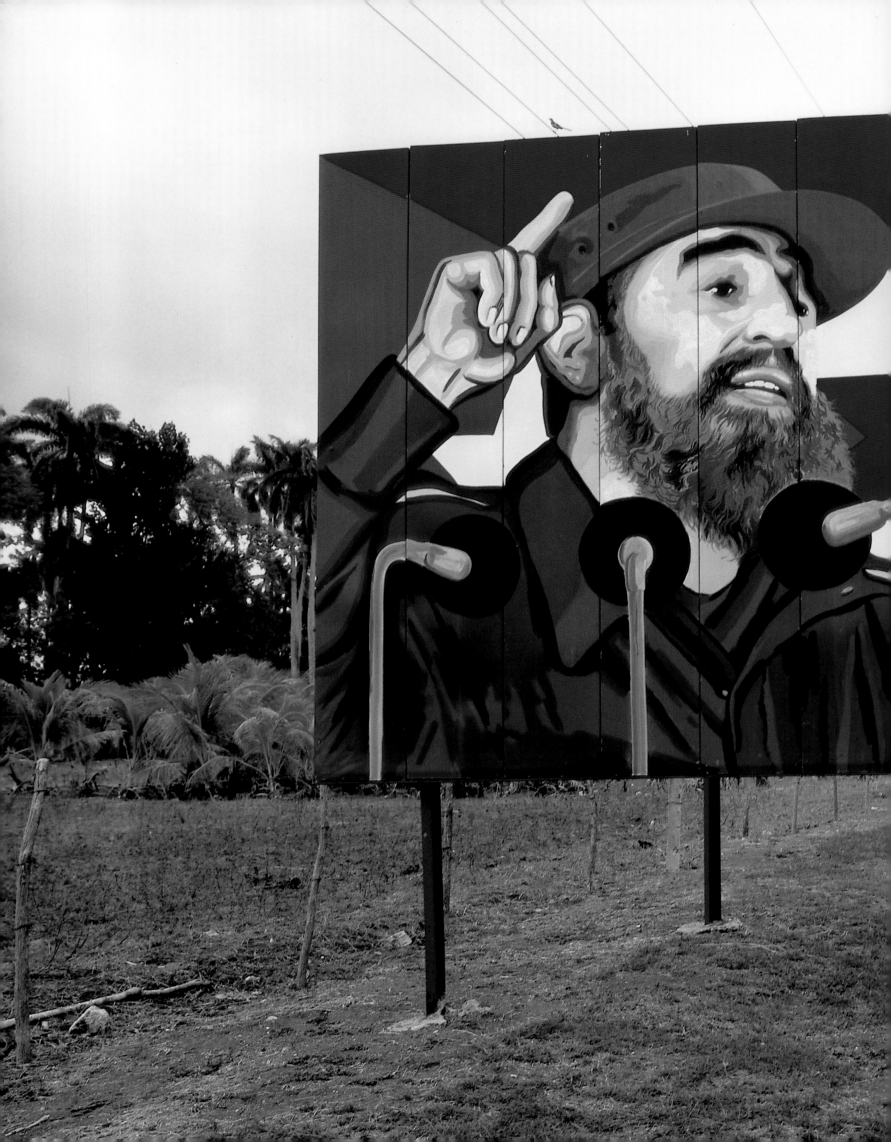

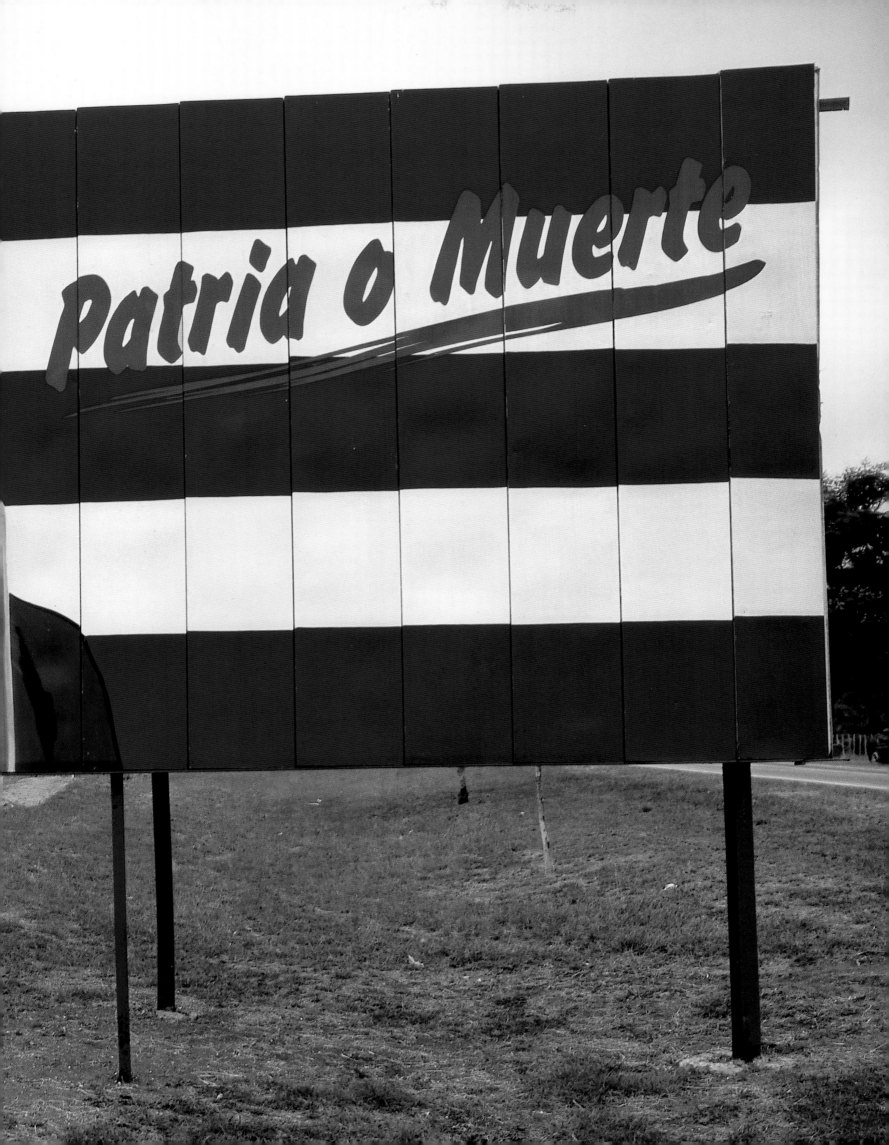

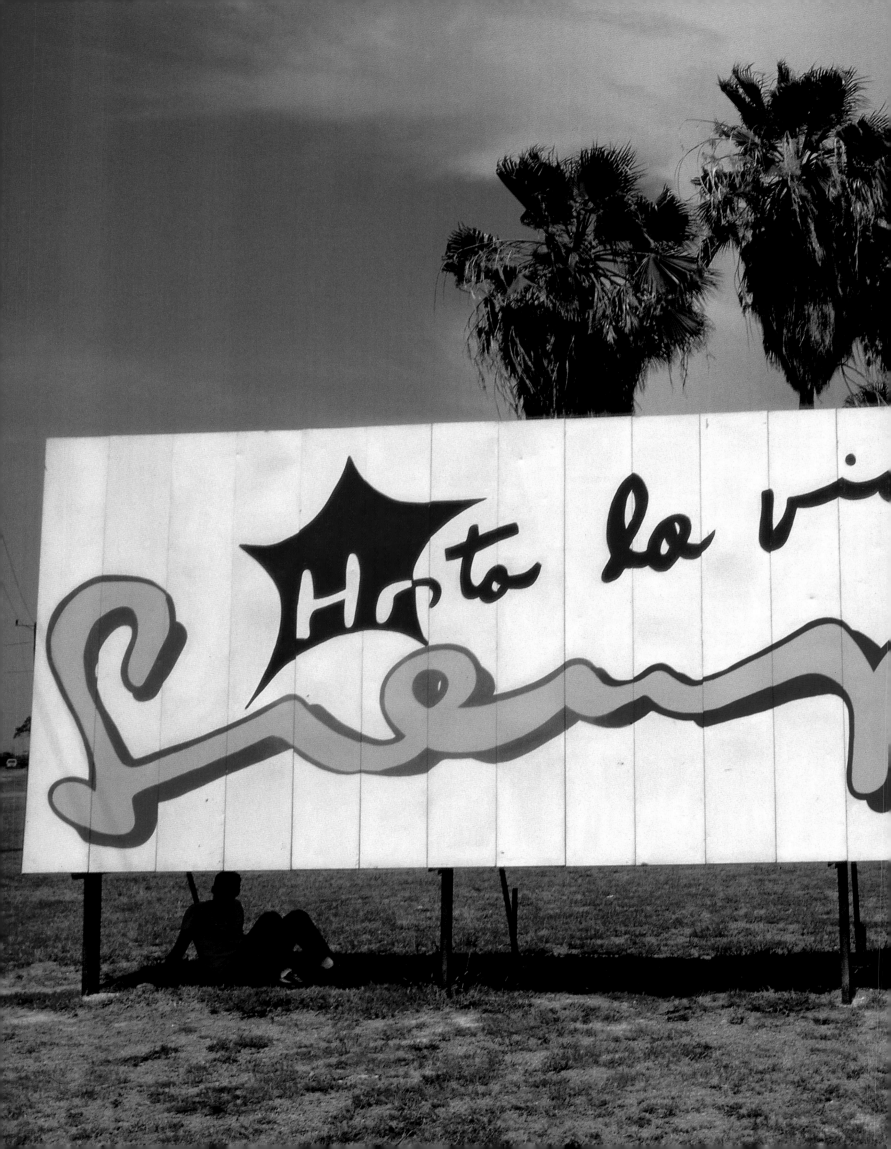

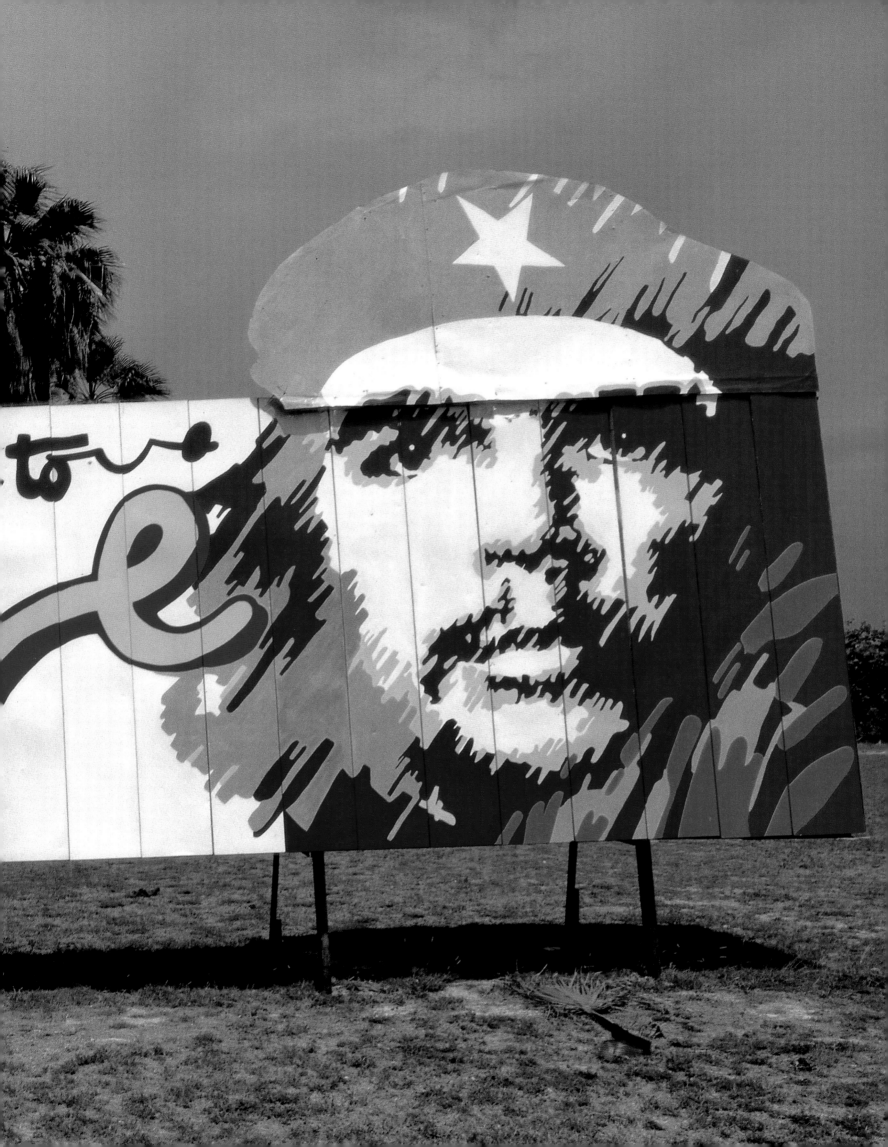

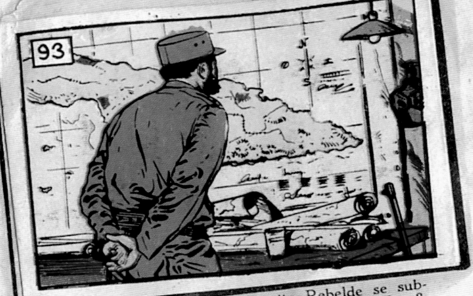

93.—Al aumentar el Ejército Rebelde se sub-
divide en mandos: Columna 1, Fidel; No. 8,
Guevara; Col. "Frank País", Raúl Castro;
Col. 7, Crescencio; Col. 2, Camilo; Col. 3,
Almeida; y la Col. Abel Santamaría.

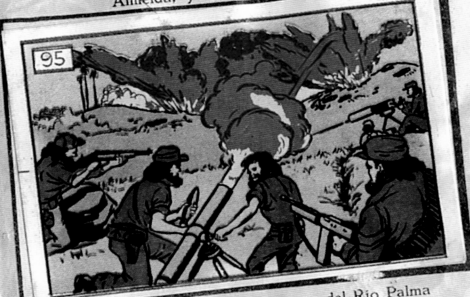

95.—El segundo encuentro cerca del Río Palma
Mocha. Los rebeldes triunfan. Después, las ba-
tallas de: El Salto; el Uvero; Pino del Agua;
Cieneguilla, etc.

96.—El Com. C
de organizar un
van a llegar ref

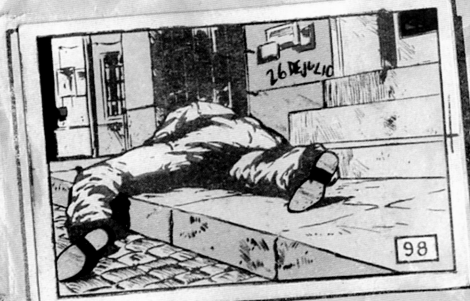

98.—En una represión sangrienta y cruel, es
asesinado, en Santiago, Frank País, jefe de las
milicias locales, por el feroz Salas Cañizares,
verdugo batistero.

99.—Entierro de
sonas en el ma
tiago. Gran ten

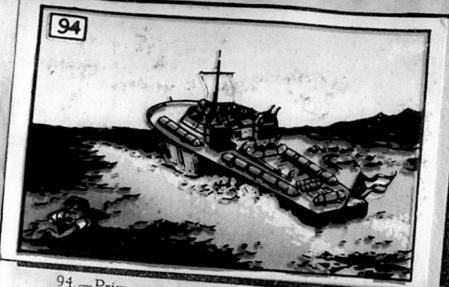

94.—Primer crimen en masa. 6 campesinos son detenidos cerca de Palma Mocha. En el guarda-costas 33 son lanzados al mar. Uno se salva.

cencio Pérez se hace cargo
po de aterrizaje, por donde
cos y equipos para la gesta
ertadora.

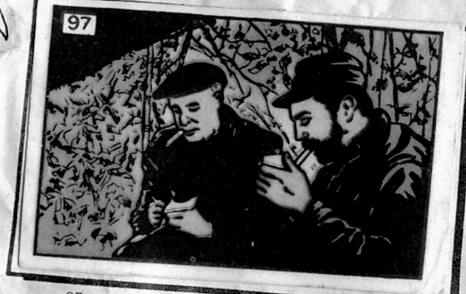

97.—Enero. 17, 1957. Herbert L. Matthews se entrevista con Fidel, en la Sierra. La Tele-visión en EE.UU. exhibe reportajes sobre la rebelión en Cuba.

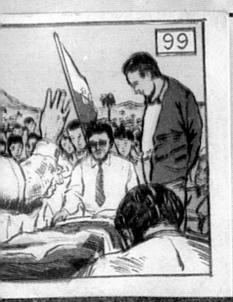

rank País. Millares de per-
sepelio que ha visto San-
Hasta las mujeres se sien-
combatientes.

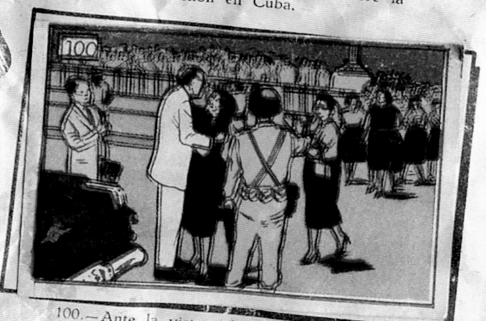

100.—Ante la vista del embajador americano, Mr. Smith, se atropella en la capital de Orien-te a una manifestación de damas que se sienten cubanas.

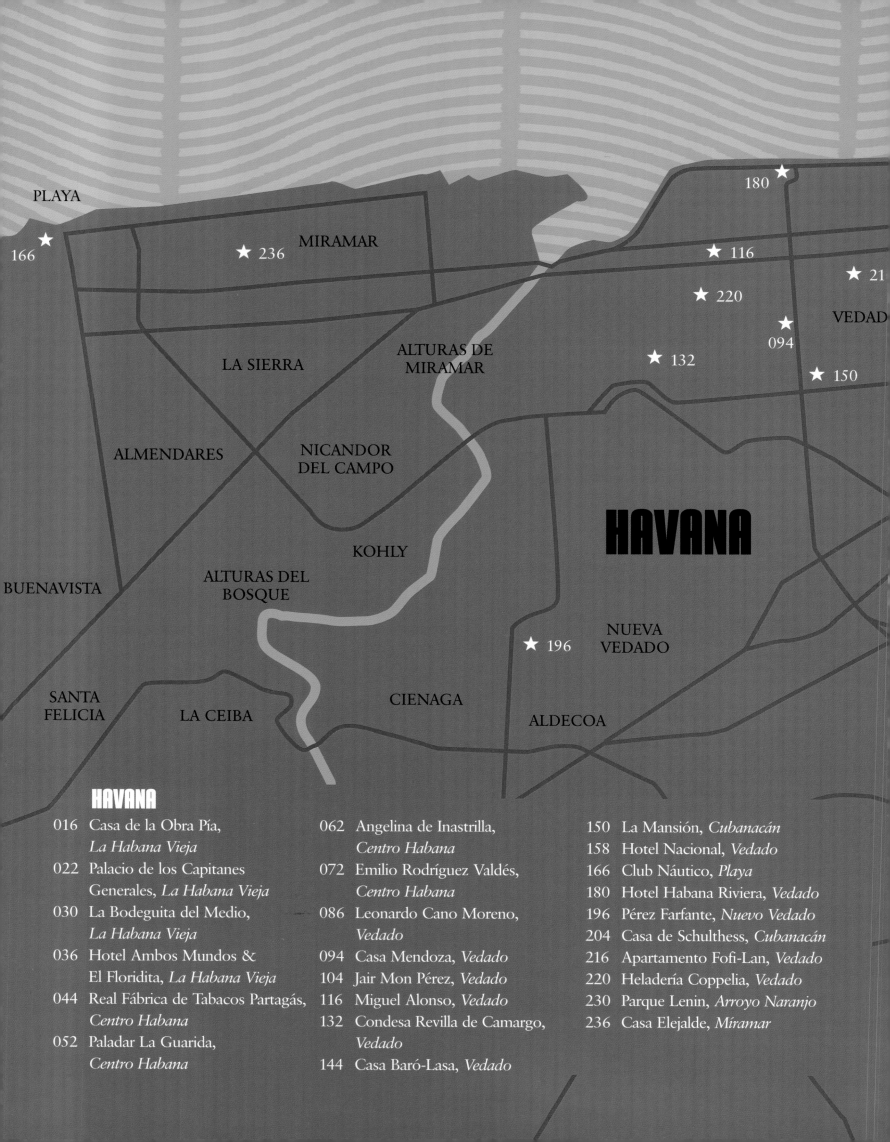

PLAYA

★ 166

★ 236 MIRAMAR

LA SIERRA

ALTURAS DE MIRAMAR

180 ★

★ 116

★ 220

VEDAD

★ 21

094 ★

★ 132

★ 150

ALMENDARES

NICANDOR DEL CAMPO

KOHLY

BUENAVISTA

ALTURAS DEL BOSQUE

HAVANA

NUEVA VEDADO

★ 196

SANTA FELICIA

LA CEIBA

CIENAGA

ALDECOA

HAVANA

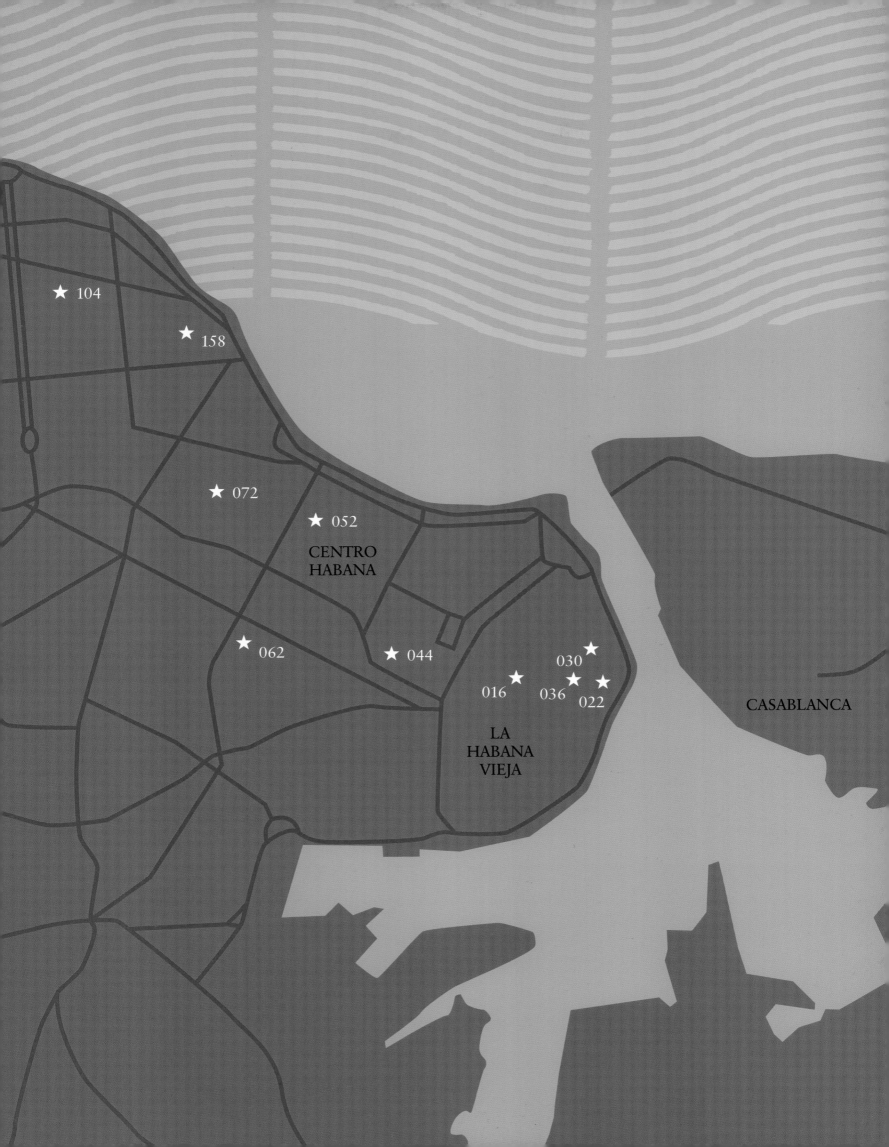

104

158

072

052

CENTRO
HABANA

062

044

030

016

036

022

LA
HABANA
VIEJA

CASABLANCA

HAVANA

Because of the geographical location of its harbor, Havana has been the capital of Cuba since 1607. In the 16th century, Spanish fleets carrying gold in convoys across the ocean gave the city great importance, which prompted Spain to build walls and fortresses as protection from attacks by pirates. The defensive structures helped delineate the urban landscape of the city on an irregular grid of narrow streets and a network of "piazzas" and "piazzetas," establishing its polycentric character. In 1982 UNESCO declared Old Havana's historic center a World Heritage Site. The abundance of civic space, the boulevards – such as Paseo del Prado and Alameda de Paula – and the

Havanna wurde 1607 dank der günstigen Lage des Hafens die Hauptstadt Kubas. Die Stadt gewann an Bedeutung, als die spanische Flotte im 16. Jahrhundert Gold in Konvois nach Havanna verschiffte. Bald ließen die Spanier Festungen und auch eine Mauer errichten, um sie von den Piraten zu schützen. Dadurch veränderte sich das Stadtbild nachhaltig. Aus dem losen Netzwerk aus schmalen Straßen, »Piazzas« und »Piazzetas« wurde eine Stadt mit verschiedenen Zentren. Bis in die 1930er entwickelte sich Havanna zur modernen Metropole mit großzügigen öffentlichen Plätzen, eleganten Boulevards wie dem »Paseo del Prado« und die »Alameda de Paula«, dem »Male-

Du fait de la position géographique de son port, La Havane est la capitale de Cuba depuis 1607. Au 16ᵉ siècle, les flottes espagnoles acheminant l'or à travers l'océan lui conférèrent une grande importance, incitant l'Espagne à construire des remparts et des forteresses pour la protéger des pirates. Ces structures défensives contribuèrent à façonner son plan irrégulier fait de ruelles étroites et d'un réseau de « piazzas » et de « piazzetas », d'où son caractère polycentrique. Dès les années 30, l'abondance d'espaces publics et de boulevards (Paseo del Prado, Alameda de Paula ainsi que le Malecón et ses beaux immeubles ont fait de la ville une métropole caribéenne moderne. En 1982,

Malecón, along with a collection of fine buildings, had turned Havana into a modern Caribbean metropolis by the 1930s. Havana was spared the injurious urban renewal and overdevelopment seen around the world during the second half of the 20th century, but is now ready for a sensitive revival. A master plan aimed at preserving the city's historic and architectural legacy, while encouraging its future urban and economic development, is being established.

cón« und einer ganzen Reihe eleganter Häuser. 1982 erklärte die UNESCO die Altstadt zur Weltkulturerbestätte. Während in der zweiten Hälfte des 20. Jahrhunderts Städte überall auf der Welt eine rasante Entwicklung durchmachten, verfiel Havanna in einen Dornröschenschlaf. Nun ist die Stadt reif für eine sanfte Renovation. Derzeit wird an einem Plan gearbeitet, der die zukünftige Stadt- und Wirtschaftsentwicklung fördern soll und gleichzeitig das historische und architektonische Erbe der Stadt bewahrt.

l'UNESCO a déclaré le centre historique de la vieille Havane patrimoine universel. La Havane a échappé aux réaménagements hideux et au surdéveloppement qui a affecté les grandes villes dans la seconde moitié du 20ᵉ siècle, mais elle est désormais prête pour une restructuration intelligente. Un plan directeur visant à préserver l'héritage architectural et historique de la ville tout en encourageant son développement urbain et économique est à l'étude.

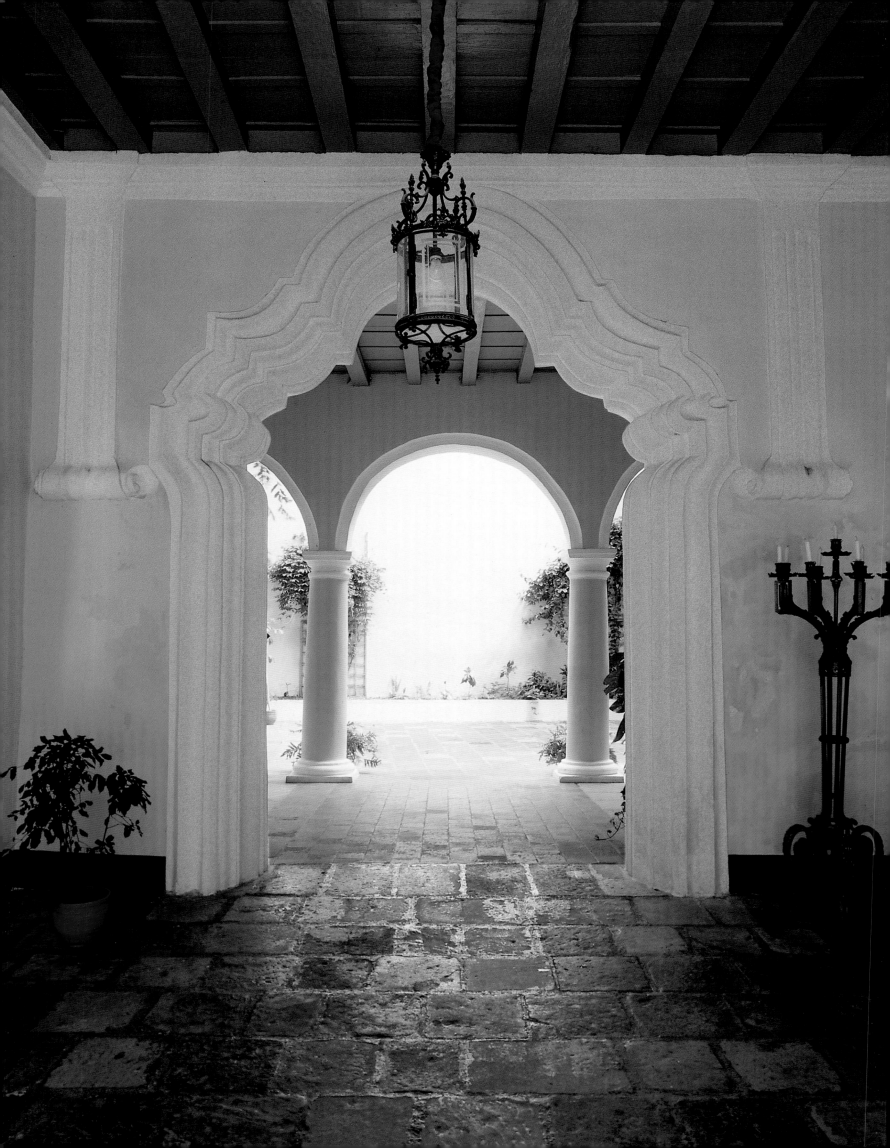

Casa de la Obra Pía

A Distinguished Example of Cuban Baroque.

José Martín Calvo de la Puerta, owner of Casa de la Obra Pía – "obrapía" meaning an act of charity – annually gave part of his fortune to five young orphans to help them create their own new family. Several features make this house not only one of the biggest but also one of the most distinguished examples of what is called Cuban baroque. In 1793, two adjacent properties that had been purchased around 1665 were merged, and renovation began. The impressive size of the house called for a massive sculptural stone doorway, exceptional and unique in colonial times its scale and design, it was crafted in Spain and shipped to Havana around 1686. Stone arcaded galleries surround the magnificent courtyard on three sides, and the dining room is located in the upstairs gallery between the main courtyard and the patio. There is an extraordinary variety of arches, ranging from the mixtilinear one of the entry hall, or "zaguán," to the three trefoil arches above the staircase that connects both floors. The upper gallery has friezes with floral motifs, which link the living spaces. They are all decorated with exquisite taste and fine furniture.

José Martín Calvo de la Puerta, der erste Besitzer der »Casa de la Obra Pía«, war ein großherziger Mann. Jedes Jahr spendete er einen Teil seines Vermögens fünf jungen Waisen, damit jeder seine eigene Familie gründen konnte. Das Haus mit dem Namen »Obra Pía«, was Wohltätigkeit bedeutet, ist ein typisches Beispiel für den kubanischen Barock. 1793 wurden die zwei aneinanderliegenden Anwesen, die de la Puerta 1665 erworben hatte, zu einem zusammengeschlossen, renoviert und ist nun von beachtlicher Größe. Das skulpturale Eingangstor ist dementprechend massiv. Seine Proportionen und das einzigartige Design sind für die Kolonialzeit außergewöhnlich. Es wurde in Spanien hergestellt und um 1686 nach Havanna transportiert. Galerien mit Arkaden aus Stein umsäumen den prächtigen Innenhof an drei Seiten. Die bestehen aus einer außergewöhnlichen Vielfalt an Torbögen – vom mixtilinearen »Zaguán« in der Eingangshalle bis zu den drei kleeblättrigen Torbögen über dem Treppenhaus, das beide Stockwerke miteinander verbindet. Die obere Galerie mit floralem Friesdekor verbindet die Wohnräume, die alle mit erlesenem Geschmack und elegantem Mobiliar eingerichtet sind.

José Martín Calvo de la Puerta, propriétaire de la Casa de la Obra Pía «l'œuvre pieuse», donnait chaque année une partie de sa fortune à cinq jeunes orphelins pour les aider à fonder une famille. Sa demeure est un exemples caractéristique du «baroque cubain». En 1973, les deux domaines adjacents achetés par la Puerta en 1665 fusionnèrent. La taille impressionnante de la maison rénovée appelait une porte sculpturale massive en pierre (exceptionnelle par son échelle et sa conception en ces temps coloniaux). Elle fut construite en Espagne et acheminée à la Havane vers 1686. Des arcades en pierre bordent trois côtés de la magnifique cour. La salle à manger est située sur la galerie supérieure entre la cour principale et le patio. La bâtisse abrite une extraordinaire variété d'arches, mixtilignes dans le «zaguán» ou hall d'entrée, ou en trèfle au-dessus de l'escalier qui mène à l'étage. La galerie supérieure ornée de frises aux motifs floraux relie les salles de séjour, toutes décorées avec un goût exquis et des meubles de qualité.

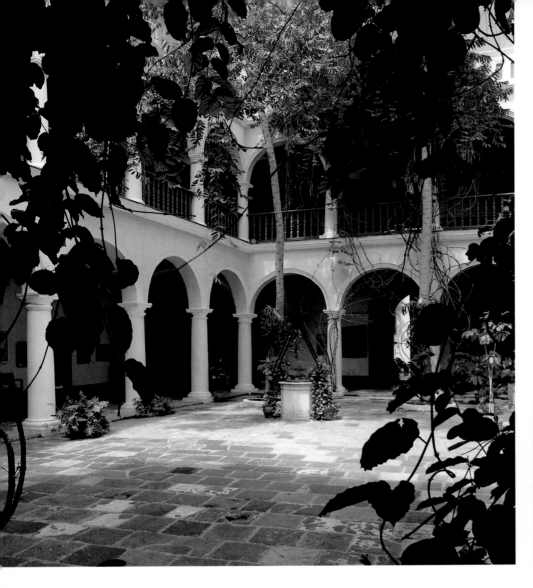

※ **ABOVE** One of the most interesting architectural features is the courtyard, due to its exceptional size and its uniform arcaded stone galleries and columns on both floors. It is embellished with plants, following the tradition. **RIGHT** A trefoil arch marks the staircase landing on one of the galleries that wrap around the courtyard on the upper floor. The wooden ceiling is painted in a color known as Havana Blue, a reference to the city's proximity to the sea. **FACING PAGE** A lovely baroque-style porch embellished with pilasters decorates the semicircular arch leading to the staircase on one of the galleries in the courtyard.

※ **OBEN** Der Innenhof ist eines der architektonisch interessantesten Elemente. Er besticht sowohl durch seine außergewöhnliche Größe als auch durch seine gleichförmigen Galerien mit Steinbögen und -säulen auf beiden Stockwerken und ist traditionsgemäß mit Pflanzen ausgeschmückt. **RECHTS** Ein Kleeblattbogen umrahmt den Treppenvorplatz in einer der Galerien des Obergeschosses, welche den Innenhof umgibt. Die Holzdecke ist in der als Havanna-Blau bekannten Farbe gehalten und spielt auf die Nähe zum Meer an. **RECHTE SEITE** Ein wunderschönes, mit Pilastern verziertes Portal barocken Ursprungs schmückt den Rundbogen am Treppenzugang in einer der Galerien des Innenhofs. ※ **CI-DESSUS** Le patio, embelli de plantes comme le veut la tradition, est particulièrement intéressant d'un point de vue architectural de par ses dimensions exceptionnelles et ses galeries à arcades dont les deux niveaux sont soutenus par des colonnes en pierre. **A DROITE** L'escalier débouche sur un arc trilobé dans une des galeries de l'étage qui ceint le patio. Le plafond en bois est peint en « bleu havane », une référence à la proximité de la mer. **PAGE DE DROITE** Dans une des galeries du patio, un arc en plein cintre couronne la belle porte d'inspiration baroque flanquée de pilastres ouvragés donnant sur l'escalier.

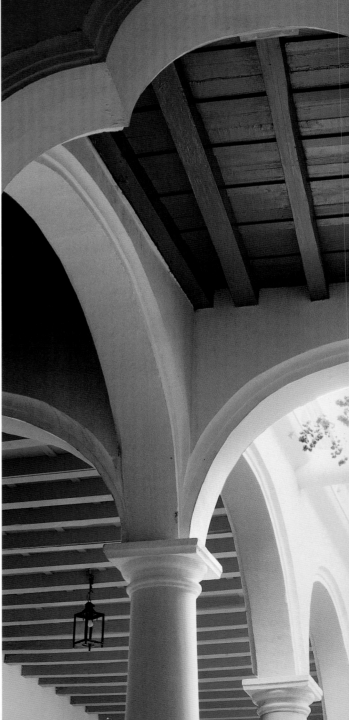

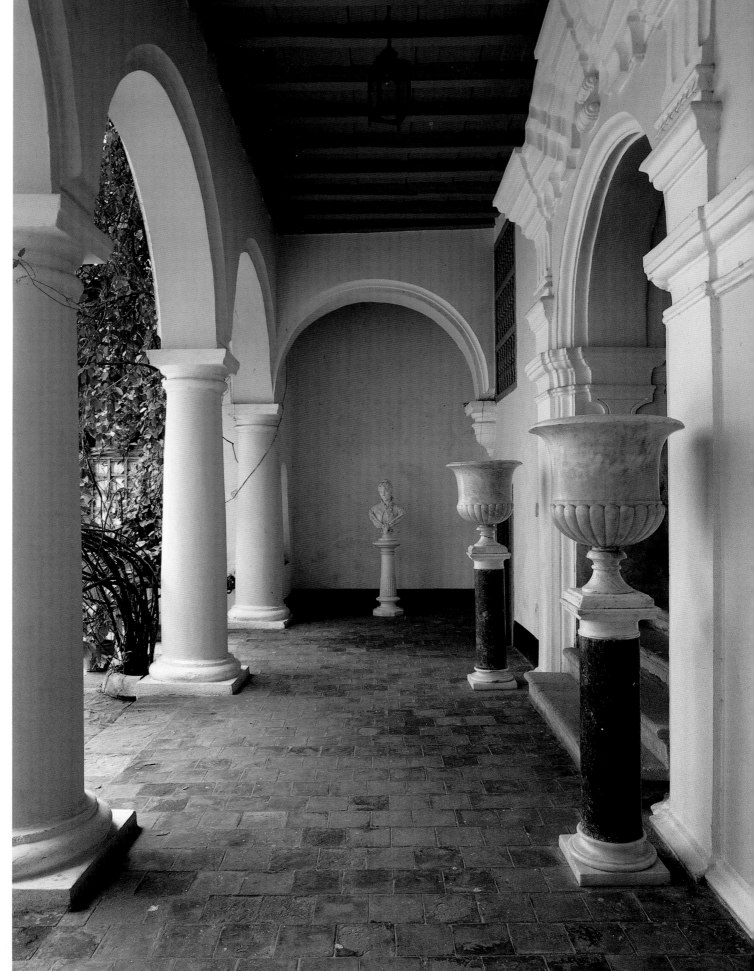

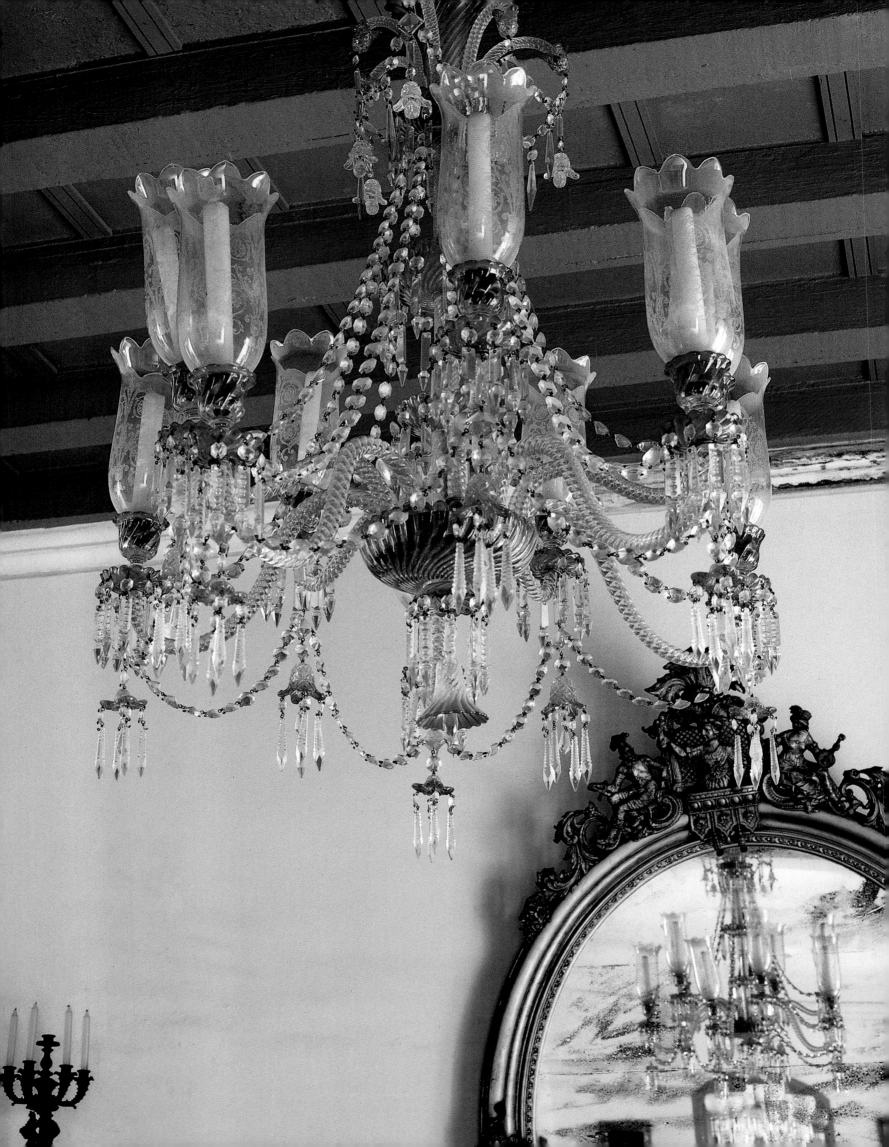

✳ **FACING PAGE** One of the beautiful bronze and crystal chandeliers hanging from the ceiling is reflected in the oval wall mirror at the back of the sumptuous living room. **RIGHT** Cuban Medallón-style chairs share space with a ceramic umbrella stand, a pink Sèvres vase and a copy of the anonymous portrait entitled "La Bella". In the background, the friezes with floral motifs retrieved during the restoration. **BELOW** The enormous living room, with 19th century Cuban furniture and objects of enormous artistic value — including French, Italian and German porcelain vases — is enhanced by its location near the street and the courtyard, providing proper ventilation and natural light. ✳ **LINKE SEITE** Eine der wunderschönen Deckenlampen aus Kristall spiegelt sich in dem ovalen Wandspiegel am Ende des prächtigen Saals. **RECHTS** Kubanische Medaillonstühle teilen sich den Raum mit einem Schirmständer aus Steingut, einer Vase aus rosafarbenem Sèvres-Porzellan und einer Nachbildung des anonymen Portraits mit dem Titel »La Bella« (»Die Schöne«). Im Hintergrund sieht man die Zierleisten mit Blumenmotiven der bei der Renovierung freigelegten Wände. **UNTEN** Der gewaltige Saal, dekoriert mit kubanischem Mobiliar aus dem 19. Jahrhundert und mit künstlerisch wertvollen Werken – Vasen aus französischem, italienischem und deutschem Porzellan –, wird dank seiner Lage zwischen Straße und Innenhof von einer angemessenen Belüftung und natürlichem Tageslicht begünstigt. ✳ **PAGE DE GAUCHE** Un des beaux lustres en bronze et cristal se reflète dans le miroir du somptueux salon. **CI-DESSOUS** Des chaises médaillons cubaines partagent l'espace avec un porte-cannes en faïence, une potiche rose de Sèvres et la copie d'un portrait anonyme intitulé « La Belle ». La plinthe peinte de motifs floraux a été récupérée lors de la restauration. **A DROITE** L'immense salon, décoré avec des meubles cubains du 19e siècle et de précieux objets d'art (potiches en porcelaine française, italienne et allemande) donne d'un côté sur la rue et de l'autre sur le patio. Il est donc bien aéré et inondé de lumière naturelle.

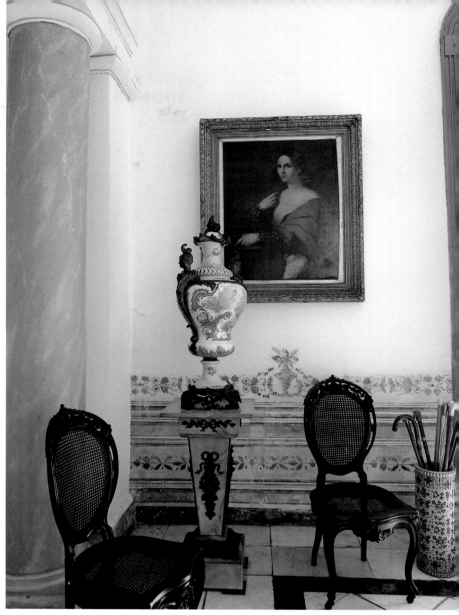

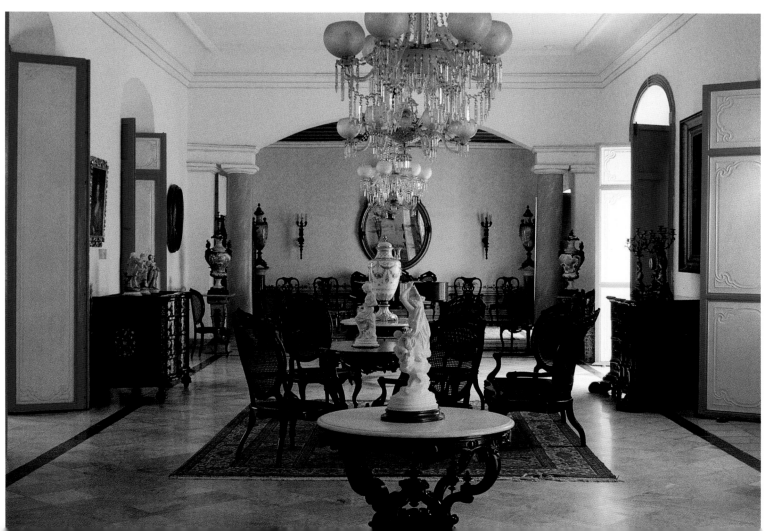

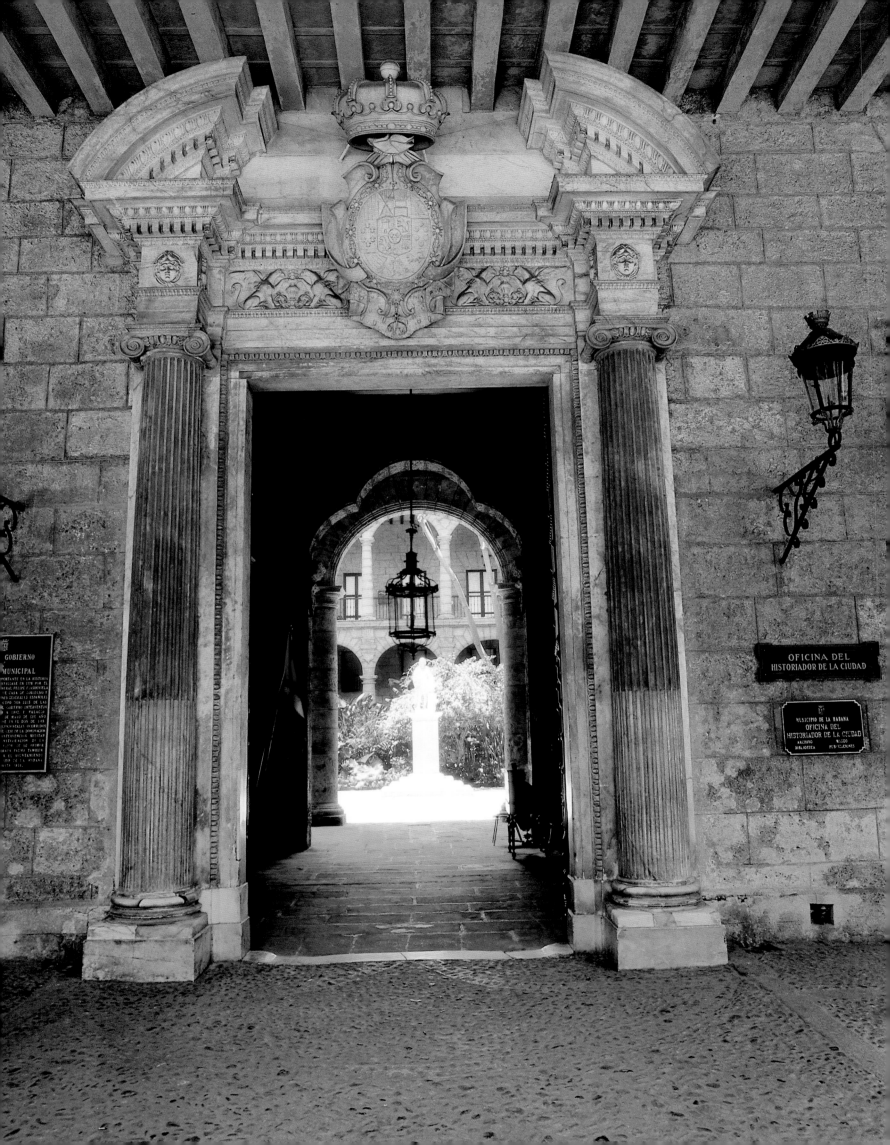

PALACIO DE LOS

Capitanes

Generales

A Monumental but Not Imposing Palace.

The city's first square, the Plaza de Armas, was laid out near Havana's harbor early in the 16th century. In 1773, under the rule of Spanish governor Marquis de la Torre, it was transformed into a civic center, and the construction of the "Palacio de los Capitanes Generales" and the Palace of the Post Office, by Fernández Trevejos and Pedro de Medina, was finished by 1791. Unanimously acclaimed as the greatest building of the 18th century, and one of the most outstanding in all of Cuba, the Governor's palace has a monumental but not imposing presence thanks to its pleasing proportions, the sober, linear, baroque style, and the detailing of its coral-stone façades. A fine Carrara marble portal, executed by the Italian sculptor Giuseppe Gaggini in 1835, leads to the vestibule and magnificent arcaded central courtyard. In the middle, surrounded by lush tropical plants, is a statue of Christopher Columbus by J. Cucchiari from 1862. The White Hall upstairs and the Hall of Mirrors are decorated with emblems and portraits of Spanish kings and queens, and the flooring is made of marble from Genoa. While the White Hall was used for feasts and celebrations, the Hall of Mirrors was employed for official ceremonies such as the transfer of the island to the US government by the last Spanish governor in 1899.

Die Plaza de Armas in der Nähe des Hafens wurde im frühen 16. Jahrhundert als erster Platz Havannas angelegt. Der spanische Gouverneur Marquis de la Torre machte daraus 1773 ein Zentrum der öffentlichen Verwaltung, und bis 1791 wurden dort der Palast der Generalherrschaft und das palastartige Postgebäude von Fernández Trevejos und Pedro de Medina fertiggestellt. Der monumentale Gouverneurspalast ist ohne Zweifel das großartigste Gebäude des 18. Jahrhunderts in Kuba. Der nüchterne, lineare Barockstil und auch die Fassade aus Korallenstein verleihen seiner Monumentalität eine gewisse Leichtigkeit. Durch ein elegantes Portal aus Carrara-Marmor des italienischen Bildhauers Giuseppe Gaggini von 1835 gelangt man ins Vestibül und danach in den wunderbaren, mit Arkaden gesäumten Innenhof. Zwischen üppigen tropischen Pflanzen steht eine Christoph-Kolumbus-Statue von J. Cucchiari aus dem Jahr 1862. Im oberen Stockwerk befinden sich die Weiße Halle und der Spiegelsaal mit Wappen und Porträts der spanischen Könige und Königinnen. Die Böden sind mit Marmor aus Genua ausgelegt. Während die Weiße Halle für Feste und Feierlichkeiten benutzt wurde, diente der Spiegelsaal für offizielle Anlässe. Hier übertrug 1899 der letzte spanische Gouverneur die Herrschaft über Kuba der US-Regierung.

La première place de la Havane, la Plaza de Armas, fut créée près du port au début du 16e siècle. En 1773, le gouverneur espagnol, le marquis de la Torre, en fit un centre civique. La construction de la capitainerie générale et du palais de la poste par Fernández Trevejos et Pedro de Medina fut achevée en 1791. Unanimement salué comme le plus beau bâtiment du 18e siècle et l'un des fleurons de Cuba, le palais du gouverneur possède une présence monumentale sans être imposant grâce à ses proportions agréables, son style baroque sobre et linéaire, les détails de ses façades en pierre de corail. Un beau portail en marbre de Carrare, œuvre du sculpteur italien Giuseppe Gaggini (1835), mène au vestibule et à la magnifique cour centrale bordée d'arcades. Au milieu, une statue de Christophe Colomb par J. Cucchiari (1862) trône au milieu des plantes tropicales. À l'étage, la galerie blanche et la galerie des miroirs sont décorées d'écus et de portraits des rois et des reines d'Espagne. Leur sol est en marbre de Gênes. Le premier accueillait des banquets et des réceptions, tandis que le second servit à des cérémonies officielles telles que le transfert de l'île au gouvernement américain par le dernier gouverneur espagnol en 1899.

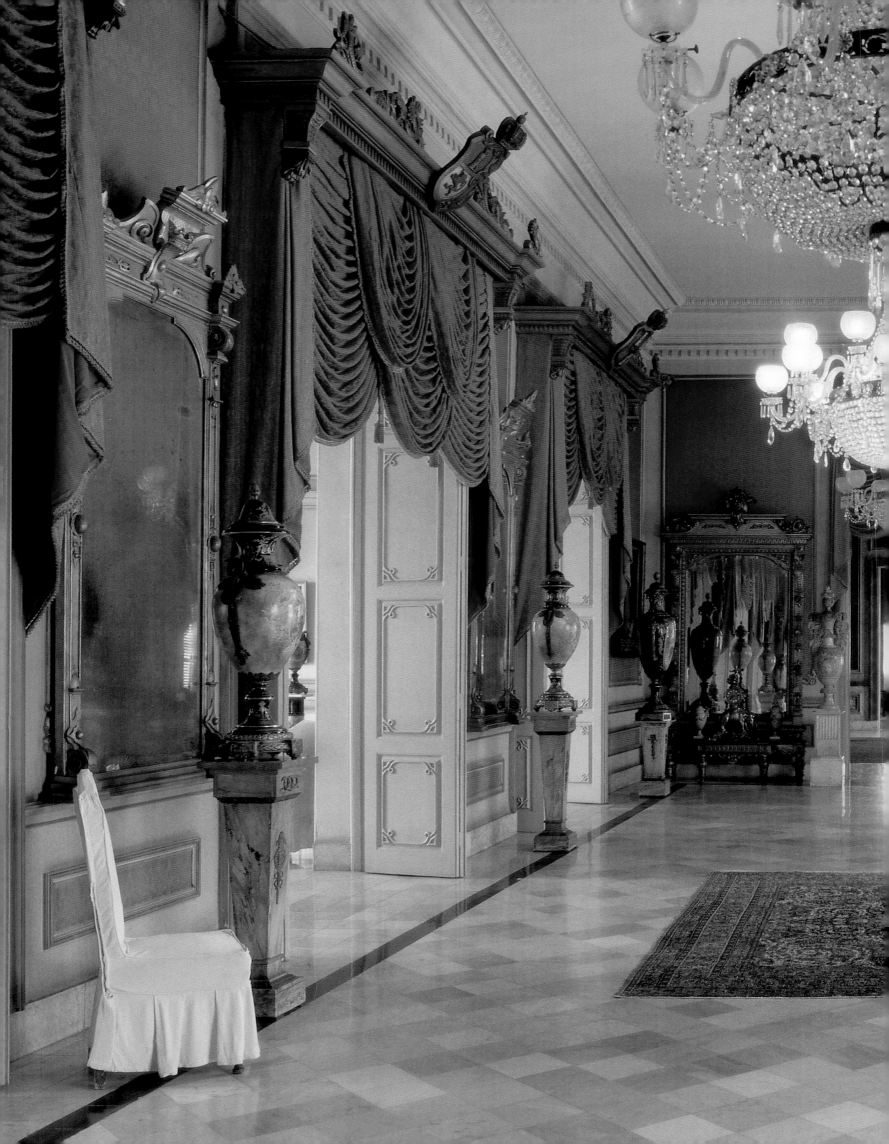

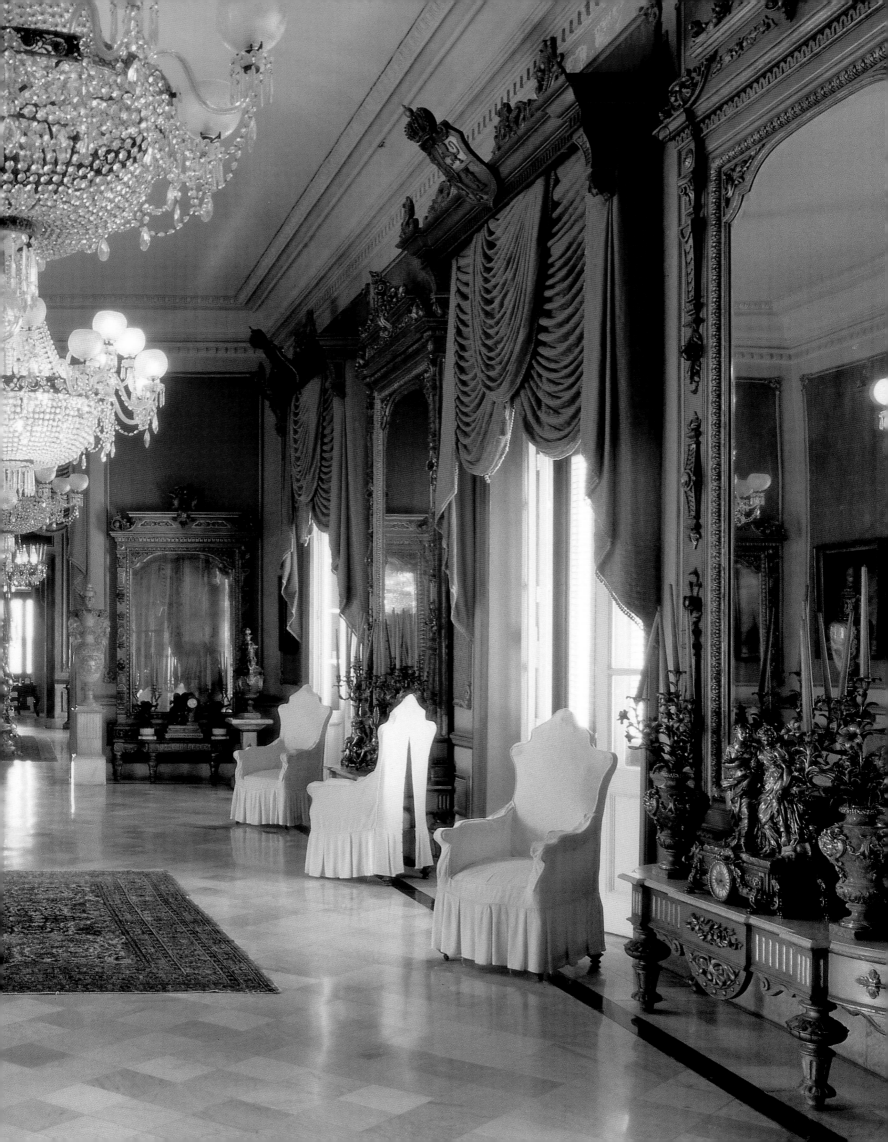

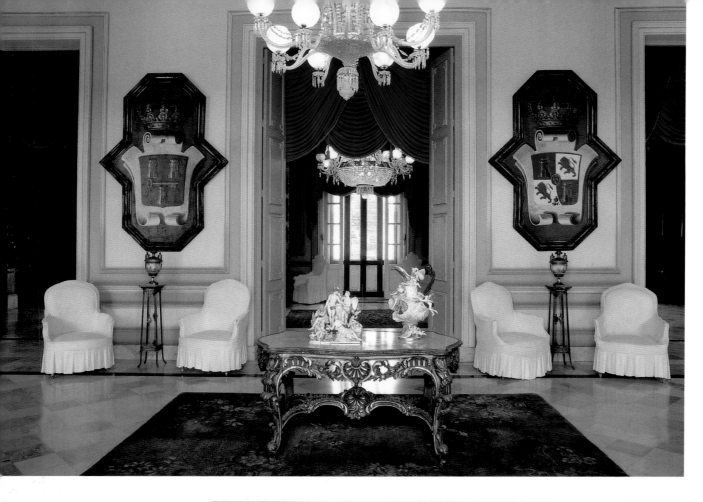

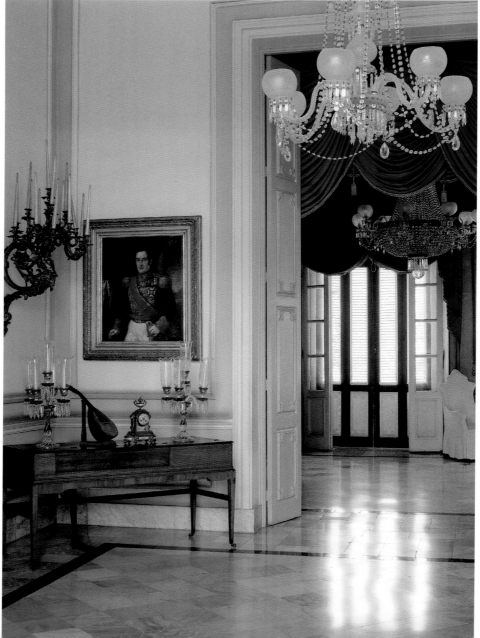

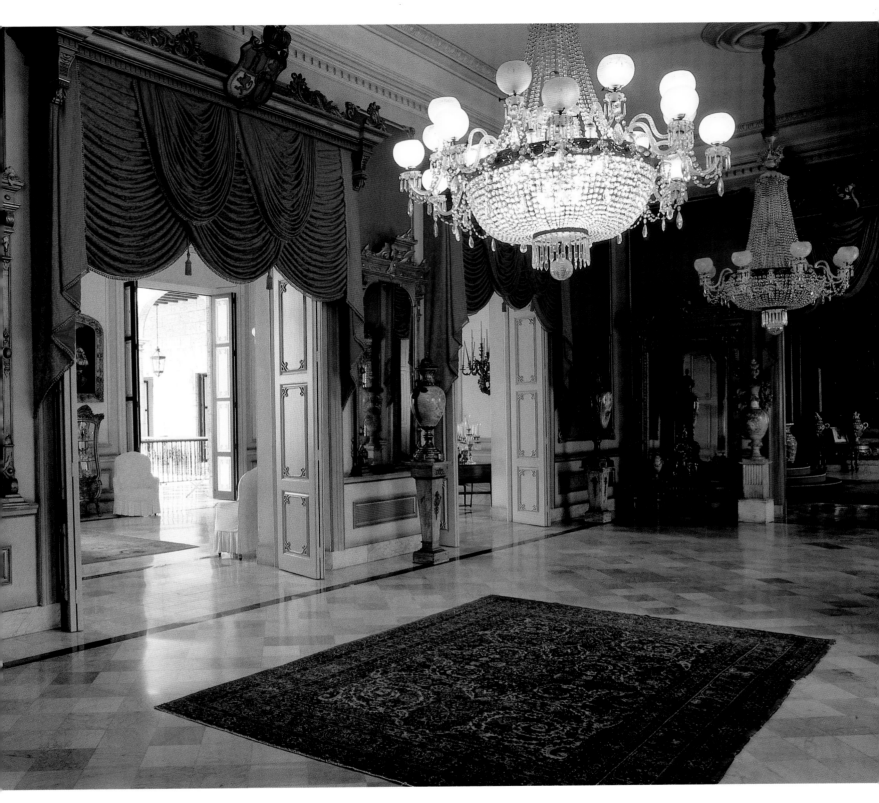

※ **PREVIOUS DOUBLEPAGE** The Hall of Mirrors is richly decorated with Baccarat crystal chandeliers, Sèvres porcelain and Venetian mirrors. **LEFT ABOVE** The White Hall, which served as an antechamber, is decorated with the emblems of the main fortresses in Havana and the Spanish kingdoms in Castilla y León. **LEFT** A mandolin, a French clock, several lovely candelabra and harpsichord in one of the corners of the White Hall. **ABOVE** The luxurious Hall of Mirrors was the most important room in the "Palacio de los Capitanes Generales," were official ceremonies held. **FOLLOWING PAGES** The French Baccarat crystal chandelier painstakingly reconstructed during the latest restoration of the "Palacio de los Capitanes Generales," now reflects the City Museum. In the background, the chapel with its baroque altar. ※ **VORHERGEHENDE DOPPELSEITE** Der Spiegelsaal ist reichlich dekoriert mit Lampen aus Baccarat-Kristall, Sèvres-Porzellan und venezianischen Spiegeln, deren Rahmen mit Gold überzogen sind. **OBEN LINKS** Der Weiße Saal diente einst als Vorzimmer und ist mit den Wappen der wichtigsten Festungen Havannas und der alten spanischen Königreiche von Kastilien und León dekoriert. **LINKS** Eine Mandoline, eine französische Uhr und prächtige Kandelaber auf einem Klavichord in einer Ecke des Weißen Saals. **OBEN** Im luxuriösen Spiegelsaal fanden die offiziellen Feierlichkeiten statt. **FOLGENDE DOPPELSEITE** Die französische Deckenlampe aus Baccarat-Kristall wurde rekonstruiert, als man den »Palacio de los Capitanes Generales« zuletzt für seine derzeitige Funktion als Stadtmuseum renovierte. Im Hintergrund sieht man die Kapelle mit ihrem Barockaltar. ※ **DOUBLE PAGE PRECEDENTE** Le salon des miroirs, richement décoré avec des lustres cristal de Baccarat, des porcelaines de Sèvres et des miroirs vénitiens dans des cadres dorés à la feuille. **PAGE DE GAUCHE, EN HAUT** Le salon blanc servait d'antichambre. Il est décoré des blasons des principales forteresses de la Havane et des anciens royaumes espagnols de Castilla y León. **A GAUCHE** Une mandoline, une horloge française et deux beaux candélabres sur un clavecin dans un coin du salon blanc. **CI-DESSUS** Le luxueux salon des miroirs accueillait les cérémonies officielles. **DOUBLE PAGE SUIVANTE** Lustre français en cristal de Baccarat minutieusement reconstitué lors de la dernière restauration du palais avant qu'il ne devienne le musée de la ville. Au fond, la chapelle avec son autel baroque.

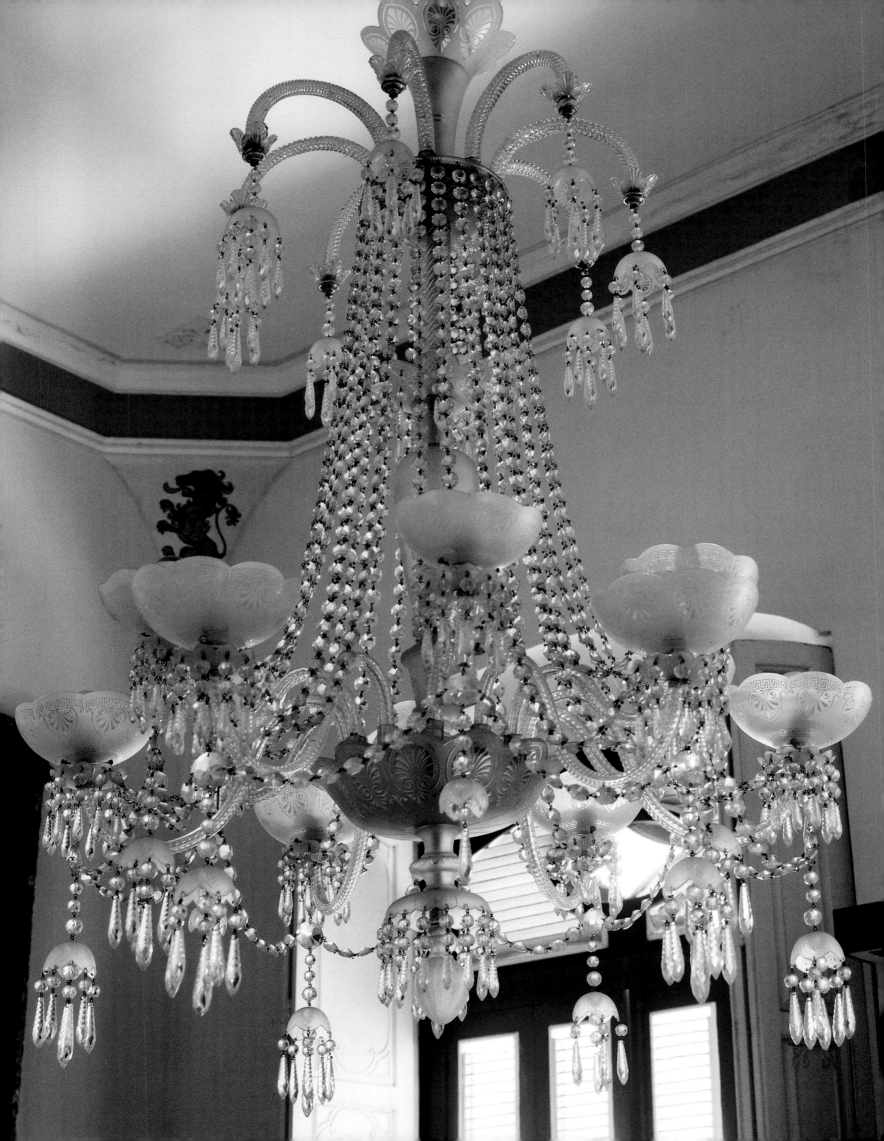

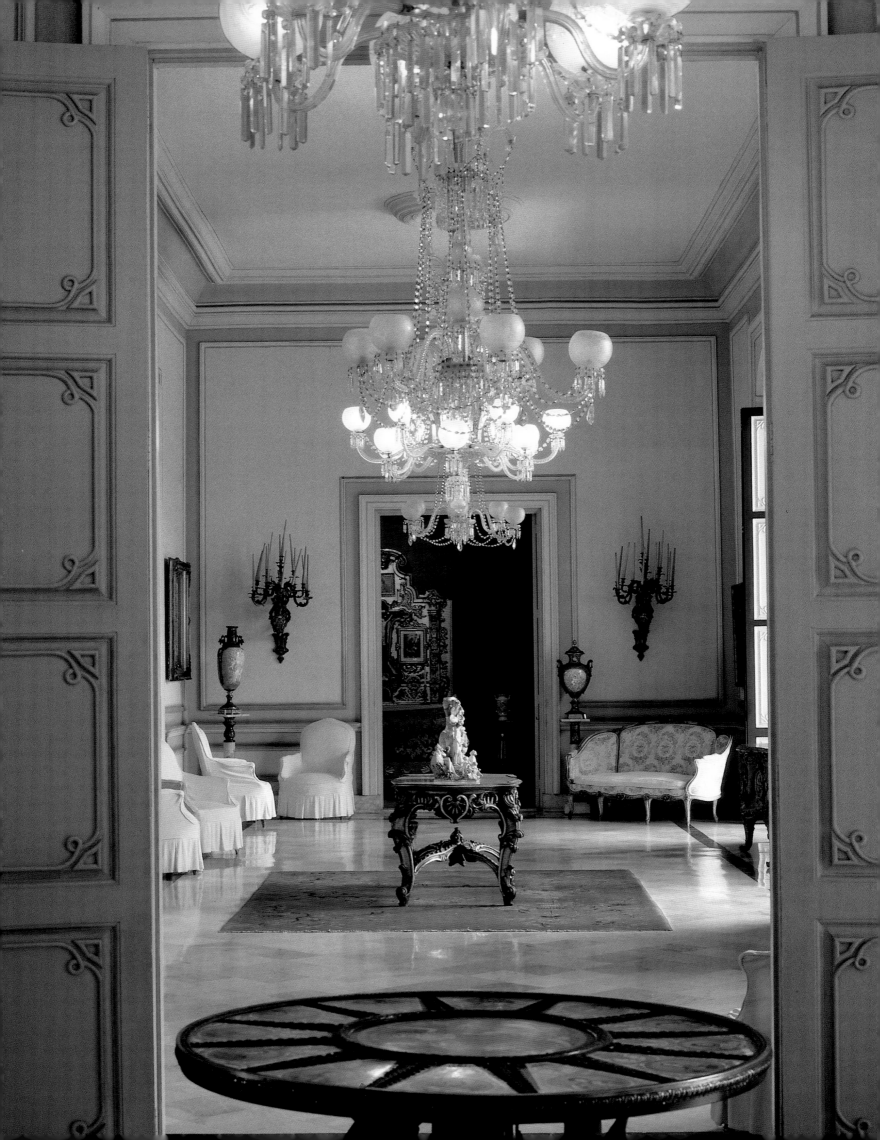

LA BODEGUITA

DEL MEDIO

"My mojito in La Bodeguita."

You might not be able to make out the lyrics, but you can still enjoy the music and the mojito cocktails that Ernest Hemingway drank at this famous bar and restaurant: it was here, when asked about his favorite Cuban rum cocktails, that he answered, "My mojito in La Bodeguita, my daiquiri in El Floridita." No neon signs are needed – the bar and restaurant open onto a street near the cathedral square and it is always jammed with foreign tourists anxious to enjoy the "moros y cristianos" (black beans and white rice), the exquisite roasted pork, and the root vegetables and fried plantains. This unique place, once a grocery store and a printing office, became famous as a center of bohemian life; this is reflected by the graffiti its walls treasure. Robert de Niro, Jack Lemmon, Muhammad Ali, Paolo Rossi, and Claudia Cardinale are among the famous visitors who have left their autographs for posterity. If you want to make a mojito like Hemingway's, put sugar, limes and a sprig of mint into a tall glass. Add a jigger of Havana Club Silver Dry, fill with ice and club soda, then stir.

»My mojito in La Bodeguita, my daiquiri in El Floridita« pflegte Ernest Hemingway zu antworten, wenn man ihn nach seinen Lieblingscocktails fragte. Die Bar und das Restaurant »La Bodeguita« findet man auch ohne leuchtende Neonschilder. Die Stammbar Hemingways in der Nähe der Kathedrale ist immer vollbepackt mit Touristen, die zwischen Musik und Rumcocktails »Moros y Cristianos« (schwarze Bohnen mit weißem Reis), köstlich gebratenes Schwein, Wurzelgemüse und frittierte Kochbananen ausprobieren. »La Bodeguita«, früher ein Lebensmittelgeschäft und eine Buchdruckerei, hat sich einen Namen für ausgelassenes Vergnügen gemacht. Die Graffiti an den Wänden stammen aus den wilden Zeiten, in denen Robert de Niro, Jack Lemmon, Muhammad Ali, Paolo Rossi und Claudia Cardinale zu den prominenten Besuchern gehörten. Sie alle haben der Nachwelt ihre Autogramme hinterlassen. Wer einen Mojito genießen möchte, ohne nach Kuba zu reisen: Zucker, Limetten mit einem Zweig Pfefferminze in ein hohes Glas füllen und zerstampfen. Eis und ein Schnapsglas mit Havana Club Silver Dry dazugeben, mit Sodawasser auffüllen und umrühren.

Même sans comprendre les paroles, on peut apprécier la musique et le mojito qu'Hemingway buvait dans ce célèbre bar et restaurant : c'est ici que, interrogé sur le cocktail cubain à base de rhum qu'il préférait, il répondit : « Mon mojito à La Bodeguita, mon daiquiri à El Floridita.» Nul besoin d'une enseigne au néon : le bar/restaurant situé près de la place de la cathédrale est toujours bondé de touristes voulant goûter au « moros y cristianos » (« maures et chrétiens », haricots noirs et riz blanc), au délicieux porc rôti, aux racines végétales et aux plantains frits. Ce lieu unique, autrefois épicerie et imprimerie, devint un célèbre centre de la vie bohème, ce dont témoignent les graffitis qui recouvrent ses murs. Robert de Niro, Jack Lemmon, Muhammad Ali, Paolo Rossi et Claudia Cardinale comptent parmi ceux qui y ont laissé leurs autographes pour la postérité. Pour préparer un mojito à la Hemingway : mettre du sucre, du citron vert et une branche de menthe dans un grand verre avec de la glace ; ajouter une mesure de Havana Club Silver Dry, remplir de soda, remuer.

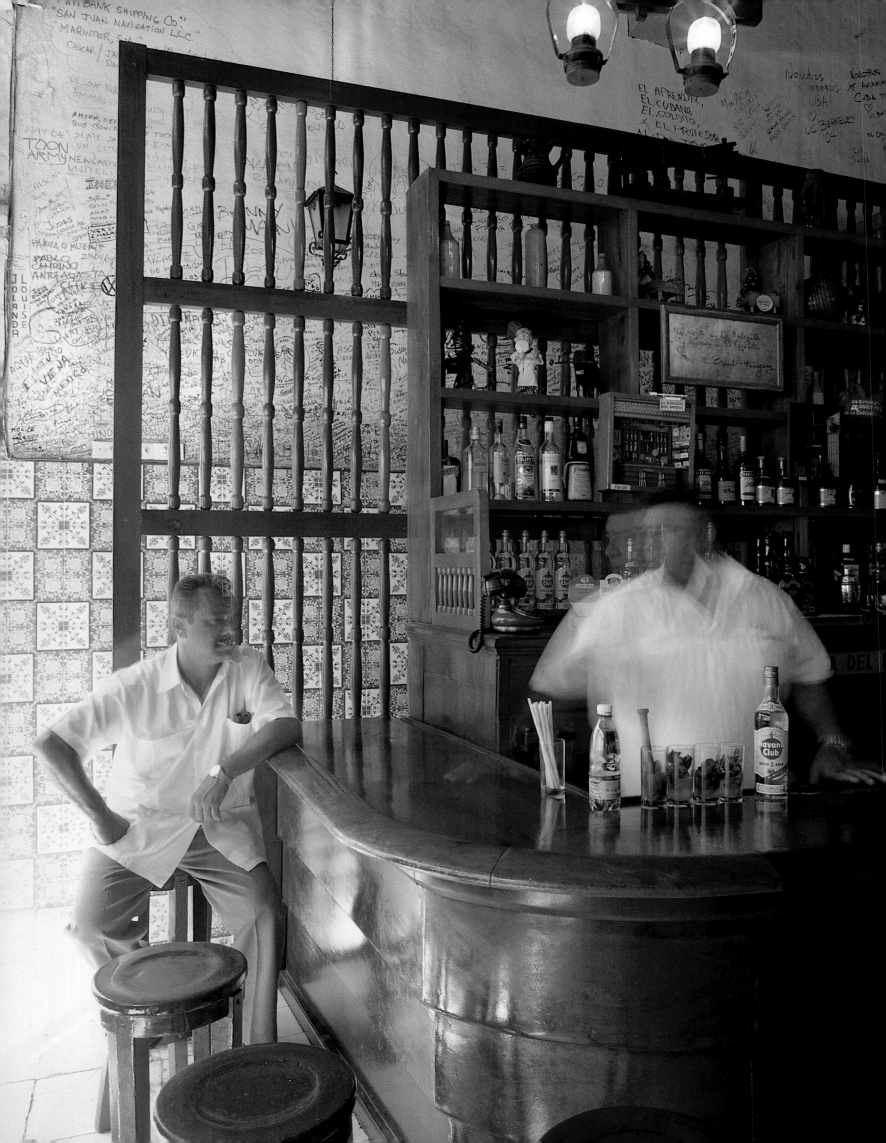

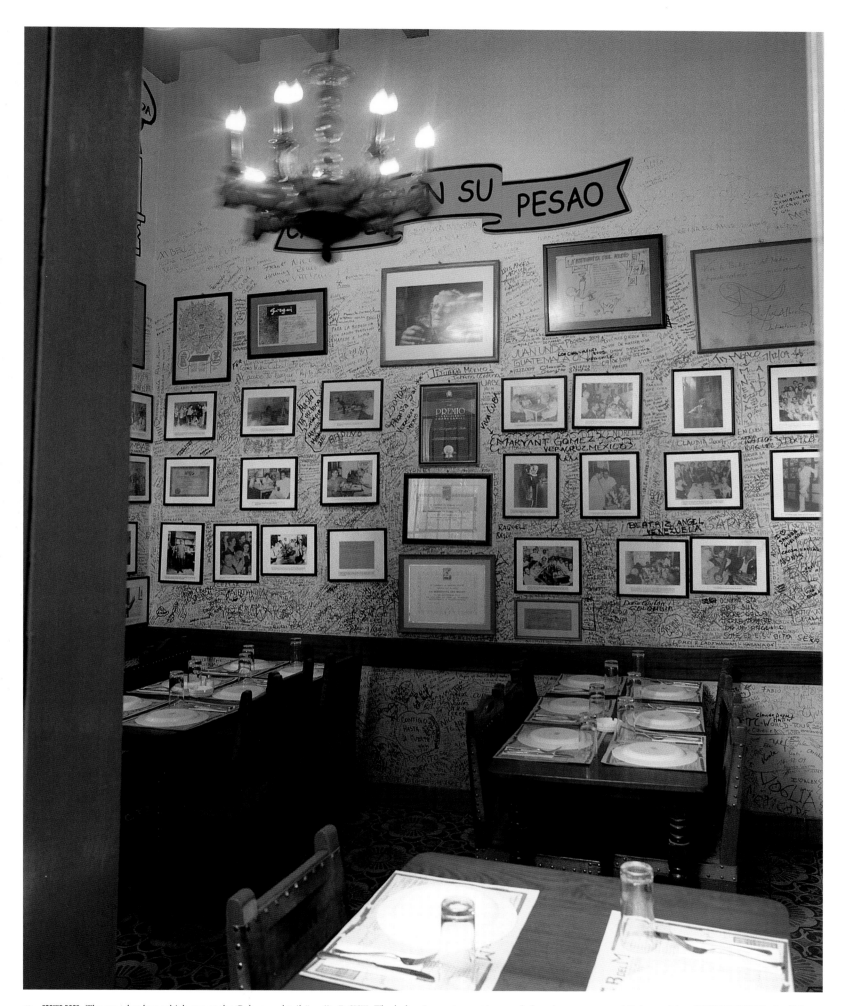

※ **FACING PAGE** The wooden bar, which serves the Cuban cocktail "mojito". **ABOVE** The bohemian restaurant is regarded as the sanctuaray of Cuban cuisine. **FOLLOWING DOUBLEPAGE** Graffiti on the tiled walls bears witness to the countless guests. ※ **LINKE SEITE** An der Bar wird der kubanische Cocktail Mojito serviert. **OBEN** Das Restaurant gilt als Tempel der kubanischen Küche. **FOLGENDE DOPPELSEITE** Die Inschriften über dem Fliesensockel zeugen von unzähligen Besuchern. ※ **PAGE DE GAUCHE**. Le comptoir en bois où l'on sert des « mojito ». **CI-DESSUS** Le restaurant bohème, considéré comme le sanctuaire de la cuisine cubaine. **DOUBLE PAGE SUIVANTE** Les graffitis qui recouvrent le mur au-dessus du lambris en azulejos témoignent des innombrables visiteurs.

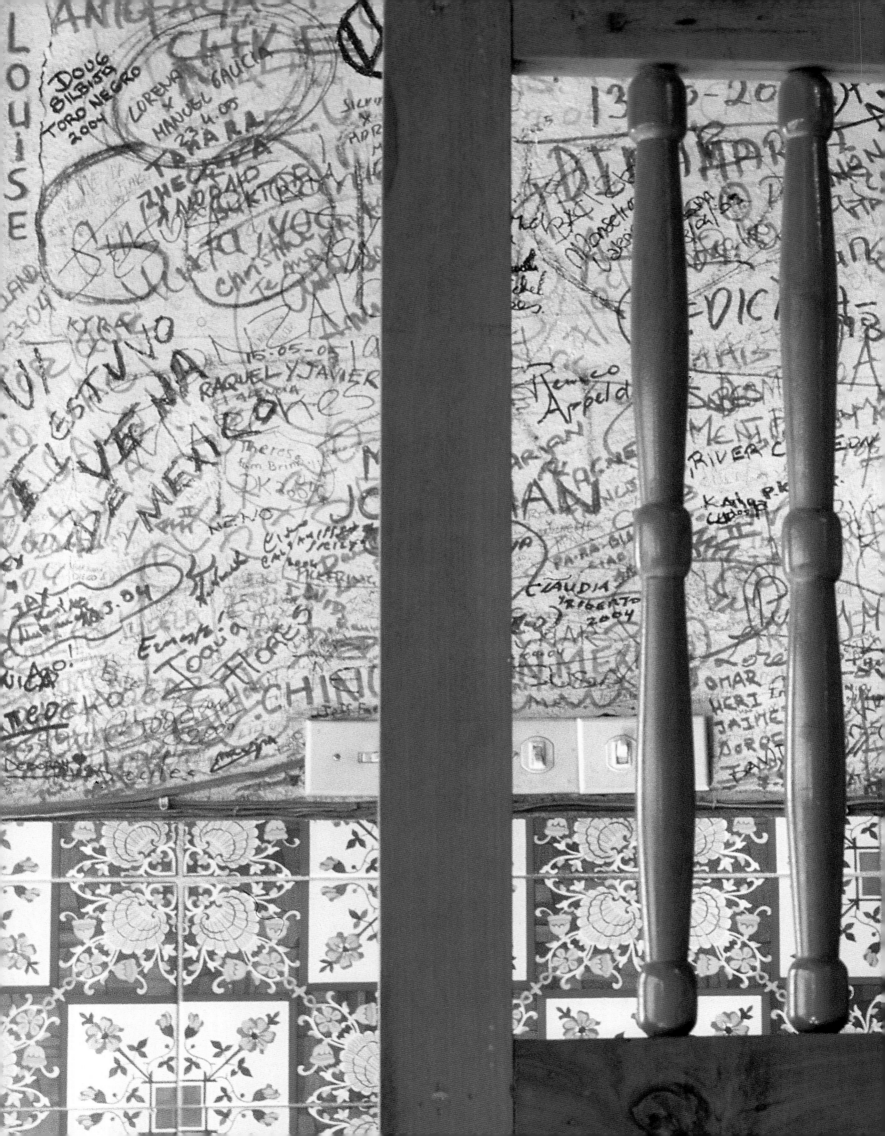

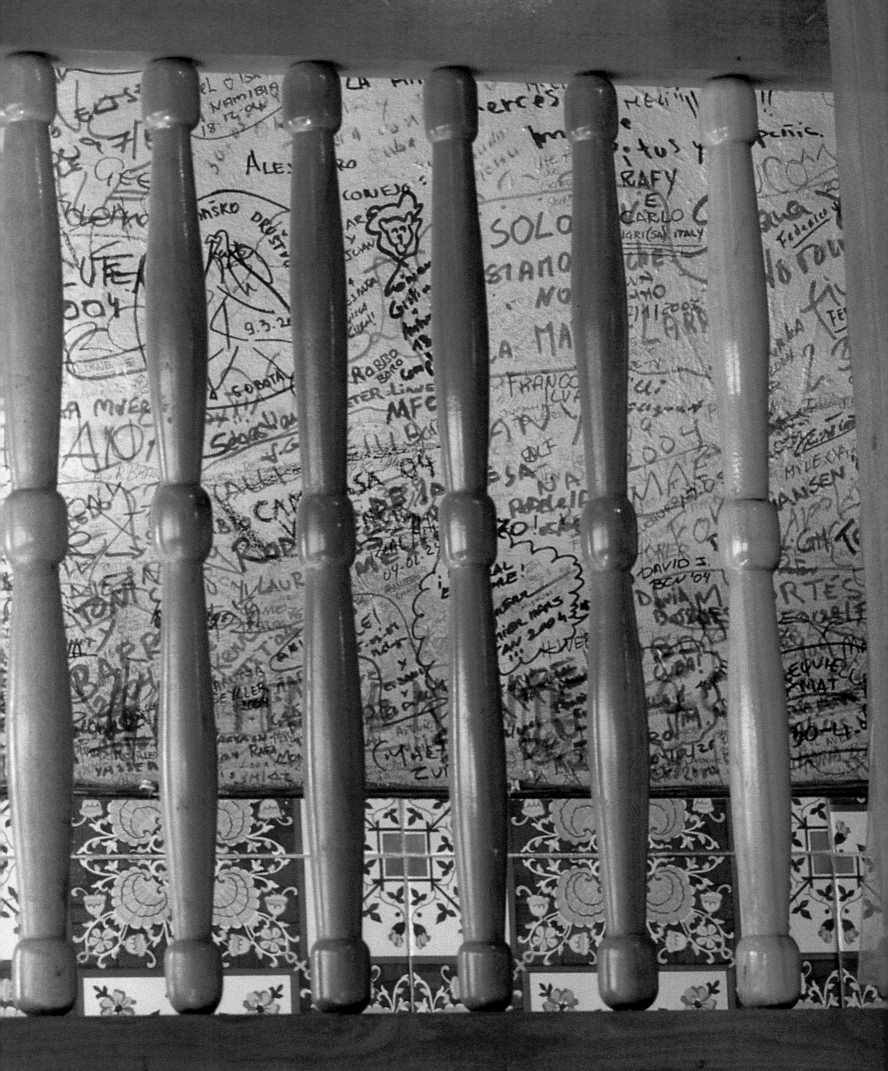

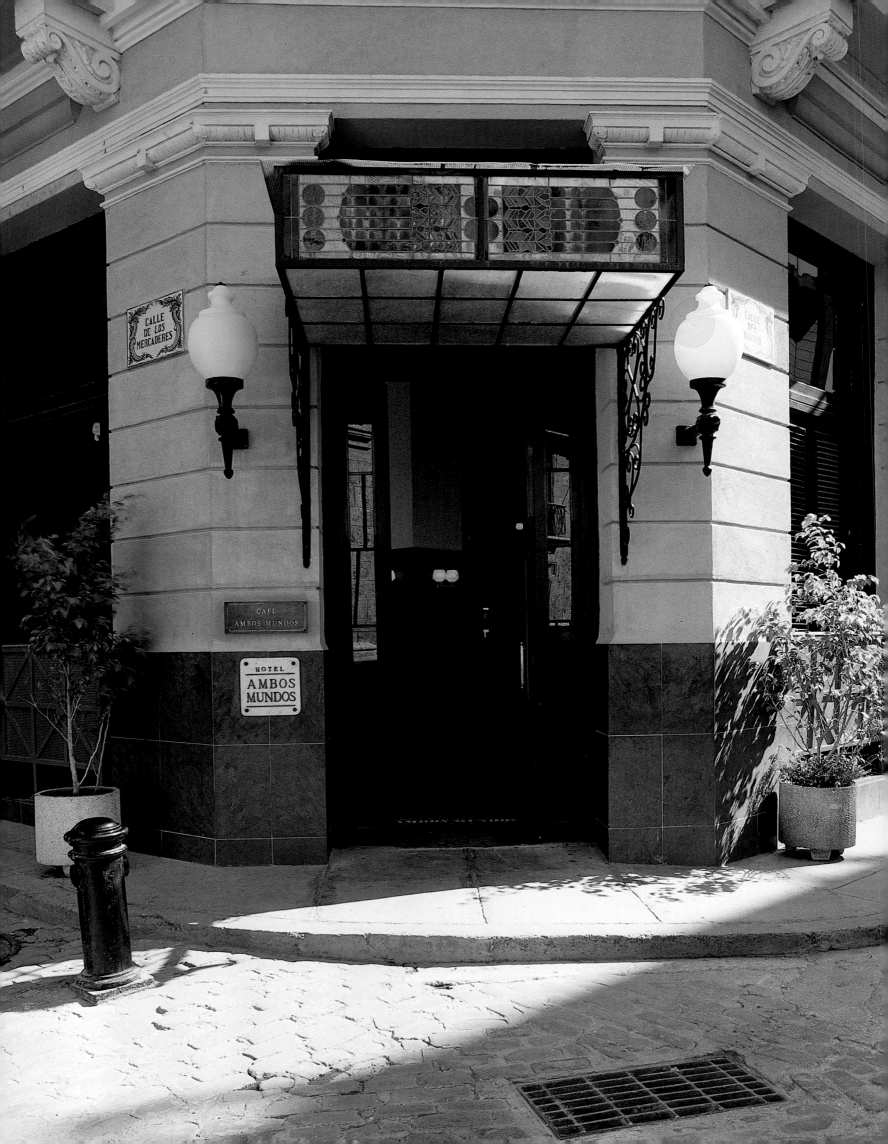

HOTEL
AMBOS MUNDOS & EL FLORIDITA

Hemingway in Cuba.

One of the main attractions of the "Hotel Ambos Mundos" is undoubtedly the same one that fascinated Hemingway: its discreet rooftop bar that has excellent views of Old Havana with the harbor in the background. He confessed in an interview that Ambos Mundos was a good place to write, and he rented the northeast corner room on the fifth floor every time he returned to the city. It was here, in 1939, that he began "For Whom the Bell Tolls," before his third wife, Martha Gellhorn, persuaded him to move to Finca Vigía. Hemingway loved walking from the "Ambos Mundos" down Calle Obispo to El Floridita for a drink. Located at the corner of Mercaderes and Calle Obispo – two of the busiest thoroughfares in Old Havana – the hotel looks inviting from the outside with its, eclectic pink façade and permanently opened doors that allow for interaction with the active street life near the Plaza de Armas. The lobby bar takes up most of the ground floor area, where you have the choice of having coffee or something a little stronger and then taking the old elevator up to room 511. Today the room is kept like a museum, housing some of Hemingway's personal belongings, and from its window you can look out at the same Old Havana Hemingway enjoyed, although it is now undergoing major restoration.

Die Bar des »Hotels Ambos Mundos« ist ein bekannter Treffpunkt. Bereits Ernest Hemingway war von der Bar auf dem Dach des Hotels begeistert. Von hier hat man eine tolle Sicht auf die Altstadt von Havanna und auf den Hafen. In einem Interview sagte Hemingway, das »Ambos Mundos« sei ein idealer Ort zum Schreiben. Wann immer er sich in der Stadt aufhielt, mietete er ein Zimmer im Nordost-Flügel im fünften Stock. Hier begann er auch seinen Roman »Wem die Stunde schlägt«. Seine dritte Frau, Martha Gellhorn, überzeugte ihn dann, die »Finca Vigía« zu seinem Wohnsitz zu machen. Hemingway liebte es, vom »Ambos Mundos« ins »El Floridita« an der Obispo Calle hinüberzulaufen. Das Hotel liegt an der Kreuzung der Mercaderes und Obispo Calle, zwei belebte Durchgangsstraßen in der Altstadt. Das rosa Hotel sieht einladend aus, die Türen sind stets offen, das Straßenleben auf der Plaza de Armas spielt sich so auch im Hotel ab. Die Bar in der Lobby nimmt fast das gesamte Erdgeschoss ein. Hier trinkt man Kaffee, aber auch Hochprozentiges. Gestärkt fährt man dann im Fahrstuhl hoch ins Zimmer 511, das ehemalige Zimmer Hemingways, heute ein kleines Museum. Von hier kann man sich an der Aussicht auf die Altstadt Havanas erfreuen, die allerdings gerade aufwändig renoviert wird.

Comme tout le monde, Hemingway n'a pas résisté à l'un des attraits principaux de l'«Hôtel Ambos Mundos»: son bar discret sur le toit qui jouit de vues imprena-bles sur la vieille Havane avec son port en toile de fond. Il a confié dans un entretien que l'hôtel était un bon endroit pour écrire. Il louait la chambre d'angle du cinquième étage donnant sur le nord-ouest chaque fois qu'il descendait en ville. C'est là, en 1939, qu'il a commencé «Pour qui sonne le glas» avant que sa troisième femme, Martha Gellhorn, ne le convainque de s'installer à la Finca Vigía. Il adorait descendre la rue Obispo pour aller prendre un verre au El Floridita. Situé au carrefour des Calle Obispo et Mercaderes, deux des artères les plus passantes de la vieille ville, l'hôtel possède une accueillante façade rose, ses portes ouvertes en permanence laissant filtrer l'animation de la Plaza de Armas voisine. Un bar occupe la quasi-totalité du rez-de-chaussée. Vous pouvez y prendre un café ou un verre de bon rhum avant de monter dans le vieil ascenseur jusqu'à la chambre 511. Devenue musée, elle abrite des effets personnels de l'écrivain. De la fenêtre, vous pourrez voir la même vieille Havane qu'aimait Hemingway, quoi qu'aujourd'hui en pleine restauration.

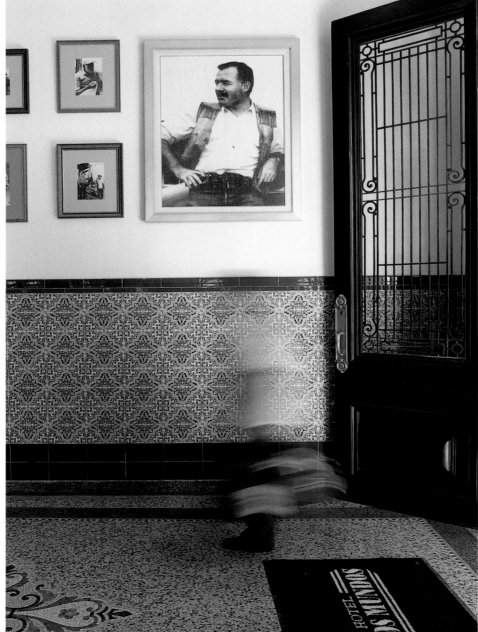

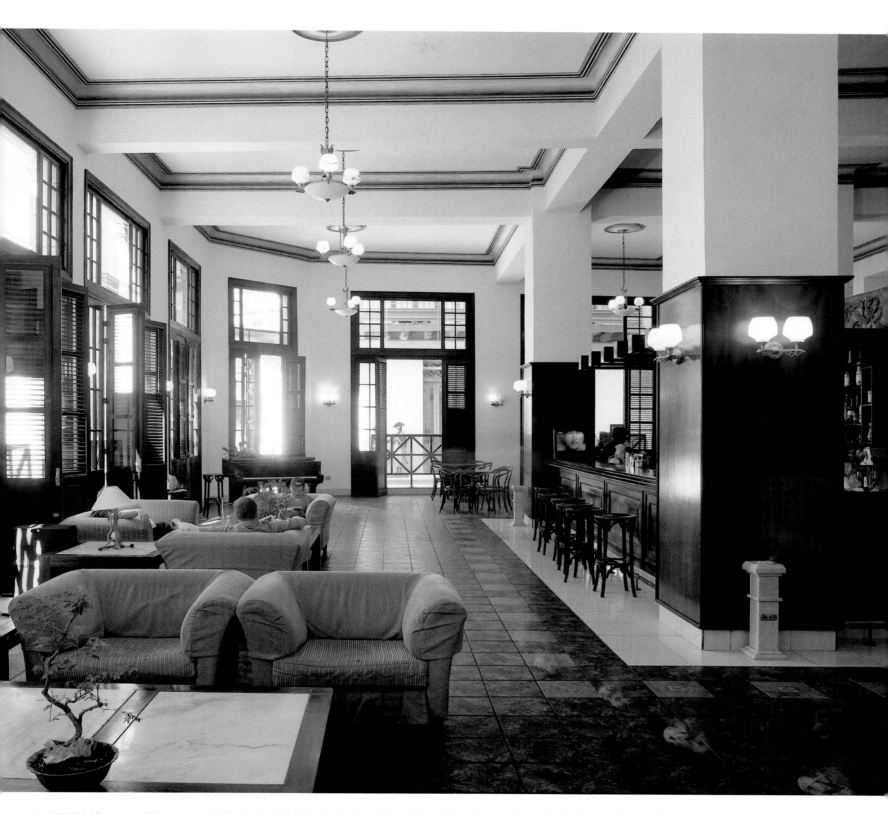

✳ **ABOVE LEFT** The corner of the reception hall at the "Hotel Ambos Mundos" with a white marble staircase and an old lift leading to the upper floors. **LEFT** The entrance to "Hotel Ambos Mundos" via Calle Obispo. Above the tile wainscot hang historical photos of the American writer Ernest Hemingway, which bear witness to his stints at the hotel during the 1930s. **ABOVE** The cozy Piano Bar in the main hall of the "Hotel Ambos Mundos" seen from the hotel's entrance via Calle Obispo. ✳ **OBEN LINKS** Die Ecke der Empfangshalle des »Hotel Ambos Mundos«, in der sich eine Treppe aus weißem Marmor und der alte Aufzug für die Obergeschosse befinden. **LINKS** Der Eingang des »Hotel Ambos Mundos« in der Calle Obispo. Über einem Fliesensockel hängen historische Aufnahmen des nordamerikanischen Schriftstellers Ernest Hemingway und zeugen von seinem Aufenthalt im Hotel in den 1930er-Jahren. **OBEN** Blick auf die einladende Piano-Bar in der Empfangshalle des »Hotel Ambos Mundos« vom Hoteleingang in der Calle Obispo. ✳ **PAGE DE GAUCHE, EN HAUT** Un coin du hall de réception de l'hôtel, avec son escalier en marbre blanc et son vieil ascenseur. **A GAUCHE** L'entrée de l'hôtel donnant sur la rue Obispo. Au-dessus des lambris en azulejos, des photos anciennes d'Ernest Hemingway témoignent de ses séjours au cours des années 30. **CI-DESSUS** L'accueillant piano-bar du vestibule, vu depuis la porte donnant sur la rue Obispo.

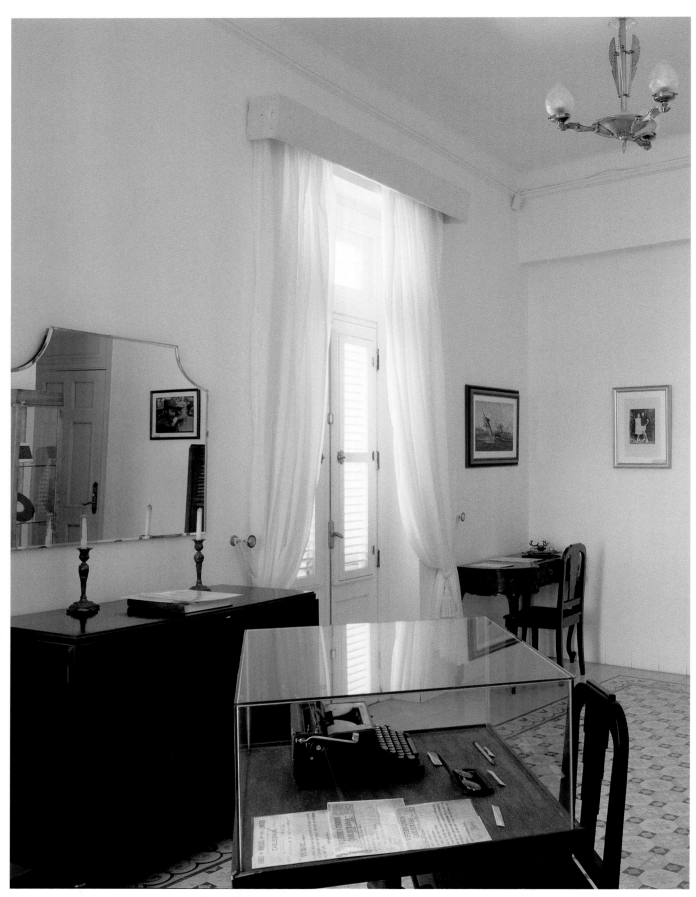

❋ **ABOVE AND FACING PAGE** Room number 511, where Ernest Hemingway began the final draft of "For Whom the Bell Tolls", conserved as a museum is decorated with some of his belongings. **FOLLOWING PAGES** The refined, cosmopolitan atmosphere of the Bar "El Floridita" with its statue of Ernest Hemingway in the background, at the spot at the bar where he used to drink daiquiris, the famous cocktail that the writer would help to immortalize. ❋ **OBEN UND RECHTE SEITE** Das Zimmer mit der Nummer 511, wo Ernest Hemingway seinen letzten Entwurf für den Roman »Wem die Stunde schlägt« begann, wird als Museum erhalten. Es ist mit einigen seiner Besitztümer dekoriert. **FOLGENDE DOPPELSEITE** Die Bar »El Floridita«, im Hintergrund die Bronzestatue von Hemingway an dem Thekenplatz, wo er sich für gewöhnlich einige Daiquiris genehmigte. ❋ **CI-DESSUS ET PAGE DE DROITE** La chambre 511, où Ernest Hemingway, entama le dernier jet de son roman « Pour qui sonne le glas ». Transformée en un musée, elle abrite quelques-uns de ses biens personnels. **DOUBLE PAGE SUIVANTE** Le bar « El Floridita », avec le buste d'Hemingway au fond, près du comptoir.

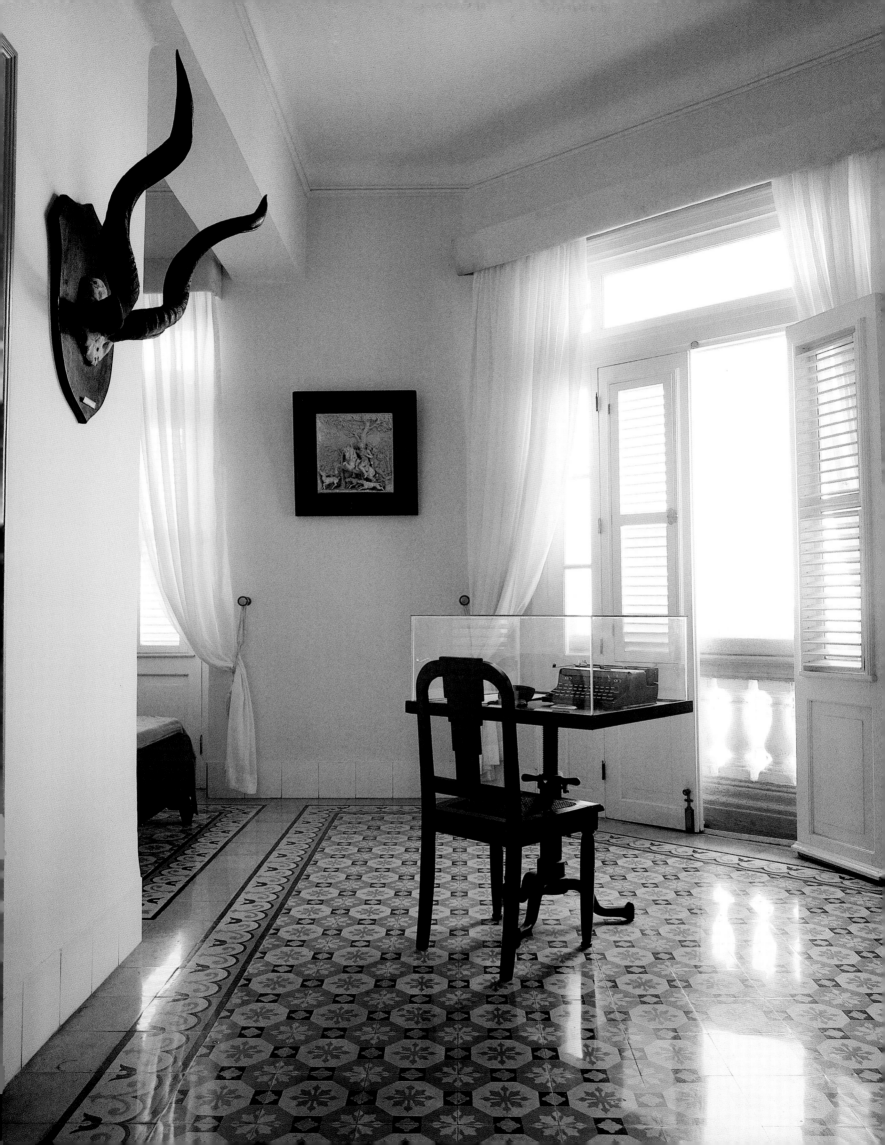

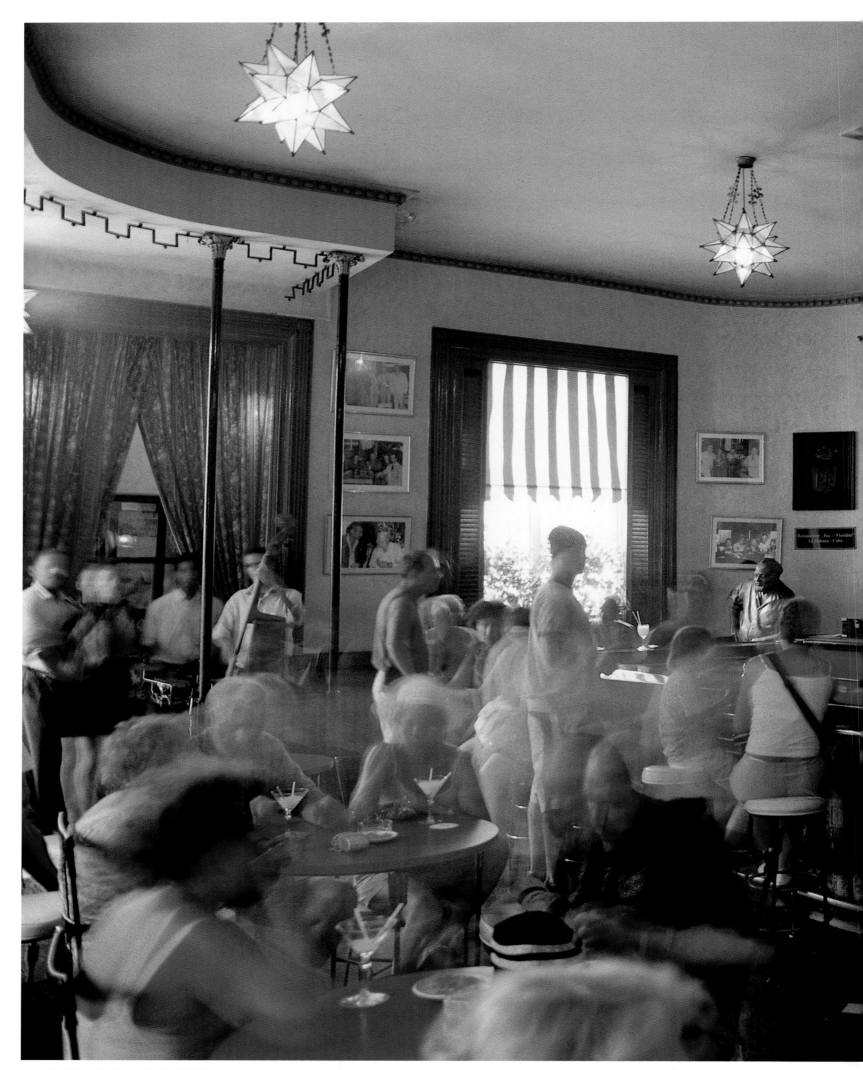

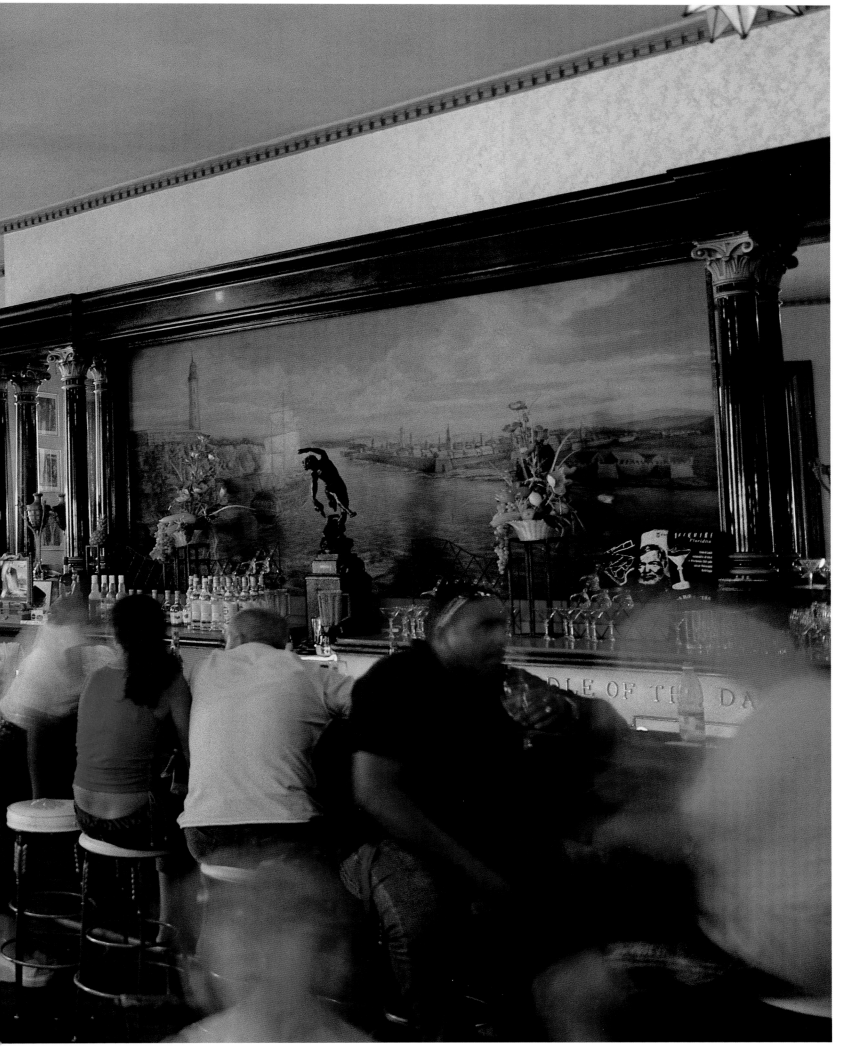

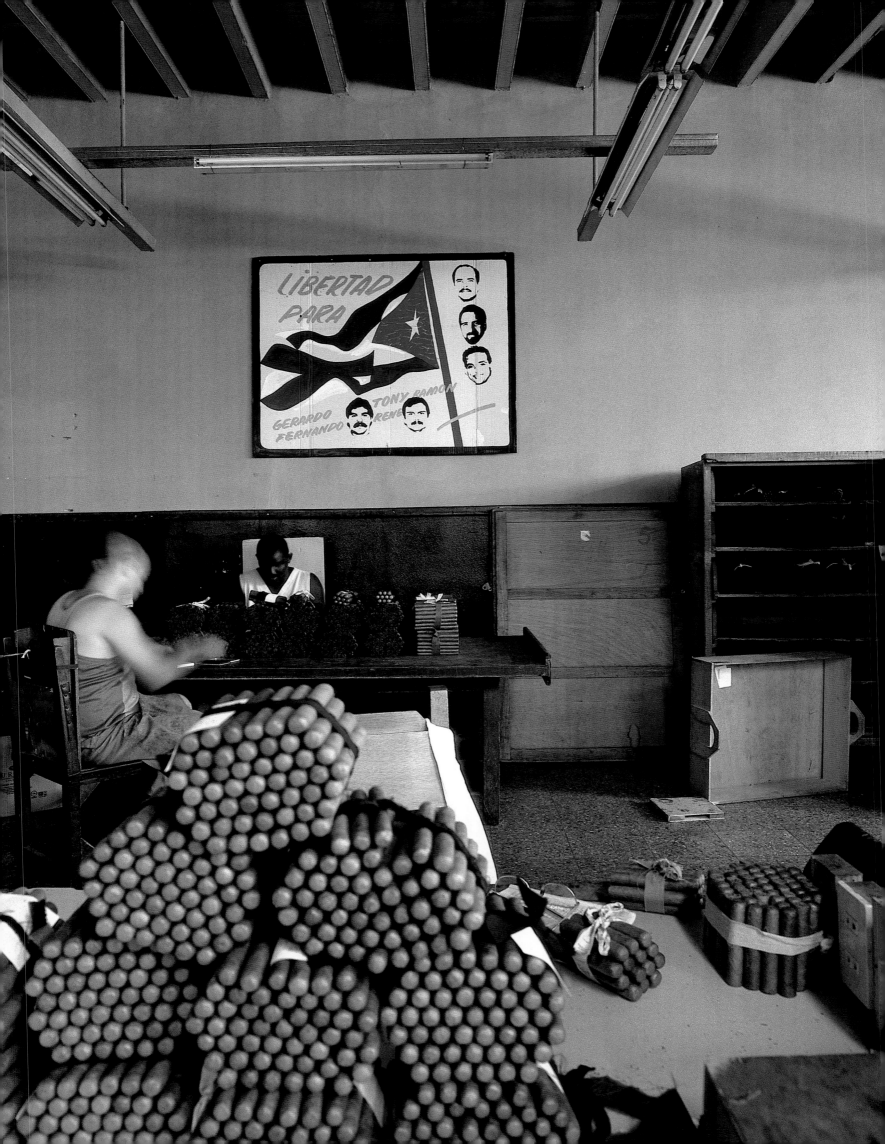

Partagás

The Ongoing Splendor of Cigar Manufacturing.

By the second half of the 19th century, tobacco manufacturing had become Havana's main industry. It is a non-polluting one, as cigar-making is an essentially manual activity. The cigar factory fits well in the existing urban fabric: its layout and decoration are the same as those of traditional mansions, with a central courtyard surrounded by arcades, a sign of refinement. There a person can read poetry out loud, tells stories, and read novels and newspapers for the men and women who sit on their wooden benches, day after day, rolling cigars. Cuban cigars, handmade "puros habanos," are considered the best in the world, and the Partagás factory, founded in 1845 and located behind the Capitol building in Havana, is among the finest and the oldest – a fact corroborated by the large, bold inscription carved into the elaborate parapet that crowns its eclectic brown and cream façade. Some of the greatest cigars in Cuba are produced here, from the "Partagás Lusitania" to the "Cohiba Robusto", to name just two. Partagás represents the ongoing splendor and tradition of cigar manufacturing, which is still one of the mainstays of the Cuban economy.

In der zweiten Hälfte des 19. Jahrhunderts wurde die Verarbeitung von Tabak zum wichtigsten Industriezweig Havannas. Da die Zigarren hauptsächlich in Handarbeit hergestellt werden, belasten sie ihre Umwelt in keinster Weise. Auch die Zigarrenmanufakturen fügen sich unauffällig in die bestehende Stadtstruktur ein. Sie haben den traditionellen Grundriss eines Wohnhauses, rund um einen Innenhof mit Arkaden, die damals als elegant galten. Dort sitzen Frauen und Männer Tag für Tag auf ihren Holzbänken und rollen Zigarren. Währenddessen werden Gedichte rezitiert, Geschichten erzählt, aus Romanen und aus der Zeitung vorgelesen. Zigarren aus Kuba, handgemachte »Puros Habanos«, gelten als die besten der Welt. Eine der renommiertesten und ältesten Manufakturen ist »Partagás«. Sie wurde 1845 gegründet und liegt hinter dem Kapitol. An der kunstvollen Attika über der braunen und cremefarbenen Fassade prangt der Name der stolzen Manufaktur in großen eingravierten Lettern. »Partagás« steht für die glanzvolle Tradition der Zigarrenherstellung und produziert einige der besten Zigarren der Welt wie die »Partagás Lusitania« oder die »Cohiba Robusto«. Bis heute ist die Herstellung von Zigarren einer wichtigsten Wirtschaftszweige Kubas geblieben.

Dès la seconde moitié du 19ᵉ siècle, la production de cigares devint l'industrie principale de la Havane. Non polluante (étant une activité essentiellement manuelle), la manufacture s'intégrait bien dans le tissu urbain et suivait le même plan et la même décoration que les grandes demeures traditionnelles avec une cour centrale entourée d'arcades, signe de raffinement. Là, quelqu'un lisait à voix haute de la poésie, des contes, un roman ou le journal pour les cigariers et cigarières assis sur des bancs en bois, jour après jour. Les «Puras Habanos» sont considérés comme les meilleurs cigares du monde et la fabrique Partagás, fondée en 1845 et située derrière le capitole, est l'une des plus anciennes et plus réputées, ce que corrobore l'inscription gravée dans le parapet sophistiqué qui couronne sa façade brune et crème. On roule ici certains des meilleurs cigares de Cuba, tels que le «Partagás Lusitania» ou le «Cohiba Robusto», pour ne citer qu'eux. Partagás incarne la tradition et le prestige de la production de cigares, aujourd'hui encore un des piliers de l'économie cubaine.

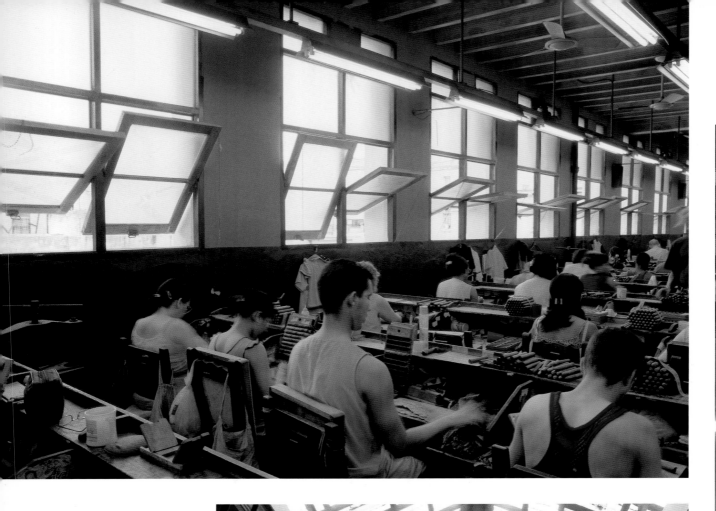
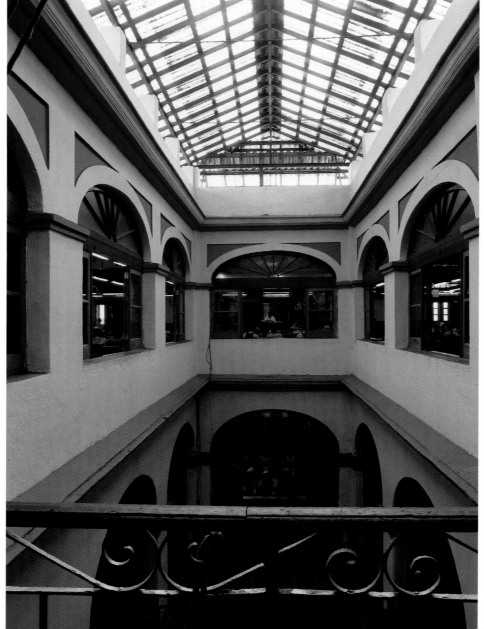

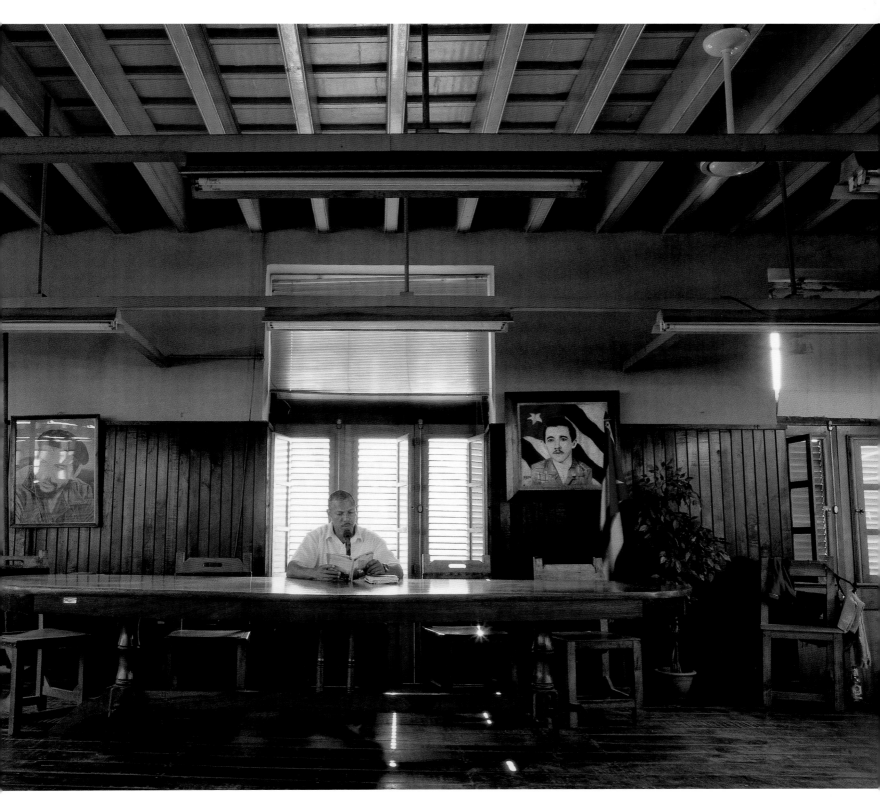

❋ **ABOVE LEFT** The staff is mixed in the area where the cigars are rolled. Men and women work eight-hour shifts. The apprentices of future rollers are also trained here. **LEFT** A skylight crowns the building's original inner courtyard to ensure that natural light reaches the different working areas. **ABOVE** The traditional job of tobacco factory reader consists of sharing news and reading aloud for the factory workers while they work, thus contributing to their entertainment and cultural education. **FOLLOWING DOUBLEPAGE** The area where the seals or labels are placed on the cigars before placing them in the beautiful cedar boxes. ❋ **OBEN LINKS** Die Belegschaft der Abteilung, in der die Zigarren gedreht werden, ist gemischt. Männer und Frauen haben einen achtstündigen Arbeitstag. In diesem Bereich werden auch die Lehrlinge zu Zigarrendrehern ausgebildet. **LINKS** Ein Glasdach bedeckt den ursprünglichen Innenhof des Gebäudes, um die unterschiedlichen Arbeitsbereiche mit Tageslicht zu versorgen. **OBEN** Die traditionelle Tätigkeit des Vorlesers in der Tabakfabrik besteht darin, den Angestellten des Werks Informationen zu vermitteln und vorzulesen, während diese ihre Arbeit verrichten. Auf diese Weise trägt er zu ihrer Unterhaltung und kulturellen Bildung bei. **FOLGENDE DOP-PELSEITE** Die gesamte Arbeit wird von Hand verrichtet. Hier sieht man den Bereich, in dem die Zigarren mit den Siegeln bzw. Zigarrenbinden versehen werden, bevor man sie in die wunderschönen Kisten aus Zedernholz legt. ❋ **PAGE DE GAUCHE, EN HAUT** Dans les ateliers où l'on roule les cigares, la main d'œuvre est mixte. Les ouvriers travaillent huit heures par jour. C'est aussi ici que l'on forme les futurs cigariers. **À GAUCHE** Une grande verrière couvre le patio original du bâtiment pour assurer l'entrée de la lumière naturelle dans toutes les aires de travail. **CI-DESSUS** Le rôle traditionnel du lecteur consiste à informer les employés et à leur lire des textes à voix haute, les distrayant tout en contribuant à leur éducation culturelle. **DOUBLE PAGE SUIVANTE** Le travail est entièrement manuel. La salle où l'on pose les bagues et les sceaux sur les cigares avant de les ranger dans leurs belles boîtes en cèdre.

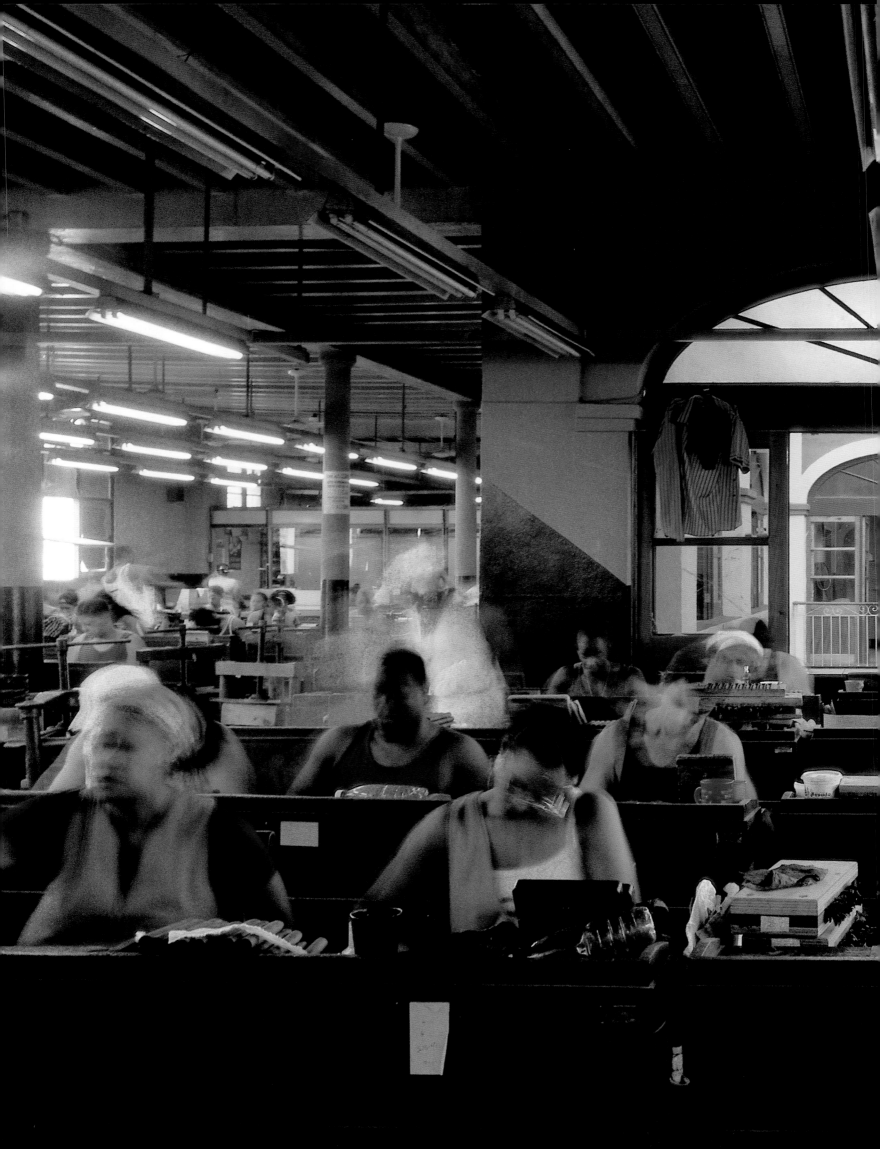

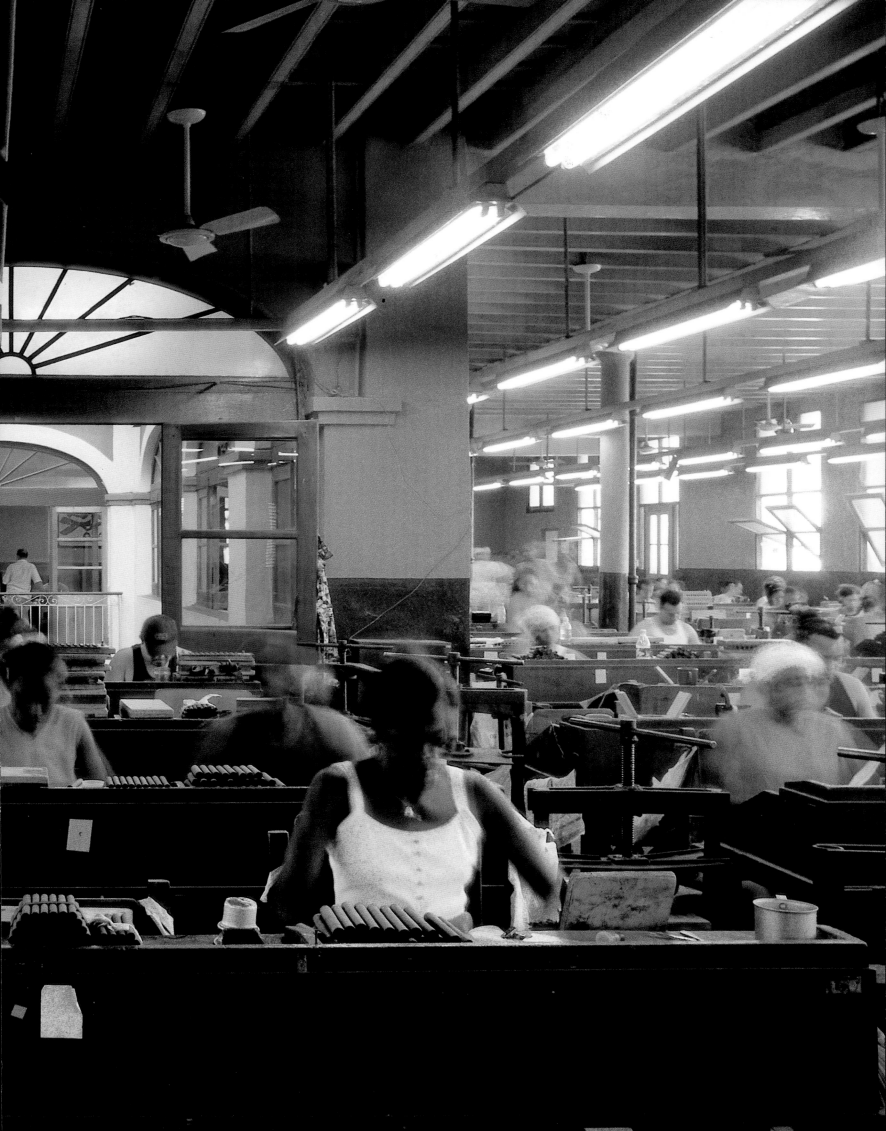

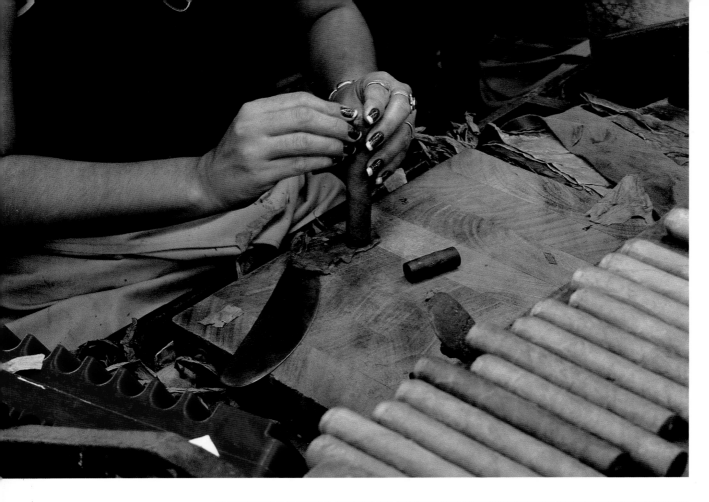

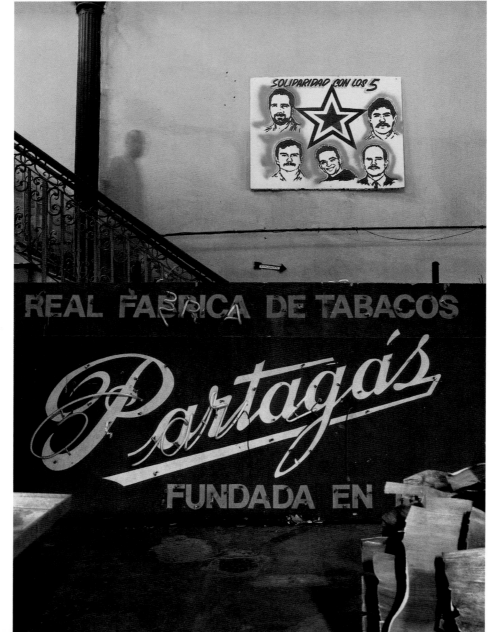

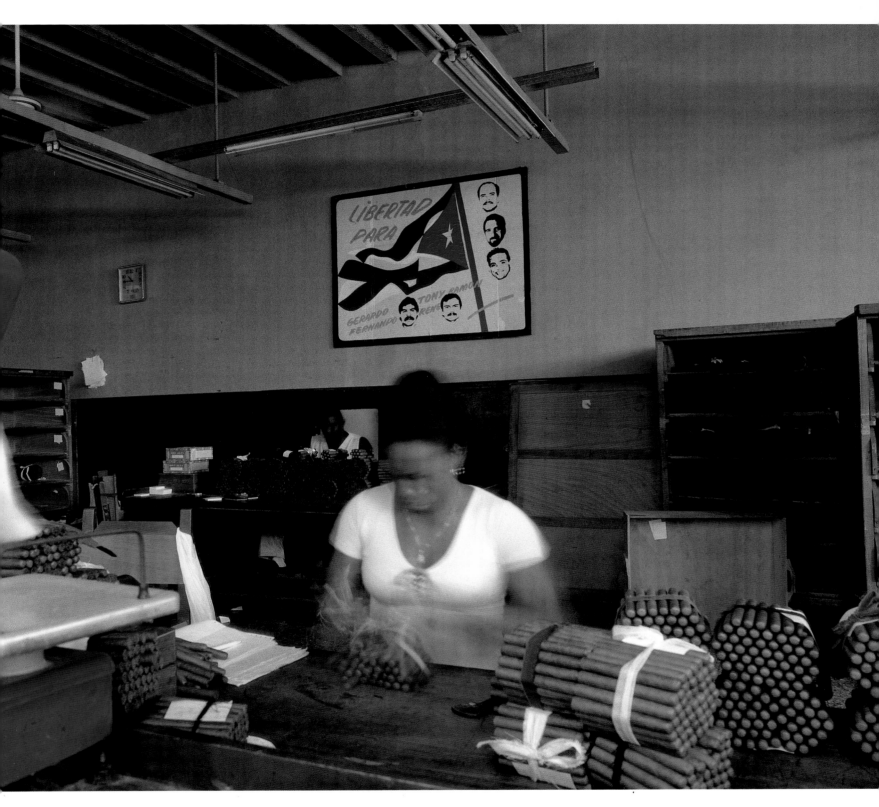

❋ **ABOVE LEFT** The instrument used to adjust the sizes of the cigars is the so-called "chaveta", a flat steel plate with a large curved blade. **LEFT** The original illuminated factory sign being restored after having sustained hurricane damage. **ABOVE** The final sorting area where all the tobacco quality parameters are meticulously checked. ❋ **OBEN LINKS** Das Werkzeug zur Angleichung der Zigarrengröße ist das so genannte »chaveta«, ein flaches Edelstahlmesser mit großer halbmondförmiger Klinge. **LINKS** Das originale Leuchtschild der Fabrik musste repariert werden, nachdem es kürzlich von einem Hurrikan beschädigt worden war. **OBEN** Der Bereich der Endauslese, in dem alle für Tabakwaren geltenden Qualitätsparameter gründlich geprüft werden. ❋ **PAGE DE GAUCHE, EN HAUT** La « chaveta », longue lame d'acier incurvée, sert à uniformiser la taille des havanes. **A GAUCHE** L'enseigne lumineuse originale de la manufacture lors de sa restauration après qu'un ouragan l'avait endommagée. **CI-DESSUS** La salle de sélection finale où l'on vérifie méticuleusement tous les paramètres intervenant dans la qualité du tabac.

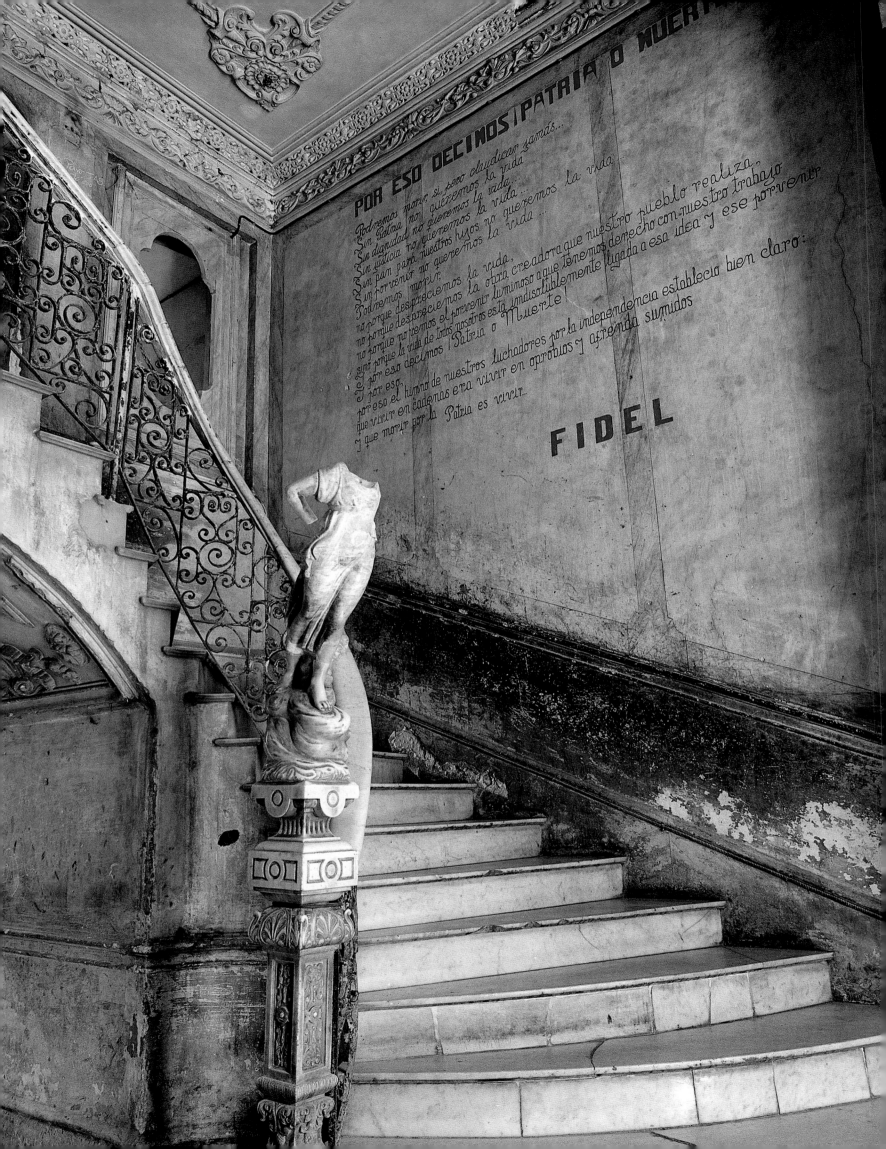

POR ESO DECIMOS ¡PATRIA O MUERTE!

Podremos morir, sí, pero claudicar jamás...

Sin Patria no queremos la vida
Sin dignidad no queremos la vida
Sin justicia no queremos la vida
Sin pan para nuestros hijos no queremos la vida
Sin porvenir no queremos la vida...

Podremos morir,
no porque despreciemos la vida,
no porque desaparecemos la obra creadora que nuestro pueblo realiza,
no porque no veamos el porvenir luminoso a que tenemos derecho con nuestro trabajo
sino porque la vida de todos nosotros está indisolublemente ligada a esa idea y ese porvenir

Y por eso decimos ¡Patria o Muerte!

Por eso,
que vibró el himno de nuestros luchadores por la independencia estableció bien claro:
que vivir en cadenas era vivir en oprobios y afrenda sumidos
y que morir por la Patria es vivir.

FIDEL

PALADAR
LA GUARIDA

A Location of an Oscar-Nominated Movie.

One of the most controversial Cuban films ever, "Fresa y chocolate," was partly filmed in this apartment, located in the heart of Centro Habana, the most decaying district of the city. The movie was nominated for an Oscar in 1995, and the otherwise ordinary home became a very successful "paladar" – a privately owned restaurant. Today it is one of the most visited tourist venues in Havana. One enters from Concordia Calle into a vast, dilapidated, dark hall of an eclectic early 20th century building; an old marble staircase with an iron railing leads you up three floors to an apartment that has been turned into one of the most famous restaurants in Havana. Thoughtfully prepared food is served in an unassuming, informal ambience by owners Enrique Núñez and his wife Odeysis, whose delicious menu includes succulent red snapper, gazpacho soup, and other tasty Cuban and international dishes. All this can be enjoyed with a fine bottle of imported Spanish wine. Whether you are in the film business or not, you are always welcome at "La Guarida".

Der viel diskutierte kubanische Film »Erdbeer und Schokolade« wurde 1995 für den Oscar nominiert. Diese Wohnung im Herzen von Centro Habana, ein heruntergekommenes Viertel, diente als Drehort für einige der Filmszenen. Aus der ganz normalen Wohnung wurde dann ein erfolgreiches Privatrestaurant, ein »Paladar«, und einer der beliebtesten Treffpunkte der Stadt. Ins eklektische Haus aus dem 20. Jahrhundert an der Calle Concordia gelangt man über eine dunkle, große, abbruchreife Eingangshalle. Ein altes Treppenhaus aus Marmor und mit einem Eisengeländer führt drei Stockwerke hoch in die Wohnung, die heute das bekannteste Restaurant der Stadt beherbergt. Das Besitzerpaar Enrique und Odeysis Núñez bringt in einfacher, entspannter Umgebung liebevoll zubereitete Speisen auf den Tisch. Darunter einen saftigen Red Snapper, Gazpacho und andere leckere kubanische und internationale Gerichte. Dazu gibt es importierte Weine aus Spanien. Jeder ist im »La Guarida« willkommen, nicht nur Filmemacher.

«Fresa y chocolate», un des films cubains les plus controversés à ce jour, fut en partie tourné dans cet appartement situé au cœur de Centro Habana, le quartier le plus détérioré de la ville. Depuis que le film a été nominé aux Oscars en 1995, cette demeure ordinaire est devenue un «paladar» (restaurant privé) branché, halte incontournable des touristes. On entre par la rue Concordia dans le vaste hall délabré et sombre d'un immeuble hétéroclite du début du 20e siècle. Un vieil escalier en marbre avec une rampe en fer forgé vous mène, trois étages plus haut, dans un appartement converti en un des plus célèbres restaurants de la Havane. Dans une ambiance bon enfant, les propriétaires Enrique Núñez et sa femme Odeysis vous mitonnent avec soin de succulentes spécialités telles que la dorade locale, le gazpacho ou d'autres plats cubains et internationaux, à savourer arrosés d'un vin espagnol. Que vous travailliez dans le cinéma ou pas, vous serez toujours bienvenu à «La Guarida».

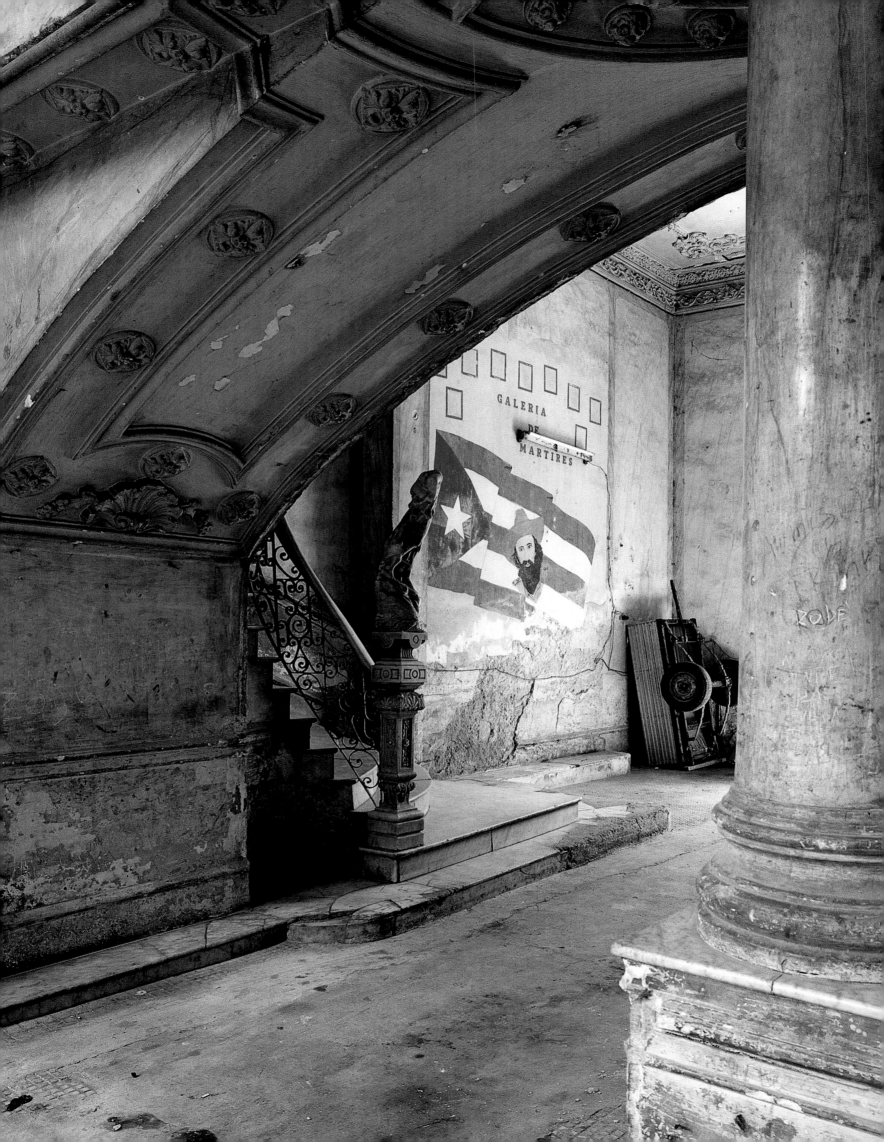

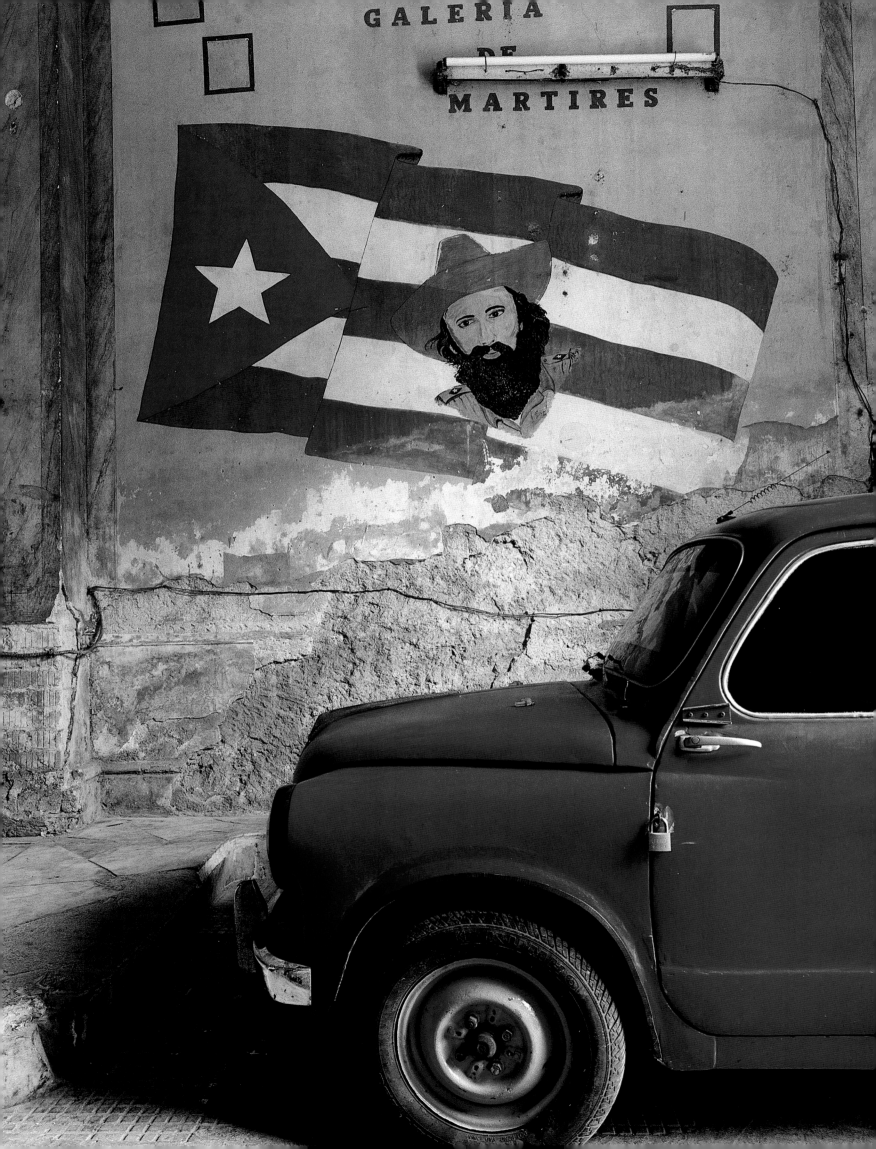

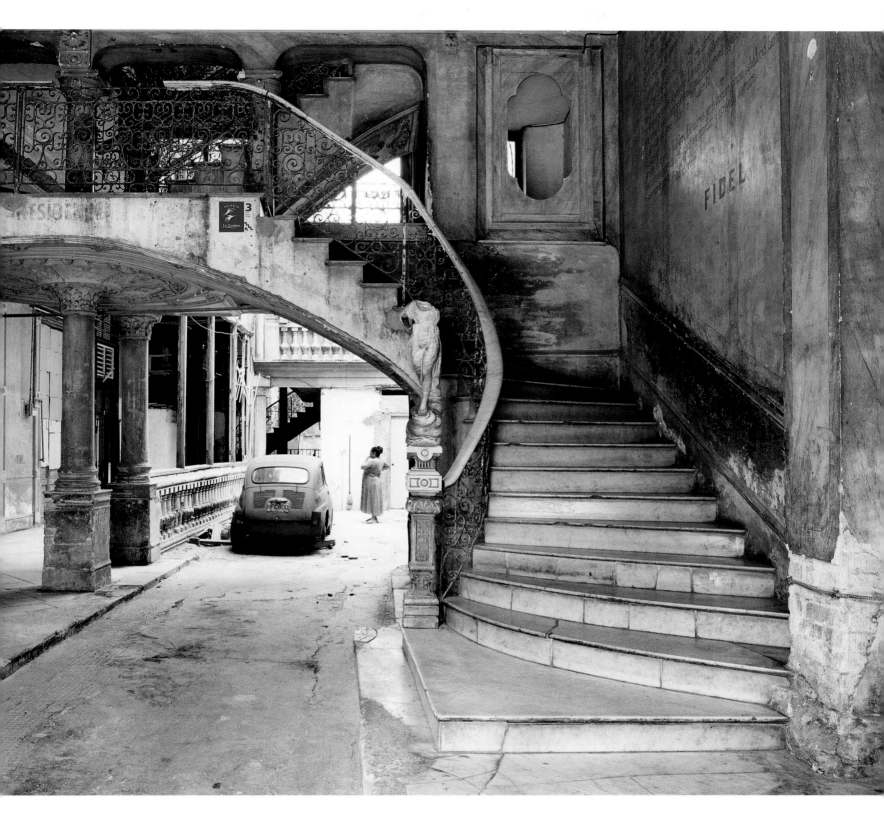

❋ **PREVIOUS DOUBLEPAGE** The height of the ornate staircase even allows vehicles to pass underneath into the building's courtyard. * On one of its walls, painted with a Cuban flag with the face of one of the martyrs of the Cuban Revolution, Camilo Cienfuegos, marks a site where the patriots of the revolution were venerated. **ABOVE LEFT** Varying sized carved wooden chairs with wickerwork form part of the original furnishings. **LEFT** The rooms surrounding the courtyard have windows with French louvered doors and small colored glass. **ABOVE** The lovely white marble staircase with its beautiful wrought-iron banister joins together the different floors of the building where "Paladar La Guarida" is located. ❋ **VORHERGEHENDE DOPPELSEITE** Die Treppe erreicht eine Höhe, die sogar die Einfahrt von Fahrzeugen in den Innenhof erlaubt. * An einer der Wände des Innenhofs weist eine gemalte kubanische Flagge mit dem Gesicht eines Märtyrers der Kubanischen Revolution, Camilo Cienfuegos, darauf hin, dass es sich um eine Kultstätte für Patrioten handelt. **LINKE SEITE OBEN** Stühle und Sessel mit Holzschnitzerei und Korbgeflecht sind Teil des originellen Mobiliars. **LINKS** Die an den Innenhof grenzenden Zimmer besitzen Fenster mit Lamellenläden und Oberlichtern aus farbigem Glas. **OBEN** Die Treppe aus weißem Marmor mit ihrem prächtigen schmiedeeisernen Geländer verbindet die verschiedenen Stockwerke des Gebäudes, in dem sich das »Paladar La Guarida« befindet.
❋ **DOUBLE PAGE PRECEDENTE** La hauteur du plafond sculpté sous l'escalier de l'immeuble où se trouve « Paladar La Guarida » permet même aux véhicules d'entrer dans le patio devenu parking. Sur un des murs, un drapeau cubain avec le portrait d'un des martyrs de la révolution, Camilo Cienfuegos, vénéré par les patriotes. **PAGE DE GAUCHE, EN HAUT** Le mobilier d'origine du restaurant. **A GAUCHE** Les fenêtres des pièces qui entourent le patio sont protégées par des persiennes et surmontées de lucarnes en verre coloré. **CI-DESSUS** Le grand escalier en marbre blanc agrémenté d'une belle rampe en fer forgé relie les différents étages de l'immeuble.

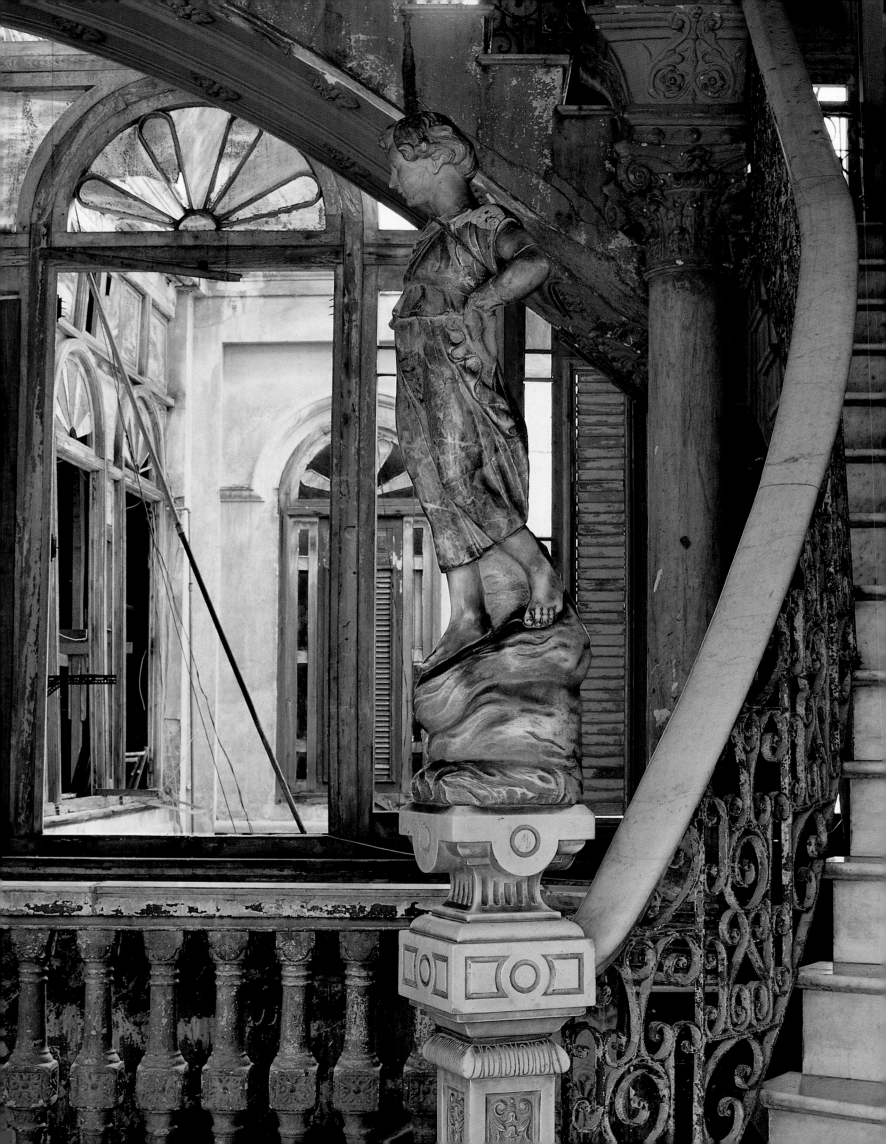

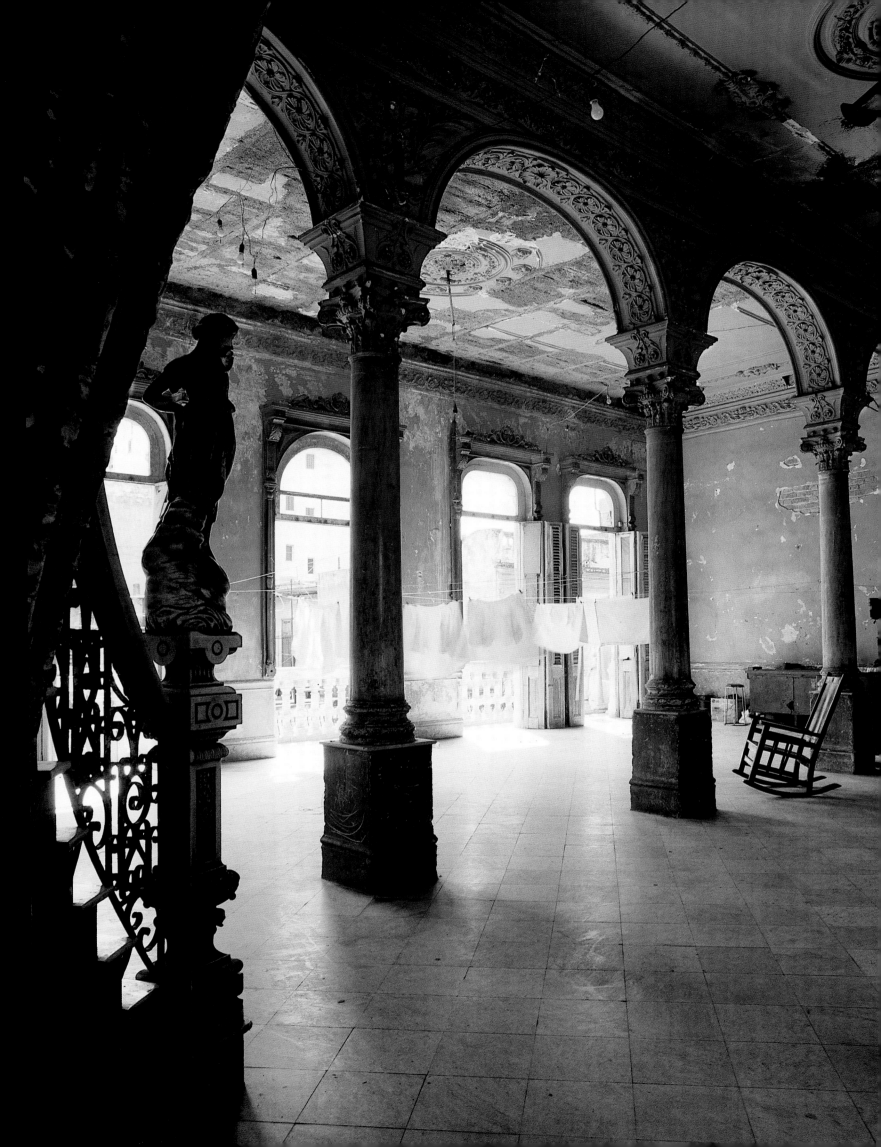

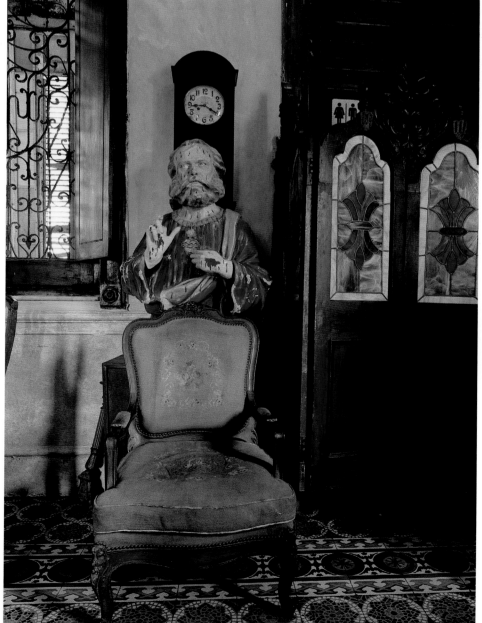

❋ **PREVIOUS DOUBLEPAGE** One of the graceful sculptures presiding over each flight in the staircase of the building. * A shared vestibule is used as a living room, resting place and as a place for drying clothes. A succession of semicircular arches over slender marble columns frames the views of the courtyard. **ABOVE LEFT** Photographs of Ernesto "Che" Guevara and the meeting between Fidel Castro and Ernest Hemingway are just a few of the pictures hanging on the walls at "Paladar La Guarida". **LEFT** A religious sculpture rendered by a friend of the main character one of the figures in the film "Fresa y Chocolate" is part of the current decoration at the "Paladar La Guarida". **ABOVE** The dining room, one of the settings in the Oscar-nominated Cuban film "Fresa y Chocolate", gains atmosphere through photographs from several scenes in the film. ❋ **VORHERGEHENDE DOPPELSEITE** Grazile Statuen befinden sich an jedem Treppenabschnitt des Gebäudes, welches das »Paladar La Guarida« im Viertel Centro Habana beherbergt. * Ein gemeinschaftlicher Eingangsbereich dient sowohl als Aufenthaltsraum als auch zum Trocknen der Wäsche. Eine Reihe von Rundbögen auf schlanken Marmorsäulen geleitet die Besucher in den Innenhof. **OBEN LINKS** Historische Aufnahmen von Ernesto »Che« Guevara und dem Treffen zwischen Fidel Castro und Ernest Hemingway im Jahr 1960 und weiteren Motiven an einer Wand des »Paladar La Guarida«. **LINKS** Eine religiöse Skulptur, die ein Freund des Hauptdarstellers im Film »Erdbeer und Schokolade« anfertigte, ist Teil der Einrichtung des »Paladar La Guarida«. **OBEN** Der Speiseraum war einer der Drehorte des kubanischen Films »Erdbeer und Schokolade«, der eine Oscar-Nominierung in Hollywood erhielt. Der Raum ist mit Aufnahmen einiger Filmszenen dekoriert. ❋ **DOUBLE PAGE PRECEDENTE** Une des élégantes statues qui domine chaque palier de l'escalier de l'immeuble. * Un vaste palier pour se détendre ou sécher le linge. Une série d'arcs en plein cintre sur de fines colonnes encadrent les vues sur le patio. **PAGE DE GAUCHE, EN HAUT** Sur des murs de « Paladar La Guarida », des photos historiques du Che Guevara et de la rencontre entre Fidel Castro et Ernest Hemingway. **A GAUCHE** La décoration actuelle du restaurant inclut une sculpture religieuse réalisée par un ami du héros de « Fresa y Chocolate », qui, dans le film, lui organise une exposition personnelle. **CI-DESSUS** Dans la salle à manger, un des décors de « Fresa y Chocolate », quelques photos montrant des scènes du film, nominé aux Oscars à Hollywood.

ANGELINA DE INASTRILLA

A Typical Row House in Havana of the 19th Century.

Havana's first organized expansion beyond its original boundary walls was propagated by the engineer Antonio María de la Torre around 1819. Old country roads would later become main thoroughfares, or "calzadas," built with neoclassical porticoes that helped define the city. Havana was later called "the City of Columns" by the Cuban writer Alejo Carpentier. The sheltered streets were suitable for merchants to sell their wares, and so they became commercial in character, and structured linear centers across the city reflecting an aspiration for modernity that would be echoed in other notable urban development projects during the government of Miguel Tacón. He promoted avenues and walkways decorated with fountains and statues, such as that of Paseo de Tacón, also called Carlos III to honor the king of Spain. This completed the appearance of the oldest of these roads, Calzada de la Reina. Angelina de Inastrilla's home is typical for this street. The façade, with its wrought-iron railing and rounded arches crowned by a cornice, echoes the decaying but still decorative richness of the interior. The entry hall has beautiful grills, and tile wainscots with floral motifs, but the most distinctive feature of the house is undoubtedly the living room's stained-glass windows, which vividly depict a galleon in front of "Castillo del Morro".

Die Ideen des Ingenieurs Antonio María de la Torre prägten um 1819 das Bild Havannas. Die Stadt wuchs über die Grenzen der ursprünglichen Stadtmauern hinaus, und aus alten Landstraßen wurden »Calzadas«, Hauptstraßen mit neoklassizistischen Säulenbögen, die das Stadtbild prägten. Deshalb nannte der kubanische Schriftsteller Alejo Carpentier Havanna »die Stadt der Säulen«. Unter den Arkaden konnten Händler ihre Ware geschützt vor Sonne und Regen feilbieten und so entstand eine Art Marktplatz. Miguel Tacón und seine Regierung planten damals eine bemerkenswert moderne Stadtentwicklung. Die Linienführung der Straßen war gerade, und es wurden Alleen und Spazierwege mit Brunnen und Statuen gebaut. Der Paseo de Tacón, auch Paseo Carlos III. nach dem damaligen König von Spanien, ergänzten das Erscheinungsbild der Stadt, das von der Calzada de la Reina, einer der ältesten Straßen, geprägt war. Das Haus von Angelina de Inastrilla ist ein für diese Straße typisches Gebäude. Die Fassade mit dem schmiedeeisernen Geländer, den runden Torbögen und ihrem Sims weist auf das opulente Dekor im Inneren hin – auch wenn heute der Zerfall daran nagt. In der Eingangshalle befinden sich wunderschöne schmiedeeiserne Gitterwerke und Wandverkleidungen aus Kacheln mit floralen Motiven. Es sind jedoch die Buntglas-Fenster, die eine Galeone vor dem »Castillo del Morro« darstellen, die als Erstes auffallen.

Vers 1819, l'ingénieur Antonio María de la Torre fut chargé de la première expansion planifiée de la Havane hors de ses remparts. Les anciennes routes de campagne devinrent de grandes rues, ou «calzadas», dont les portiques néoclassiques donnaient à la ville une allure nouvelle. L'auteur cubain Alejo Carpentier baptisa plus tard la Havane «la cité des colonnes». Les artères ainsi protégées pouvaient abriter des échoppes et devinrent commerçantes, tandis que les lignes droites qui quadrillaient la ville témoignaient d'un désir de modernité confirmé par d'autres grands travaux d'urbanisme sous le gouvernement de Miguel Tacón. Ce dernier fit tracer des avenues et des allées ornées de fontaines et de statues, telles que le Paseo de Tacón appelé aussi Paseo Carlos III en hommage au roi d'Espagne, qui parachevaient l'aspect de la plus ancienne d'entre elles, la Calzada de la Reina. La maison d'Angelina de Inastrilla en est représentative. Sa façade, avec ses balustrades en fer forgé et ses arcs surmontés d'une corniche, reflète la richesse délabrée de l'intérieur. Le hall possède de belles grilles et des lambris carrelés aux motifs floraux, mais ce sont surtout les vitraux du salon, représentant un galion devant le «Castillo del Moro», qui frappent les esprits.

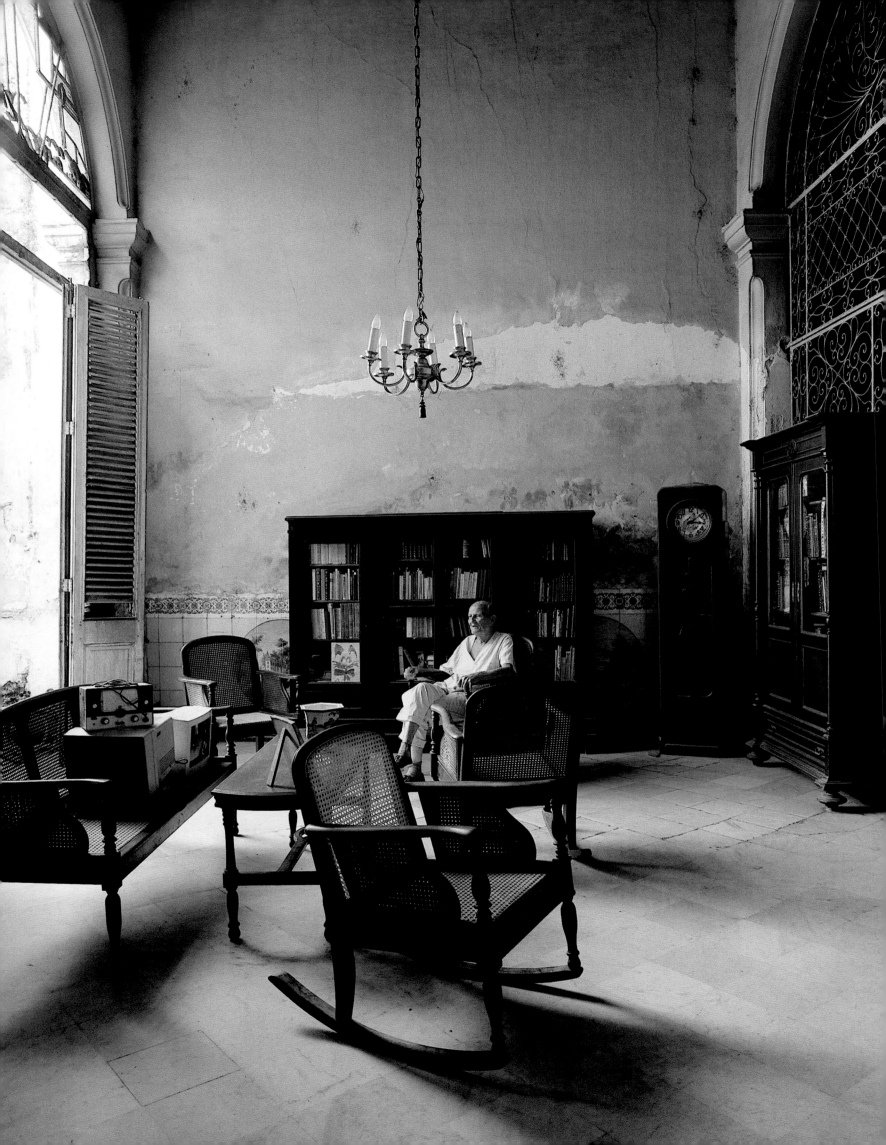

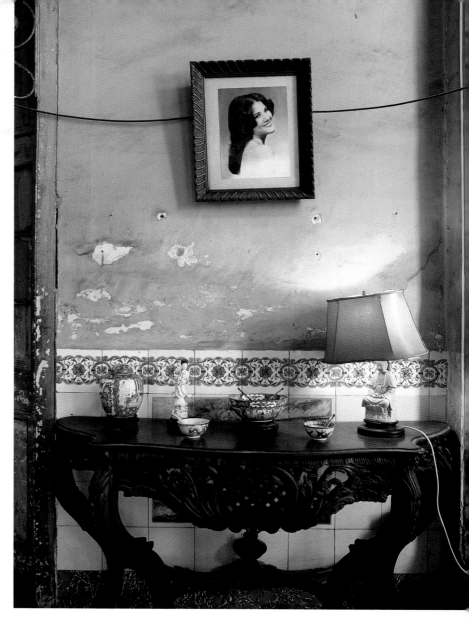

✳ **FACING PAGE** The living room of Angelina de Inastrilla's home is located between the courtyard and the "zaguán". The bays of the courtyard are crowned by semicircular arches, enclosed by stained glass windows worthy of restoration due to their enormous artistic value. **RIGHT** A portrait of Angelina in her youth hanging above a mahogany table with several porcelain knick-knacks is highly symbolic. The polychrome of the tile wainscots contrasts with the oppressive atmosphere of the flaking walls. **BELOW** The house's beautiful grills and the tiles on the wainscots are a testimony to the past splendor of Angelina de Inastrilla's home. ✳ **LINKE SEITE** Das Wohnzimmer im Haus von Angelina de Inastrilla befindet sich zwischen dem Innenhof und dem Hausflur. Die Fenster zum Innenhof enden in Rundbögen und sind mit Buntglasfenstern verschlossen, die angesichts ihres künstlerischen Werts restauriert werden müssten. **RECHTS** Das Porträt der jungen Angelina, das über einem Mahagonitisch mit verschiedenen Dekorationsgegenständen aus chinesischem Porzellan hängt, ist sehr symbolträchtig. Die glanzvolle Farbenpracht der Fliesensockel steht im Gegensatz zu den abbröckelnden Wänden. **UNTEN** Das prächtige schmiedeeiserne Gitterwerk und die Fliesensockel zeugen vom vergangenen Glanz des Hauses von Angelina de Inastrilla. ✳ **PAGE DE GAUCHE** Le séjour se trouve entre le vestibule et la cour intérieure. Les arcs en plein cintre donnant sur le patio sont fermés par de très beaux vitraux qui mériteraient d'être restaurés. **A DROITE** Tout un symbole : le portrait de jeunesse d'Angelina suspendu au-dessus d'une console en acajou sur laquelle sont posés divers bibelots en porcelaine chinoise. Les azulejos polychromes contrastent avec l'atmosphère oppressante des murs délabrés. **CI-DESSOUS** Les belles grilles et les azulejos des lambris témoignent de la splendeur passée de la maison d'Angelina de Inastrilla.

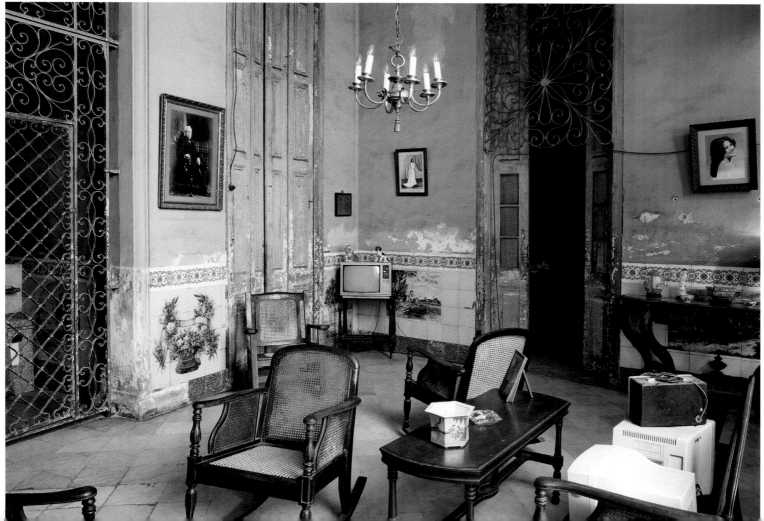

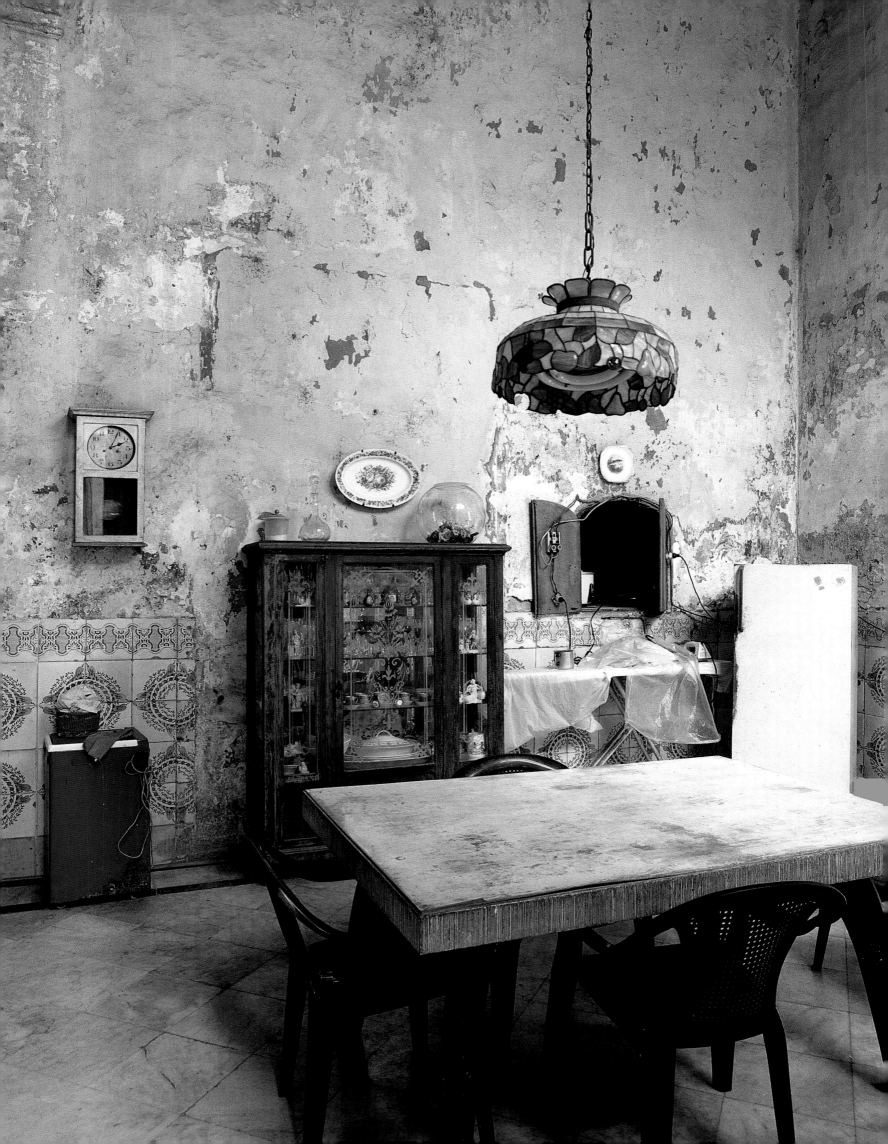

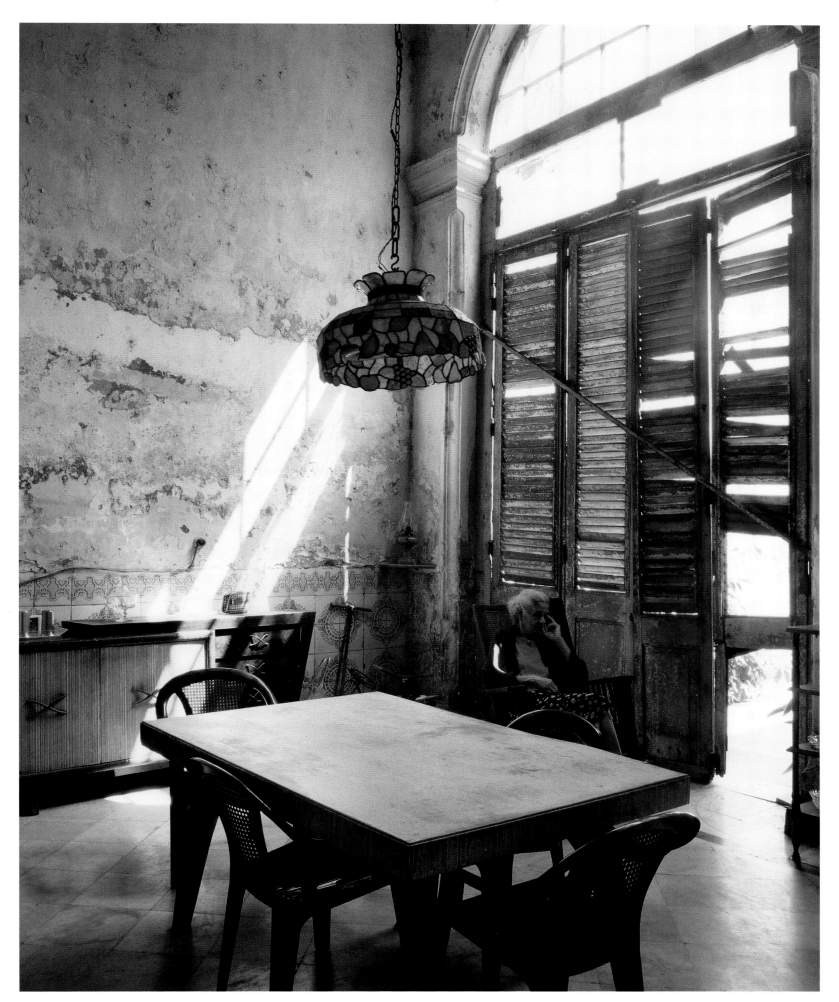

※ **FACING PAGE AND ABOVE** The spacious dining room has a wainscot made of Spanish tiles. **FOLLOWING DOUBLEPAGES** The bedrooms, run parallel to the longest side of the inner courtyard.* The mosaic floors in the bedrooms create a certain visual unity. ※ **LINKE SEITE UND OBEN** Das geräumige Esszimmer besitzt einen Sockel aus spanischen Fliesen. **FOLGENDE DOPPELSEITEN** Die hohen Schlafzimmer grenzen an die Längsseite des Innenhofs. * Die Mosaikböden der Schlafzimmer sind gut erhalten. ※ **PAGE DE GAUCHE ET CI-DESSUS** La spacieuse salle à manger, est également tapissée d'azulejos espagnols. **DOUBLES PAGES SUIVANTES** Les chambres, spacieuses avec de hautes portes, sont parallèles au grand côté du patio. * Les sols en mosaïque des chambres à coucher ont été préservés.

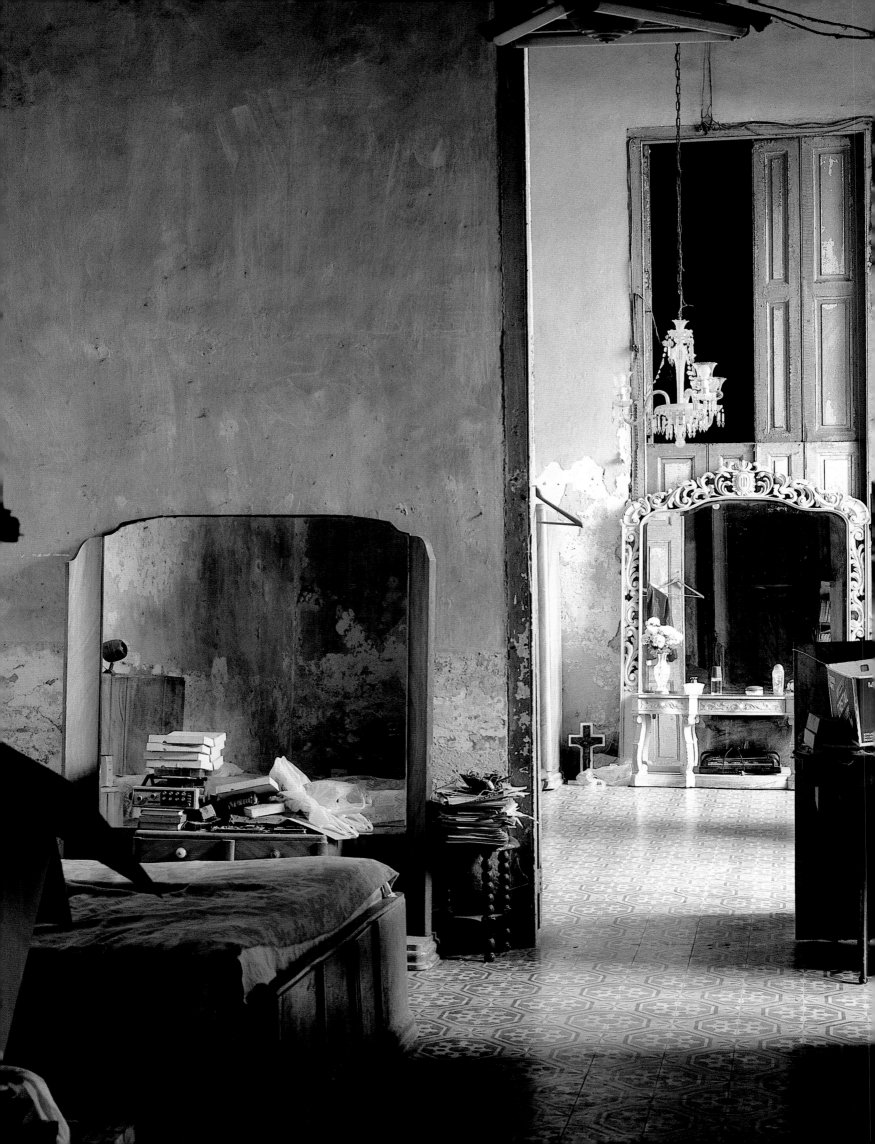

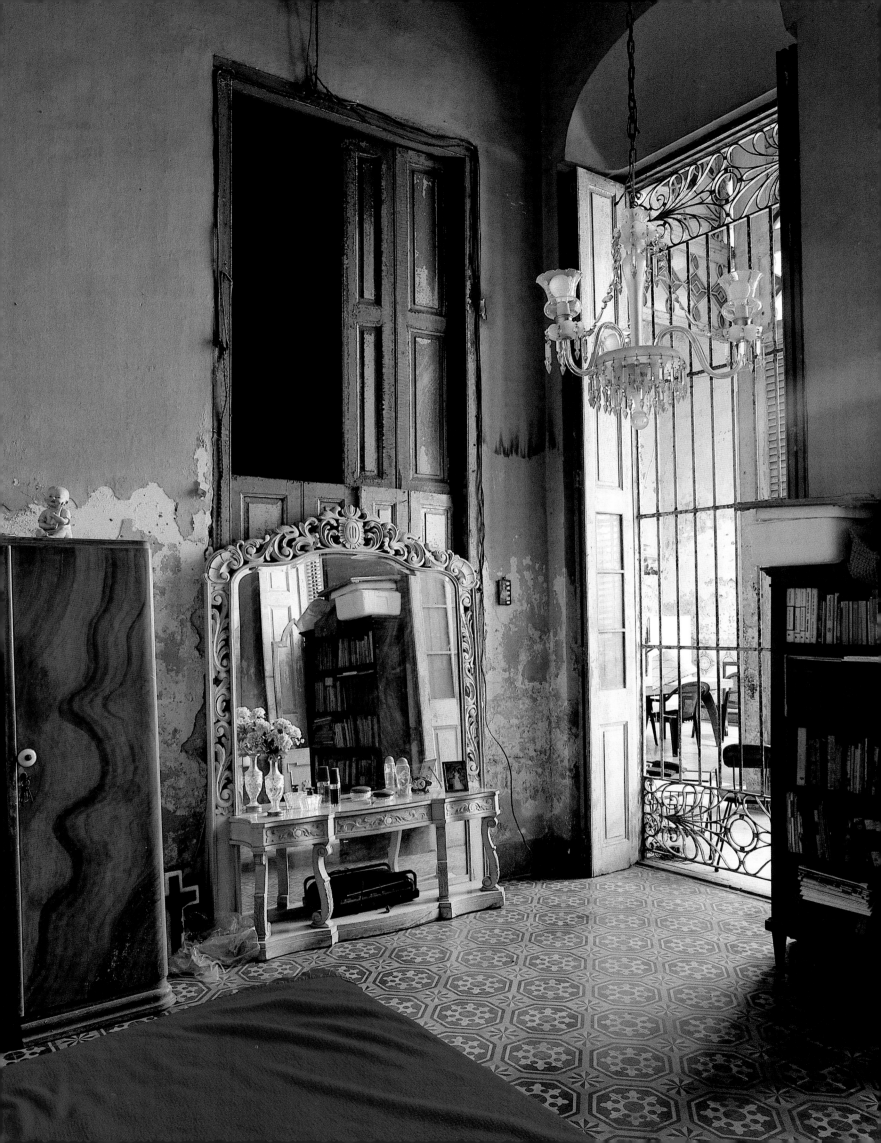

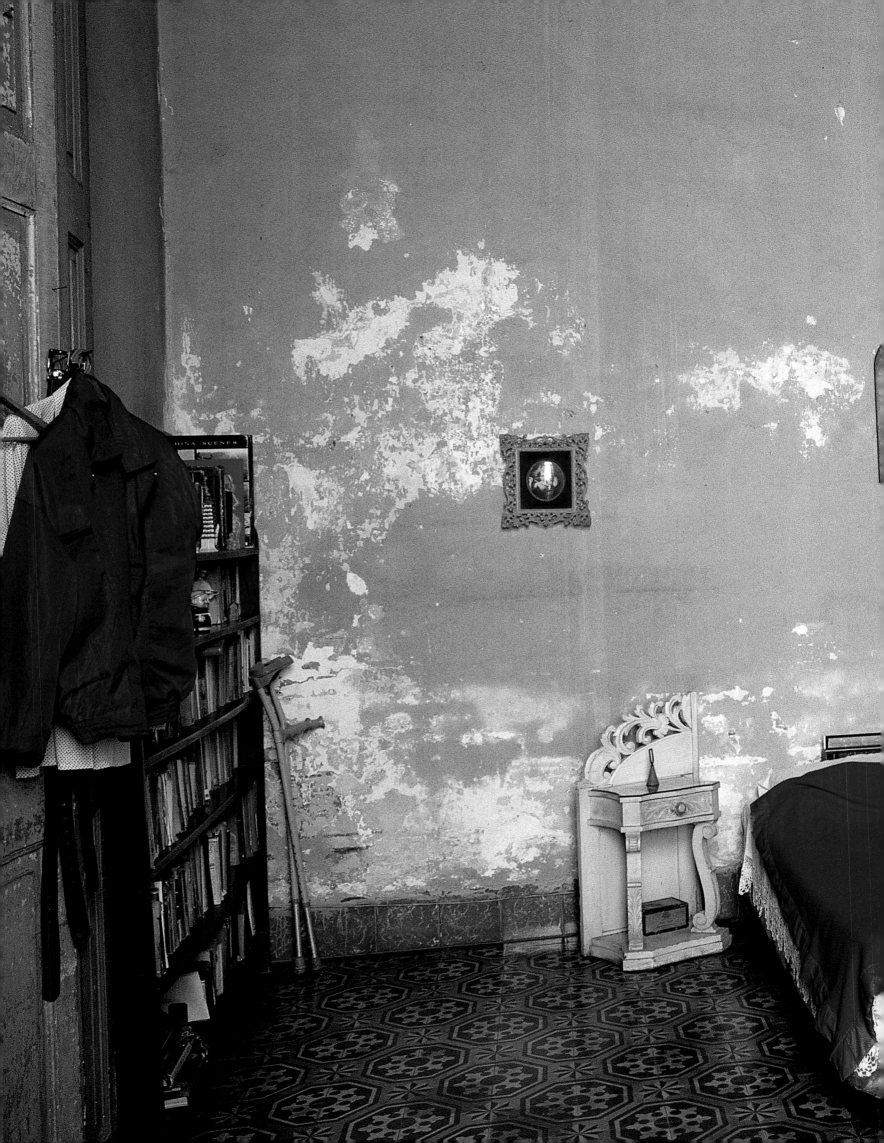

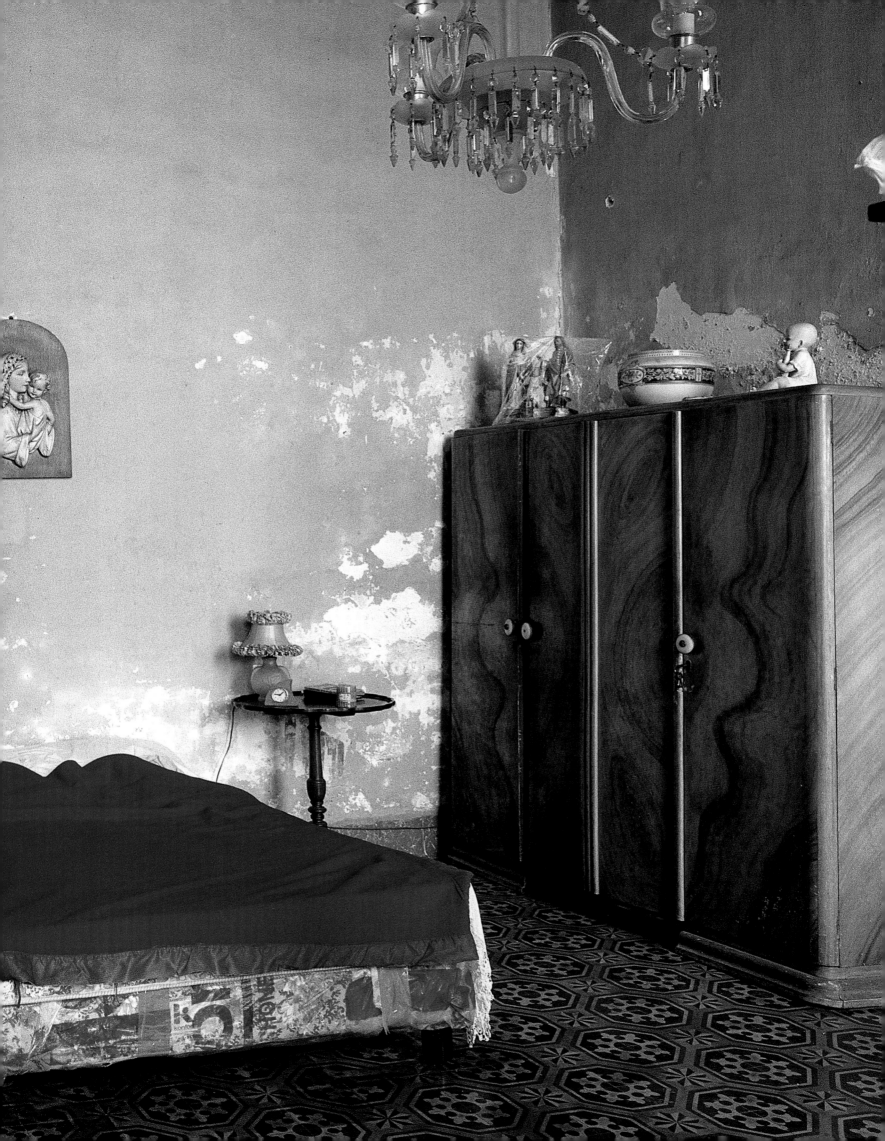

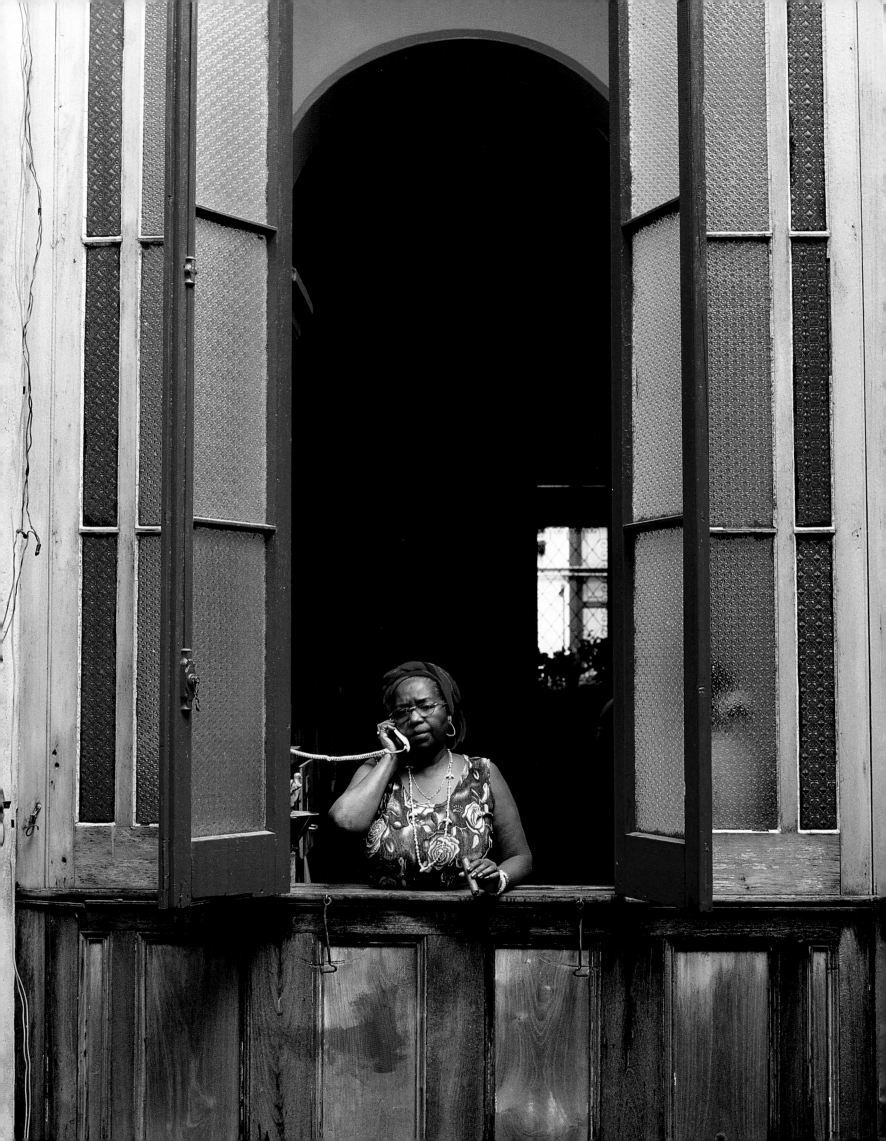

EMILIO RODRÍGUEZ VALDÉS

A Home Where You Seek Spiritual Guidance.

Myths help man justify his existence and explain the world. African mythology is integral to Cuban culture: It is poetic and mysterious, attractive and artistic, full of light, rhythm and color. Afro-Cuban deities, or "orishas," from the Yoruba religion – introduced to Cuba by slaves brought from Africa to work on the sugar and tobacco plantations – are sometimes amalgamated with the saints from Catholicism, the country's dominant religion. This practice mirrors Cuba itself, whose people are a mix of European and African. The resulting religious system, "santería" or "Regla de Ocha," derives from the slaves' beliefs and ritual practices, which have survived several centuries. Emilio Rodríguez Valdés' home, on Concordia street in Centro Habana, is a Yoruba temple where people from different backgrounds come from all over seeking spiritual guidance and relief from health problems or from existential conflicts. A priest, or "babalao," with 35 years experience, consults and leads "Santería" and "Yoruba" ceremonies. The house's façade has an arrangement of vertical gaps with a continuous balcony over the heavy wooden double-leaf door that leads to the upper floor via a marble staircase.

Die afrikanische Mythologie ist ein wichtiger Teil der kubanischen Kultur. »Orishas«, afro-kubanische Gottheiten, sind Teil des Yoruba-Glaubens, den die afrikanischen Sklaven, die für Arbeit auf den Zucker- und Tabakplantagen hergeholt wurden, mit nach Kuba brachten. Ihr Glaube hat sich zusammen mit dem in Kuba vorherrschenden Katholizismus zu einer neuen Religion entwickelt, genau wie in jedem anderen Land, dessen Bewohner eine Mischung aus Europäern und Afrikanern darstellen. Die »Santería« oder »Regla de Ocha« ist stark von den Ritualen der Sklaven geprägt und hat die Jahrhunderte überlebt. Einer der Yoruba-Tempel ist das Haus von Emilio Rodríguez Valdés an der Calle Concordia im Zentrum Havannas. Menschen verschiedenster Herkunft suchen hier spirituelle Führung bei der Suche nach dem Sinn des Lebens und Hilfe bei gesundheitlichen Problemen. Rodríguez Valdés ist seit 35 Jahren ein »Babalao«-Priester und führt durch »Santería«- und »Yoruba«-Zeremonien. Die Fassade des Hauses besteht aus vertikalen Fugen und einem durchgängigen Balkon über einer schweren Doppeltüre. Von hier gelangt man in ein Treppenhaus aus Marmor, das ins obere Stockwerk führt.

Les mythes aident l'homme à justifier son existence et à expliquer le monde. La mythologie africaine fait partie intégrante de la culture cubaine, reflet d'un peuple dont les racines africaines et européennes se mêlent. Poétique, mystérieuse, séduisante et artistique, elle est pleine de lumière, de rythmes et de couleurs. Les divinités afro-cubaines ou «orishas» introduites par les esclaves yoruba amenés d'Afrique pour travailler sur les plantations de cannes à sucre et de tabac sont parfois amalgamées avec les saints catholiques, culte dominant sur l'île. Le système religieux qui en résulte, la «Santería» ou «Regla de Ocha», est imprégné des croyances et des rites des esclaves qui ont survécu au fil des siècles. La demeure d'Emilio Rodríguez Valdés, sur la rue Concordia dans Centro Habana, est un temple yoruba où toutes sortes de gens viennent chercher un soutien spirituel pour des problèmes de santé ou existentiels. Le «babalao», fort de ses 35 ans d'expérience, les reçoit et dirige des cérémonies «santería» et «yoruba». La façade de la maison, percée d'ouvertures verticales, possède un balcon panoramique qui surmonte la lourde double porte en bois s'ouvrant sur un escalier en marbre menant à l'étage.

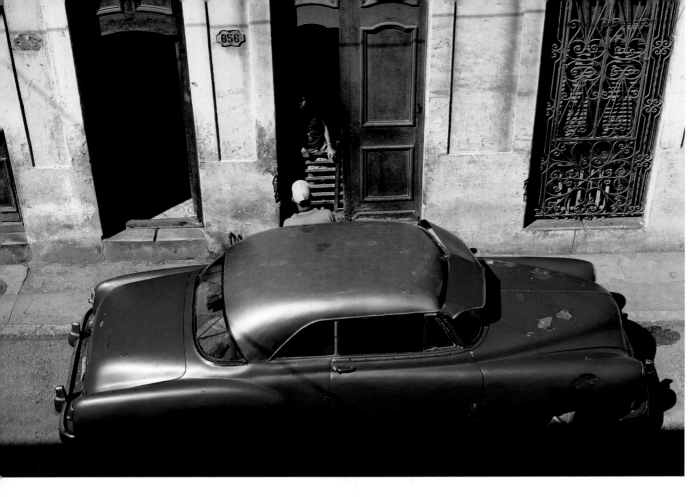

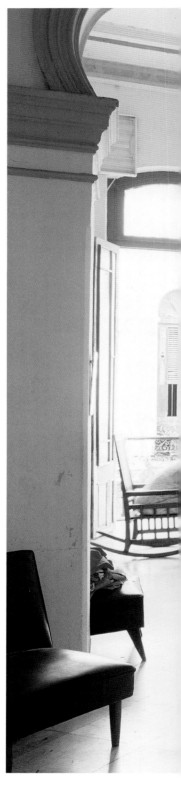

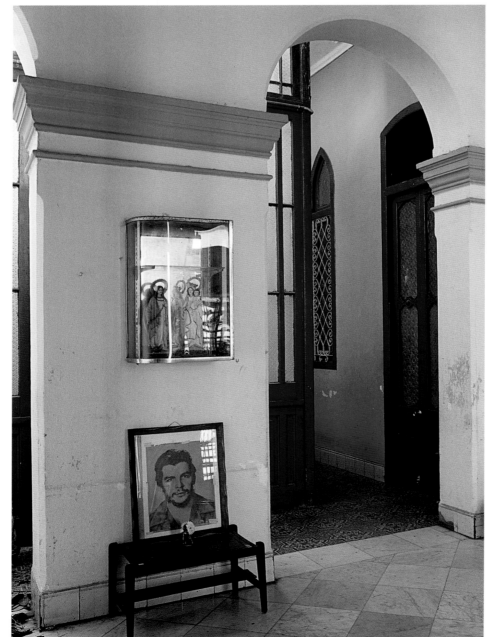

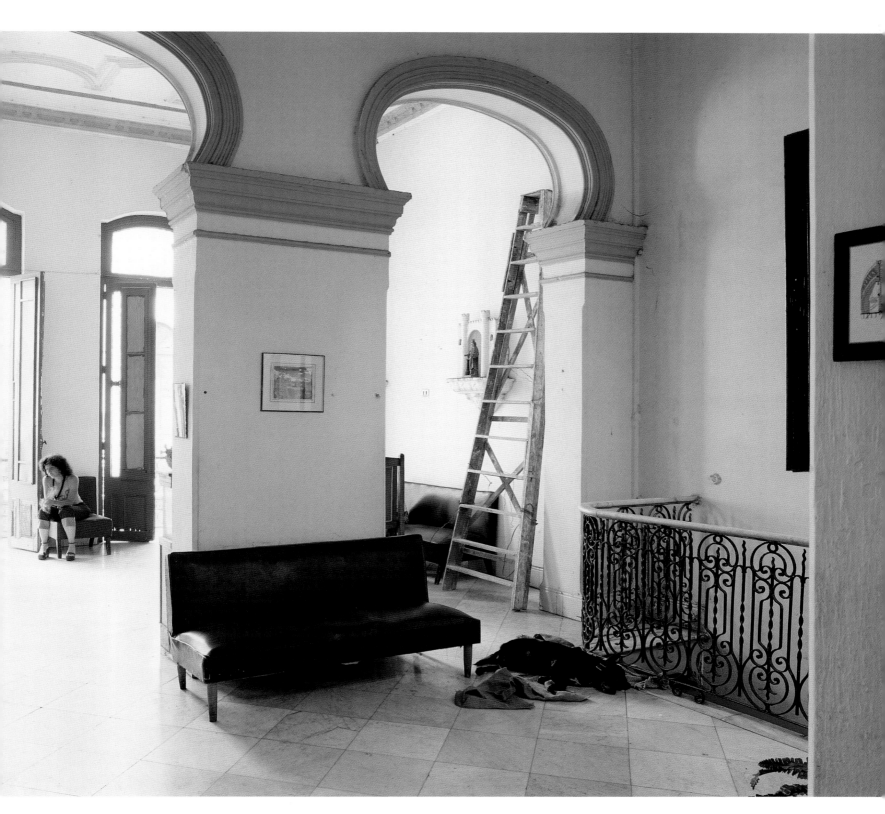

✳ **ABOVE LEFT** An old car from the United States parked in front of the building located in the Centro Habana neighborhood awaits a customer who is undergoing a check-up by the "babalao" Emilio Rodríguez Valdés. **LEFT** On one of the walls in the sitting room of Emilio Rodríguez Valdés's house, there is a small glass cabinet with religious icons above a photograph of Ernesto "Che" Guevara. **ABOVE** The wide doors of the living room lead to the balcony and illuminate the living room and the hall, which are solely divided by unique Moorish arches painted blue. The staircase lands in the sitting room, watched over by a dog. **FOLLOWING DOUBLEPAGE** On one of the walls in the living room, an image of "Changó", the "Santería" name of the Catholic Saint Barbara of Bitinia, on a small altar. ✳ **OBEN LINKS** Ein altes nordamerikanisches Auto parkt vor dem Gebäude im Viertel Centro Habana und wartet auf einen Kunden, während sich dieser vom »Babalao«-Priester Emilio Rodríguez Valdés beraten lässt. **LINKS** An einer Wand des kleinen Vorzimmers im Haus von Emilio Rodríguez Valdés hängt eine kleine Vitrine mit religiösen Ikonen über einem Foto von Ernesto »Che« Guevara. **OBEN** Die großen Balkontüren des Wohnzimmers durchfluten diesen Raum und das Vorzimmer mit Licht. Beide Zimmer werden nur durch außergewöhnliche, blau gestrichene, maurisch anmutende Bögen getrennt. Die Treppe endet im Vorzimmer, wo ein Hund wacht. **FOLGENDE DOPPELSEITE** An einer Wand im Wohnzimmer hängt ein kleiner Altar mit dem Bildnis von »Changó«, wie der »Santería«-Kult die im Katholizismus als Heilige Barbara von Bithynien bekannte Figur kennt. ✳ **PAGE DE GAUCHE, EN HAUT** Une vieille voiture américaine, garée devant l'immeuble dans le quartier de Centro Habana, attend un client en consultation avec le « babalao » Emilio Rodríguez Valdés. **A GAUCHE** Sur un mur de la petite salle, une vitrine accueille des statuetts de saints au-dessus d'une photo d'Ernesto « Che » Guevara. **CI-DESSUS** Les grandes portes-fenêtres qui donnent sur le balcon laissent pénétrer la lumière dans les deux salles, divisées uniquement par des arcs en fer à cheval peints en bleu. L'escalier débouche sur la petite salle, gardée par un chien. **DOUBLE PAGE SUIVANTE** Sur un mur de la grande salle, un petit autel accueille une représentation de « Changó », l'équivalent dans la « santería » de sainte Barbe de Bithynie.

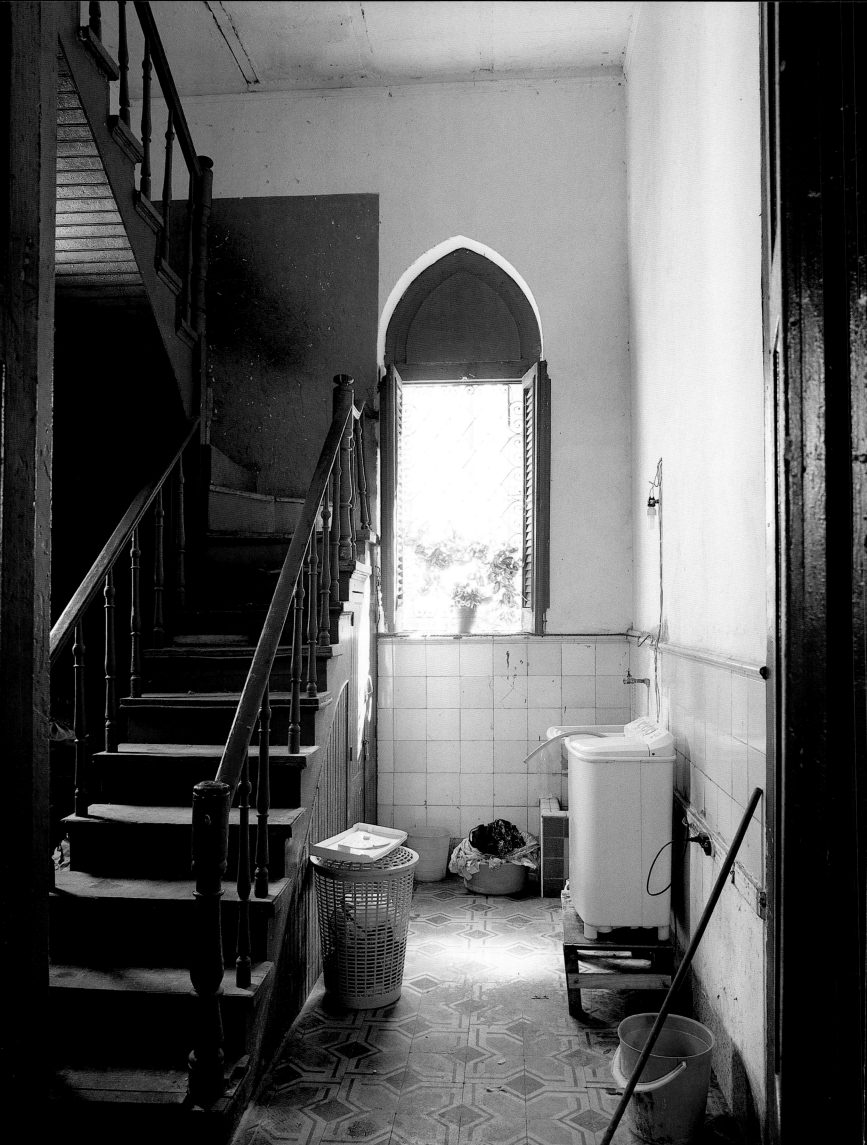

✳ **FACING PAGE** The laundry area has a wooden staircase for drying clothes on the roof. **RIGHT** An altar with images and offerings to the Afro-Cuban deities. **BELOW** The room where Emilio Rodríguez Valdés consults is decorated with an altar featuring diverse attributes of the syncretic religious cults of worship. The colored robes correspond to the different deities in the Yoruba religion called "Santería". **FOLLOWING DOUBLEPAGES** The spacious and well-lit kitchen with its tile veneer in white, one of the symbolic colors in Santería that corresponds to "Obatalá", a syncretism of "Our Lady of Mercy". * The bright, spacious dining room is also used as a classroom for teaching initiates the rituals and meaning of the objects of worship. ✳ **LINKE SEITE** Vom Waschraum führt eine Holztreppe zur Dachterrasse hinauf, wo die Wäsche zum Trocknen aufgehängt wird. **RECHTS** Ein Altar mit Abbildungen und Opfergaben für die Gottheiten der afro-kubanischen Religion. **UNTEN** Das Beratungszimmer von Emilio Rodríguez Valdés ist mit einem Altar eingerichtet, der diverse Merkmale der synkretischen Religionskulte aufweist. Die bunten Kleidungsstücke entsprechen den verschiedenen Gottheiten der als »Santería« bezeichneten Yoruba-Religion. **FOLGENDE DOPPELSEITEN** Die geräumige, helle Küche ist mit weißen Kacheln verkleidet, denn Weiß ist eine der symbolträchtigen Farben des »Santería«-Kults und wird »Obatalá« zugeschrieben, die der Jungfrau »Nuestra Señora de las Mercedes« entspricht.* Das große, helle Esszimmer des Hauses wird auch genutzt, um den Eingeweihten Unterricht in den Ritualen und der Bedeutung der Kultobjekte zu erteilen. Religiöse Figuren sind Teil der Dekoration. ✳ **PAGE DE GAUCHE** Dans la buanderie, un escalier en bois mène à la terrasse où l'on fait sécher le linge. **A DROITE** Un autel avec des offrandes et des représentations de divinités afro-cubaines. **CI-DESSOUS** Dans la salle de consultation d'Emilio Rodríguez Valdés, un autel avec divers attributs des cultes syncrétiques. Les habits colorés correspondent aux différentes divinités de la « santería », dérivant de la religion yoruba. **DOUBLE PAGE SUIVANTE** La cuisine, spacieuse et claire, avec son carrelage blanc, la couleur symbole d'« Obatalá », syncrétisme de « Notre-Dame des Grâce » dans la « santería », * Dans la grande salle à manger bien éclairée, on enseigne aussi les rituels et la signification des objets de culte aux initiés.

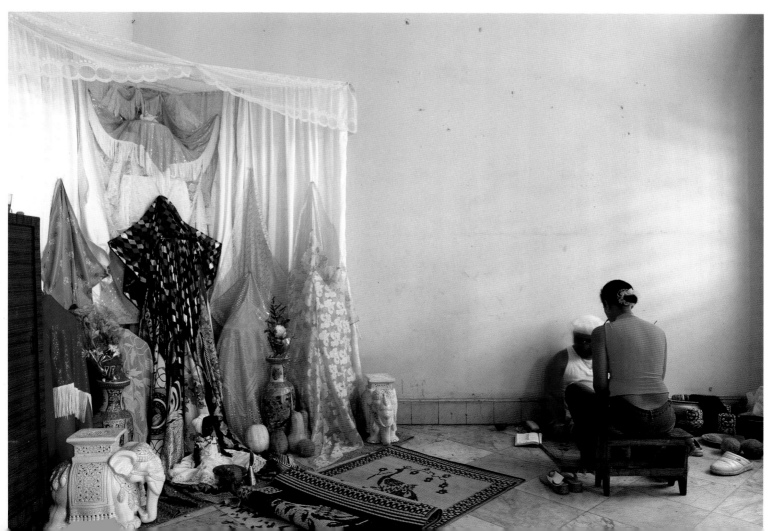

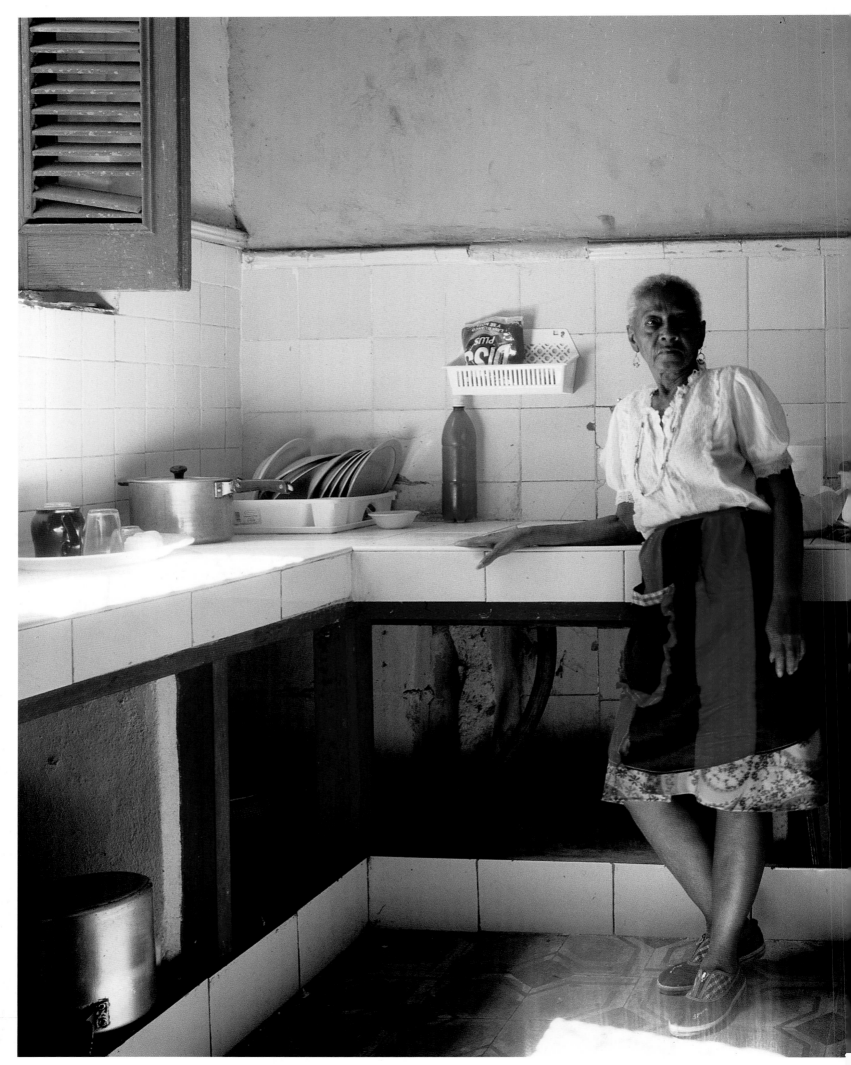

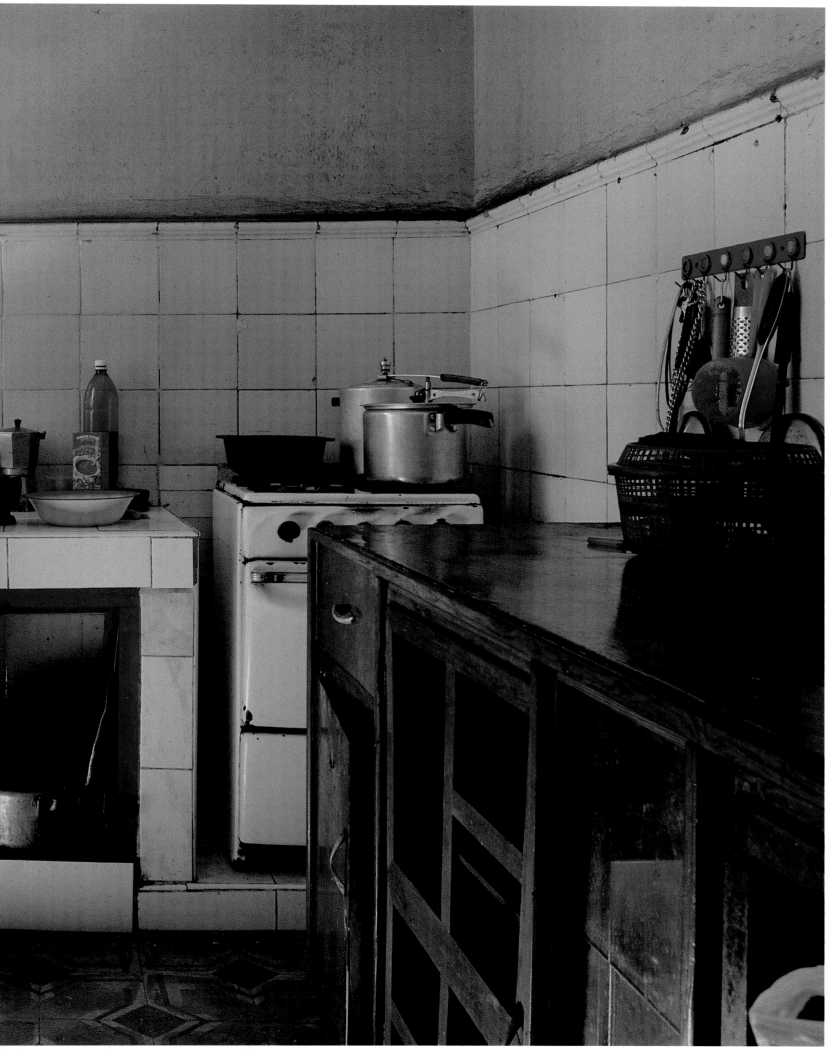

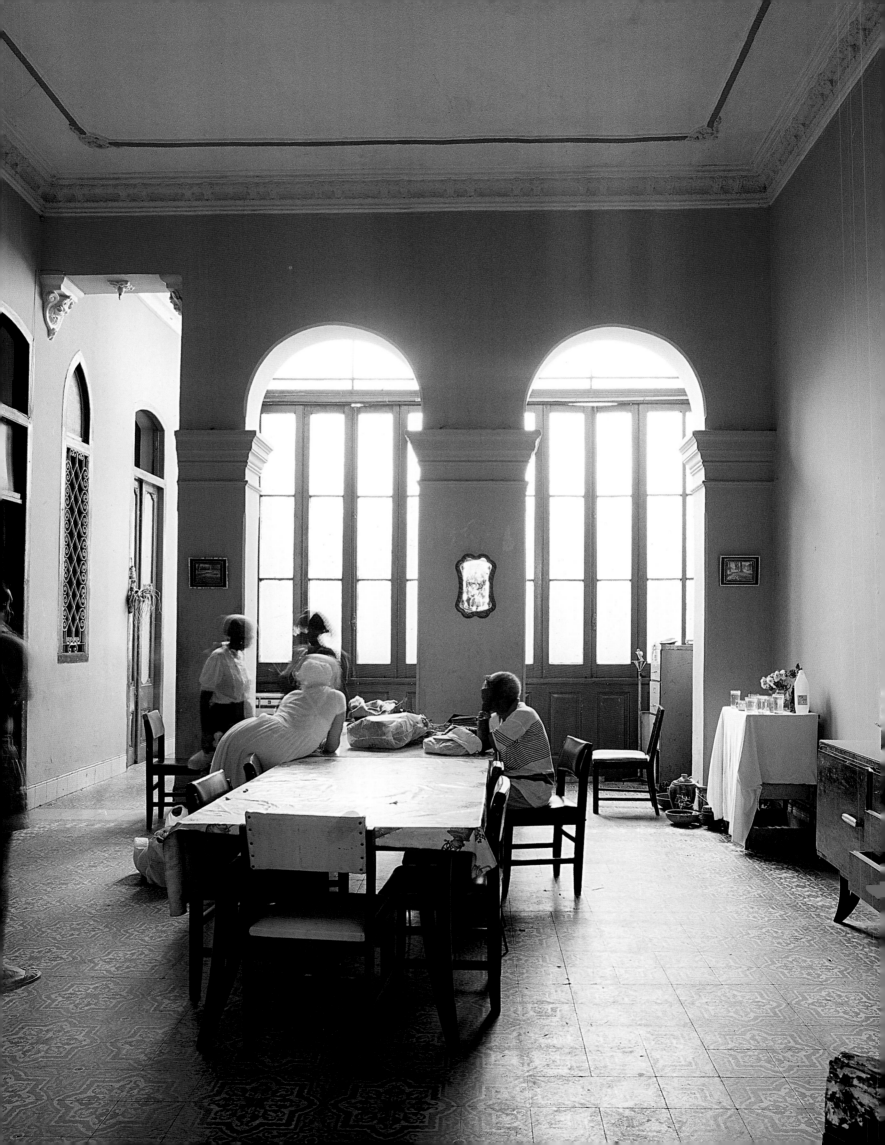

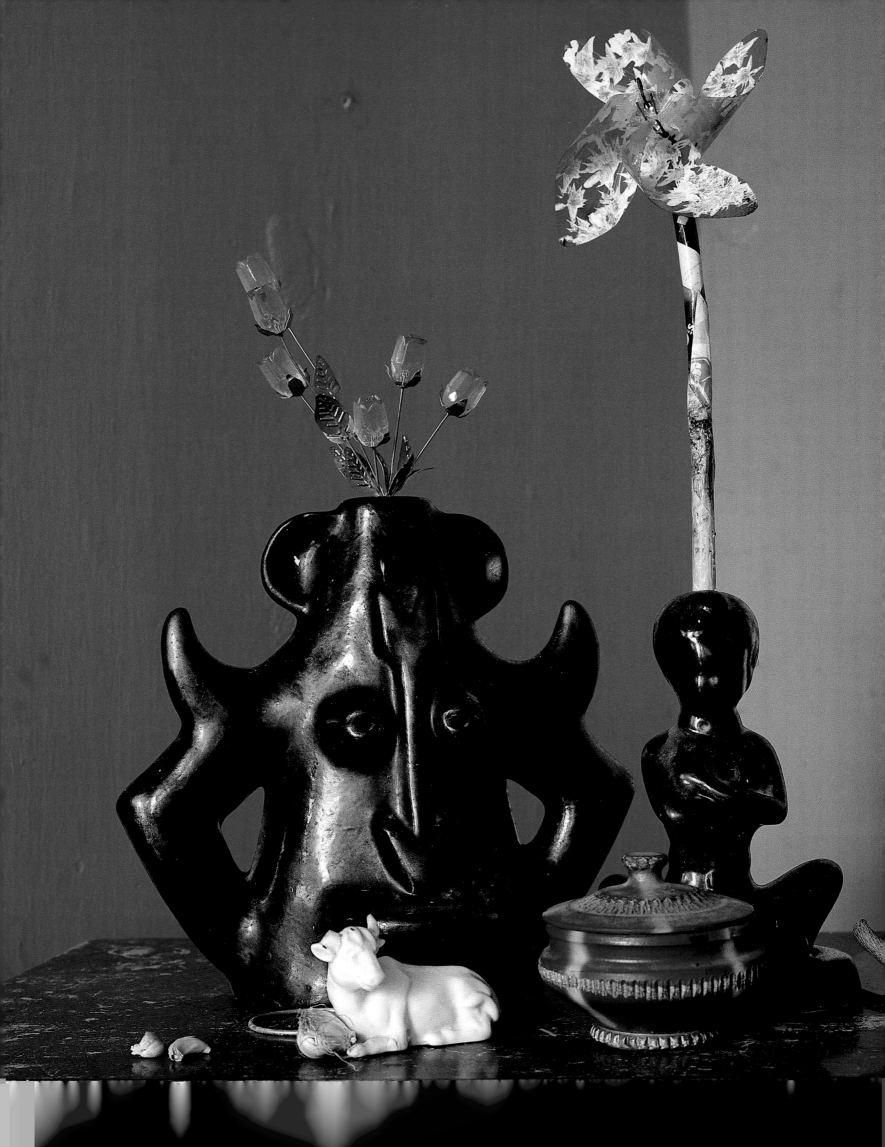

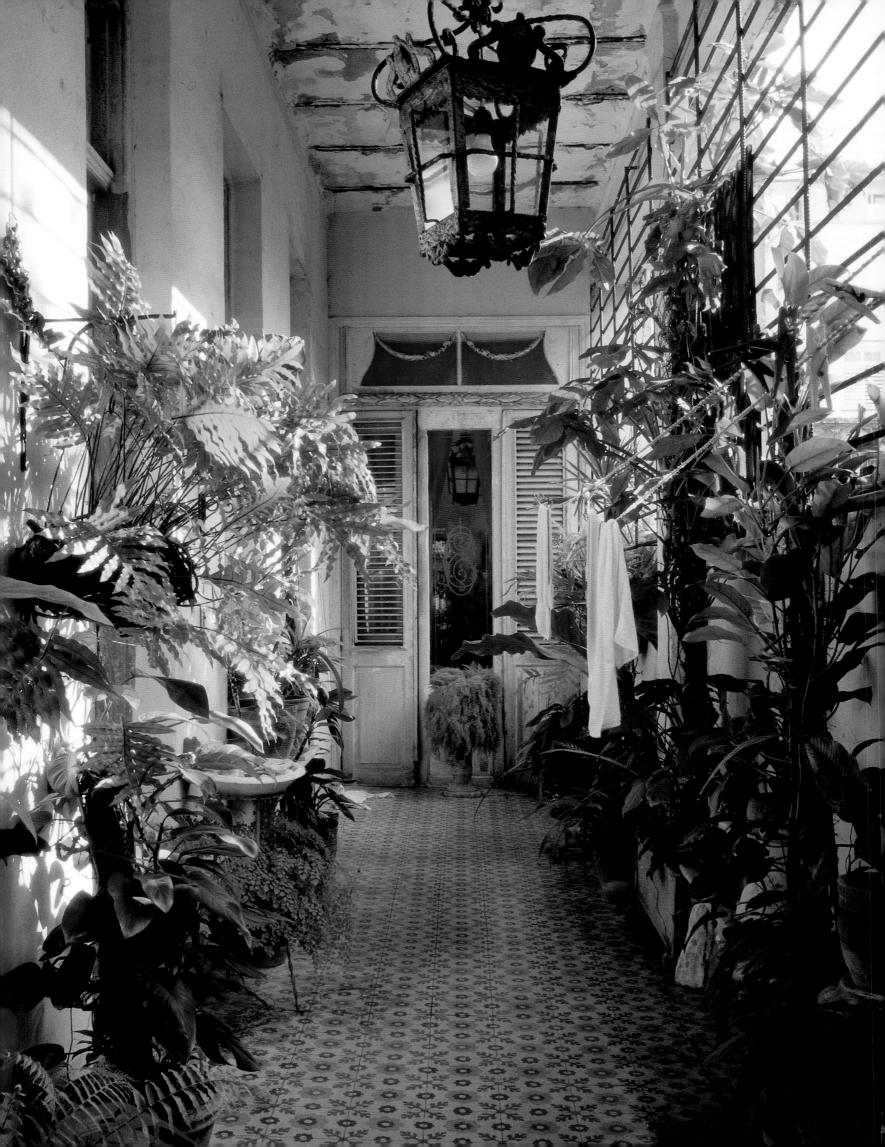

LEONARDO CANO MORENO

A Painter's Home.

Because of Leonardo Cano Moreno's extraordinary taste and imagination his otherwise ordinary two-storey house has been used in films such as "Mascaró: el cazador Americano," and more recently the striking "Siete días, siete noches." He is a painter and cartoon illustrator whose award-winning drawings for the 1990s Cuban cartoon "Vampiros en La Habana" have been exhibited at the Museum of Modern Art in New York. His house, located in the Vedado neighborhood of Havana, was built in the early 20th century and currently seems to have been invaded by nature: a climbing orange tree has weaved its way around the cement balusters and Corinthian columns of the façade's front terrace. The hedonistic and almost surreal interior combines beautiful 18th century furniture, a reproduction of "The Three Graces," old lamps, and clocks with contemporary erotic painting and stained glass. Friezes have been painted by the artist in an art nouveau style. The bedrooms and the dining room are arranged along an open corridor, filled with ferns, birds, and plants, that supplies natural light and ventilation to the rooms.

Eigentlich ist dies ein ganz gewöhnliches Haus. Doch der Maler und Illustrator Leonardo Cano Moreno hat es äußerst fantasievoll eingerichtet und damit einige Filmemacher angelockt. So wurde der Film »Mascaró: el cazador Americano« dort gedreht und kürzlich »Siete días, siete noches«. Cano Morenos preisgekrönte Zeichnungen für den kubanischen Comic aus den 1990ern, »Vampiros en La Habana«, wurden bereits im »Museum of Modern Art« in New York ausgestellt. Sein Haus liegt in Vedado, einem Viertel in Havanna, und stammt aus dem frühen 20. Jahrhundert. Heute wirkt es verwildert, rund um die Balustraden aus Beton und die korinthischen Säulen der vorderen Terrasse wächst ein Orangenbaum. Das hedonistische, leicht sukurrile Interieur besteht aus wunderschönen Möbeln aus dem 18. Jahrhundert, einer Reproduktion der »Drei Grazien«, alten Lampen und Uhren, zeitgenössischen erotischen Malereien und Buntglas. Dazu hat der Künstler ein Art-Nouveau-Friesdekor an die Wände gemalt. Ein offener Korridor, voller Farn, Vögel, Pflanzen, frischer Luft und Sonnenlicht, führt ins Schlafzimmer und ins Wohnzimmer.

Décorée avec goût et imagination, cette maison du début du 20ᵉ siècle, au départ ordinaire, a servi de décor à des films tels que «Mascaró : el cazador Americano» et, plus récemment, «Siete días, siete noches». Elle appartient au peintre et dessinateur Leonardo Cano Moreno, dont la bande dessinée créée dans les années 90, «Vampiros en La Habana», a été exposée au Musée d'Art Moderne de New York. Située dans le quartier de Vedado, elle est envahie par la nature. Un oranger grimpant s'est enroulé autour de la balustrade en ciment et des colonnes corinthiennes de la terrasse qui domine la façade. La décoration intérieure hédoniste et presque surréaliste associe de beaux meubles du 18ᵉ siècle, une reproduction des «Trois Grâces», des lampes et des pendules anciennes, avec des peintures érotiques contemporaines et des vitraux. Cano Moreno y a peint des frises dans un style Art nouveau. Les chambres et la salle à manger donnent sur un couloir aéré rempli de fougères, d'oiseaux et de plantes vertes, qui les inonde de lumière naturelle.

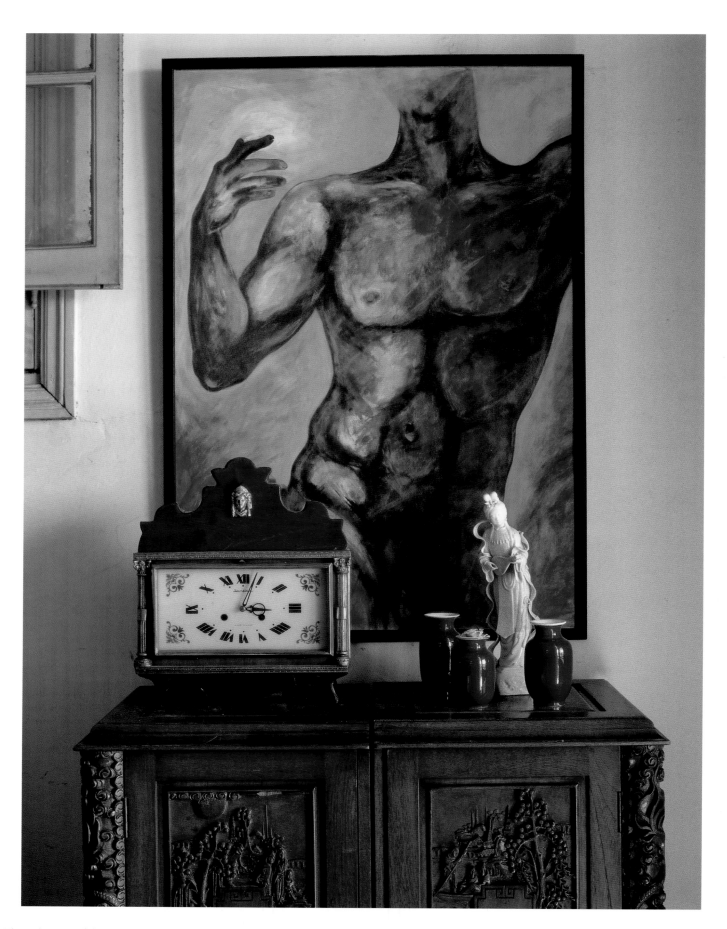

❋ **ABOVE** The nude is one of the recurring themes in the oeuvre of painter Leonardo Cano Moreno. One of his paintings hangs over a lovely piece of wood furniture with relief decorations. **FACING PAGE** The studio of painter and illustrator Leonardo Cano Moreno in one of the rooms in his house displays several of his works illuminated by a lovely chandelier hanging from the ceiling. ❋ **OBEN** Der Akt ist eines der immer wiederkehrenden Motive im Werk des Malers Leonardo Cano Moreno. Eines seiner Gemälde hängt über einem reizenden, mit Reliefschnitzereien verzierten Holzschränkchen. **RECHTE SEITE** Das Atelier des Malers und Illustrators Leonardo Cano Moreno wird von einer prächtigen Deckenlampe ins rechte Licht gerückt. ❋ **CI-DESSUS** Le nu est un des thèmes récurrents de l'œuvre de Leonardo Cano Moreno. Une de ses peintures au-dessus d'un beau meuble en bois sculpté. **PAGE DE DROITE** Dans l'atelier du peintre et illustrateur, quelques-unes de ses œuvres, éclairées par un beau lustre en cristal.

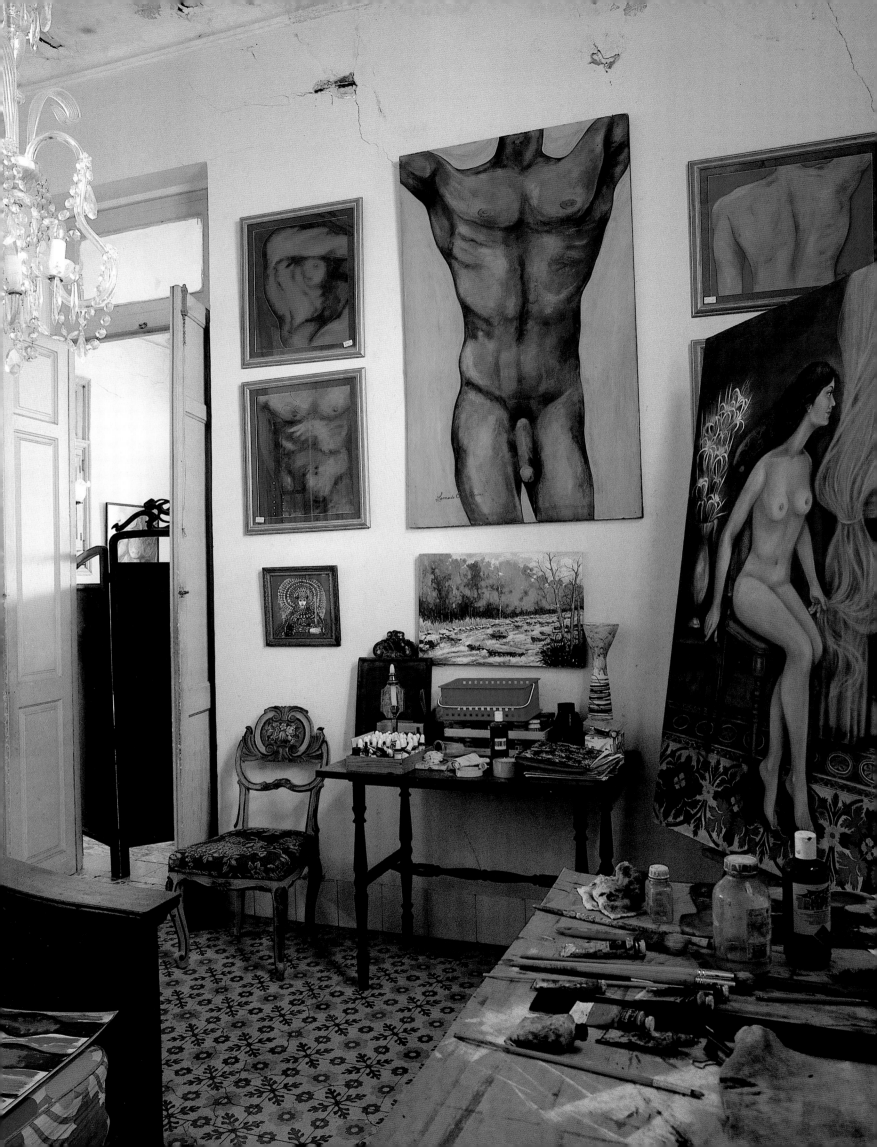

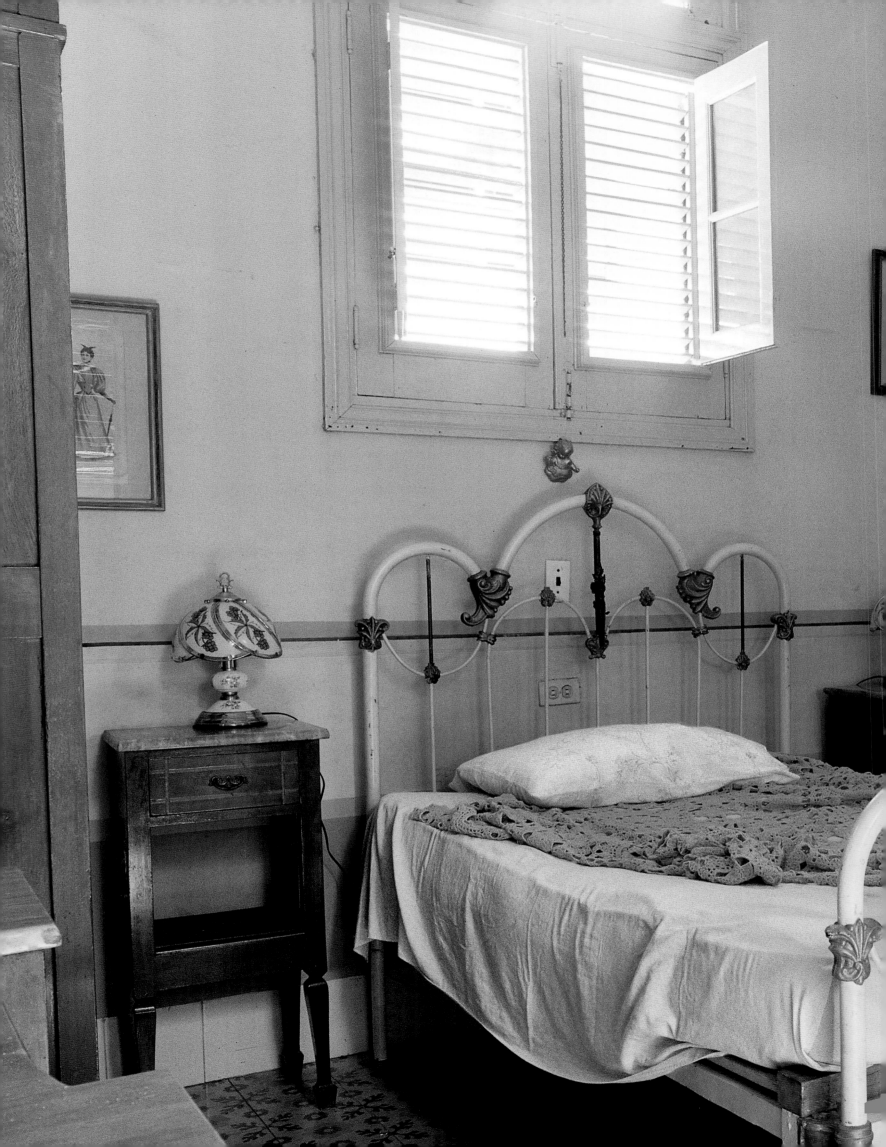

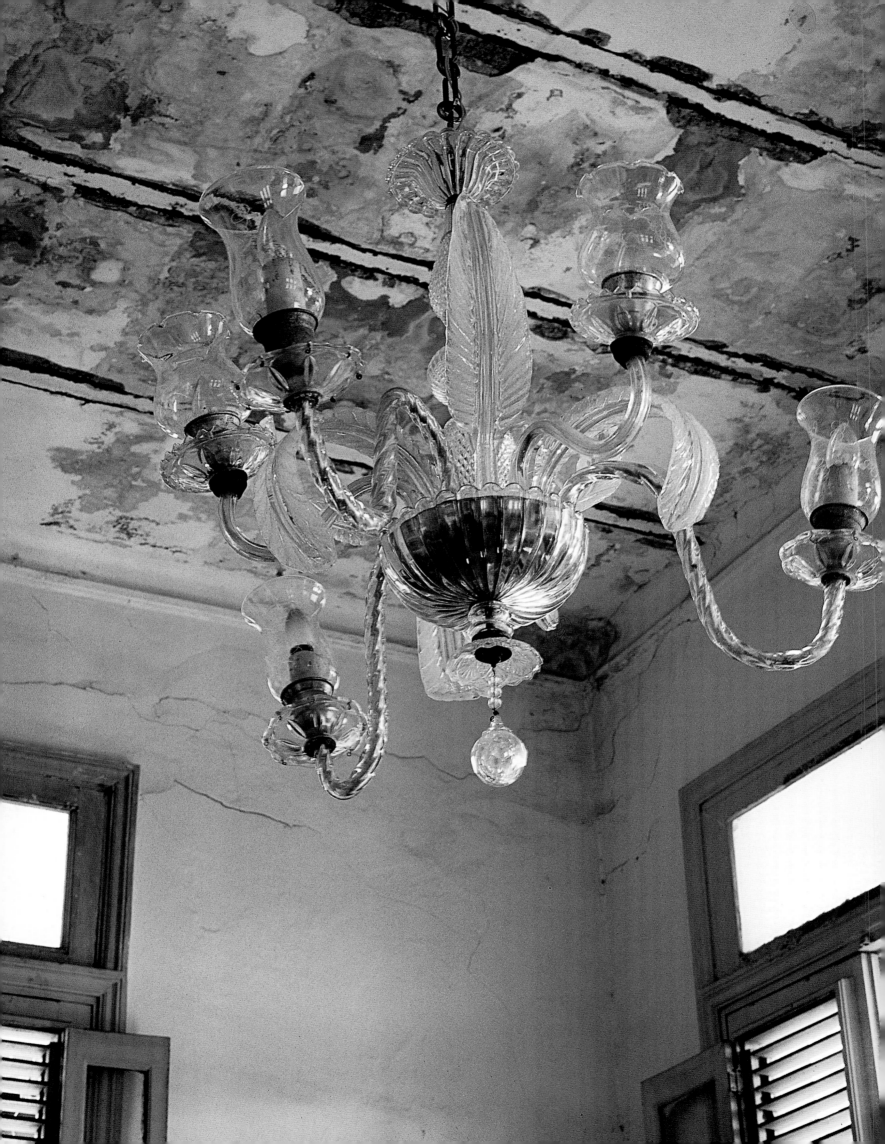

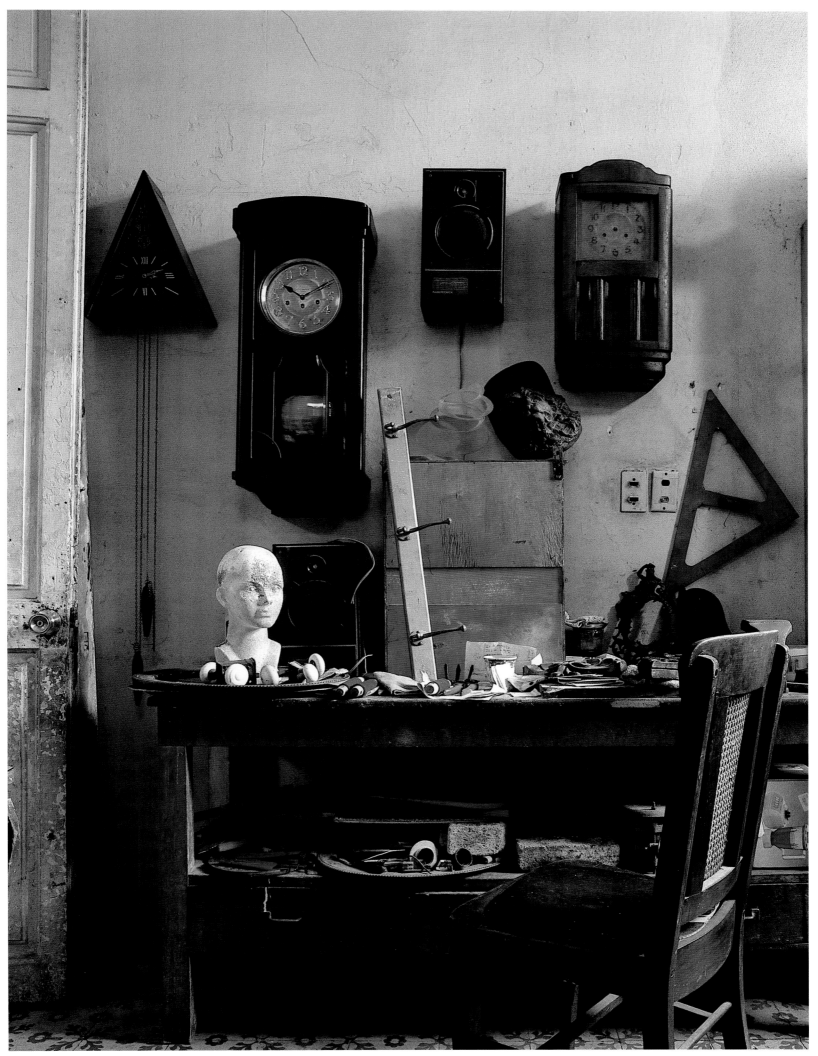

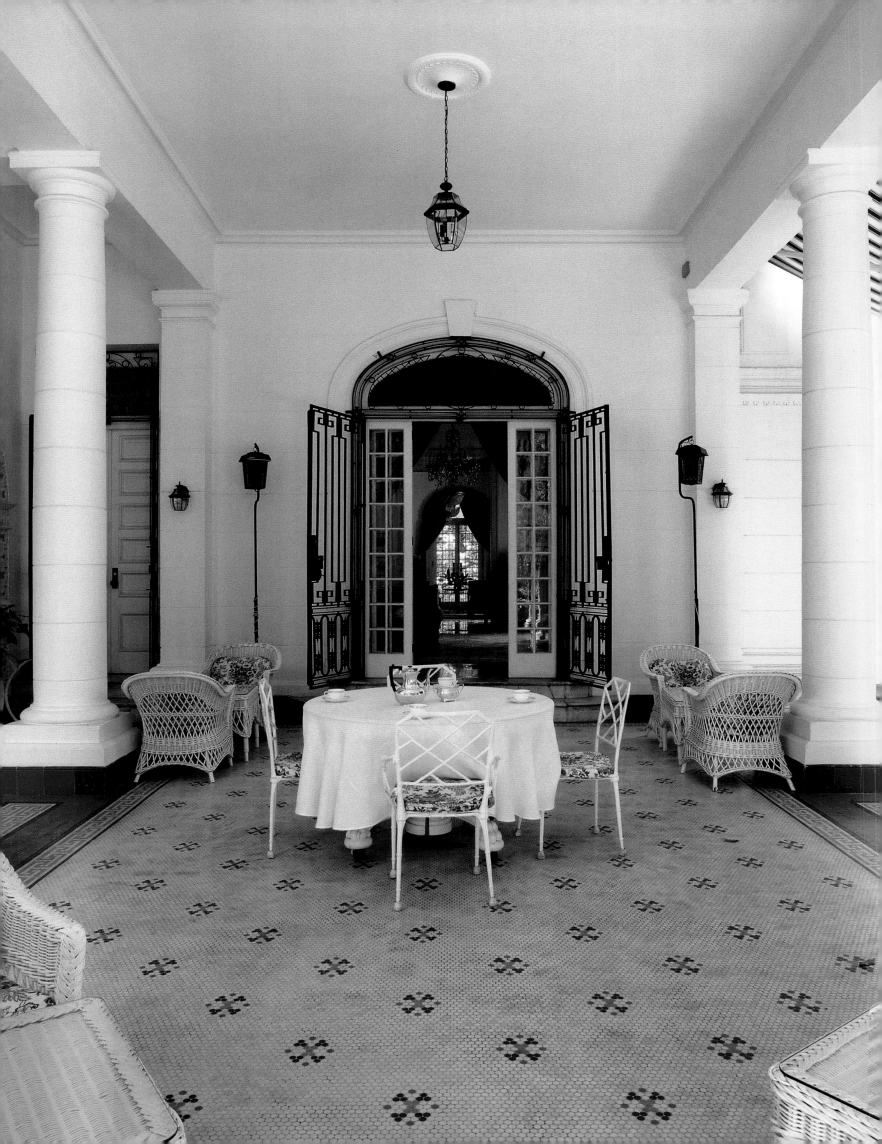

Casa

MENDOZA

Styles of Choice.

Vedado was a forbidden forest until José Yboleón laid out a plan for a new district in 1860, based on modern planning principles and a grid defined by wide, tree-lined avenues. As the Cuban War of Independence lasted from 1868 until 1898, this plan could only be realized in the first decades of the 20th century. In 1916, Cuban architect Leonardo Morales built a residence for banker and landowner Pablo González de Mendoza on Paseo Avenue. Influenced by classicism as it was practiced in the US, his architectural style is prevalent in this neighborhood as it was popular at that time among the wealthy who were building stately new residences. Set back from the street, the house was approached via a driveway leading first to a fountain, then to a circular iron-and-glass-canopied porch and entry hall. A lovely marble staircase lit by a stained-glass window makes a strong impression. The living room, reception room and dining hall all have views to the rear garden. In 1918, Morales and US architect John H. Duncan added a pavilion for a Roman-style pool: A statue of Aphrodite is surrounded by classical columns and wooden screens, and the highly refined wooden trusses and skylight above her make this space reminiscent of a Pompeian impluvium.

Das Viertel Vedado war früher ein unberührter Wald. José Yboleón entwarf 1860 auf diesem Gebiet einen neuen Bezirk nach modernen Planungsprinzipien. Er bestand aus einem Netzwerk weiter Alleen. Allerdings wurde er wegen des kubanischen Unabhängigkeitskrieges zwischen 1868 bis 1898 erst in den ersten Jahrzehnten des 20. Jahrhunderts umgesetzt. Für den Banker und Landbesitzer Pablo González de Mendoza baute der kubanische Architekt Leonardo Morales 1916 am Paseo in Vedado ein Haus. Die auffällige Architektur orientierte sich am amerikanischen Klassizismus, und schnell wurde das Haus für die damaligen Reichen zum Vorbild für ihre aristokratischen Residenzen. Ein Anfahrtsweg mit einem Brunnen führt zum von der Straße zurückversetzten Haus. Hinter einer runden, gedeckten Veranda aus Eisen und Glas befindet sich die Eingangshalle mit herrlichem Marmortreppenhaus, in das farbiges Licht durch Buntglasfenster fällt. Wohnzimmer, Empfangsraum und Esszimmer haben alle Sicht auf den Garten hinter dem Haus. Morales baute 1918 zusammen mit dem amerikanischen Architekten John H. Duncan einen Pavillon als römisches Bad mit einer Statue von Aphrodite, klassischen Säulen und Holzgittern, edlem Fachwerk aus Holz und einem Oberlicht. Dies war an ein pompejanisches Impluvium angelehnt.

Vedado était autrefois une forêt interdite, jusqu'à ce que, en 1860, José Yboleón n'établisse le plan d'un nouveau quartier basé sur des principes modernes d'urbanisme avec de grandes avenues bordées d'arbres. La guerre d'indépendance ayant duré de 1868 à 1898, son projet ne put être réalisé qu'au cours des premières décennies du 20e siècle. En 1916, l'architecte cubain Leonardo Morales bâtit une résidence pour le banquier et propriétaire terrien Pablo González de Mendoza sur l'avenue Paseo. Influencé par le classicisme nord-américain, son style fit école dans le quartier, devenant très prisé des riches qui, à l'époque, se faisaient construire de nouvelles grandes demeures. On accède à la maison, en retrait de la rue, par une allée menant à une fontaine, puis à un perron couronné d'une marquise ronde et vitrée en fer forgé. Dans le hall, un escalier en marbre éclairé par un vitrail est du plus bel effet. Le salon, la réception et la salle à manger donnent sur le jardin arrière. En 1918, Morales et l'architecte américain John H. Duncan ajoutèrent un pavillon pour abriter une piscine à la romaine. La statue d'Aphrodite entourée de colonnes classiques et d'écrans en bois, la charpente richement ouvragée et l'ouverture dans le toit rappellent un impluvium pompéien.

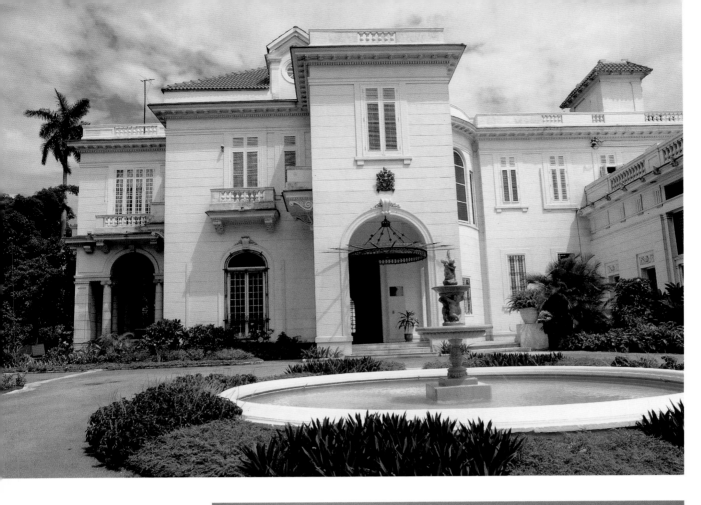

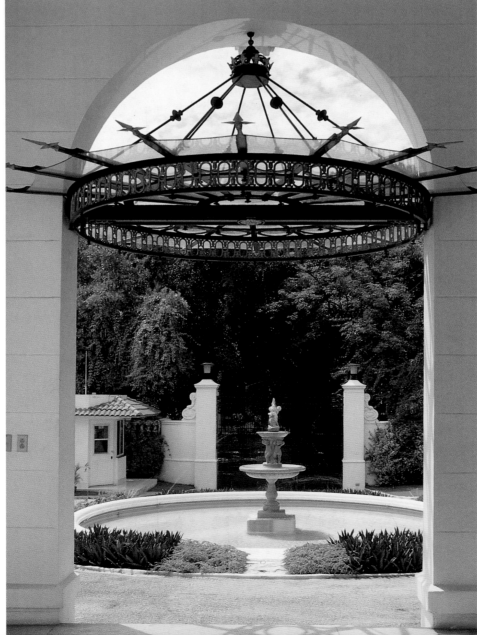

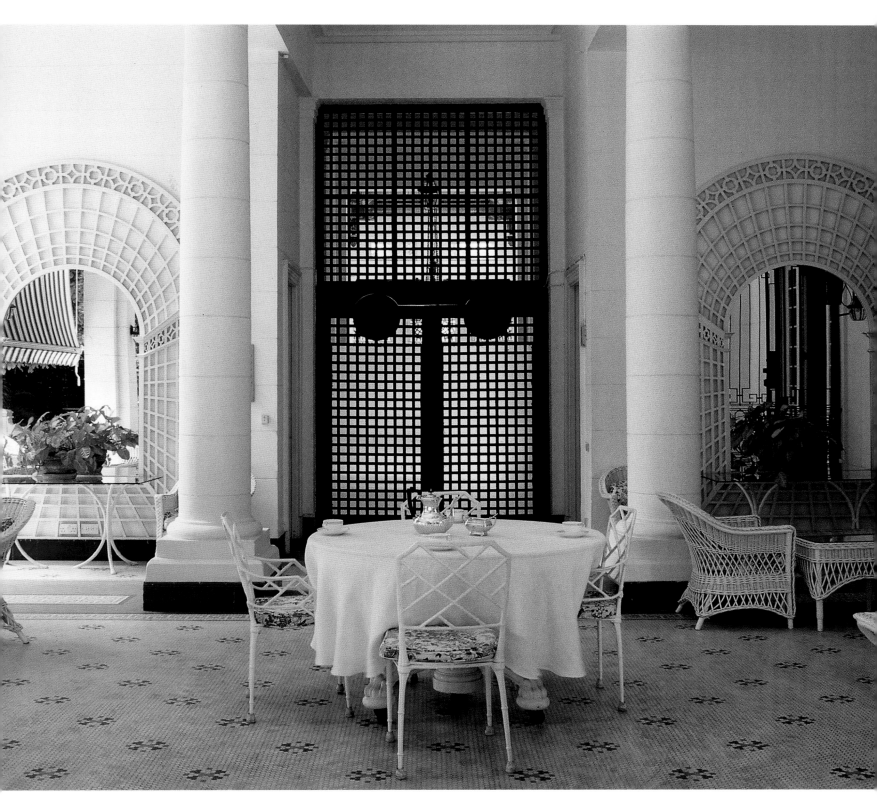

✳ **ABOVE LEFT** The main façade of the house is preceded by a fountain in the middle of the entryway via Calle 15 in the neighborhood of Vedado. The house is currently the residence of the British ambassador to Cuba. **LEFT** A circular iron and glass marquee hangs from a semicircular arch at the house's main entrance. **ABOVE** The terrace that serves as an antechamber to the swimming pool. The large bay dividing both spaces is closed off by a door made of wooden strips, flanked by two mirrors with latticework frames. **FOLLOWING DOUBLEPAGE** The fabulous Roman swimming pool, an exquisite and extremely beautiful space due to its unique, refined atmosphere. ✳ **OBEN LINKS** Der Hauptfassade des Hauses geht ein Brunnen voraus, der sich in der Mitte der Zufahrt von der Calle 15 im Stadtviertel Vedado befindet. Derzeit hat hier der britische Botschafter in Kuba seinen Wohnsitz. **LINKS** Ein rundes Sonnendach aus Eisen und Glas hängt am Haupteingang des Hauses von einem Rundbogen herab. **OBEN** Die Terrasse dient als Vorraum des Swimmingpools. Die große Lichtöffnung zwischen beiden Räumlichkeiten ist mit einer aus Holzlatten gestalteten Tür verschlossen. Auf beiden Seiten der Tür befinden sich Spiegel, die von einem zarten Holzgeflecht gerahmt werden. **FOLGENDE DOPPELSEITE** Der großartige, römisch gestaltete Swimmingpool befindet sich in einem erlesenen, prächtigen Raum, der durch sein einzigartiges und elegantes Ambiente besticht. ✳ **PAGE DE GAUCHE, EN HAUT** La façade principale, précédée d'une fontaine. On y accède par une allée depuis la Calle 15, dans le quartier de Vedado. C'est aujourd'hui la résidence de l'ambassadeur du Royaume-Uni. **A GAUCHE** Une marquise ronde et vitrée en fer forgé suspendue à une arche en plein cintre dans l'entrée principale. **CI-DESSUS** La terrasse servant d'antichambre à la piscine. La grande baie qui divise les espaces est fermée par une porte en lattes de bois, flanquée de deux miroirs bordés de treillis en osier. **DOUBLE PAGE SUIVANTE** La somptueuse piscine romaine, lieu de détente exquis et raffiné.

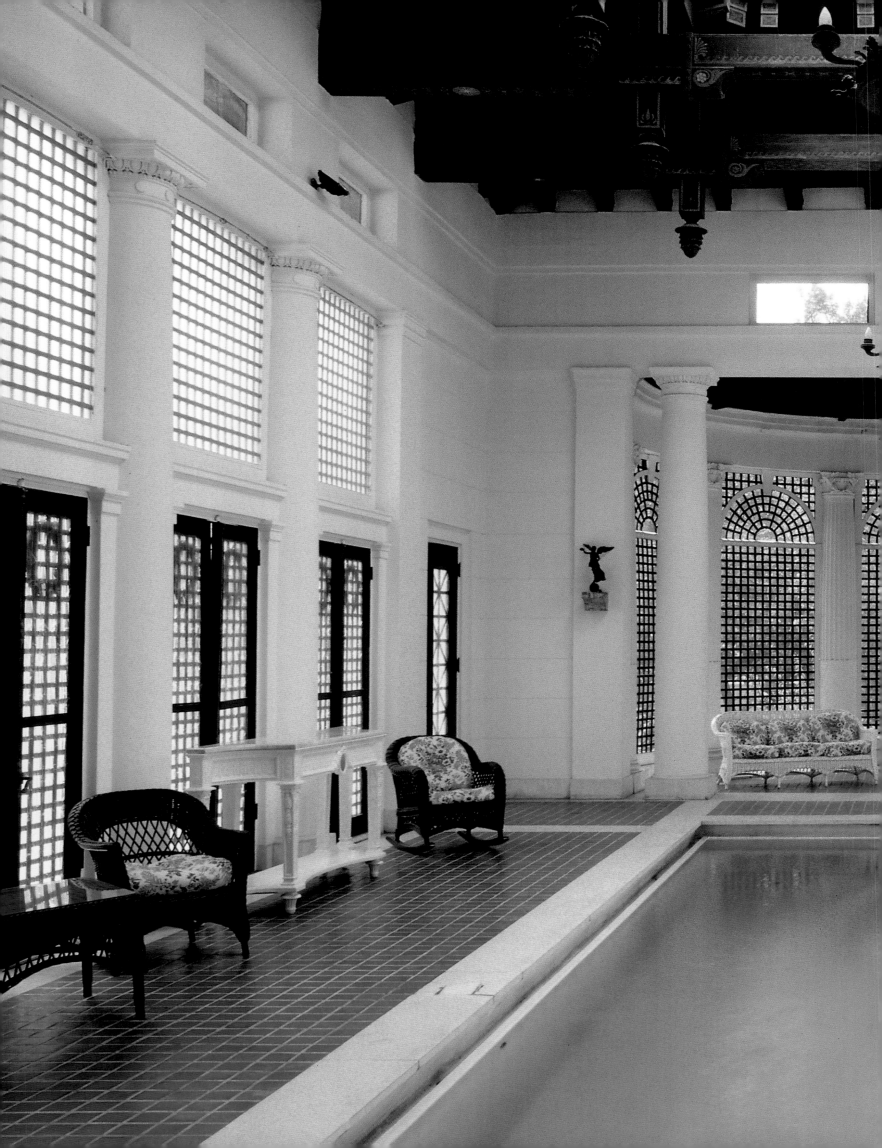

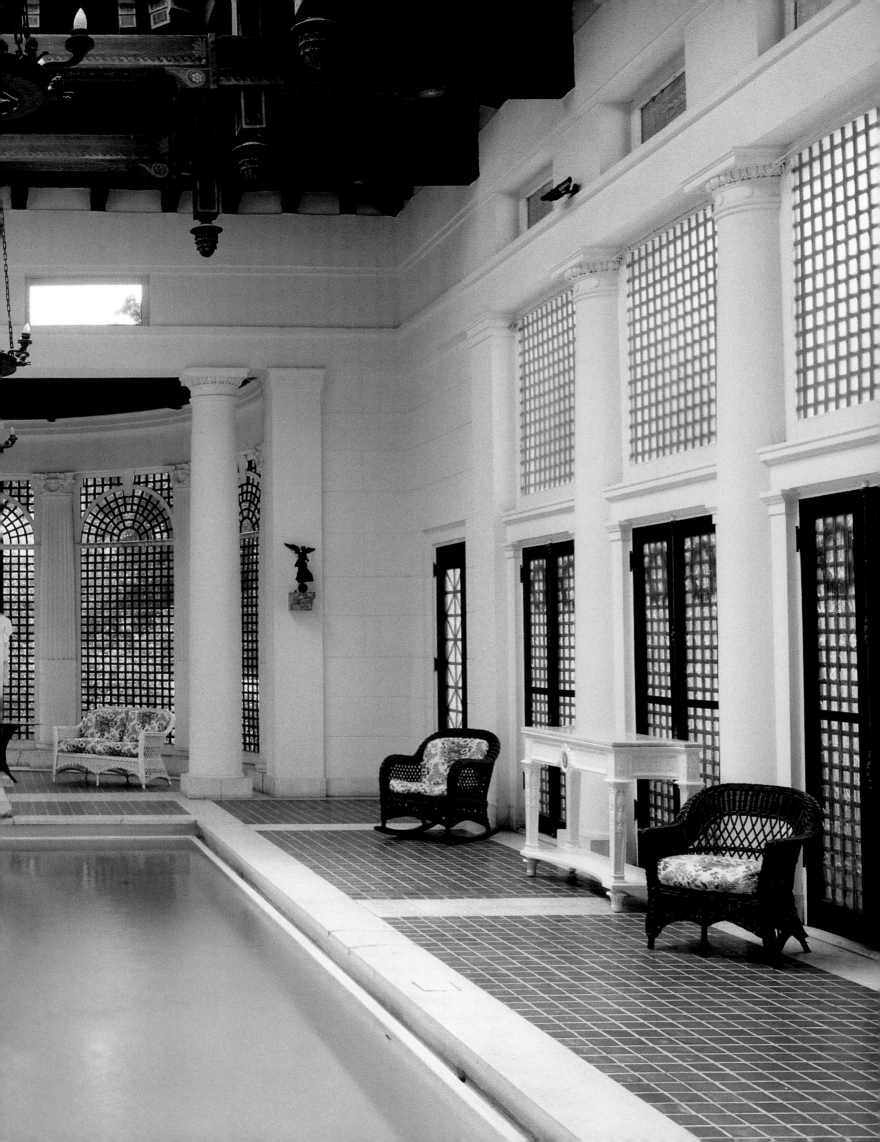

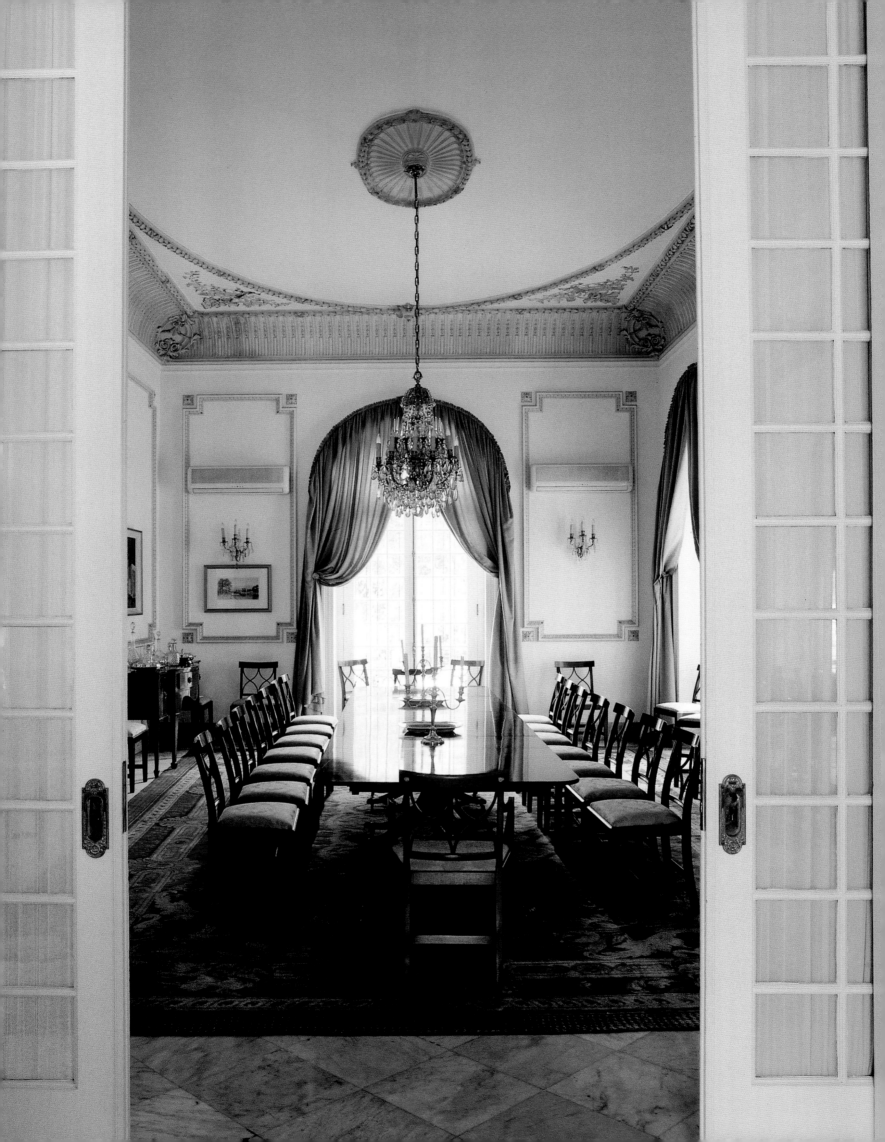

❋ **FACING PAGE** The dining room in the Pablo González de Mendoza home, next to the entrance hall, has views of the gardens. A lovely chandelier is suspended over the table. **RIGHT** The piano takes up a corner in the house's living room which features a beautiful lamp hanging from the ceiling. **BELOW** The cozy, intimate atmosphere in the sitting room, with its high ceilings and its eclectic yet exquisite decoration based on gypsum friezes.

❋ **LINKE SEITE** Der Speiseraum der Casa Pablo González de Mendoza grenzt an das Vestibül und bietet eine Aussicht auf die Grünanlagen. Über dem Tisch hängt eine prunkvolle Lampe. **RECHTS** Das Klavier steht in einer Ecke des Wohnzimmers, an dessen Decke eine schöne Lampe hängt. **UNTEN** Das gemütliche und einladende Ambiente des Wohnraums mit seiner hohen Decke und der eklektischen, jedoch erlesenen Einrichtung mit einem Fries aus Stuckleisten aus Gips. ❋ **PAGE DE GAUCHE** La salle à manger, contiguë au vestibule, donne sur les deux jardins. Au-dessus de la table, un beau lustre. **A DROITE** Le piano occupe un coin du salon, sous une belle suspension. **CI-DESSOUS** Le petit salon, intime et accueillant, avec son haut plafond, sa décoration éclectique mais raffinée, ses belles frises en plâtre.

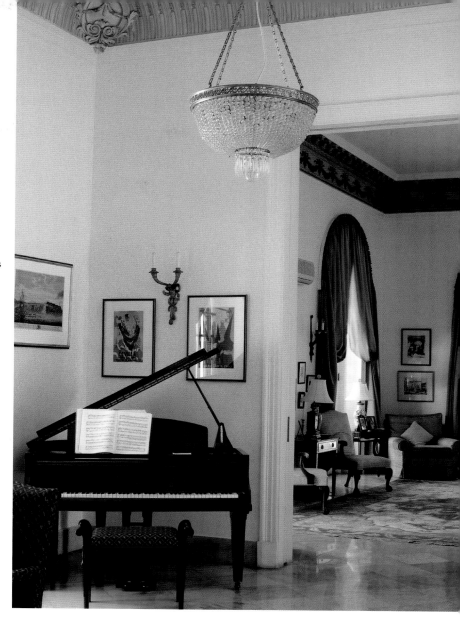

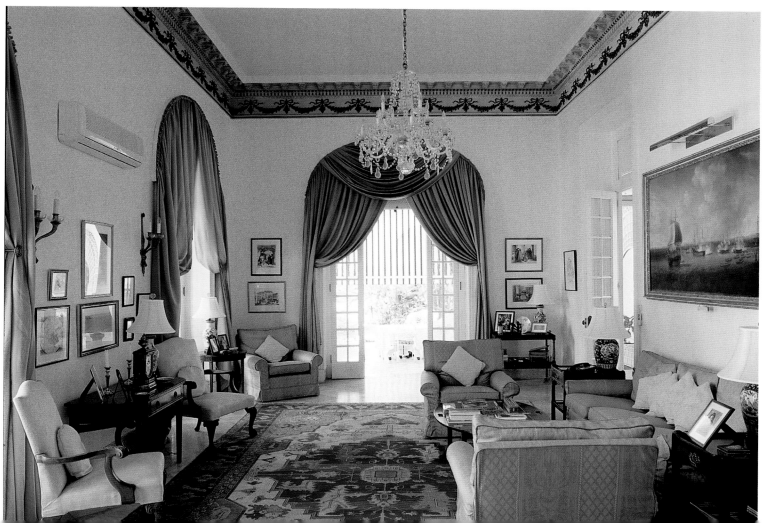

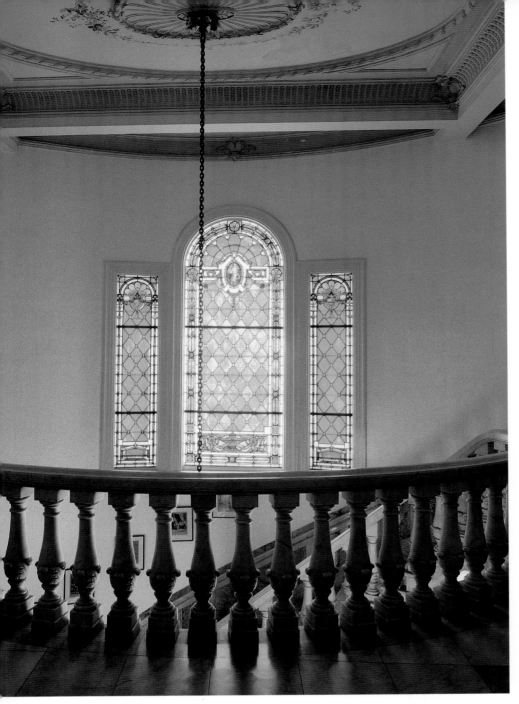

✳ **ABOVE** The entrance gallery to the upper storey is protected by a white marble balustrade. In the background are the stained glass windows that illuminate the elegant staircase joining the two stories. **RIGHT** A beautifully designed wrought-iron grill delimits the private bedroom area on the upper floor of the house. **FACING PAGE** The sumptuous marble staircase connecting the two stories, bathed by the colorful light penetrating through the stained glass windows. ✳ **OBEN** Diese Galerie im Obergeschoss ist mit einer Balustrade aus weißem Marmor geschützt. Die Buntglasfenster im Hintergrund beleuchten die Treppe, welche die beiden Stockwerke des Hauses vereint. **RECHTS** Ein herrliches schmiedeeisernes Gitter begrenzt den Privatbereich der Schlafzimmer im Obergeschoss. **RECHTE SEITE** Die üppige Marmortreppe zwischen beiden Stockwerken erstrahlt im farbigen Licht, das durch die Buntglasfenster fällt. ✳ **CI-DESSUS** Le grand palier à l'étage est protégé par une balustrade en marbre blanc. Au fond, les vitraux qui éclairent l'élégant escalier. **A DROITE** À l'étage, une belle grille en fer forgé isole les chambres à coucher du reste de la maison. **PAGE DE DROITE** Le sompteux escalier en marbre est baigné par la lumière colorée qui filtre par les vitraux.

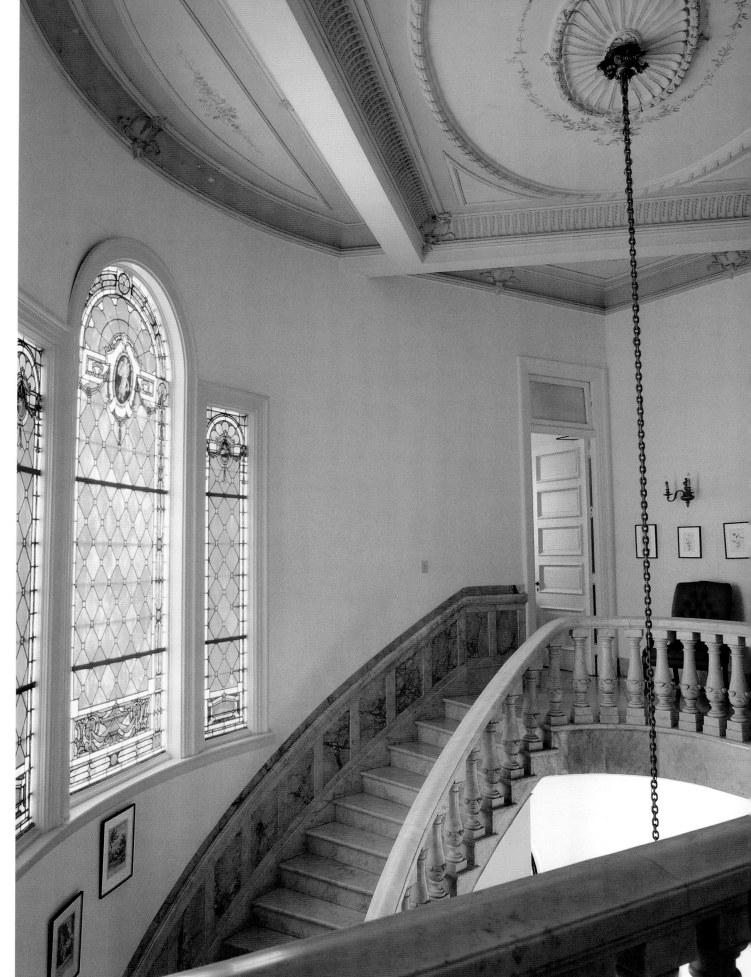

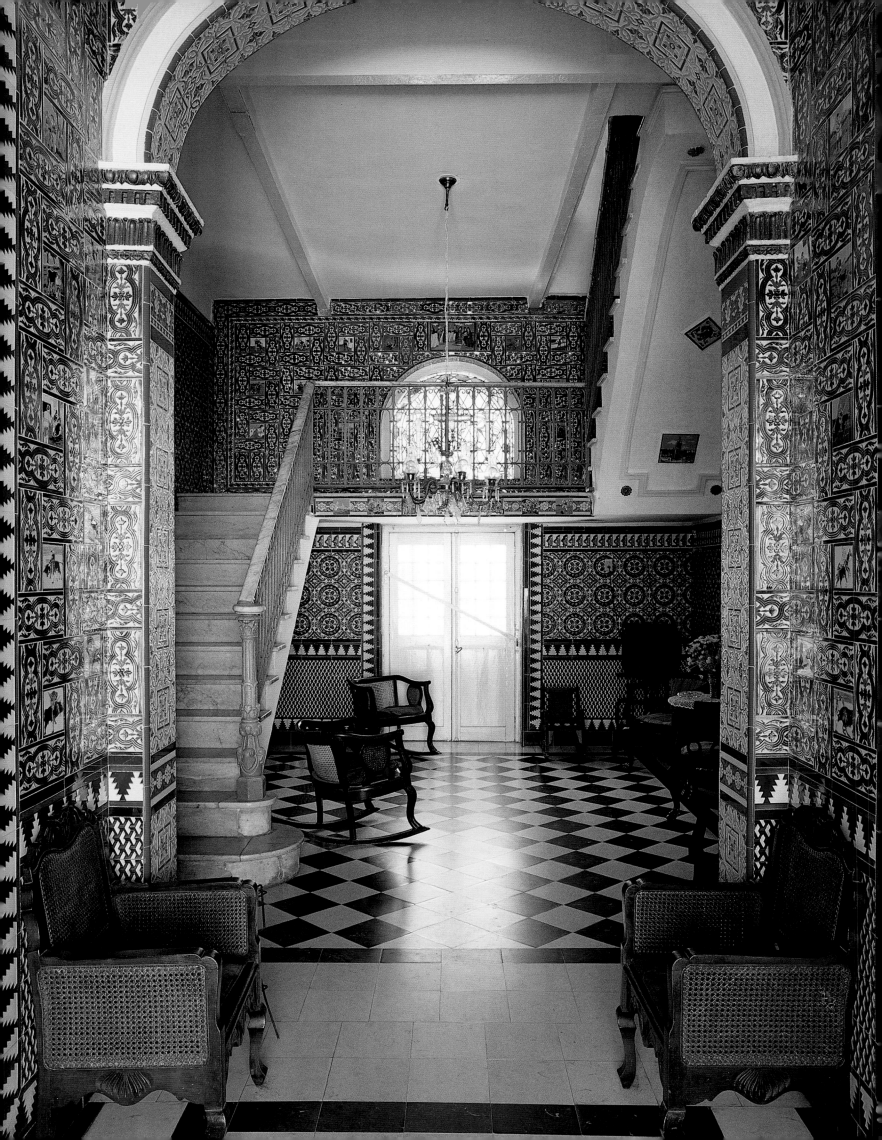

Jair Mon Pérez

A Feast of Spanish Tiles.

Reproductions of several works by the famous Spanish painter Francisco de Goya and some passages from Spanish writer Miguel de Cervantes' masterpiece "Don Quixote" are found among the thousands of tiles that decorate the walls of the Casa Mon. These colorful tiles from Seville, depicting bullfighting scenes and heraldic motifs, are repeated almost ad infinitum inside the house, which was originally built in Havana's Vedado district in 1928 for a Jewish jeweler, today it is owned by Jair Mon Pérez, inherited from his father. From the street one can see a riot of tiles on the planters in the front garden and on the steps leading to the porch. They continue along the façade where the main entrance and two windows are surrounded by tiles, which form a wainscot recalling the magnificent Alhambra palaces in Granada, the so-called "palacios nazaries". The entry vestibule leads to the spacious dining room which is also decorated with grand wainscoting around the windows. But the star of the show is another hallway, where a marble staircase with elaborate wrought-iron railings is lit by an arched stained-glass window – a fantastic display of many jewel-like colors!

An den Wänden der »Casa Mon« stellen tausende von farbigen Kacheln aus Sevilla Werke des spanischen Malers Francisco de Goya dar und auch Szenen aus »Don Quixote«, dem Meisterwerk des spanischen Schriftstellers Miguel de Cervantes. Im Haus, das ursprünglich im Viertel von Havanna Vedado für einen jüdischen Juwelier gebaut wurde, begegnet man unzähligen Stierkampfszenen und heraldischen Motiven. Heute wohnt hier Jair Mon Pérez, der das Haus von seinem Vater geerbt hat. Die Kacheln sind bereits von der Straße aus zu sehen: an Pflanzentöpfen, die auf den Stufen der Treppe stehen, die zur Veranda hinaufführt, rund um den Haupteingang und die beiden Fenster. Die Kachelverkleidung erinnert an die großartigen Alhambra-Paläste in Granada, den so genannten »palacios nazaries«. Das Vestibül führt in das Esszimmer, in einen großen Raum, dessen Fenster auch nochmals mit Kacheln verziert sind. Am schönsten ist allerdings der Flur mit einem Marmortreppenhaus mit einem kunstvollen schmiedeeisernen Geländer. Das Licht, das durch ein Buntglasfenster fällt, funkelt dabei wie Juwelen.

Parmi les milliers de carreaux qui ornent les murs de la Casa Mon, on trouve des reproductions de tableaux de Goya ou l'illustration de certains passages de «Don Quichotte», le chef-d'œuvre de Miguel de Cervantès. Ces compositions colorées provenant de Séville dépeignent également des scènes de corrida ou des motifs héraldiques et se répètent à l'infini à l'intérieur de la maison, construite à Vedado en 1928 pour un joaillier juif. Aujourd'hui Jair Mon Pérez, qui a hérité la demeure de son père, habite ici. Dès la rue, on aperçoit une profusion de carreaux sur les jardinières et les marches qui mènent au porche. Ils se poursuivent le long de la façade, encadrent l'entrée principale et les deux fenêtres, évoquant le magnifique palais de l'Alhambra à Grenade. Le vestibule et la salle à manger donnent sur un grand salon dont les lambris grandioses bordent les fenêtres. Mais le clou de la visite se trouve dans un autre couloir, où un escalier en marbre avec une belle rampe en fer forgé est éclairé par un vitrail en demi-lune, véritable joyau projetant mille feux colorés !

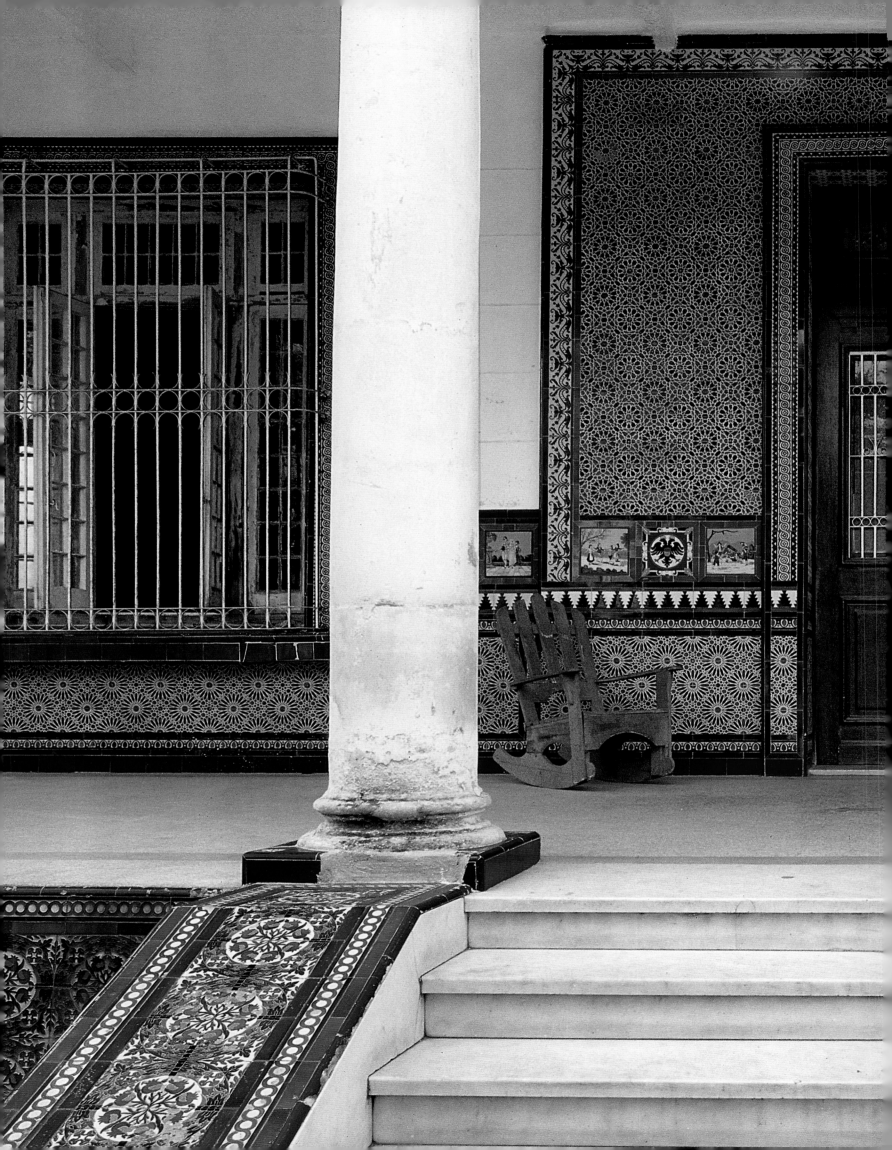

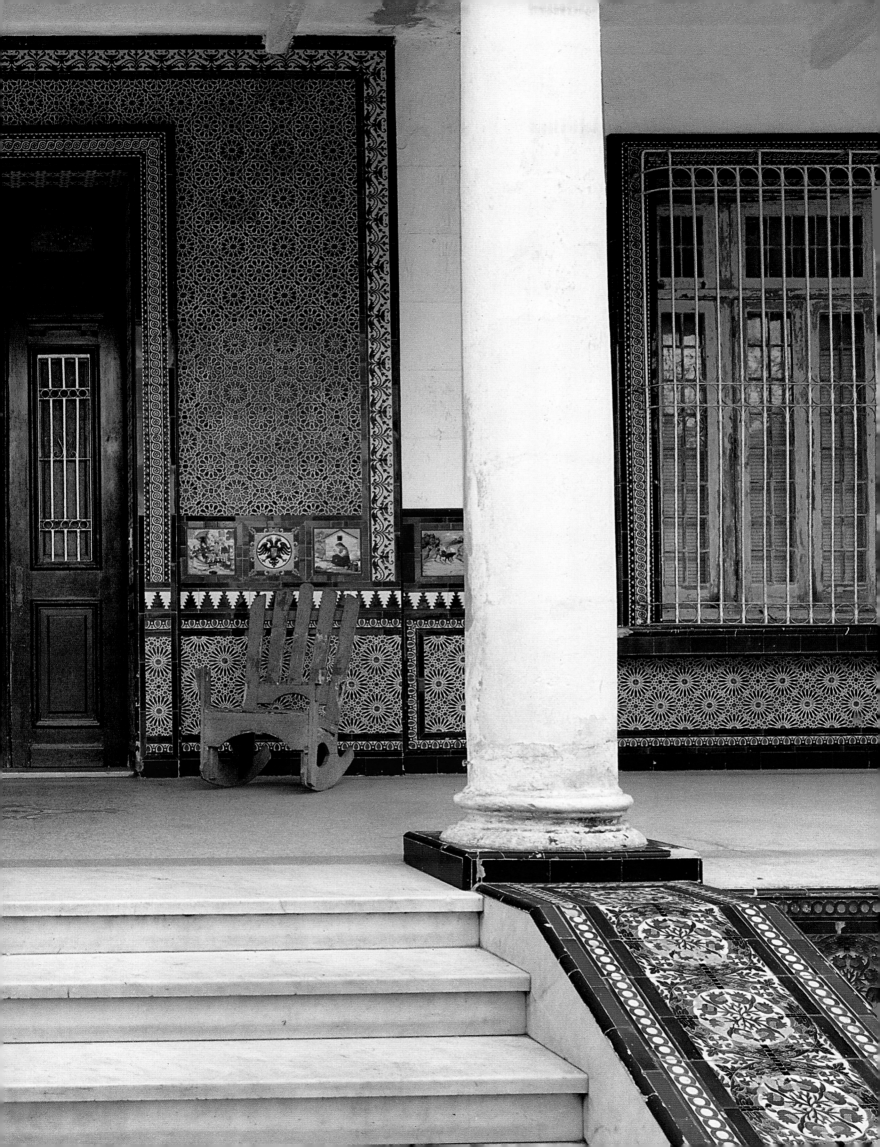

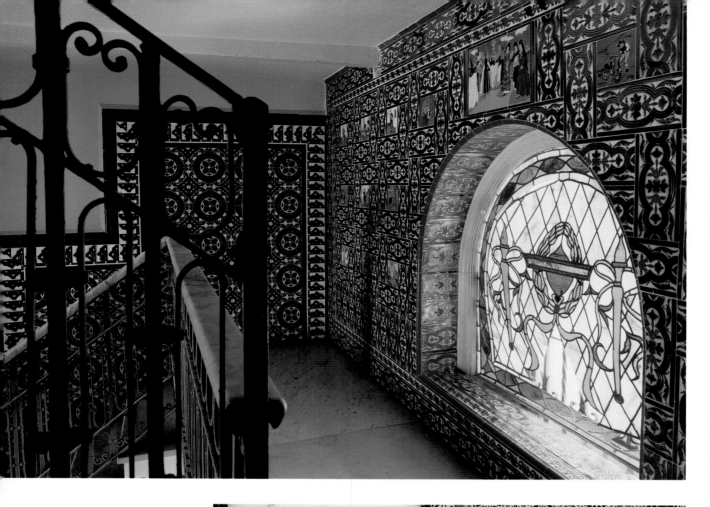

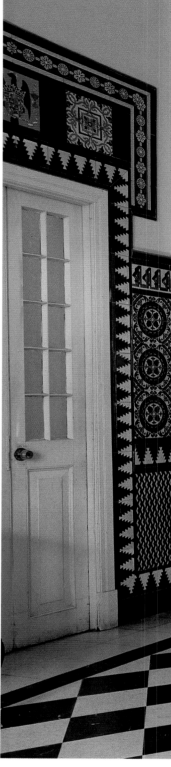

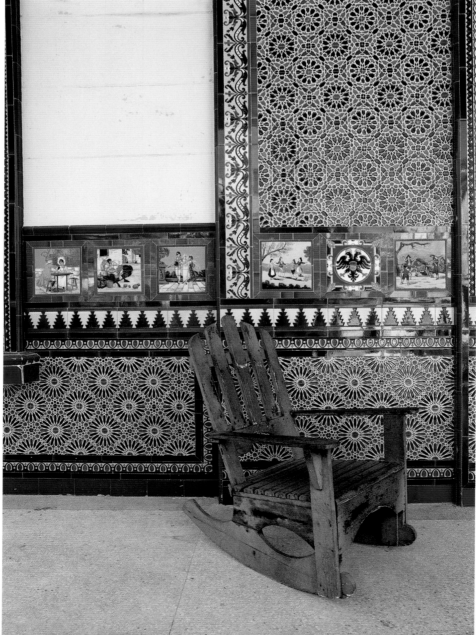

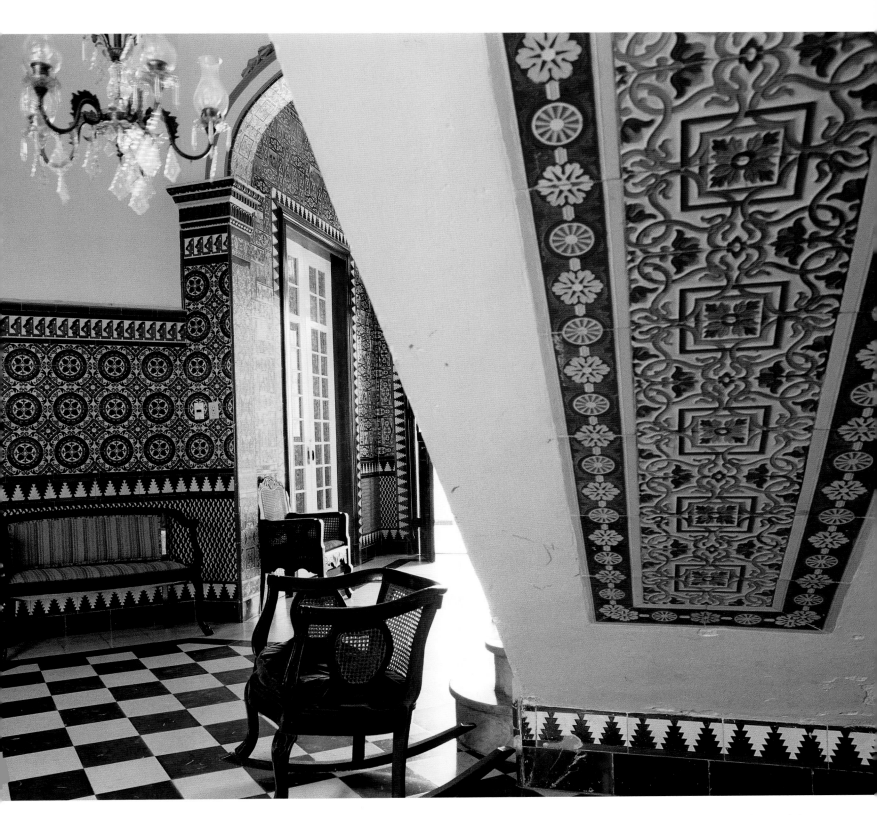

※ **PREVIOUS DOUBLEPAGES** Entrance to the house of Jair Mon Pérez. The main façade is decorated with magnificent wainscots made of tiles from Seville. **ABOVE LEFT** The lovely stained glass window illuminating the landing on the staircase is a point of light amidst a riot of bright colors. **LEFT** The wainscot on the main façade of the Jair Mon Pérez house with tiles depicting works by Goya. **ABOVE** Even the soffit of the staircase is decorated. **FOLLOWING DOUBLEPAGE** Detail of the portal wainscot with tiles depicting parts of Goya's 1776 painting "Baile a Orillas del Río Manzanares", now in the Prado. * Inside, the tile wainscots also include mosaics with chivalric scenes and vignettes from works by Goya. Partial view of his work "La Vendimia/El Otoño" rendered in 1786. ※ **VORHERGEHENDE DOPPELSEITE** Der Eingang des Hauses von Jair Mon Pérez. Die Hauptfassade besticht durch prachtvolle Sockel und eine Umrahmung der Haustüre mit Fliesen aus Sevilla. **OBEN LINKS** Das wunderschöne Buntglasfenster lässt den Treppenabsatz wie in einem Meer von Farben erstrahlen. **LINKS** Auf dem Fliesensockel bilden die Keramikkacheln die Werke des spanischen Malers Francisco de Goya nach. **OBEN** Die dekorativen Keramikfliesen sind sogar an der Treppenuntersicht angebracht. **FOLGENDE DOPPELSEITE** Nahansicht des Portalsockels, auf dem die Fliesen Ausschnitte von Goyas Werk »Picknick am Ufer des Manzanares« von 1776 nachbilden. Das Original befindet sich im Prado-Museum in Madrid. * Im Inneren zeigen die Fliesensockel auch Mosaike mit Reitszenen und Ausschnitte aus den Werken des spanischen Malers Goya. Teilansicht des 1786 von Francisco de Goya geschaffenen Werks »Die Weinlese/Der Herbst«. ※ **DOUBLE PAGE PRÉCÉDENTE** L'entrée de la maison. La façade est tapissée de magnifiques frises et scènes en azulejos sévillans. **PAGE DE GAUCHE, EN HAUT** Le beau vitrail est un point lumineux dans un océan de couleurs vives. **À GAUCHE** Les carreaux en céramique reprennent des scènes empruntées. **CI-DESSUS** Les carreaux en céramique couvrent même le dessous de l'escalier. **DOUBLE PAGE SUIVANTE** Détail des lambris du vestibule avec les carreaux représentant partiellement la « Danse de majos au bord du Manzanares » de Goya (1776), dont l'original est conservé au Musée du Prado à Madrid. * À l'intérieur, les lambris en azulejos incluent également des scènes de chevaleries et des œuvres de Goya. Vue partielle de « L'Automne ou la vendange », d'après un carton réalisé par Goya en 1786.

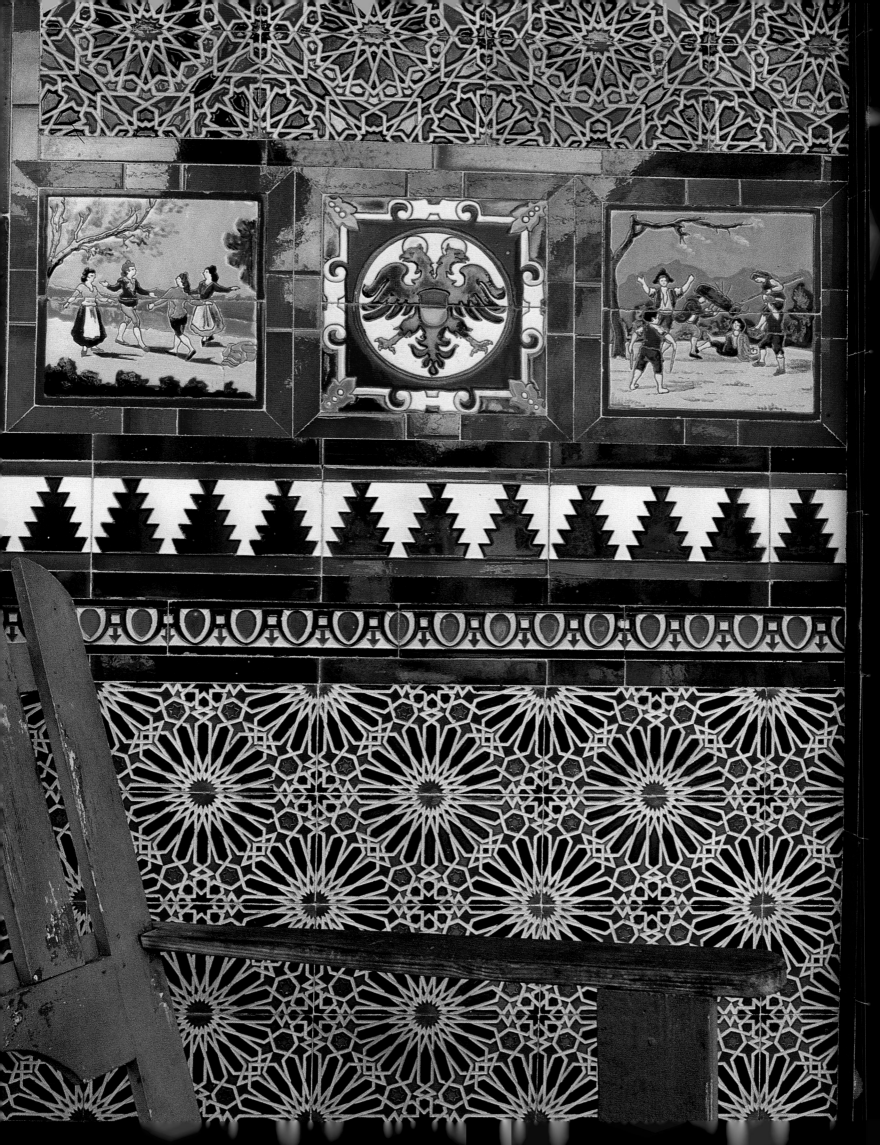

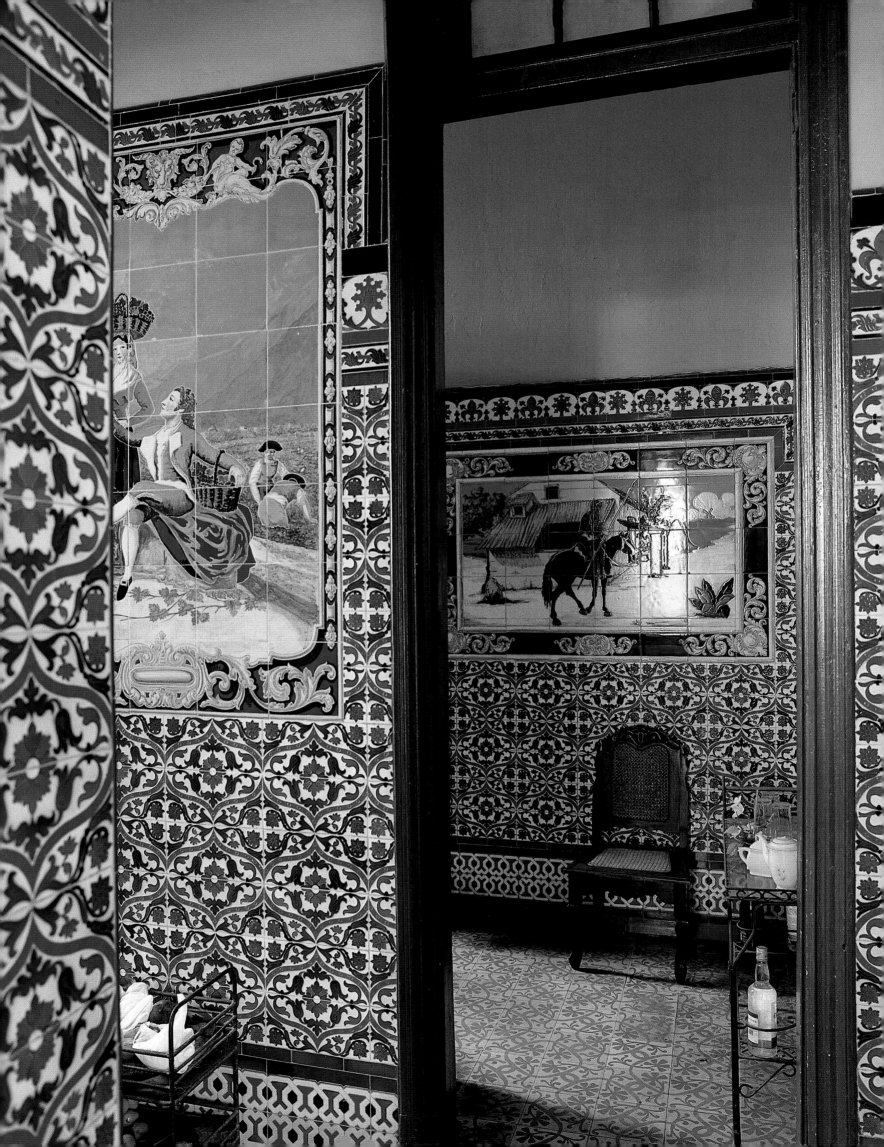

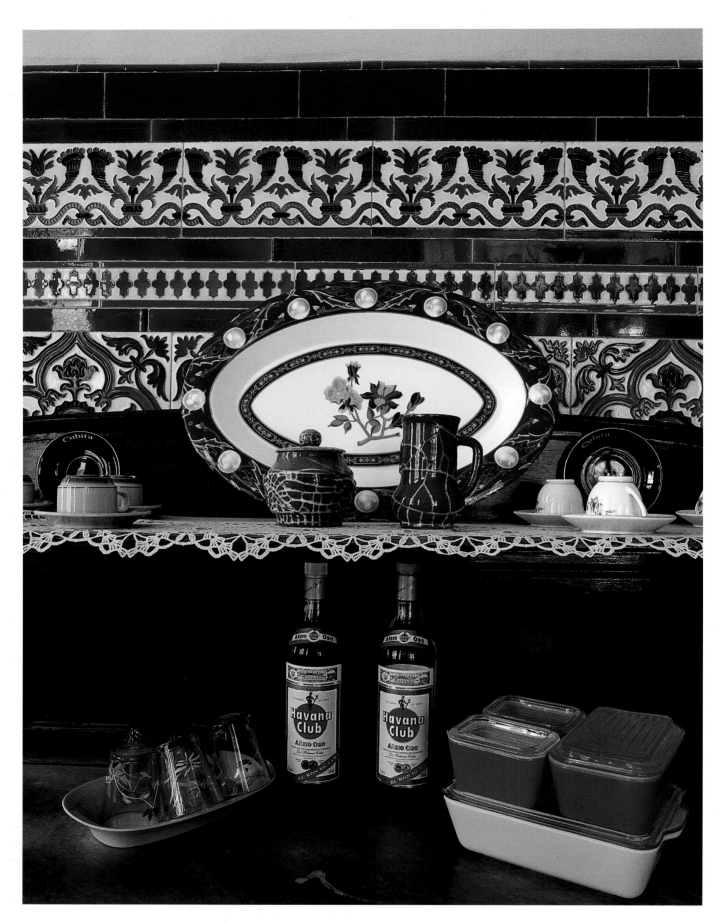

✳ **ABOVE** Bottles filled with Havana Club, the best rum in the world, and ceramic vessels. **FACING PAGE** The sober tiled walls of the kitchen contrast with the colourful mosaic of Goya's 1792 work "Muchachos trepando a un árbol", visible in the background. **FOLLOWING DOUBLEPAGE** An antique piece of furniture for storing glassware. ✳ **OBEN** Flaschen der weltbesten kubanischen Rummarke Havana Club und Keramikgeschirr. **RECHTE SEITE** Der Kontrast zwischen der schlichten Verkachelung der Küche und dem farbenprächtigen Mosaik an der Wand im Hintergrund, welches Goyas Werk »Jungen beim Klettern auf einen Baum« aus dem Jahr 1792 zeigt. **FOLGENDE DOPPELSEITE** Ein altes Vitrinenschränkchen für Gläser. ✳ **CI-DESSUS** Des bouteilles de rhum cubain Havana Club, le meilleur du monde, et des petits vases en céramique. **PAGE DE DROITE** Le sobre carrelage blanc contraste avec les azulejos aux couleurs vives reproduisant les « Enfants grimpant à un arbre », de Goya (1792), sur le mur du fond. **DOUBLE PAGE SUIVANTE** Un vieux meuble en bois sculpté.

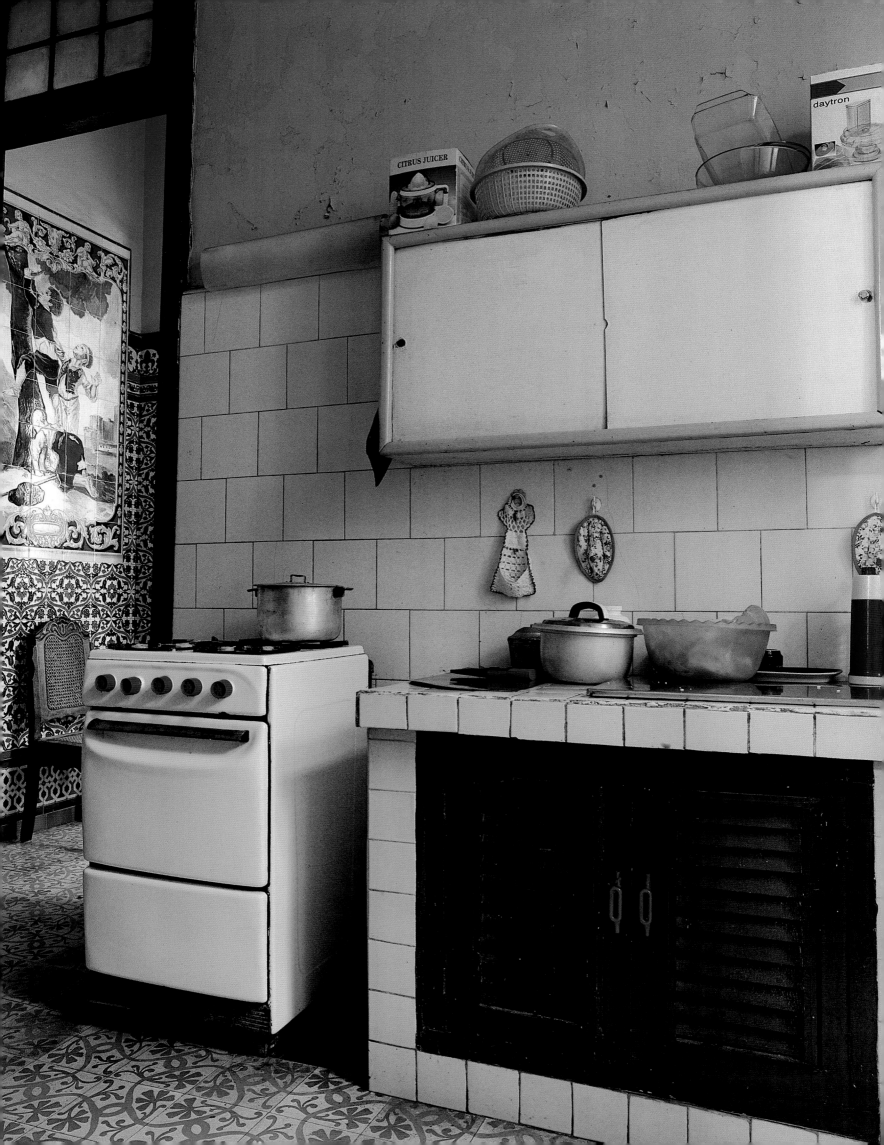

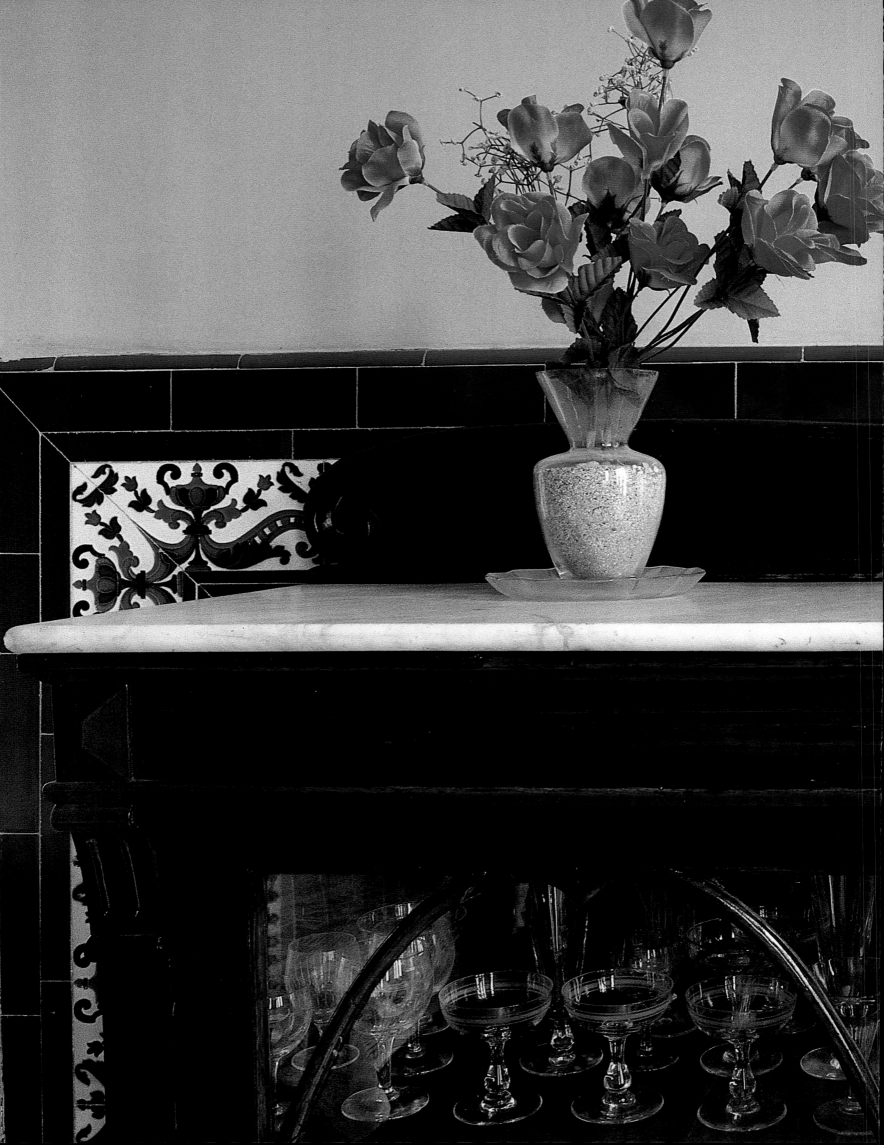

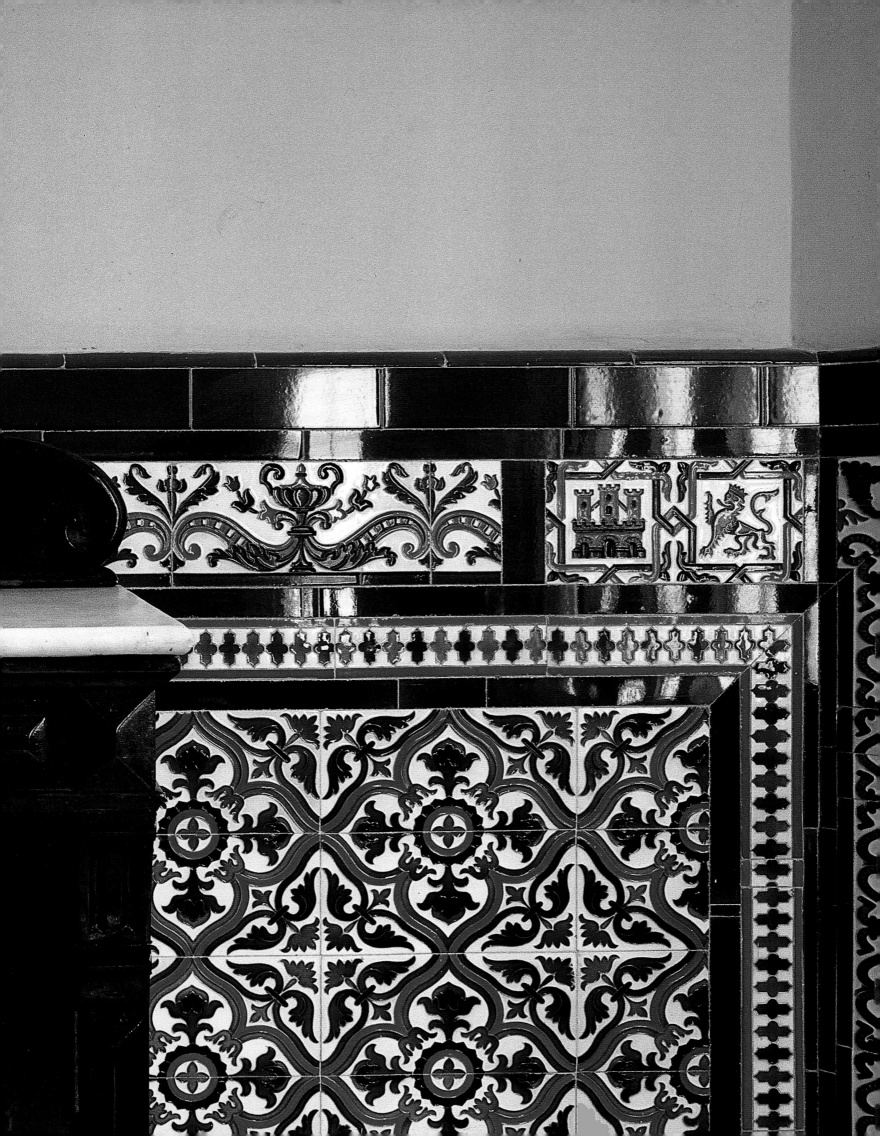

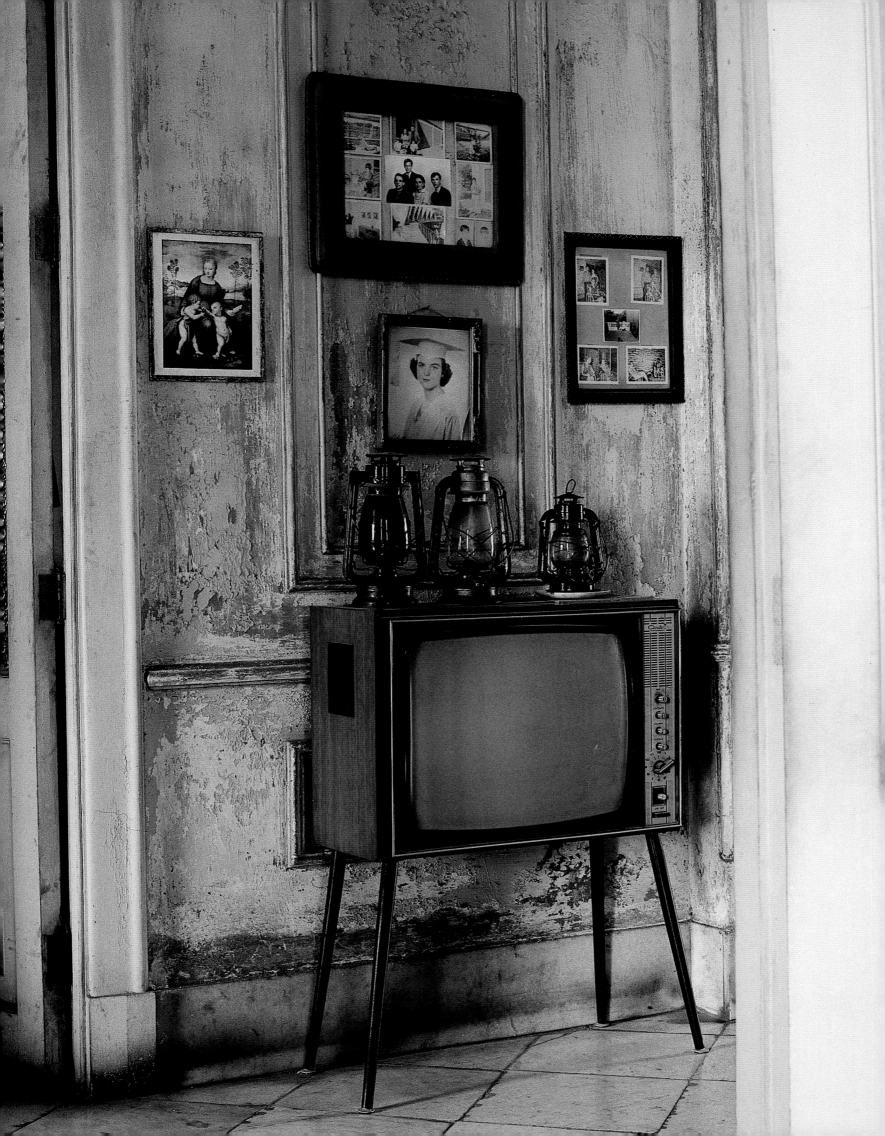

MiGUEL ALONSO

Splendor of the Past.

Miguel Alonso's home was used for several scenes in the Cuban film "Las Noches de Constantinopla." The mysterious house is barely visible from the street because of the lush trees that have grown up around it. Built in 1926, the house has a cylindrical volume with an elaborate balcony and a curved pediment. This feature anchors the two wings containing the living rooms on the ground floor and the bedrooms on the upper floor – their side porches and terraces catch delightful breezes and allow one to gaze out and watch the world go by. The unassuming entrance has terrazzo floors and is protected by a shaded porch with Corinthian columns. It leads to an elongated entrance hall with marble floors that links the spacious living room and the library on one side to the dining room and kitchen on the other. The dining room itself is decorated with gypsum moldings and friezes, and has high ceilings with an antique chandelier. But it is the magnificent marble staircase with a wrought-iron railing and dark mahogany handrail that dominates this house.

Das Haus von Miguel Alonso ist im kubanischen Film »Nächte in Konstantinopel« in mehreren Szenen zu sehen. Von der Straße hat man wegen der üppigen Bäume beschränkte Sicht auf das mysteriös aussehende Haus. Der mittlere Teil des 1926 gebauten Hauses wurde in zylindrischer Form und mit einem kunstvollem Balkon gebaut. Der gewölbte Dachgiebel hält zwei Flügel zusammen; im Erdgeschoss befinden sich die Wohnräume und im oberen Stockwerk die Schlafzimmer. Durch die seitlichen Veranden und Terrassen wehen angenehme Brisen, und man kann von hier die Welt rundherum beobachten. Der unspektakuläre Eingang mit Terrazzoböden liegt unter einer schattigen Terrasse mit korinthischen Säulen. Von da gelangt man in eine in die Länge gezogene Eingangshalle mit Marmorböden. Sie verbindet die verschieden großen Wohnräume und die Bibliothek auf der einen, das Esszimmer und die Küche auf der anderen Seite. Das Esszimmer mit hohen Decken und einem antiken Kronleuchter ist mit Gipsformen und Friesdekor verziert. Doch es ist das wunderschöne Marmortreppenhaus mit schmiedeeisernem Geländer und einem Handlauf aus dunklem Mahagoni, das sofort ins Auge sticht.

La demeure de Miguel Alonso a servi de décor à plusieurs scènes du film cubain «Les Nuits de Constantinople». Mystérieuse, on la devine à peine depuis la rue entre les arbres au feuillage dense qui l'entourent. Bâtie en 1926, elle est cylindrique avec un beau balcon et un fronton incurvé. Les deux ailes abritent des salles de séjour au rez-de-chaussée et des chambres à l'étage, leurs porches latéraux et leurs terrasses, balayées par une douce brise, permettant de contempler la vie suivre son cours au dehors. L'entrée sobre, avec son sol en mosaïque, est protégée d'un porche soutenu par des colonnes corinthiennes. Elle donne sur un long hall au sol en marbre qui relie le spacieux salon et la bibliothèque d'un côté, la cuisine et la salle à manger de l'autre. Cette dernière, ornée de moulures en stuc et de frises, possède un haut plafond auquel est suspendu un lustre ancien. Mais c'est le magnifique escalier en marbre avec sa balustrade en fer forgé et sa rampe en acajou qui domine la maison.

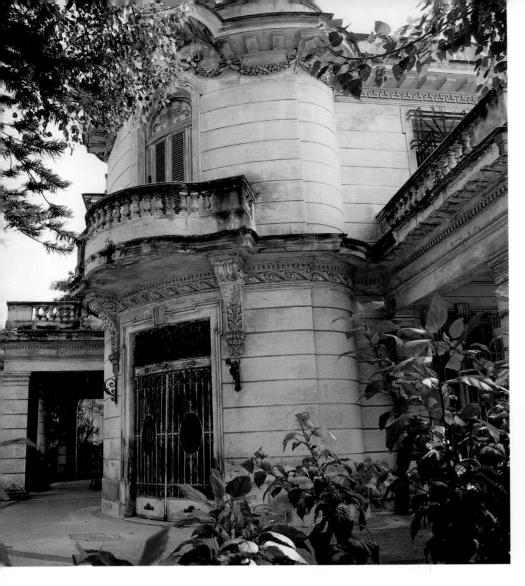

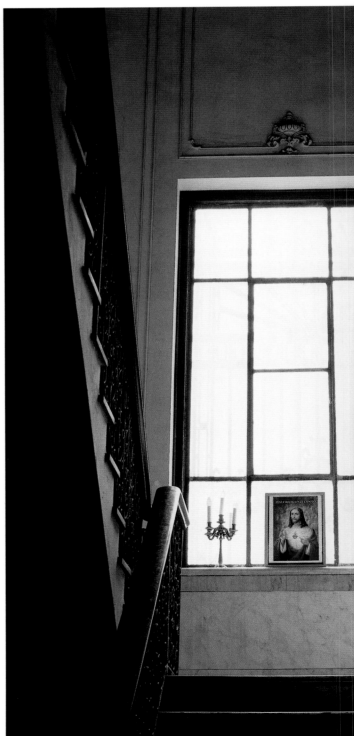

※ **ABOVE** The curved volume that joins the terraces in front of each façade of the house has an elegant balcony, highlighting its corner location. **RIGHT** The imperial marble staircase, on the same axis as the entrance, is the most striking element on the ground floor. Its lovely wrought-iron banister has a handrail made of Cuban mahogany. **FACING PAGE** The eclectic house of Miguel Alonso with its equally eclectic furnishings. The spacious sitting room reflects the home's overall state of deterioration, with its peeling ceilings where the rusted iron can be seen. ※ **OBEN** Der gebogene Gebäudevorsprung, der die Terrassen an allen Fassaden des Hauses mit einem eleganten Balkon verbindet, unterstreicht dessen Ecklage. **RECHTS** Die prächtige Marmortreppe bildet eine Linie mit dem Eingang und ist das herausragende Element des Erdgeschosses. Das schöne Eisengeländer ist mit einem Handlauf aus kubanischem Mahagoni versehen. **RECHTE SEITE** Miguel Alonsos eklektisches Haus mit seinem eklektischen Mobiliar. Das geräumige Vorzimmer mit der abgebröckelten Decke und den zerfressenen Stahlstreben spiegelt den allgemeinen Verfall des Hauses. ※ **CI-DESSUS** Les terrasses donnant sur chaque façade sont reliées par des pavillons d'angle arrondis. **A DROITE** L'escalier impérial en marbre blanc, en face de l'entrée, domine le rez-de-chaussée. Sa belle balustrade en fer forgé est surmontée d'une rampe en acajou cubain. **PAGE DE DROITE** La décoration éclectique de la maison de Miguel Alonso avec son mobilier dépareillé. Le grand séjour reflète le délabrement général de la maison avec ses plafonds crevés qui laissent apparaître les poutres métalliques rouillées.

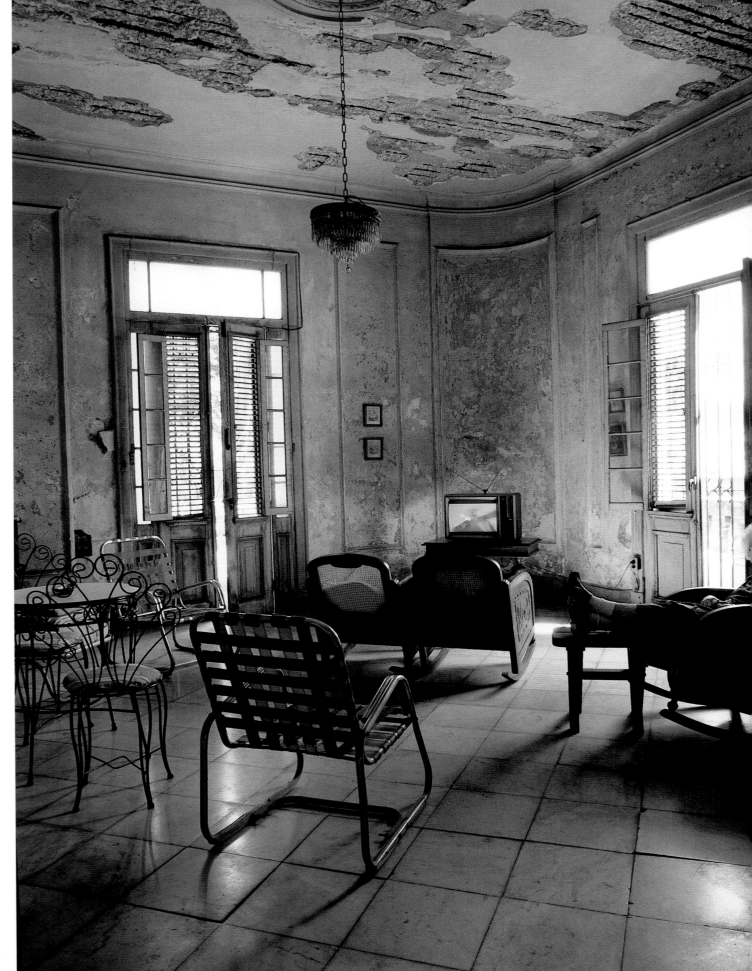

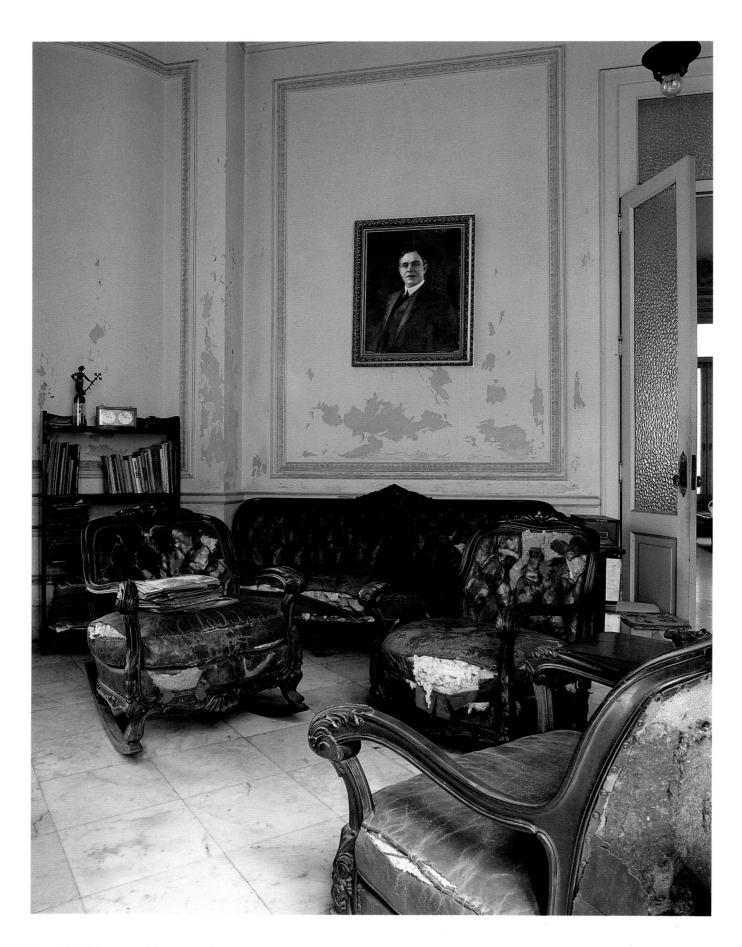

✻ **ABOVE AND FACING PAGE** The living room of the Miguel Alonso house, with its lovely wood and cut glass doorways and elegant English Chippendale-style furniture. **FOLLOWING DOUBLEPAGE** Large windows illuminate the dining room, one of the best-preserved spaces in the house. ✻ **OBEN UND RECHTE SEITE** Das Wohnzimmer des Hauses von Miguel Alonso betritt man durch Holztüren mit geschliffenen Glaseinsatz, und man sitzt im eleganten englischen Mobiliar im Chippendale-Stil. **FOLGENDE DOPPELSEITE** Große Fenster erhellen das Esszimmer, einen der am besten erhaltenen Räume des Hauses. ✻ **CI-DESSUS ET PAGE DE DROITE** Le séjour, avec ses belles portes en bois et verre taillé, et son mobilier Chippendale. **DOUBLE PAGE SUIVANTE** La salle à manger, l'espace le mieux conservé de la maison, est éclairée par de grandes fenêtres.

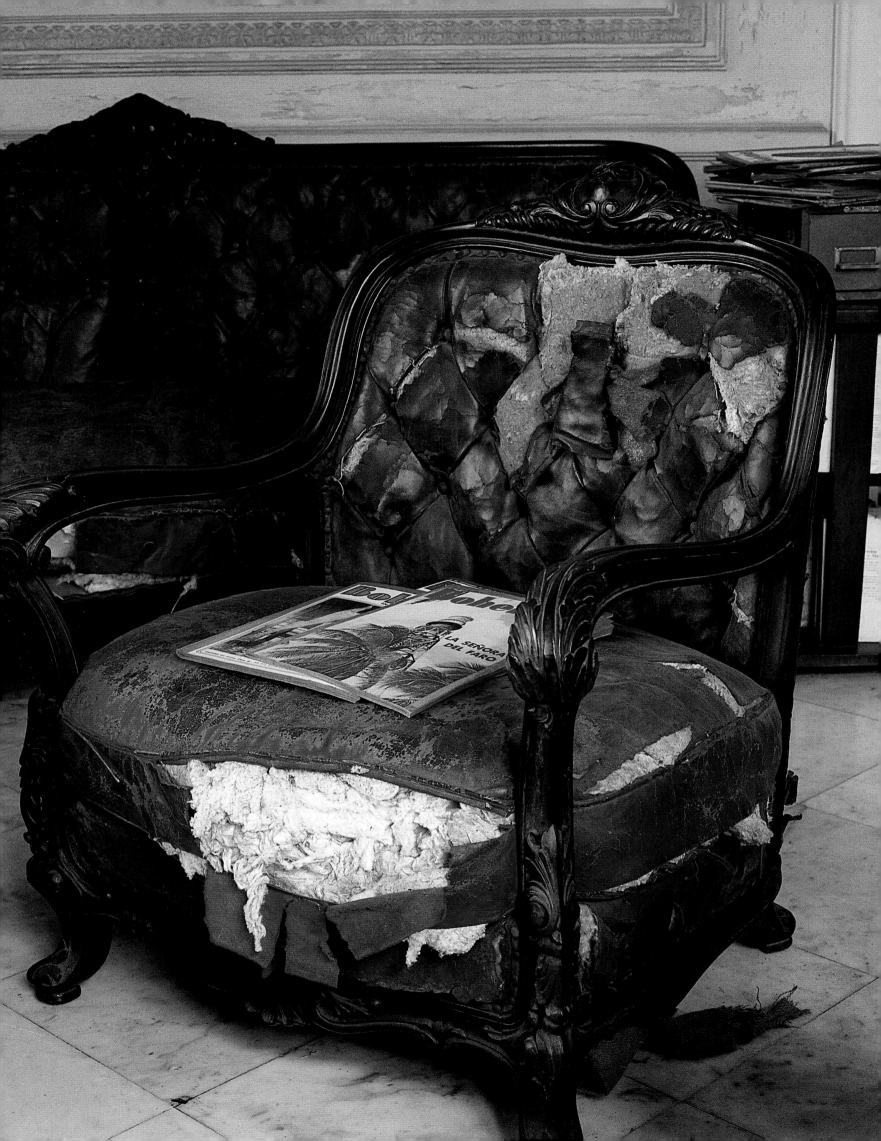

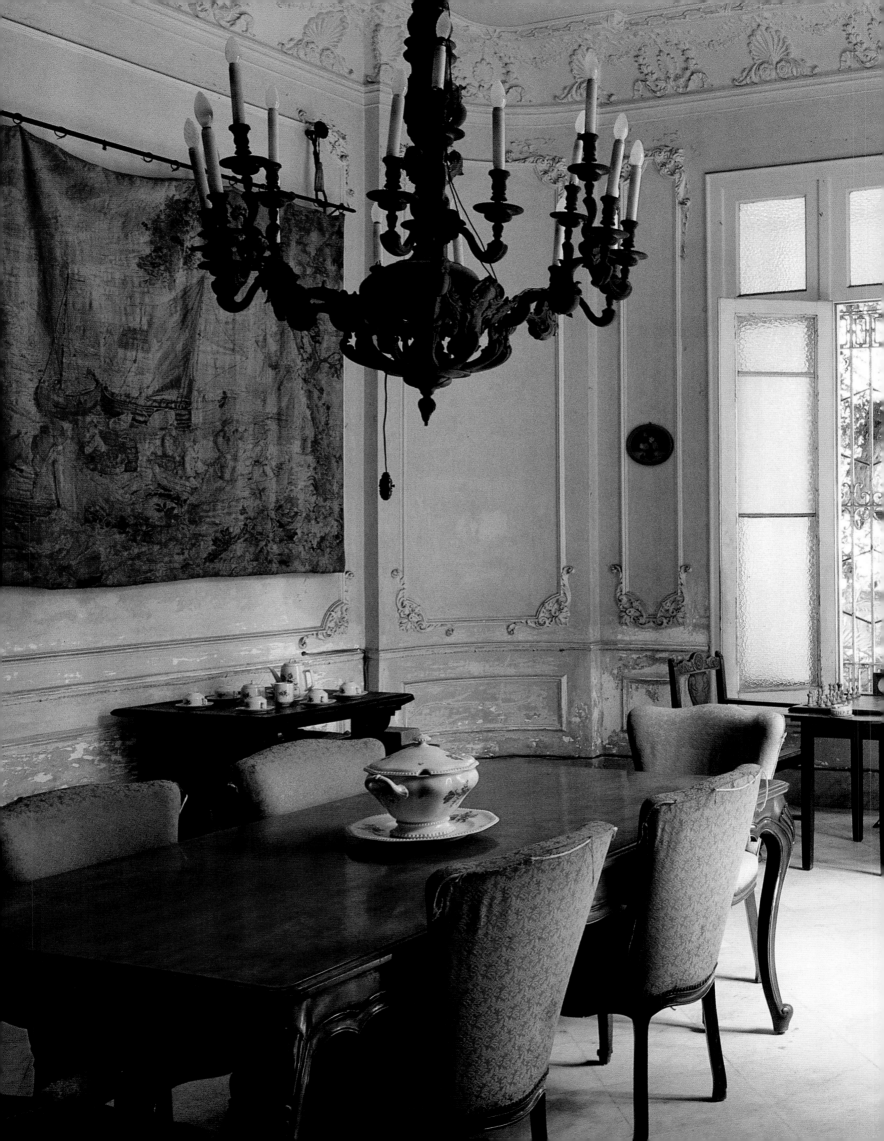

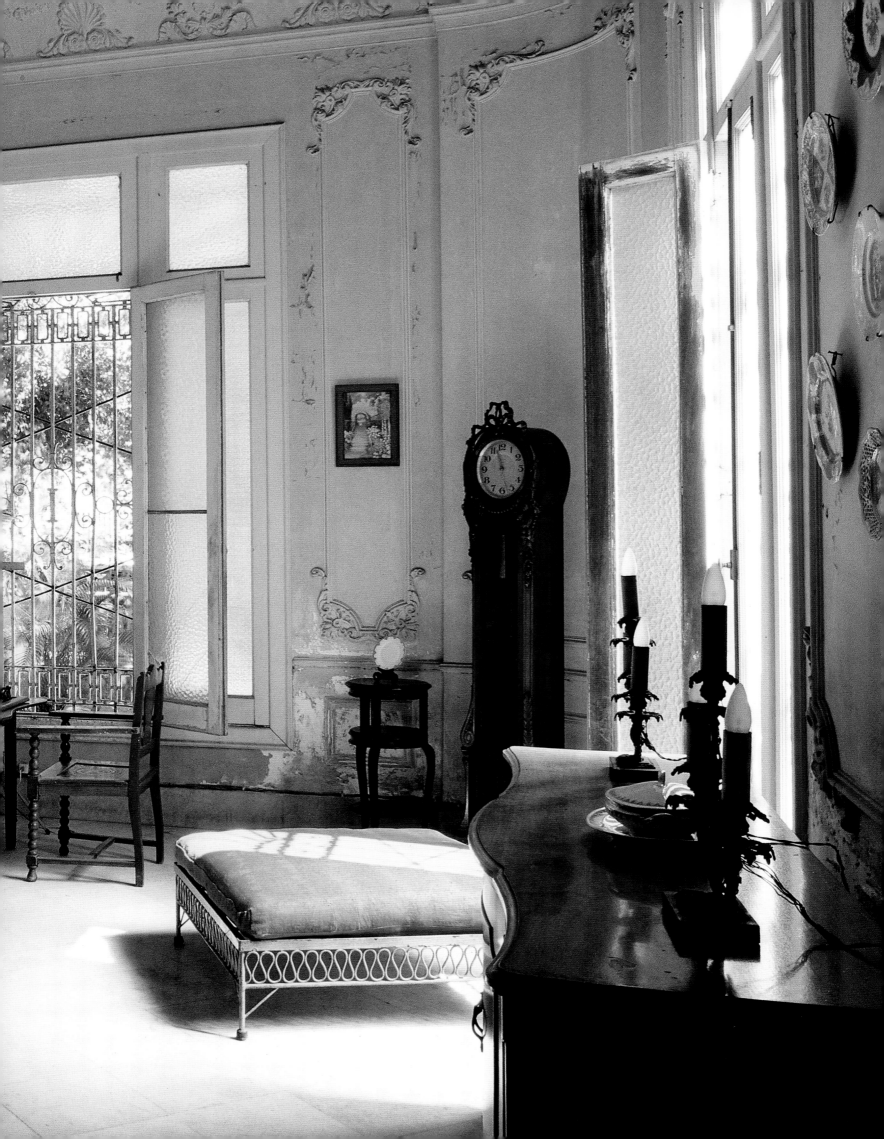

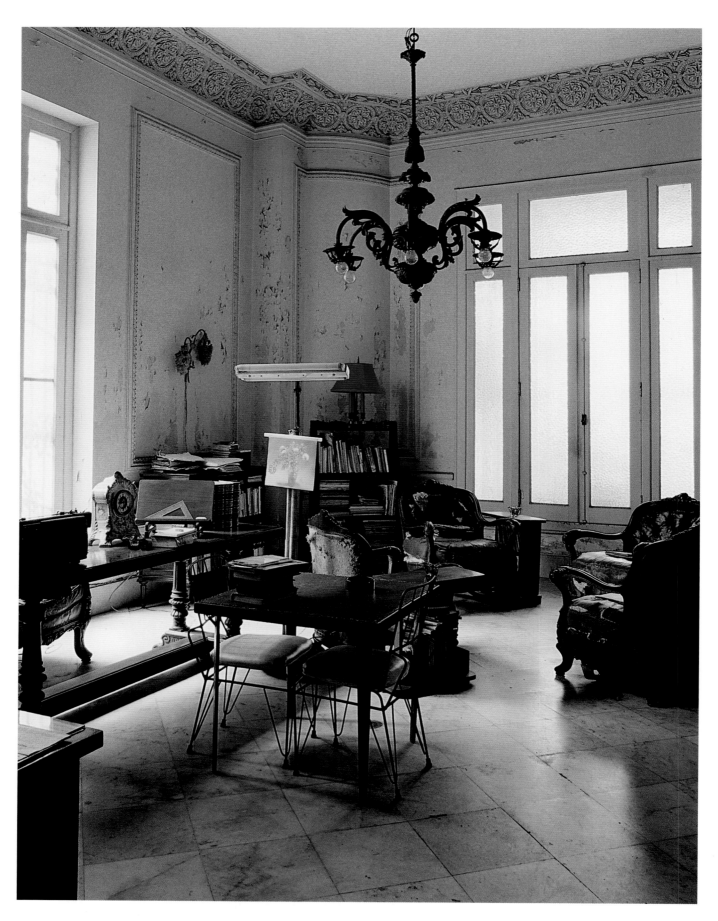

ABOVE The well-lit library, used in the Cuban film "Las Noches de Constantinopla". **FACING PAGE** An image of the Virgen del Rosario on top of an English console. **FOLLOWING DOUBLEPAGES** A traditional image from Cuban Catholic religious iconography. "The Sacred Heart", over a kitchen cabinet. * A spiral staircase leads from the kitchen, with its lovely mosaic floors, to the upper floor. ❀ **OBEN** Die lichtdurchflutete Bibliothek diente als Kulisse für den kubanischen Film »Nächte in Konstantinopel«. **RECHTE SEITE** Eine »Jungfrau des Rosenkranzes« auf einer englischen Konsole. **FOLGENDE DOPPELSEITE** Das in der katholischen Ikonographie Kubas traditionelle Bild »Herz Jesu« über einem Küchenschrank. ❀ **CI-DESSUS** La bibliothèque est une des pièces utilisées lors du tournage du film « Les Nuits de Constantinople ». **PAGE DE DROITE** Une Vierge du Rosaire posée sur une console anglaise. **DOUBLES PAGES SUIVANTES** Dans la cuisine, au-dessus d'un buffet, une image traditionnelle de l'iconographie catholique cubaine, appelée « Le cœur de Jésus ». * L'escalier métallique en colimaçon monte à l'étage.

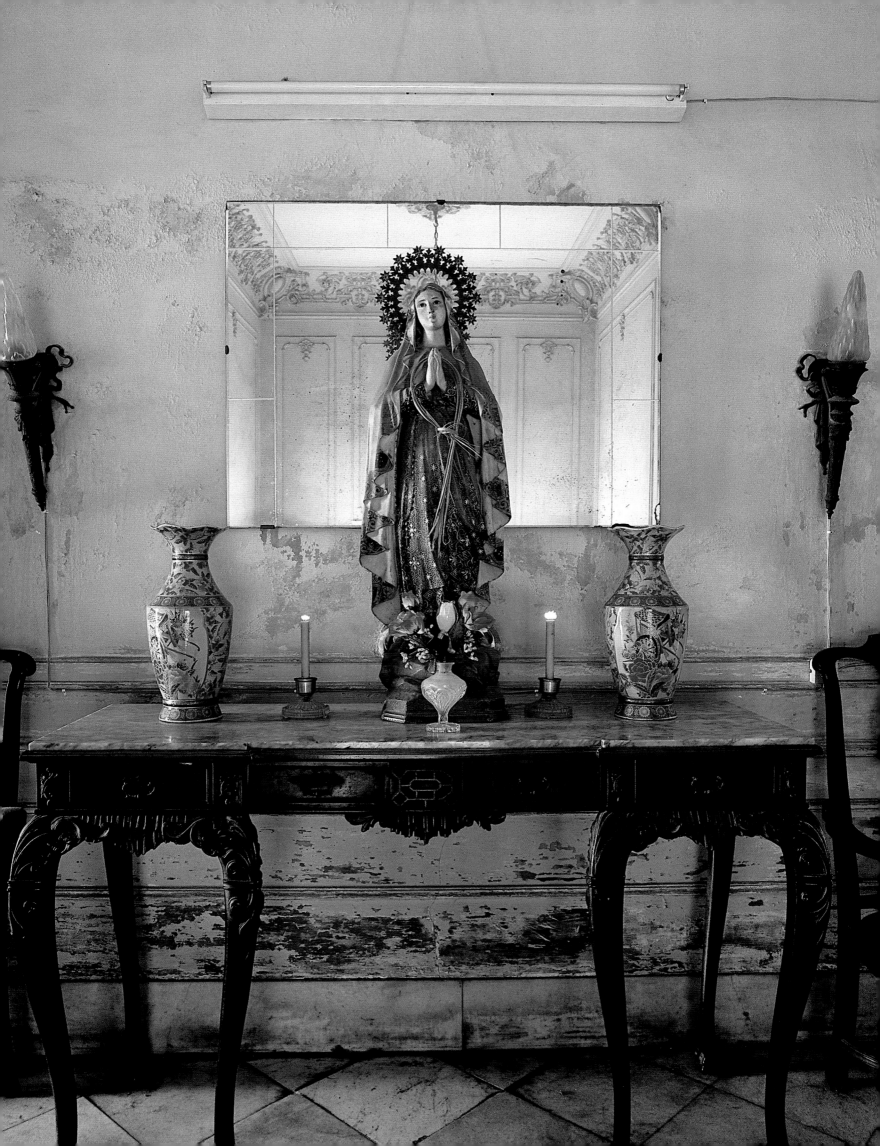

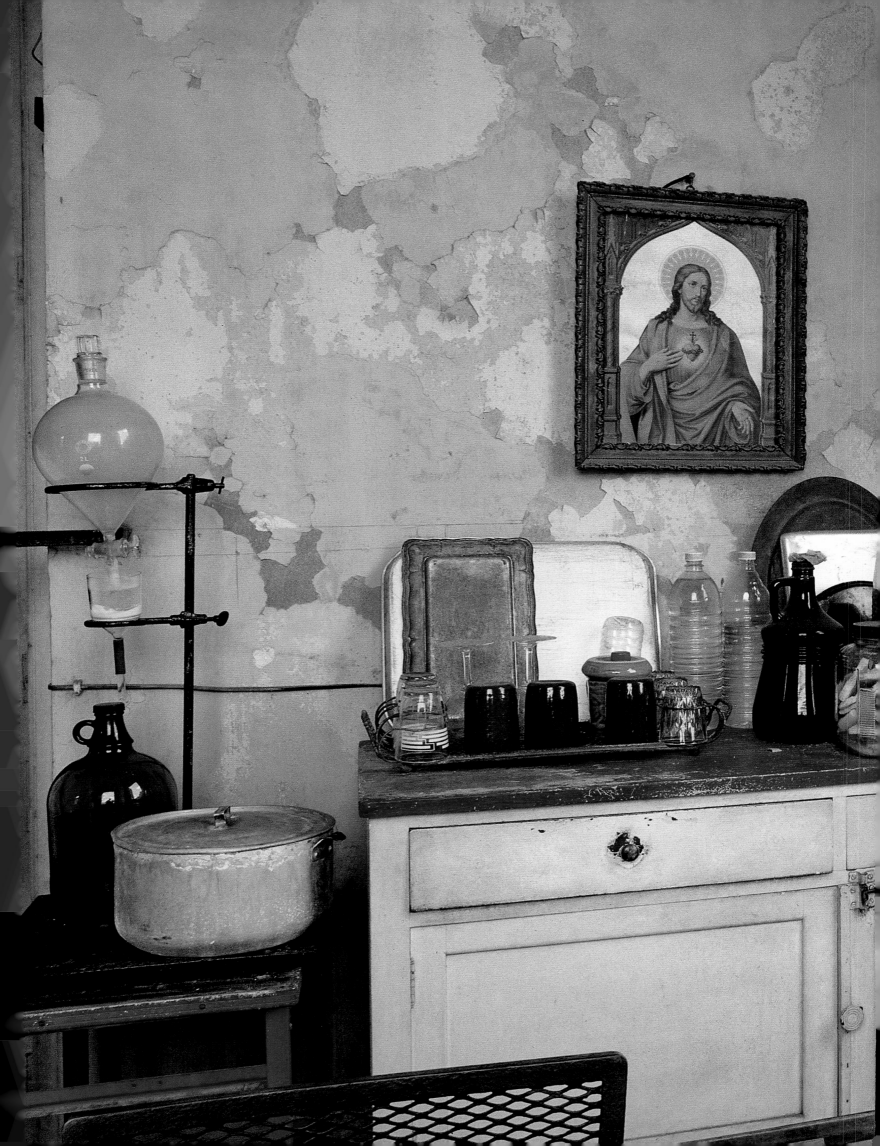

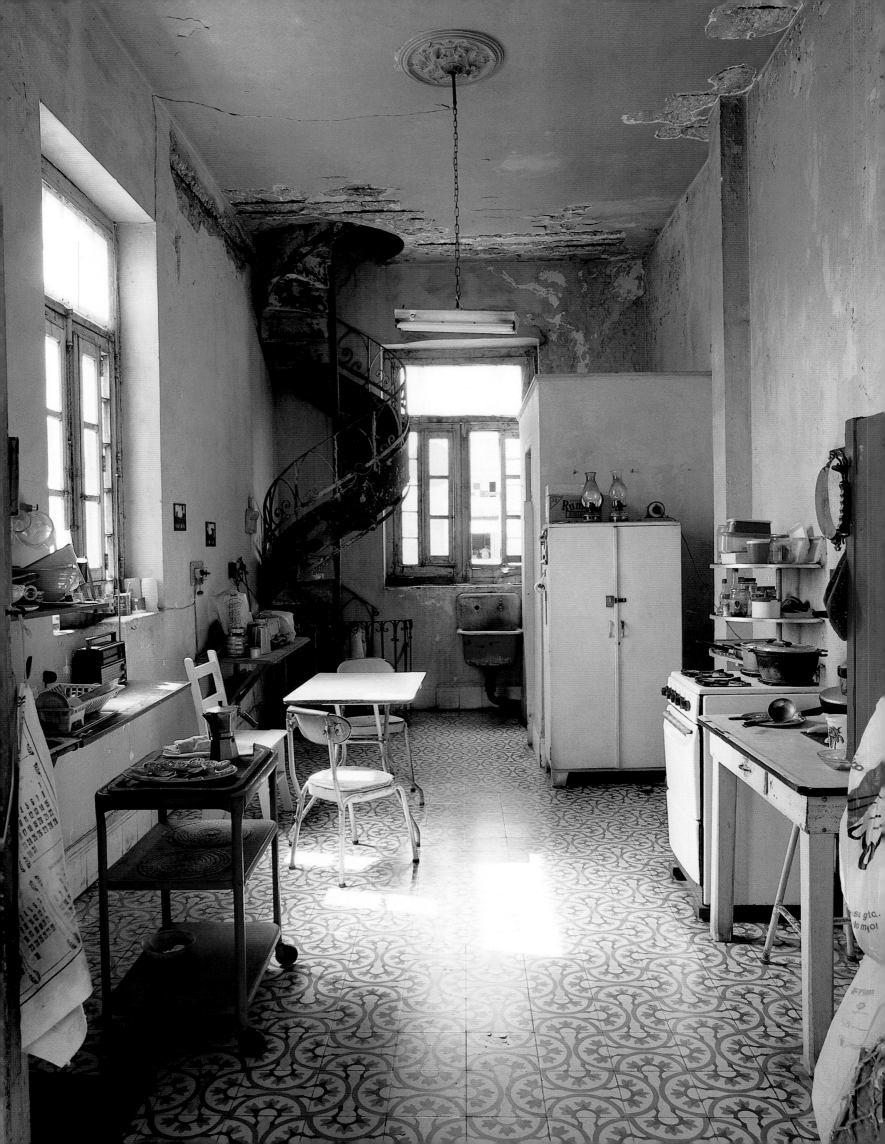

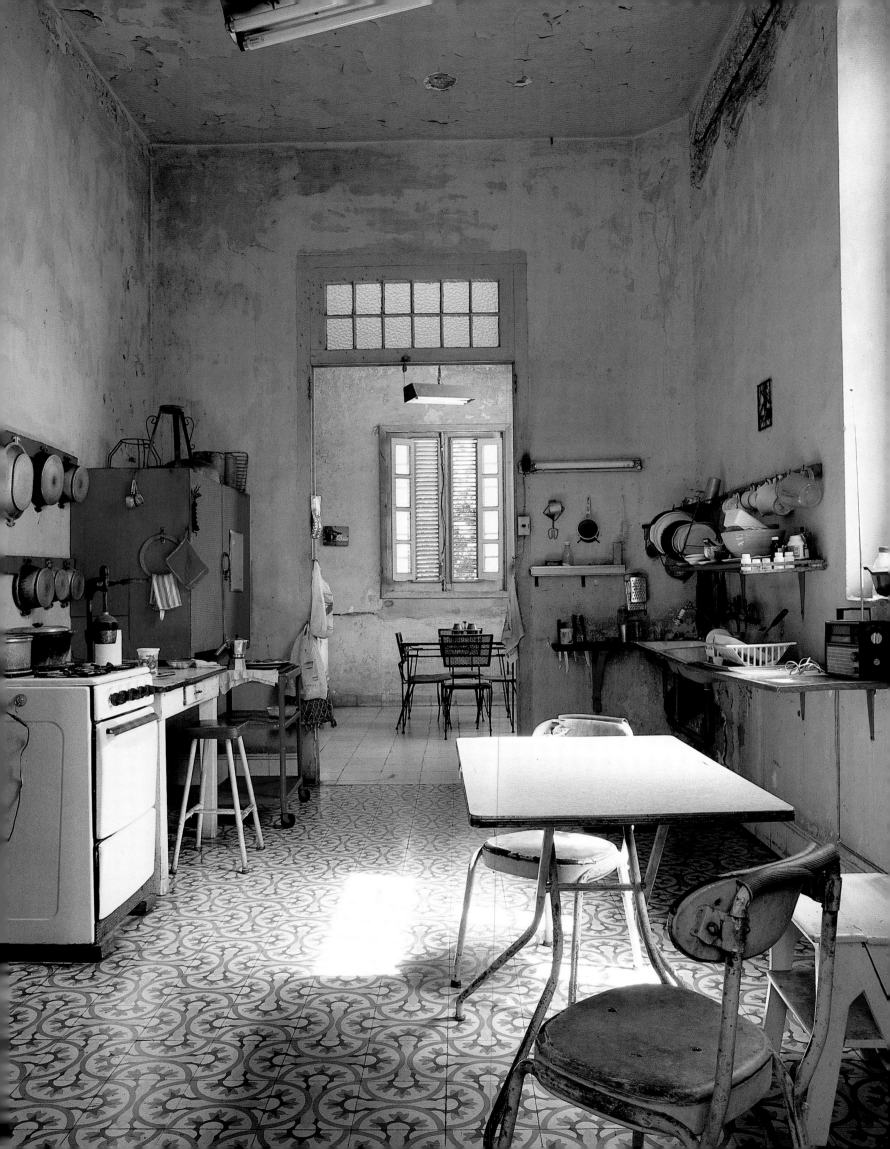

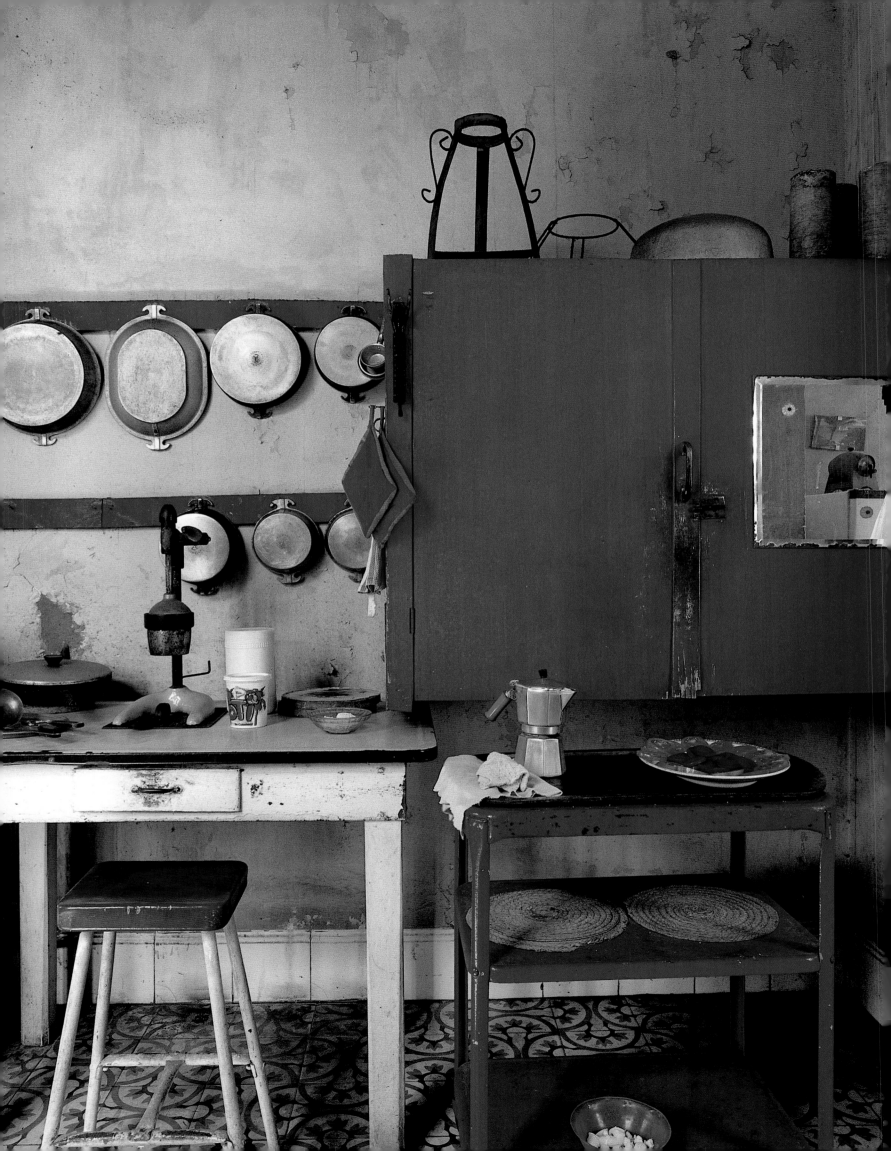

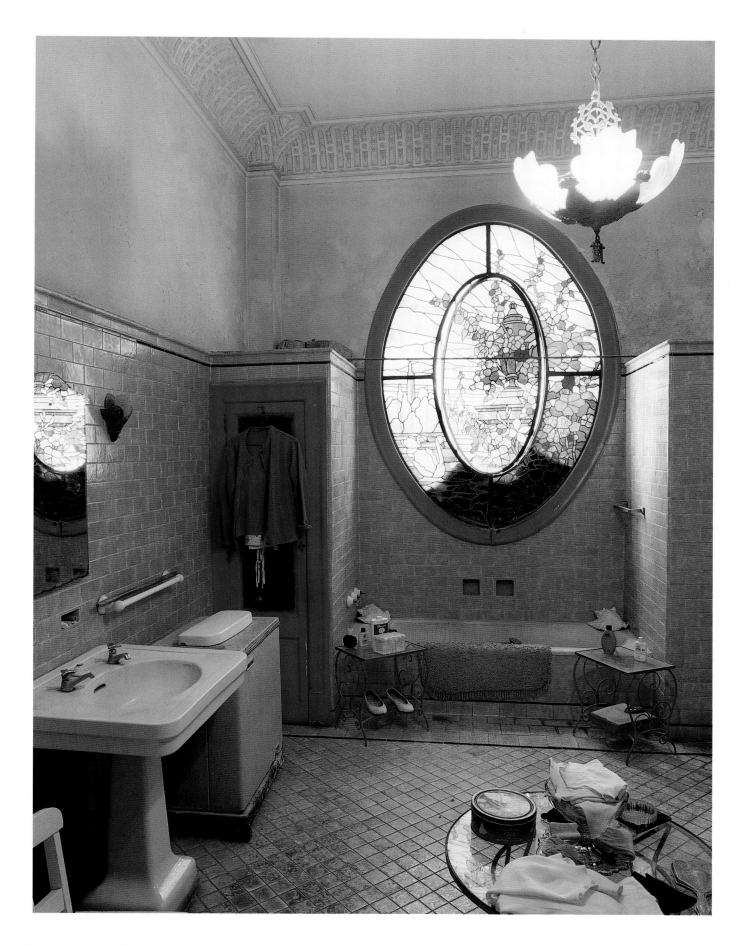

✳ **FACING PAGE** The cube-shaped cabinet in one of the corners of the kitchen becomes an artistic object due to its bright red color, which marks a clear contrast with the yellow walls.
ABOVE A lovely oval-shaped stained glass window illuminates the spectacular master bathroom in the Miguel Alonso house, located on the upper floor. ✳ **LINKE SEITE** Der quadratische rote Schrank in einer Ecke der Küche wirkt aufgrund seiner leuchtenden Farbe, die einen starken Kontrast zu den gelben Wänden herstellt, wie ein Kunstobjekt. **OBEN** Ein prächtiges, oval geformtes Buntglasfenster wirft Licht in das riesige Hauptbad im Obergeschoss des Hauses von Miguel Alonso. ✳ **PAGE DE GAUCHE** Avec sa couleur rouge intense qui contraste avec le reste de la cuisine aux murs jaunes, ce placard cubique devient un objet d'art. **CI-DESSUS** Un beau vitrail ovale illumine la spectaculaire salle de bains principale, située à l'étage.

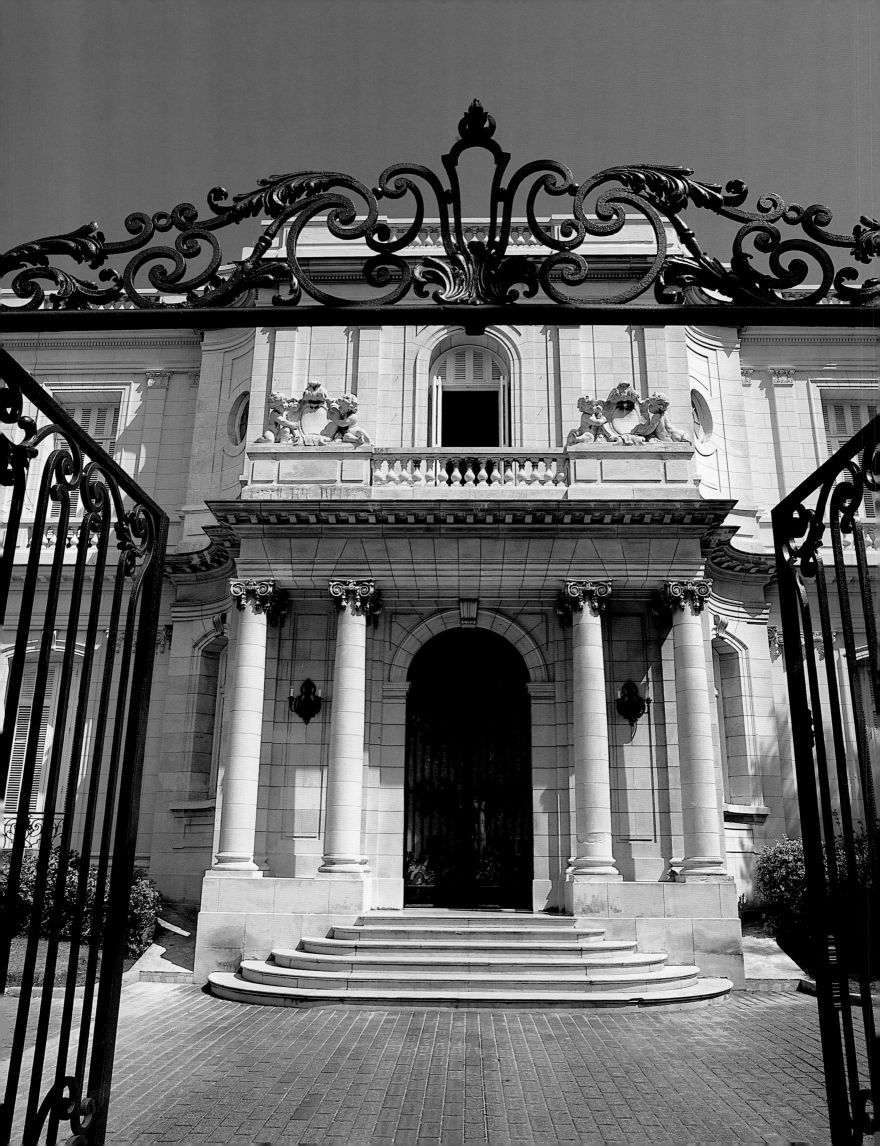

CONDESA REVILLA

DE CAMARGO

A French Mansion for a Cuban Countess.

The early 20th century saw a carnival of styles, and in the 1920s ornament was *not* a crime for the enlightened Cuban bourgeoisie, flush with money from the high war price of sugar. These tycoons were inspired by European extravagance, and in 1927 the very wealthy José Gómez Mena commissioned French architects P. Viard and M. Destugue to design a mansion for him in Vedado. The gardens surrounding it are named "The Four Seasons and The Night." The main entrance to the residence is framed by four Ionic columns, and a small vestibule opens directly onto a stunning grand hall which contains a sumptuous staircase of monumental proportions. It is aligned along an axis with the ornate glass and metal ceiling which is said to have been influenced by the Paris Opera. The house is composed around this grand hall, somehow echoing traditional Cuban architecture, which is designed around a central place. This luxurious mansion was decorated by "Maison Jansen" of Paris with Carrara marble floors and walls in the dining room, bronze and gold iron work, oriental pieces, and porcelains from Sèvres, Limoges and Meißen.

Im frühen 20. Jahrhundert tauchten in Kuba die verschiedensten Stilrichtungen auf. Die aufgeklärten kubanischen Bürger der 1920er, die nach dem Krieg mit viel Geld aus den hohen Zuckerpreisen gesegnet waren, hatten eine besondere Vorliebe für Dekoratives und ließen sich von der europäischen Extravaganz inspirierten. 1927 beauftragte der superreiche José Gómez Mena die französischen Architekten P. Viard und M. Destugue mit dem Bau einer Villa in Vedado. Die Gartenanlagen der Villa nannte er »Die vier Jahreszeiten und die Nacht«. Der Haupteingang der Residenz wird von vier ionischen Säulen flankiert und führt in ein schmales Vestibül, das sich zu einer großen Halle mit einem prächtigen, monumentalen Treppenhaus öffnet. Die Treppe liegt in der Achse mit dem Eingang und ist von einer Glas-Eisen-Konstruktion bekrönt, die den Bau der Pariser Oper beeinflusst haben soll. Das Haus ist um die große Halle herum angelegt und erinnert damit an traditionelle kubanische Architektur rund um einen Innenhof. Die luxuriöse Villa wurde vom der Pariser »Maison Jansen« eingerichtet. Für die Böden wählten sie Carrara-Marmor, aber auch die Wände im Esszimmer sind aus Marmor, dazu gesellen sich Arbeiten aus Bronze und vergoldetem Eisen, Objekte aus dem Orient und Porzellan aus Sèvres, Limoges und Meißen.

Le début du 20ᵉ siècle vit défiler une ribambelle de styles et l'excentricité des années folles n'avait rien de honteux pour la bourgeoisie cubaine cultivée qui avait fait fortune grâce à la hausse des prix du sucre dans l'après-guerre. En 1927, le richissime José Gómez Mena demanda aux architectes français P. Viard et M. Destugue de lui construire un manoir à Vedado dans le style de la renaissance française. Les jardins qui l'entourent sont baptisés «Les quatre saisons et la nuit». L'entrée principale est flanquée de quatre colonnes ioniques et le petit vestibule s'ouvre sur un hall grandiose abritant un somptueux escalier monumental placé dans l'axe de l'entrée qui est coiffée d'une structure de verre ouvragé et de métal, dont on a dit qu'elle aurait influenccé l'Opéra de Paris. La maison respecte toutefois l'architecture traditionnelle cubaine avec une grande cour centrale entourée de galeries qui donnent sur les nombreuses chambres. Cette luxueuse demeure fut décorée par la «maison Jansen» de Paris, avec des sols en marbre de Carrare tout comme les murs de la salle à manger, des grilles ouvragées en bronze et fer doré, des antiquités orientales, des porcelaines de Sèvres, de Limoges et de Meißen.

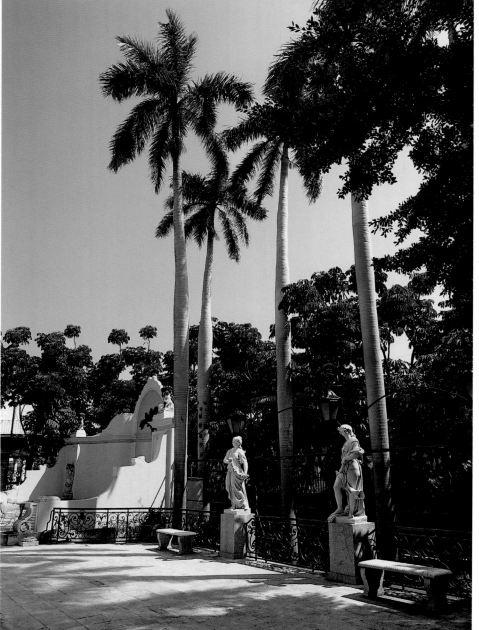

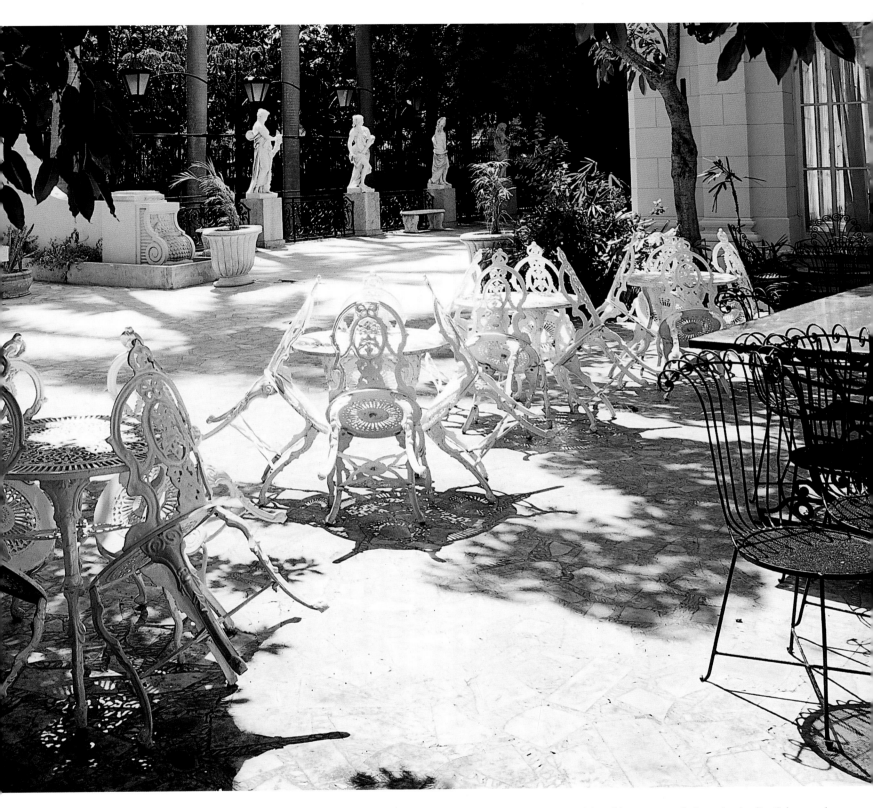

❋ **FACING PAGE AND ABOVE** "The Four Seasons and The Night" garden at the house of Countess Revilla de Camargo with its beautiful marble statues watched over by the slim Cuban royal palm trees. **FOLLOWING DOUBLEPAGE** The elegant and sumptuous double-storey space of the grand hall, with its Carrara marble floors, is decorated with great refinement. The Guéridon table with its inlaid Italian marble top and the Venetian torch holders with figures of Moors date from the 19th century. ❋ **LINKE SEITE UND OBEN** Der Garten des Hauses der Gräfin Revilla de Camargo mit wunderschönen Marmorstatuen zwischen hoch gewachsenen kubanischen Königspalmen. **FOLGENDE DOPPELSEITE** Die elegante, prächtige Eingangshalle erstreckt sich über zwei Geschosshöhen und besitzt einen aufwändig verzierten Boden aus Carrara-Marmor. Der Guéridon-Tisch mit einer Platte mit Intarsien aus italienischem Marmor stammt ebenso aus dem 19. Jahrhundert wie die venezianischen Leuchter mit maurischen Figuren. ❋ **PAGE DE GAUCHE ET CI-DESSUS** Le jardin « Les quatre saisons et la nuit » avec ses belles statues en marbres protégées par de sveltes palmiers royaux de Cuba. **DOUBLE PAGE SUIVANTE** Le sompteux grand hall, avec sa double hauteur sous plafond et ses sols en marbre de Carrare, est décoré avec un grand raffinement. Le guéridon en marqueterie de marbre et les torchères vénitiennes représentant des maures sont du 19ᵉ siècle.

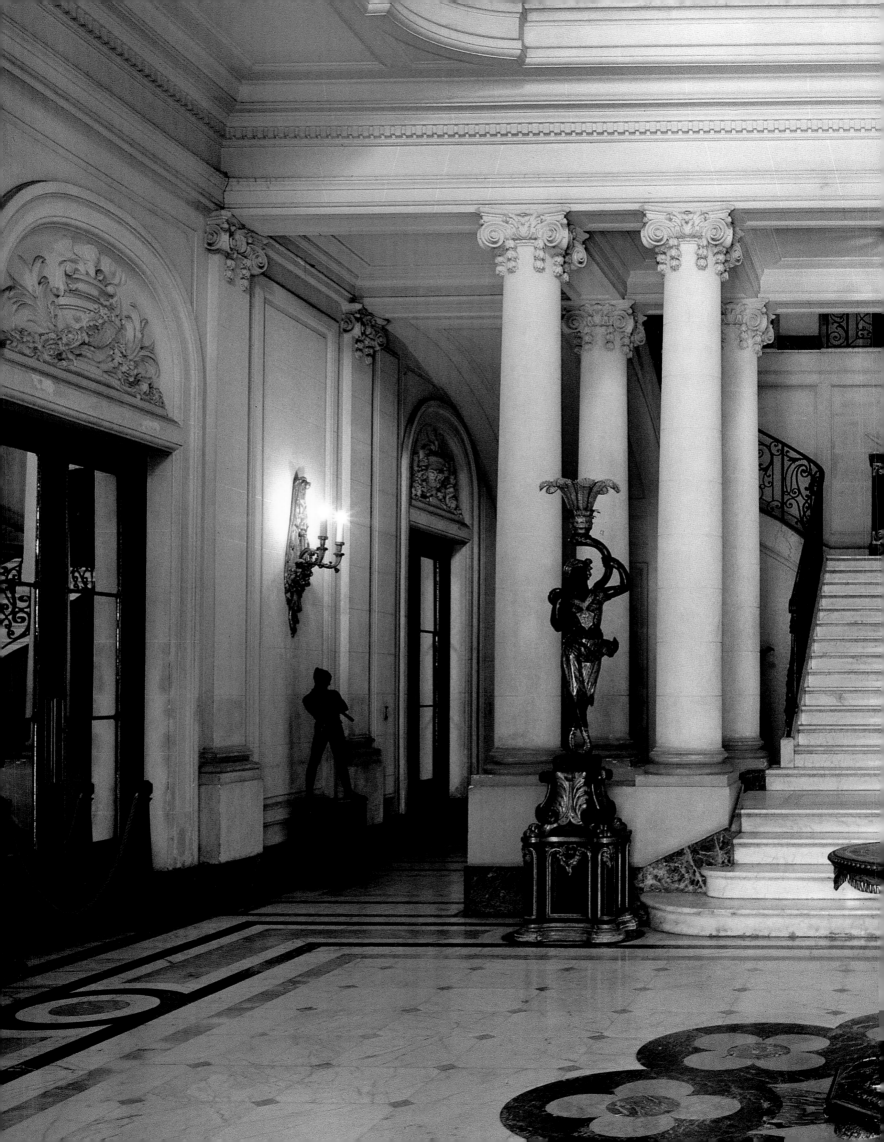

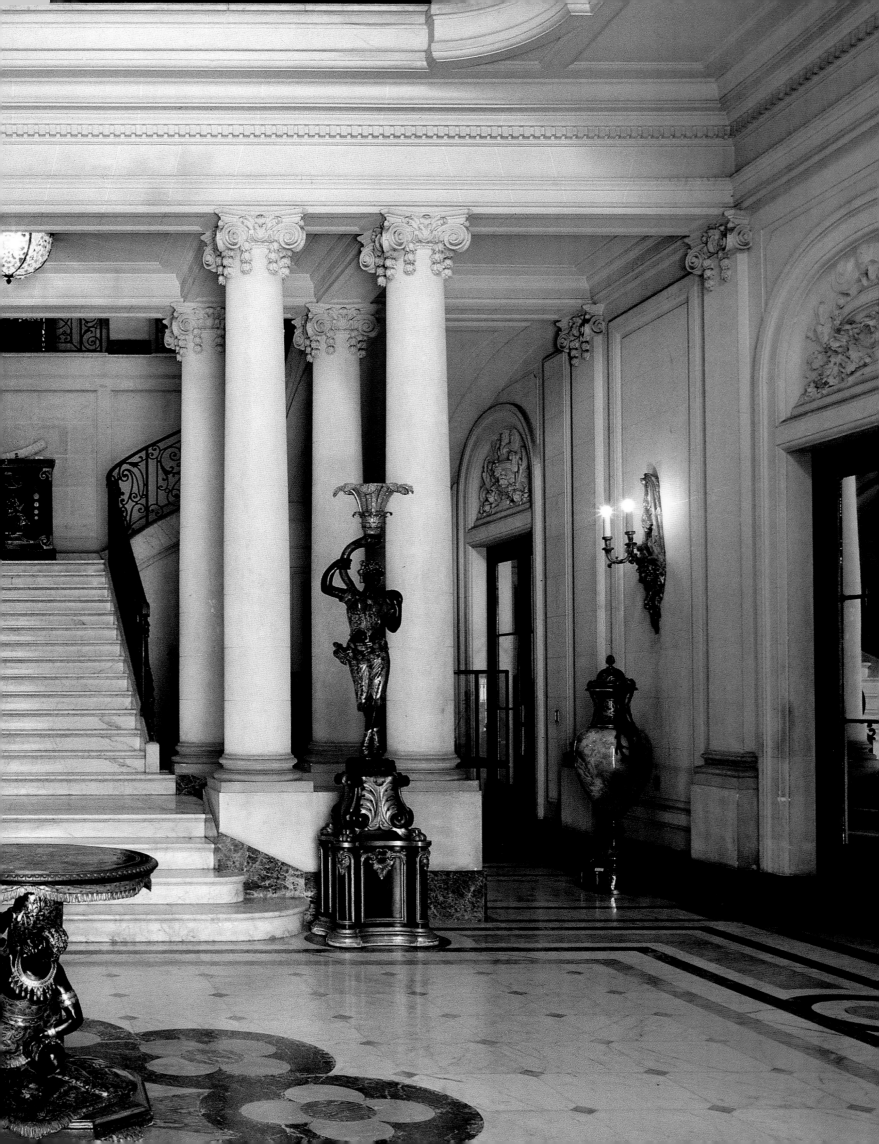

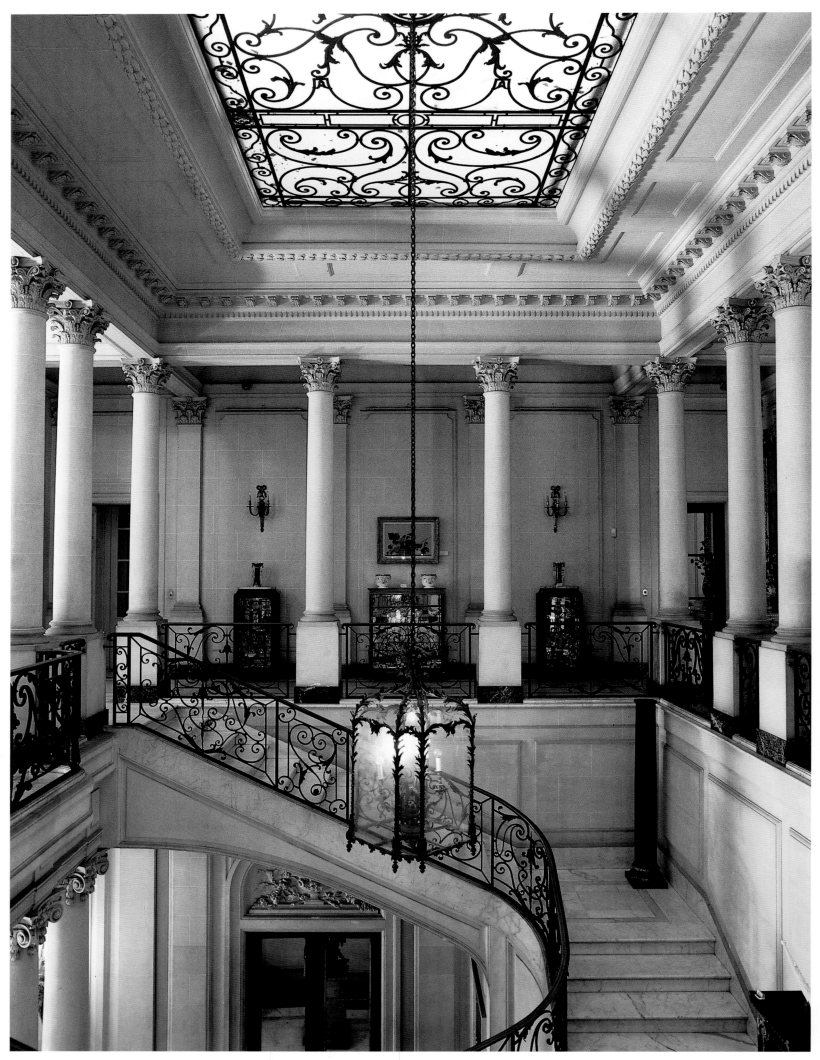

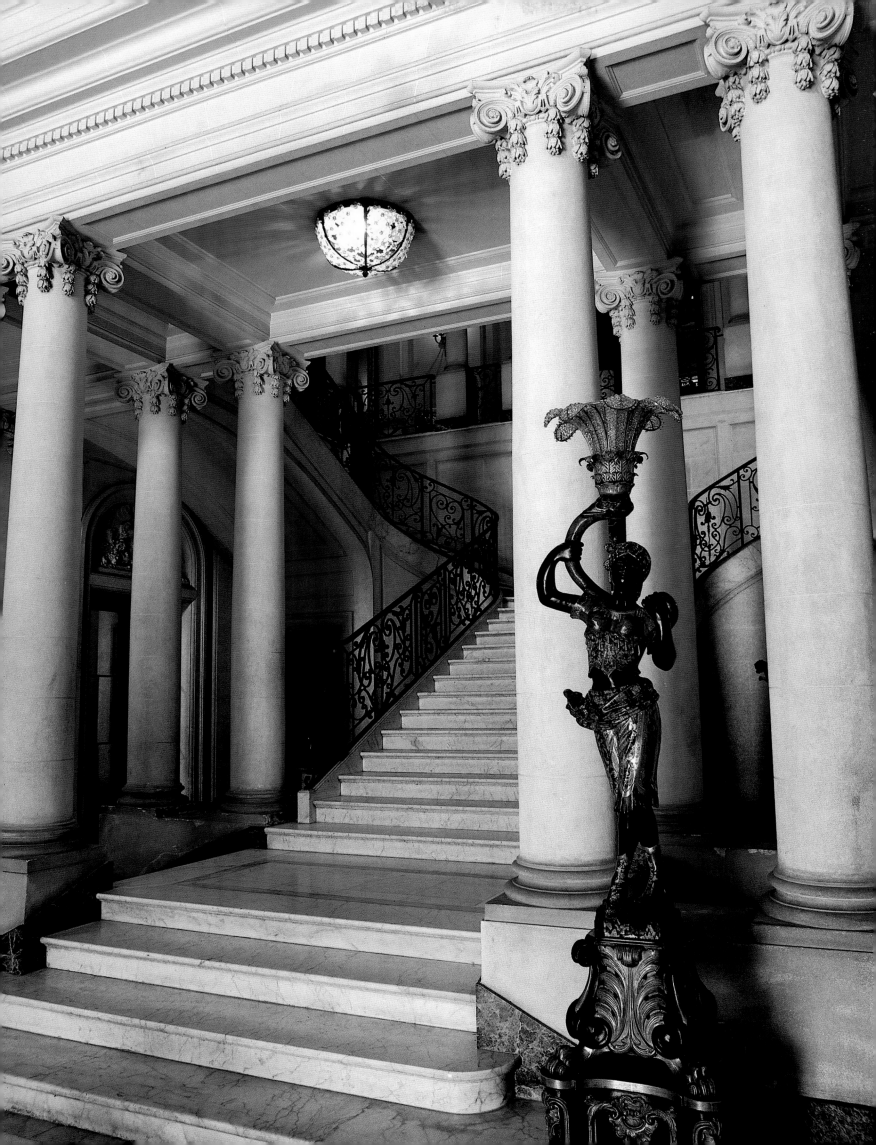

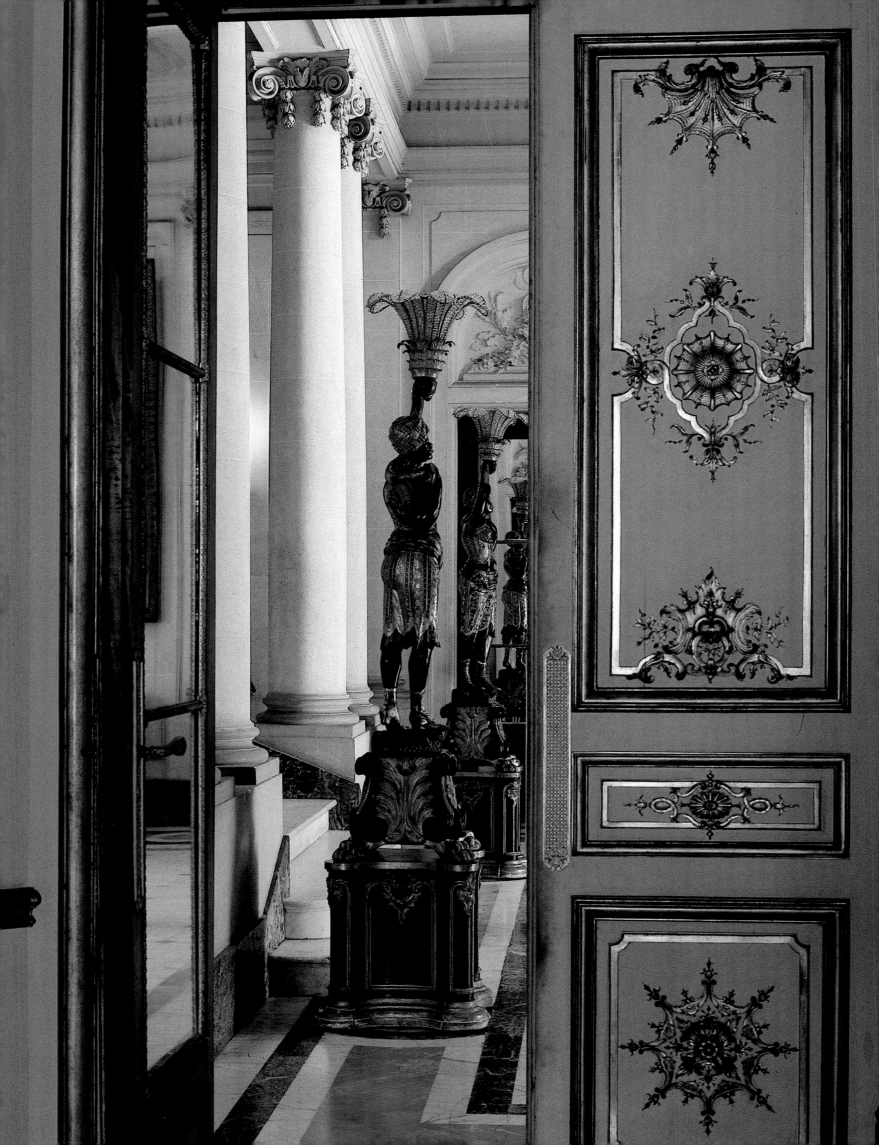

※ **PREVIOUS PAGES** The luxurious imperial staircase made of Carrara marble and surrounded by columns. Its ceiling boasts an iron and glass structure resembling a skylight. **FACING PAGE** The antechamber of the staircase with the Venetian lamps crafted out of kiln-dried wood and polychromed. **RIGHT** "The Hunter's Rest", is one of the four Sèvres biscuit porcelain figures crafted by the Frenchman Bachelier in the 18th century. **BELOW** The walls of the dining room, decorated in 19th century Regency style, are paneled with Italian marble, at the centre is an Aubusson tapestry. **FOLLOWING PAGES** One of the Girándola bronze and rock crystal candelabra in the main salon, which is decorated in rococo style. * One of the Baccarat crystal candelabras alongside the rich Limoges dinnerware on the dining room table. ※ **VORHERGEHENDE DOPPELSEITE** Die prächtig und aufwändig gestaltete Treppe aus Carrara-Marmor ist von Säulen gesäumt. Über ihr befindet sich ein aus Eisen und Glas gefertigtes Oberlicht. **LINKE SEITE** Blick durch eine der reich dekorierten Türen des Hauptsalons auf den Treppenaufgang und die venezianischen Lampen aus mehrfarbigem Holz mit Sgraffitotechnik. **RECHTS** »Die Ruhe des Jägers« ist eine der vier Figurengruppen, die der Franzose Bachelier im 18. Jahrhundert aus Biskuitporzellan von Sèvres fertigte. **UNTEN** Das Esszimmer ist im Regency-Stil des 19. Jahrhunderts gehalten und an den Wänden mit italienischem Marmor verkleidet; in der Mitte hängt ein Aubusson-Teppich. **FOLGENDE DOPPELSEITE** Ein Kandelaber aus Bronze und Bergkristall aus dem 18. Jahrhundert steht im Hauptsalon, der im Rokokostil eingerichtet ist. * Außerdem ein Kandelaber aus Baccarat-Kristall, umringt vom prachtvollen Limoges-Geschirr auf dem Esszimmertisch. ※ **DOUBLE PAGE PRECEDENTE** Les colonnes rendent le luxueux escalier impérial en marbre de Carrare plus impressionnant encore. Il est éclairé par une verrière à armature en fer forgé. **PAGE DE GAUCHE** Le grand hall avec ses torchères vénitiennes en bois polychrome stuqué vu à travers une des portes richement décorées du salon principal. **A DROITE** Dans le grand salon, une pièce d'une beauté extraordinaire, « Le Repos du chasseur », faisant partie d'un ensemble de quatre biscuits réalisés pour la manufacture de Sèvres par le Français Bachelier au 18e siècle. **CI-DESSOUS** Dans la salle à manger, décorée dans le style Regency 19e siècle les murs sont tapissés de marbres italiens ; au centre, une tapisserie d'Aubusson. **DOUBLE PAGE SUIVANTE** Un des candélabres en bronze et cristal de roche du 18e siècle faisant partie de la décoration rococo du grand salon. * Sur la table de la salle à manger, un des deux candélabres en cristal de Baccarat entouré d'une belle vaisselle en porcelaine de Limoges.

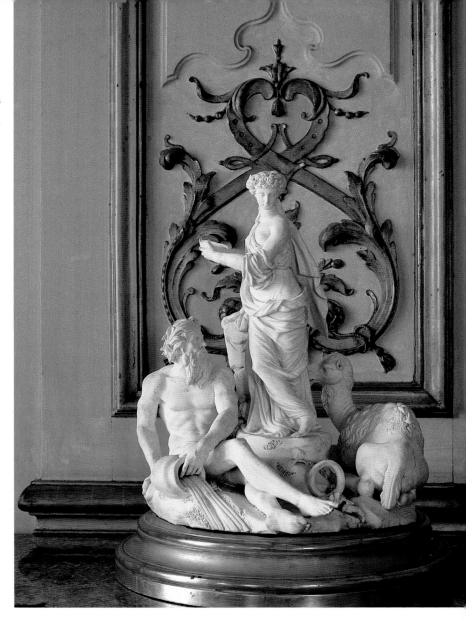

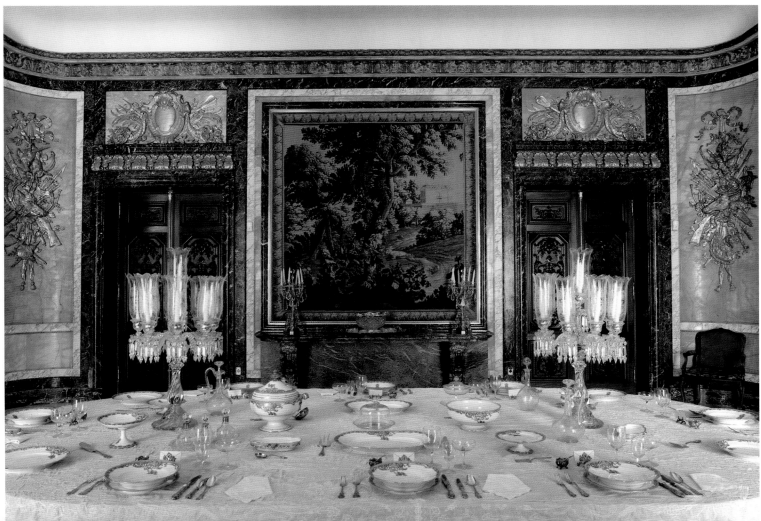

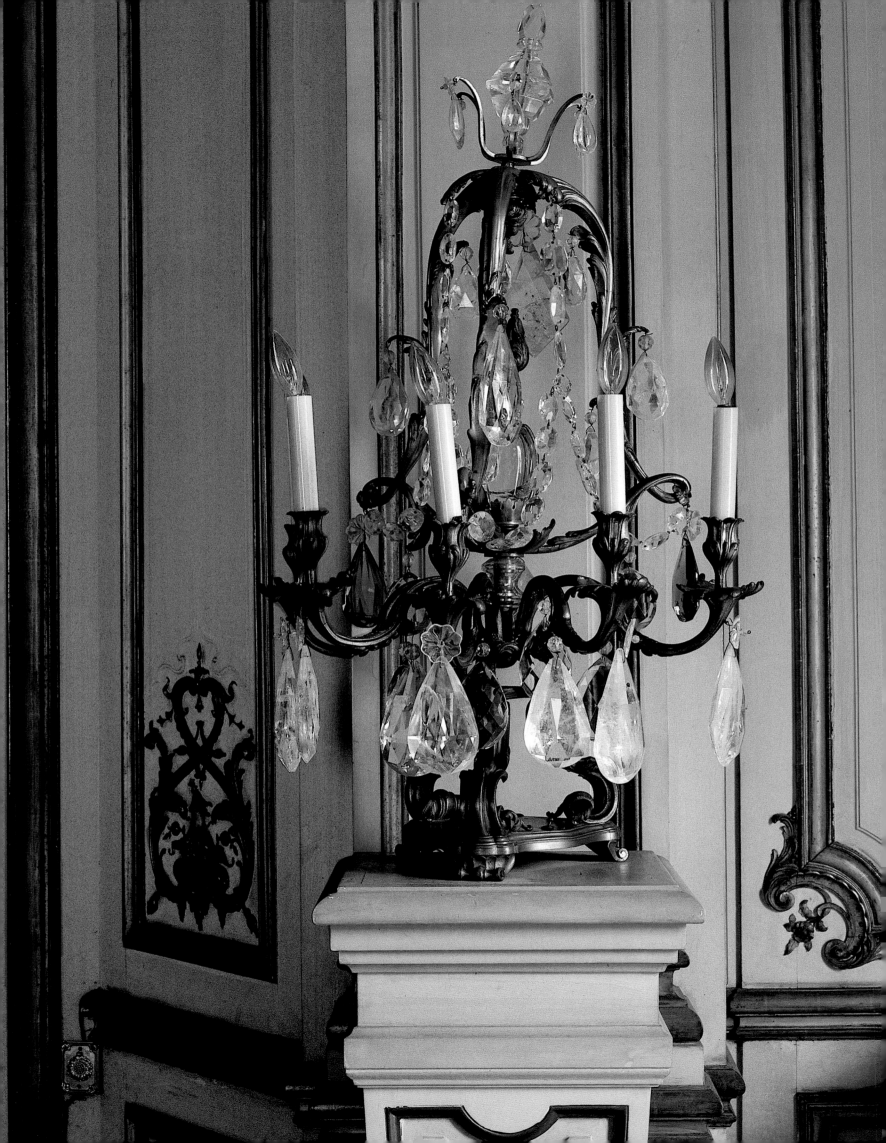

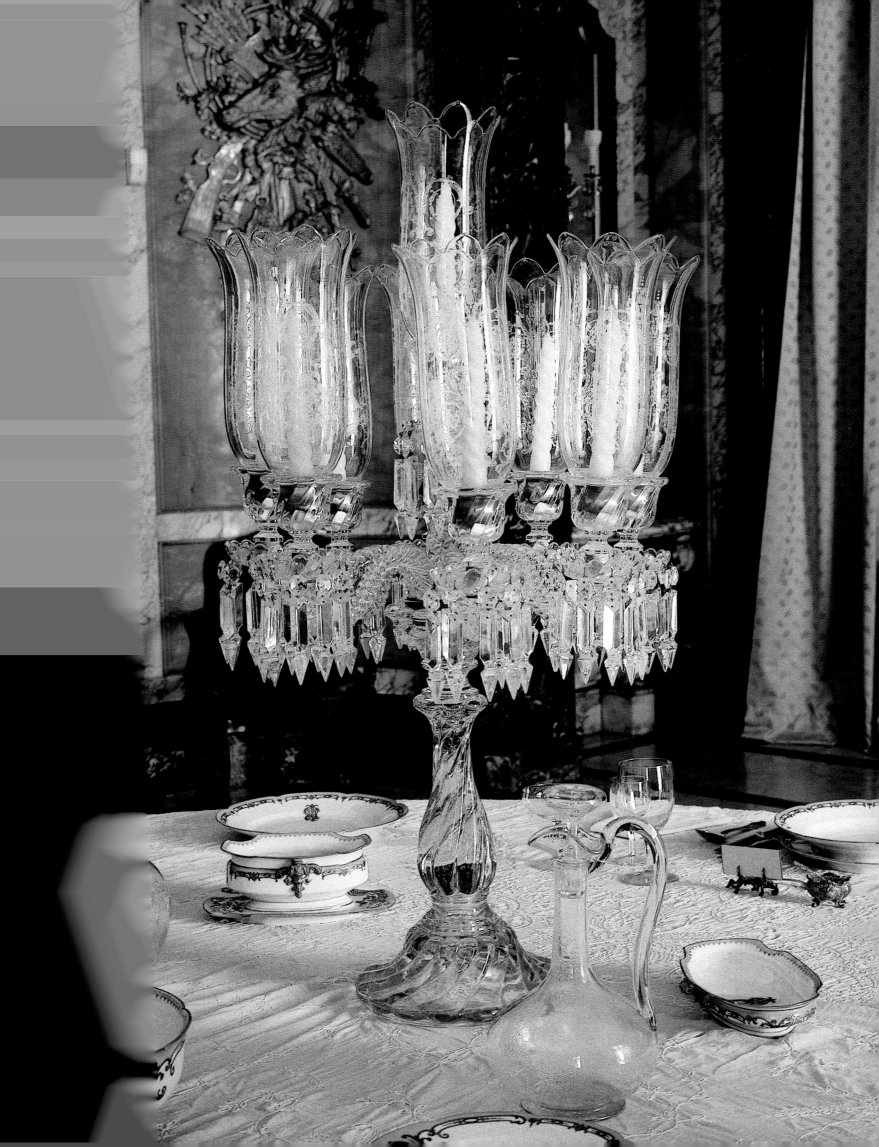

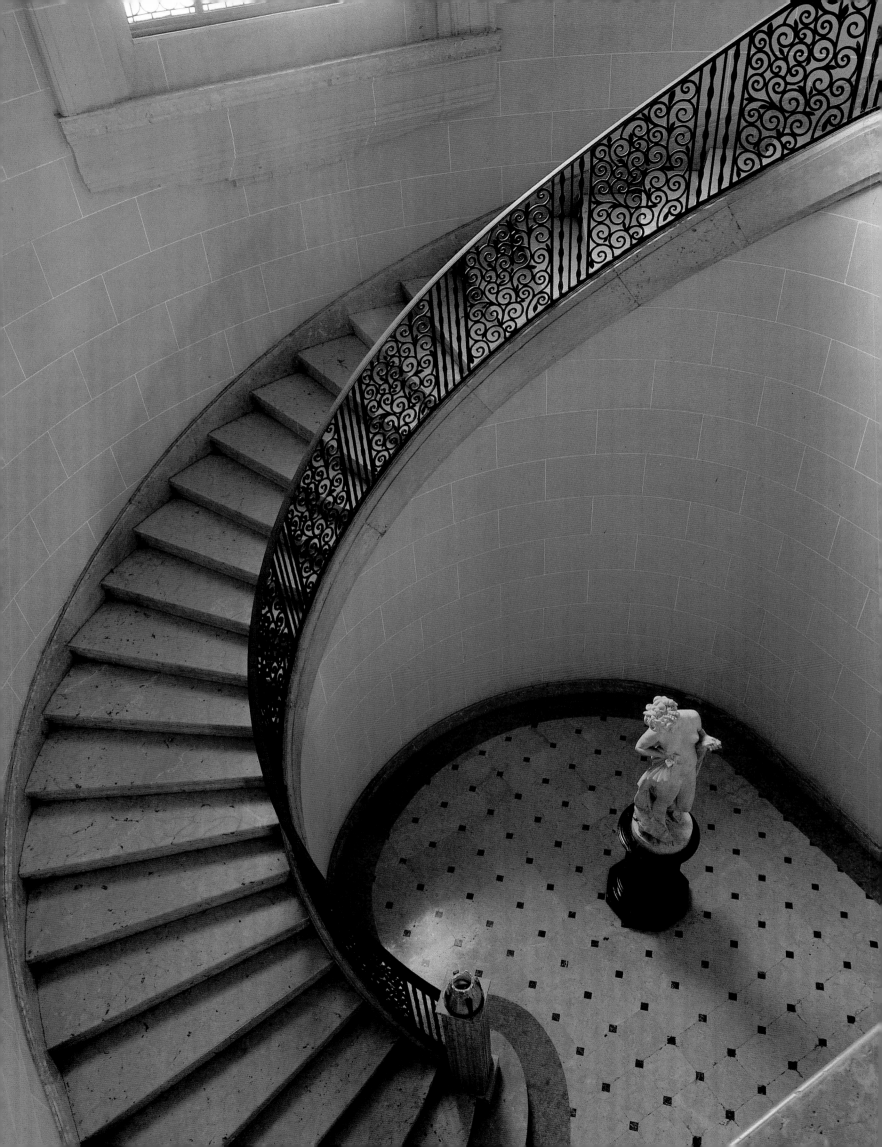

Casa
Baró-Lasa

Love at First Sight.

Catalina Lasa and Juan Pedro Baró fell in love at first sight when they met at a ball; but their love caused a big scandal as they were both married, and divorce did not exist in Cuba. Catalina was the most beautiful woman in Havana – she had won beauty contests in 1902 and 1904 – and Juan Pedro was a rich landowner. Rejected by society, they left for Europe where Juan Pedro arranged for the Pope to annul their previous marriages and the Cuban president to approve a divorce law. They were married in Paris, returned to Havana with presents for those they defied, and invited them to the grand opening of the home Juan Pedro had secretly built as a gift for his new wife. The Italian Renaissance-style villa was designed by Cuban architects Govantes and Cabarrocas, with interiors by the fashionable French designer René Lalique in art deco style with Egyptian details, and gardens by French landscape designer J. C. N. Forestier. The 1927 mansion is noted not only for its elegant proportions, but also for the beauty and luxury of the materials used: French and Italian marbles, Parisian wrought-iron grills, special stucco made with sand from the Nile, and glasswork by Lalique.

Catalina Lasa und Juan Pedro Baró lernten sich auf einem Ball kennen und verliebten sich auf der Stelle. Da beide verheiratet waren, provozierten sie einen Skandal, zumal Scheidung in Kuba undenkbar war. Catalina war die schönste Frau in Havanna – 1902 und 1904 gewann sie Schönheitswettbewerbe – und Juan Pedro war ein reicher Landbesitzer. Das Liebespaar reiste, von der kubanischen Gesellschaft ausgeschlossen, nach Europa. Dort brachte Juan Pedro den Papst dazu, seine erste Ehe und auch die seiner Geliebten zu annulieren, und der kubanische Präsident stimmte einem Scheidungsgesetz zu. Das Paar heiratete in Paris, kehrte vollbepackt mit Geschenken für die, die sie verachtet hatten, nach Havanna zurück und lud zur Einweihungsparty in das Haus, das Juan Pedro heimlich als Geschenk für seine neue Frau hatte bauen lassen. Die Villa im italienischen Renaissance-Stil wurde 1927 von den kubanischen Architekten Govantes und Cabarrocas gebaut, und der französische Designer René Lalique entwarf eine Inneneinrichtung im Art-Déco-Stil mit ägyptischen Anklängen. Den Garten gestaltete der französische Landschaftsarchitekt J. C. N. Forestier. Mit luxuriösen Materialen wie französischem und italienischem Marmor, schmiedeeisernen Gittern aus Paris, Stuck und Wänden aus Nilsand und Glasarbeiten von Lalique hat sich die elegante Villa einen Namen gemacht.

Catalina Lasa et Juan Pedro Baró tombèrent éperdument amoureux dès leur première rencontre dans un bal. Leur liaison fit scandale car ils étaient tous deux mariés et le divorce n'existait pas à Cuba. Catalina était la plus belle femme de la Havane (élue deux fois reine de beauté en 1902 et 1904) et Juan Pedro un riche propriétaire terrien. Rejetés par la société, ils s'enfuirent en Europe où Juan Pedro convainquit le pape d'annuler leurs premières unions et le président cubain d'approuver une loi autorisant le divorce. Ils se marièrent à Paris, rentrèrent à la Havane chargés de présents pour ceux qu'ils défiaient et les invitèrent à la pendaison de crémaillère de la demeure que Juan Pedro avait fait construire en secret pour sa nouvelle épouse. La villa de style renaissance conçue en 1927 par les architectes cubains Govantes et Cabarrocas, décorée par René Lalique dans le style Art Déco avec des détails égyptiens, entourée d'un parc dessiné par le paysagiste français J. C. N. Forestier, est célèbre non seulement pour ses proportions élégantes mais aussi pour la beauté et le luxe des matériaux utilisés : marbres français et italiens, grilles en fer forgé importées de Paris, stuc fabriqué avec du sable du Nil, verreries de Lalique.

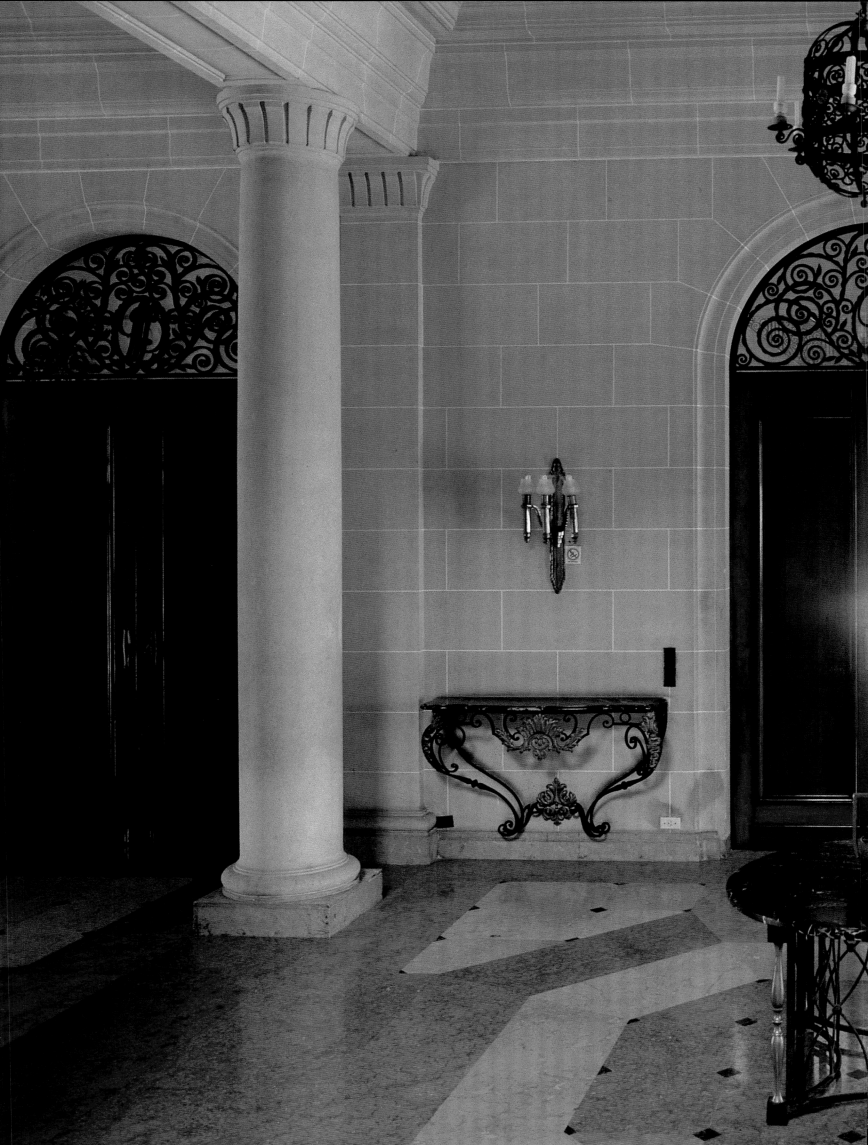

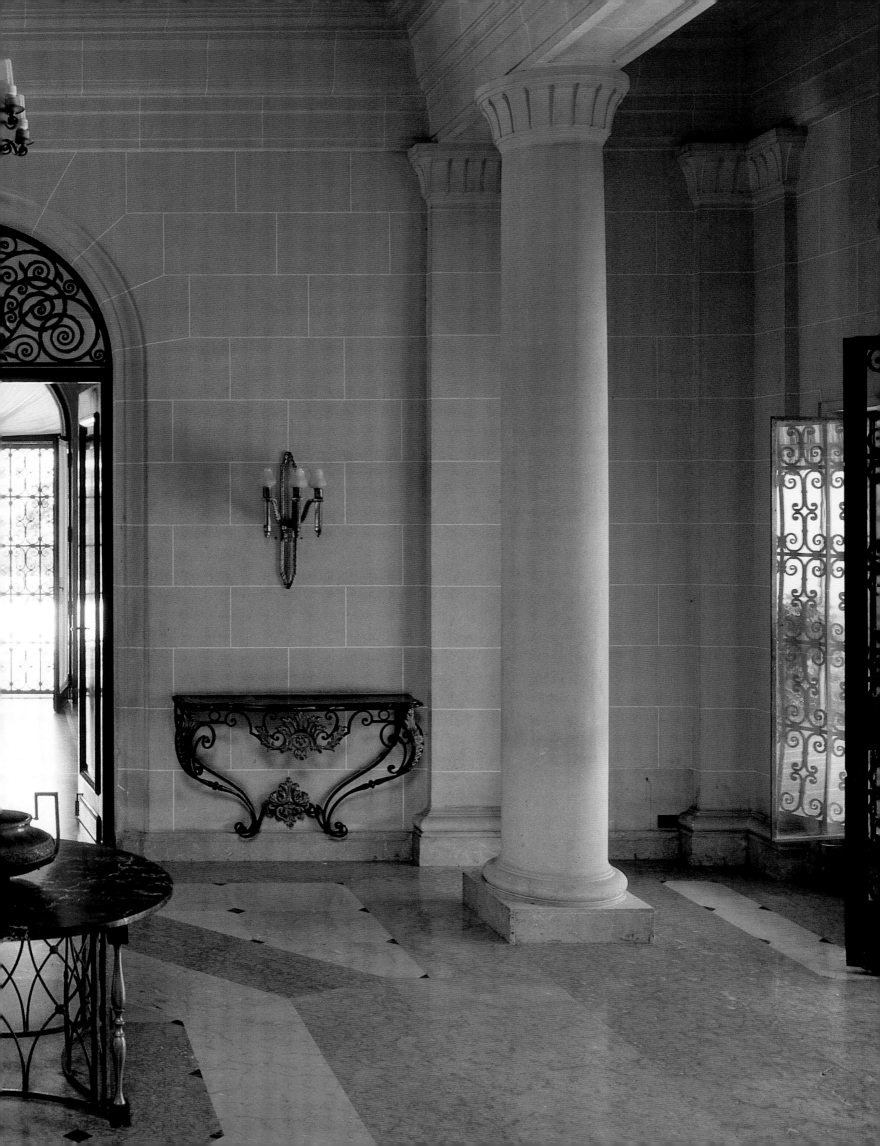

✳ **PREVIOUS DOUBLEPAGE** The beautifully proportioned entrance hall of the Baró-Lasa house evokes the majesty of hypostyle halls, with their Egyptian references. The walls were covered with sand brought over from the River Nile, and the floors with different types of Italian marble. **ABOVE** The stained glass windows that illuminate the staircase were built using the bases of French wine glasses. **BELOW** A colorful canvas protects the space from the afternoon sun and imitates the initials "BL" of the couple that was incorporated in the original grills. The original chandelier hangs from the ceiling. **FACING PAGE** The Palm Room, with its modern iron and glass lamp designed by the famous French designer René Lalique and the trelace structure attached to the walls and vaulted ceiling for climbing plants. ✳ **VORHERGEHENDE DOPPELSEITE** Das wohl proportionierte Vestibül der »Casa Baró-Lasa« erinnert mit seinen ägyptischen Anklängen an die Erhabenheit eines Hypostylons. Seine Wände wurden mit importiertem Nilsand verputzt; der Boden besteht aus verschiedenen italienischen Marmorarten. **OBEN** Das Buntglasfenster an der Treppe wurde aus den Füßen französischer Weingläser gefertigt. **UNTEN** Eine bunte Markise schützt vor der Nachmittagssonne. Darauf prangen die Buchstaben »BL« – es sind die Initialen des Paares, das ursprünglich einen Teil des Original-Eisengeflechts* darstellte. An der Decke hängt der Originalleuchter. **RECHTE SEITE** Das so genannte »Palmenzimmer« besticht durch eine moderne Lampe aus Eisen und Glas nach einem Entwurf des berühmten französischen Designers René Lalique sowie durch das feine Holzlattengerüst, das für Kletterpflanzen an den Wänden und an der Bogendecke befestigt wurde. ✳ **DOUBLE PAGE PRECEDENTE** Le vestibule, avec ses belles proportions et ses références égyptiennes, a la majesté des salles hypostyles. Ses murs sont revêtus d'un enduit réalisé avec du sable du Nil et ses sols sont en différents types de marbre italien. **CI-DESSUS** Le vitrail qui illumine l'escalier a été réalisé avec des pieds de verres à vin français. **CI-DESSOUS** Une toile aux couleurs vives protège l'espace du soleil de l'après-midi et reproduit les initiales « BL » du couple que l'on retrouve également dans les grilles. Au plafond, le lustre d'origine. **PAGE DE DROITE** Le « salon aux palmiers », avec sa suspension moderne en métal et verre dessinée par René Lalique et son treillis en fines baguettes de bois qui recouvre les murs et le plafond voûté.

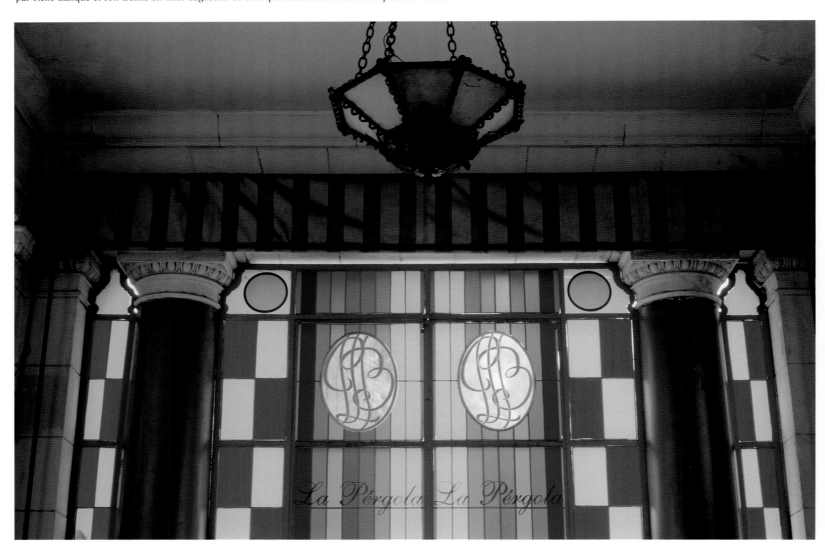

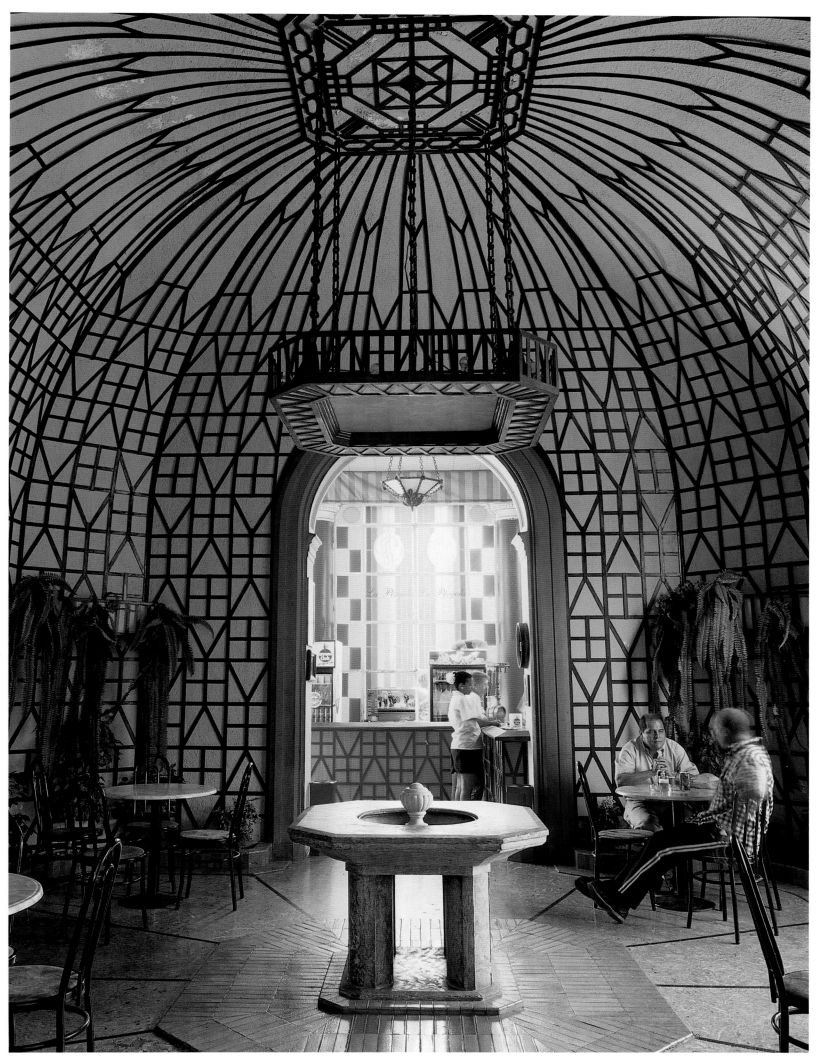

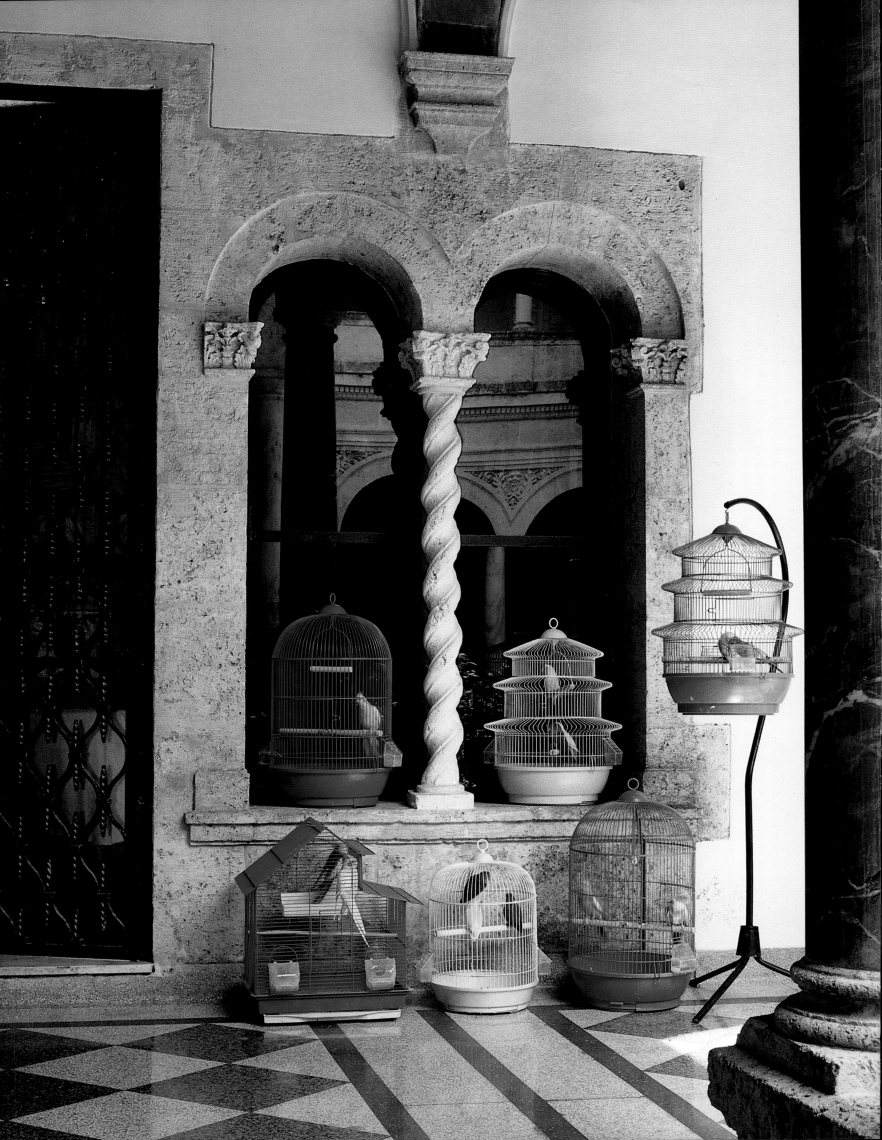

La mansión

A Florentine Palace in Havana.

The house, built for the rich businessman Mark A. Pollack, was the swansong both of eclecticism and of its most important practitioner, architect Leonardo Morales. No more would the traditional Cuban court-yard, here majestic and opulent, suggest a Florentine "cortile." Water gushes in the fountain of the extraordinary central patio, surrounded by galleries of imported columns, vaulted ceilings, marble floors and decorated with Catalonian tiles. In the morning the sun strikes the fountain; it becomes a blinding flash of light that changes in intensity throughout the day, and casts different light and shadows on the beautiful arcade. Located in the middle of a huge corner lot in the exclusive old Country Club area, the building, finished in 1930, is surrounded by large gardens. Morales masterfully balances airy terraces and huge windows against the spacious rooms. The double-height main room by the entrance loggia, with its coffered ceilings, is especially beautiful, as is the upstairs studio. The lavish decoration employs the widest choice of rich materials, ranging from precious woods to stained glass. In the end, art conspires with magic to lift the spirits in this refined atmosphere where the muses seem to dwell.

Das Haus, ein Schwanengesang auf den Architekten Leonardo Morales, ein Experte des eklektischen Stils, wurde für den reichen Geschäftsmann Mark A. Pollack gebaut. Der traditionelle kubanische Innenhof, hier majestätisch und opulent, könnte auch ein florentinischer »Cortile« sein. Aus dem Brunnen plätschert das Wasser, rundherum stehen Galerien mit gewölbten Decken und importierten Säulen, die Böden sind aus Marmor, an den Wänden katalanische Kacheln. Am Morgen fällt Sonnenlicht auf den Brunnen und wirft ein Licht- und Schattenspiel auf die Arkaden, das sich je nach Tageszeit verändert. Das Gebäude mitten in einem großen Garten liegt auf einem Eckgelände in der Nähe des exklusiven alten Country Clubs von Havanna und wurde 1930 fertiggestellt. Morales hatte ein außerordentliches Gespür für Proportionen und wusste die luftigen Terrassen mit den großen Fenstern und den großzügigen Räumen untereinander auszubalancieren. Das doppelt hohe Hauptzimmer mit Kassettendecke neben der Eingangshalle ist besonders schön, genau wie das Studio im oberen Stockwerk. Aufwändige Dekorationen aus Edelhölzern, Buntglas und anderen schweren Materialien bringen Kunst und Magie zusammen.

Achevée en 1930 pour le riche homme d'affaires Mark A. Pollack, cette demeure fut le chant du cygne de l'éclectisme et de son principal contributeur, l'architecte Leonardo Morales. Le patio traditionnel cubain, ici majestueux et opulent, n'aurait plus jamais des allures de «cortile» florentin. L'eau gargouille dans la fontaine de cette superbe cour intérieure bordée de galeries soutenues par une colonnade, avec des plafonds voûtés, des sols en marbre et des lambris en carreaux catalans. Le matin, le soleil fait briller le bassin, lançant des éclats aveuglants qui changent d'intensité au fil des heures, projetant des ombres changeantes sur les arcades. Située au milieu d'un immense terrain d'angle dans le quartier chic du Country Club, la maison est entourée de vastes jardins. Morales a su créer un bel équilibre entre les terrasses, les grandes fenêtres et les intérieurs spacieux. La grande salle qui donne sur la loggia de l'entrée, avec ses hauts plafonds à caissons, est particulièrement belle, tout comme l'atelier d'artiste à l'étage. La décoration luxueuse recourt à un large éventail de matériaux, des bois précieux aux vitraux. L'art s'unit à la magie pour engendrer une atmosphère raffinée et exaltante qui semble habitée par les muses.

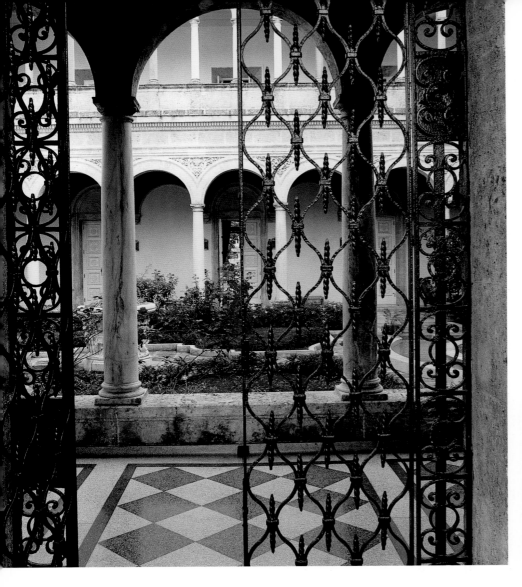

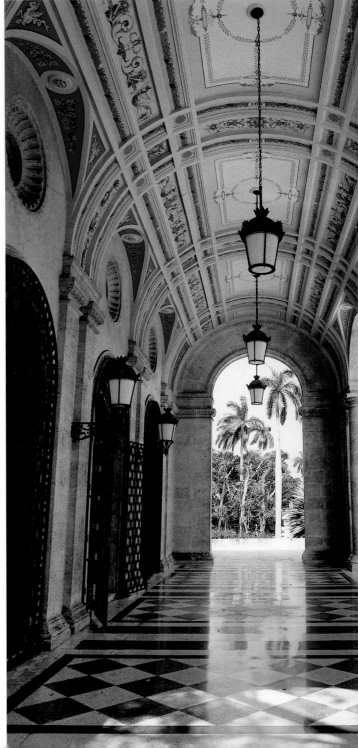

❋ **ABOVE** A lovely wrought-iron grill frames the view of the extraordinary inner courtyard with its columns made of different types of marble imported from several countries. The vast proportions of the courtyard and its painstaking design make it enormously attractive. **RIGHT** The monumental entrance portal with its lovely vaulted ceiling evokes memories of Florentine "palazzos". The columns, which recall the Palladian motif so often employed in the works of Cuban architect Leonardo Morales, frame the views toward the gardens. **FACING PAGE** The terrace that serves as an antechamber to the entrance portal acts as a transition between the gardens and the "loggia" and initiates a spatial sequence traversing the spacious main salon in the house and culminating in the courtyard. **FOLLOWING DOUBLE PAGE** The house's main salon with its high ceilings is exceptional due to its size, its pleasant proportions based on two perfect cubes, and its decoration. The primary and secondary concrete ceiling beams are clad in cedar wood.

❋ **OBEN** Ein wunderschönes schmiedeeisernes Gitter rahmt den Blick auf den außergewöhnlichen zentralen Innenhof und seine Säulen aus unterschiedlichen Marmorarten, die aus verschiedenen Ländern importiert wurden. Die riesigen Ausmaße des Innenhofs und seine besondere Gestaltung machen ihn besonders reizvoll. **RECHTS** Das monumentale Eingangsportal mit seiner prächtigen Bogendecke erinnert an einen florentinischen Palast. Der Säulengang erinnert an den häufig von dem kubanischen Architekten Leonardo Morales zitierten Andrea Palladio und lenkt den Blick auf die Gartenanlagen. **RECHTE SEITE** Die Terrasse dient als Vorhalle des Zugangsportals sowie als Übergang zwischen Garten und Loggia. Sie leitet eine Raumfolge ein, die durch den großen Hauptsalon des Hauses führt und in den Innenhof mündet. **FOLGENDE DOPPELSEITE** Der Hauptsalon erstreckt sich über eine doppelte Geschosshöhe und beeindruckt mit seinen Ausmaßen und den harmonischen Proportionen, die auf zwei perfekten Würfeln basieren. Die aus Beton bestehenden Haupt- und Nebenträger der Decke sind mit Zedernholz verkleidet.

❋ **CI-DESSUS** Une belle grille en fer forgé s'ouvre sur l'extraordinaire patio central, avec ses différentes colonnes en marbre importées de plusieurs pays. Les vastes proportions du patio et son plan soigné en font un lieu unique. **A DROITE** Le porche monumental avec son beau plafond voûté évoque les palais florentins. La colonnade, un motif d'Andrea Palladio fréquemment utilisé par l'architecte cubain Leonardo Morales, encadre la vue sur les jardins. **PAGE DE DROITE** La terrasse devant le porche de l'entrée assure la transition entre les jardins et la loggia, amorçant une perspective qui culmine avec le patio en passant par le grand salon de la maison. **DOUBLE PAGE SUIVANTE** Le salon principal, avec sa double hauteur sous plafond, est exceptionnel de par ses dimensions, ses proportions agréables basées sur deux cubes parfaits et sa décoration. Les poutres et solives en béton sont revêtues d'un placage en cèdre.

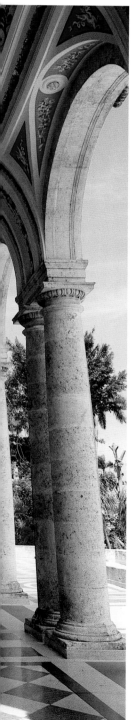

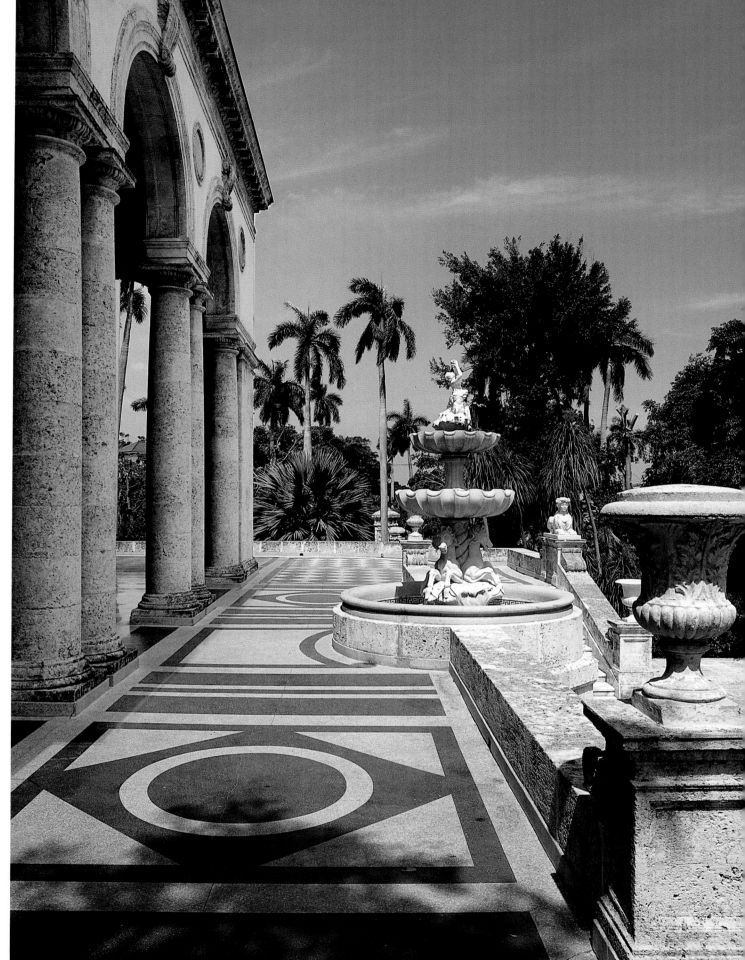

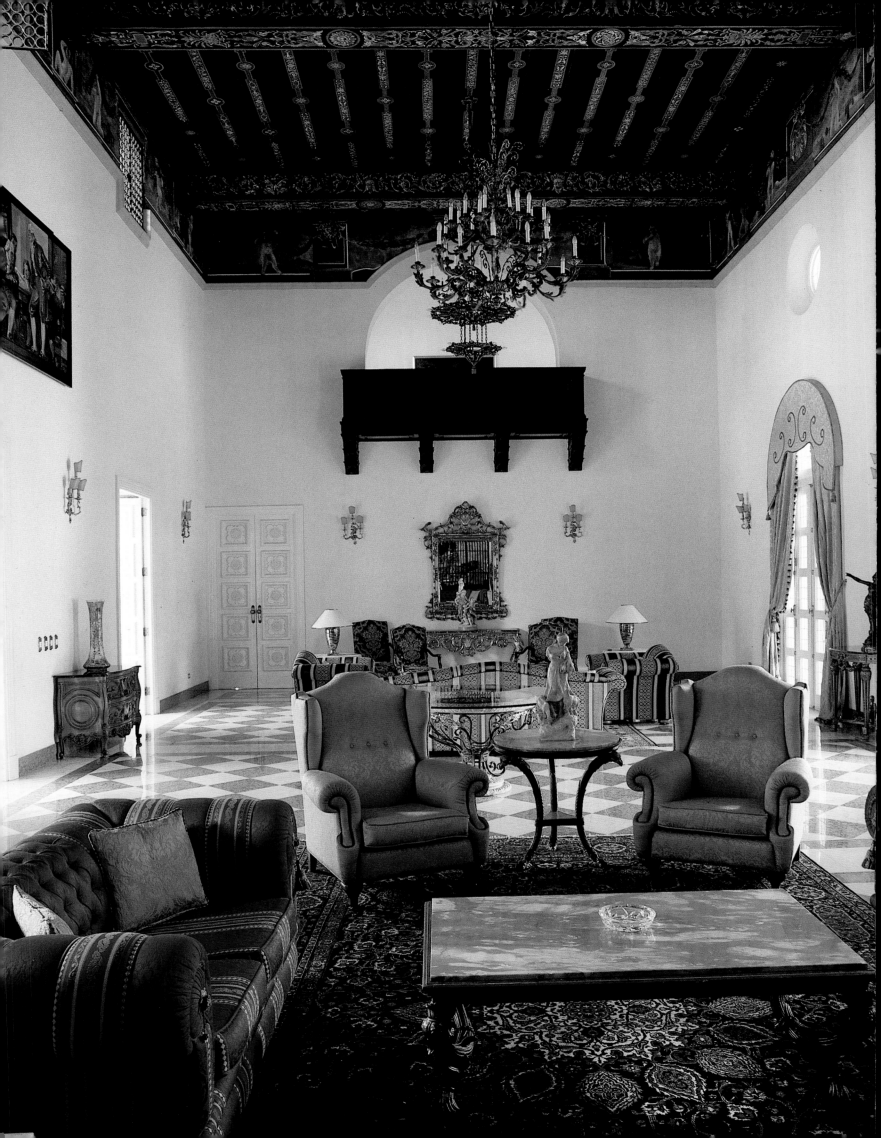

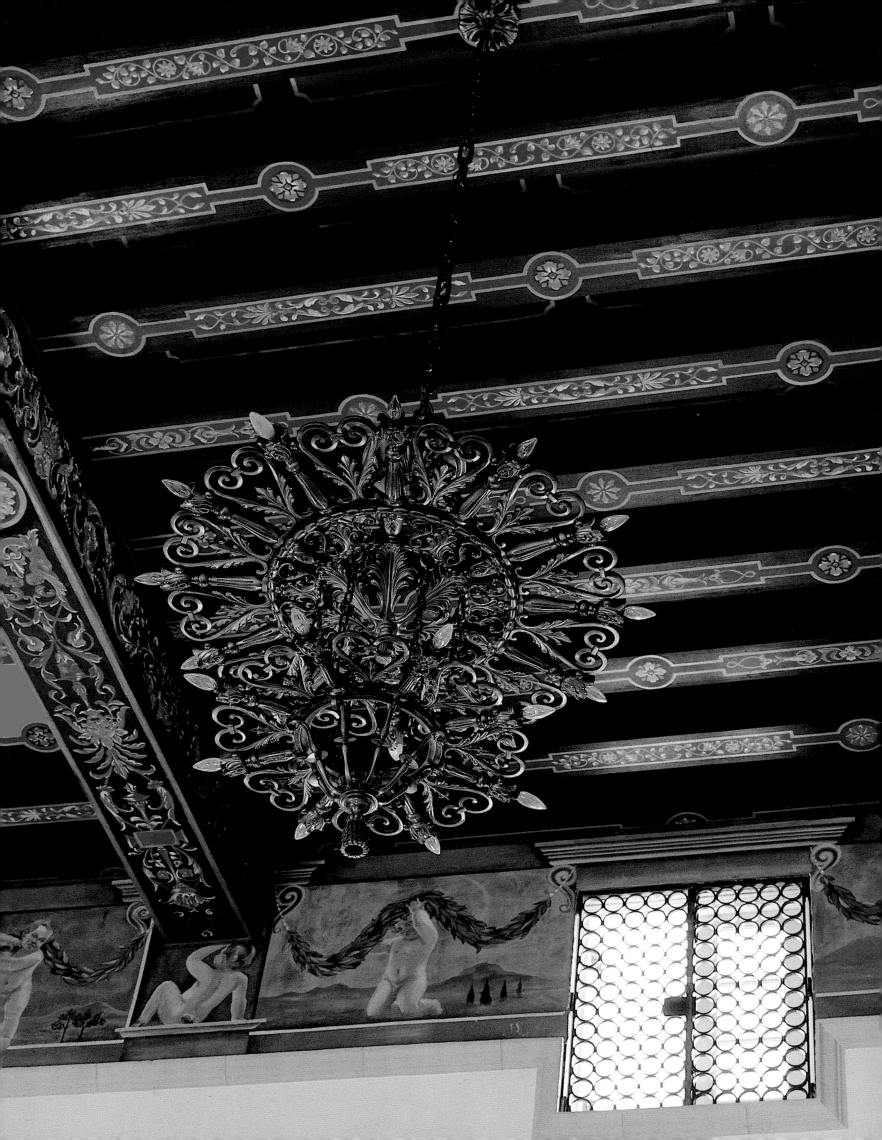

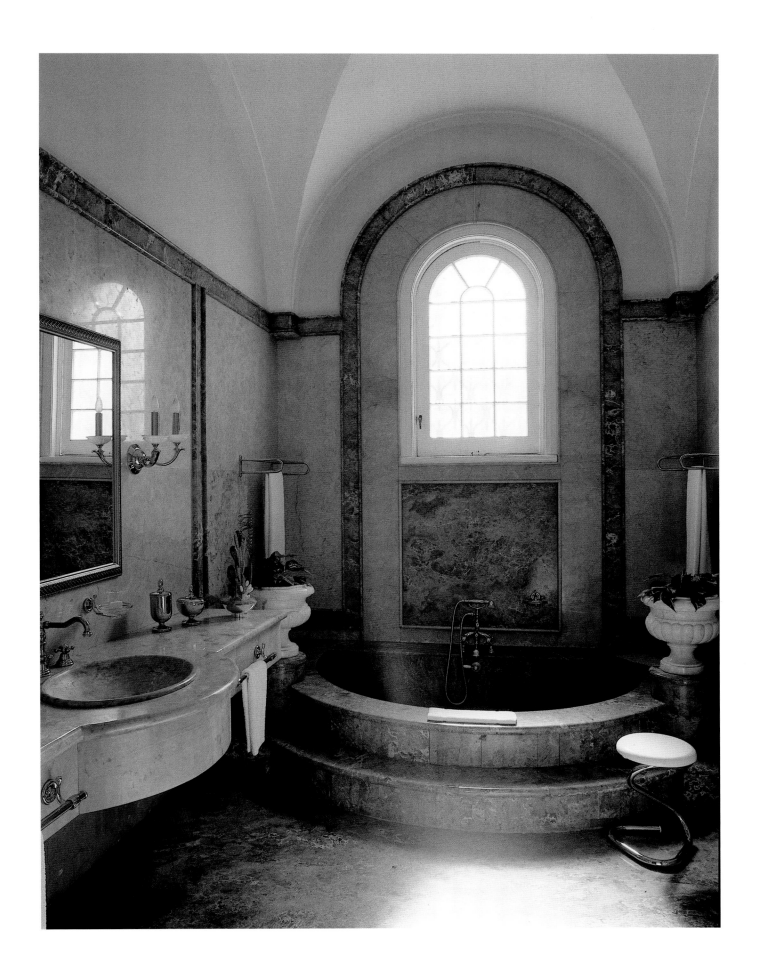

❋ **FACING PAGE** An exquisite vase located in the dining room is visible from the vestibule of the house's carriage entrance. **ABOVE** The master bathroom of the house is clad in Mexican marble. ❋ **LINKE SEITE** Eine prachtvolle Vase steht im Esszimmer, von dem man in die Kutscheneinfahrt des Hauses blickt. **OBEN** Das Hauptbadezimmer des Hauses ist mit mexikanischem Marmor verkleidet. ❋ **PAGE DE GAUCHE** Derrière la belle potiche de la salle à manger, on aperçoit le vestibule donnant sur la porte cochère. **CI-DESSUS** La salle de bains principale avec ses marbres provenant du Mexique.

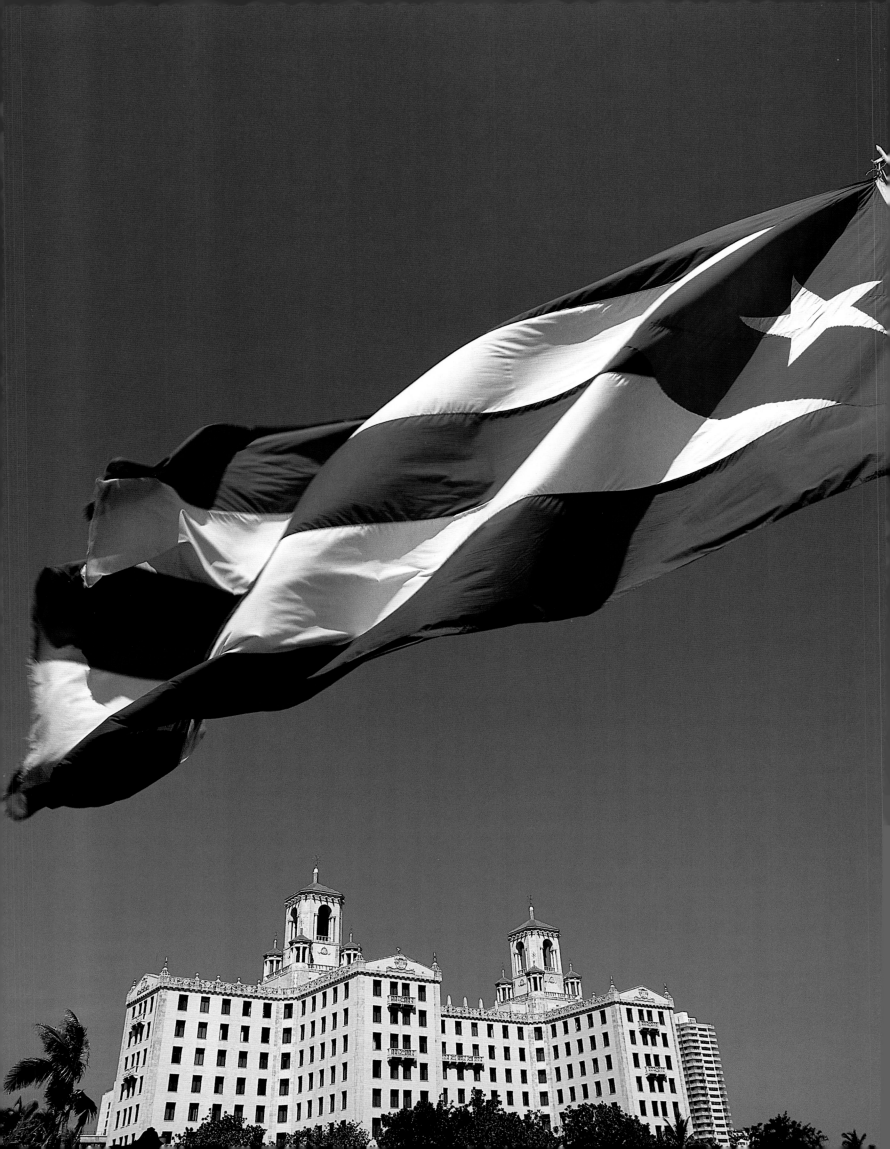

HOTEL NACIONAL

Where the Rich and Famous – and the Gangsters – Liked to Stay.

Sunsets are spectacular and unforgettable in Havana, especially if you enjoy them from the luxurious Hotel Nacional. From the moment it opened its doors on the evening of December 30, 1930, it became the place for the international rich and famous: gangsters Meyer Lansky and Charles "Lucky" Luciano, Hollywood stars like Errol Flynn, Frank Sinatra, Ava Gardner and Marlon Brando, and other public figures such as Sir Alexander Fleming, Sir Winston Churchill, and the Duke of Windsor have all stayed here. More recent visitors include Pierre Cardin, Naomi Campbell, and winner of the Nobel Prize for Literature Gabriel García Márquez. The hotel was built on a hill that housed the Santa Clara gun battery; this position allows for superb views of both the Florida Straits and the city. The building was designed by the acclaimed New York firm McKim, Mead & White in an eclectic style that combined details from art deco, neoclassicism, and the architecture of the Spanish revival. It is set back from the street by a palm-tree-lined "alley," which leads to an elegant foyer decorated with Sevillean tiled wainscoting and a coffered ceiling. Doors open onto the large verandah by the gardens. The foyer also connects the various indoor and outdoor restaurants as well as the popular cabaret, where several members of the legendary Buena Vista Social Club perform Cuban music on weekends.

Sonnenuntergänge in Havanna sind ein unvergessliches Erlebnis, besonders wenn man sie vom Luxushotel »Nacional« aus betrachtet. Es wurde am Abend des 30. Dezember 1930 eröffnet und zog gleich eine illustre Klientel an: Errol Flynn, Frank Sinatra, Ava Gardner und Marlon Brando reisten aus Hollywood an. Persönlichkeiten wie Sir Alexander Fleming, Sir Winston Churchill und der Duke of Windsor stiegen hier ab, und sogar Meyer Lansky und Charles »Lucky« Luciano, zwei schwergewichtige amerikanische Mafiosi packten im »Nacional« ihre Koffer aus. Heute heißen die berühmten Gäste Pierre Cardin und Naomi Campbell, auch der Nobelpreisträger für Literatur Gabriel García Márquez gehört dazu. Das Hotel wurde auf dem Hügel gebaut, wo sich früher die Unterkunft der Geschütztruppe von Santa Clara befand. Von hier hat man einen tolle Sicht auf Havanna und die Meeresenge von Florida. Das Gebäude, eine Mischung aus Art Déco, Neoklassizismus und spanischem Revival, wurde von den renommierten New Yorker Architekten McKim, Mead & White entworfen. Über eine Palmenallee wird man ins elegante Foyer mit Kassettendecke und Kacheln aus Sevilla geführt. Das Foyer verbindet die Restaurants innen und im Garten mit dem Kabarett des Hotels, wo an den Wochenenden Mitglieder des legendären Buena Vista Social Clubs auf der Bühne stehen.

Les couchers de soleil de la Havane sont spectaculaires et inoubliables, surtout contemplés depuis le luxueux Hotel Nacional. Dès son inauguration le soir du 30 décembre 1930, il fut adopté par les riches et célèbres : les gangsters Lucky Luciano et Meyer Lansky y côtoyaient les stars de Hollywood – Errol Flynn, Frank Sinatra, Ava Gardner, Marlon Brando – et d'autres personnalités telles que sir Alexander Fleming, sir Winston Churchill ou le duc de Windsor. Plus récemment, ses hôtes illustres ont inclus Pierre Cardin, Naomi Campbell et le lauréat du prix Nobel de littérature Gabriel García Márquez. Construit sur la colline qui abritait la batterie de canons de Santa Clara, l'hôtel jouit de vues imprenables sur le détroit de Floride et la ville. Il fut conçu par le célèbre cabinet d'architectes new-yorkais McKim, Mead & White dans un style éclectique qui conjugue des détails Art Déco, néoclassiques et méditerranéens. Depuis la rue, une allée bordée de palmiers mène à l'élégant hall d'entrée décoré de lambris en carreaux sévillans et d'un plafond à caissons. La large véranda qui donne sur les jardins relie les restaurants intérieur et extérieur ainsi que le fameux cabaret. Plusieurs membres du légendaire Buena Vista Social Club y jouent de la musique cubaine les week-ends.

MONUMENTO NACIONAL

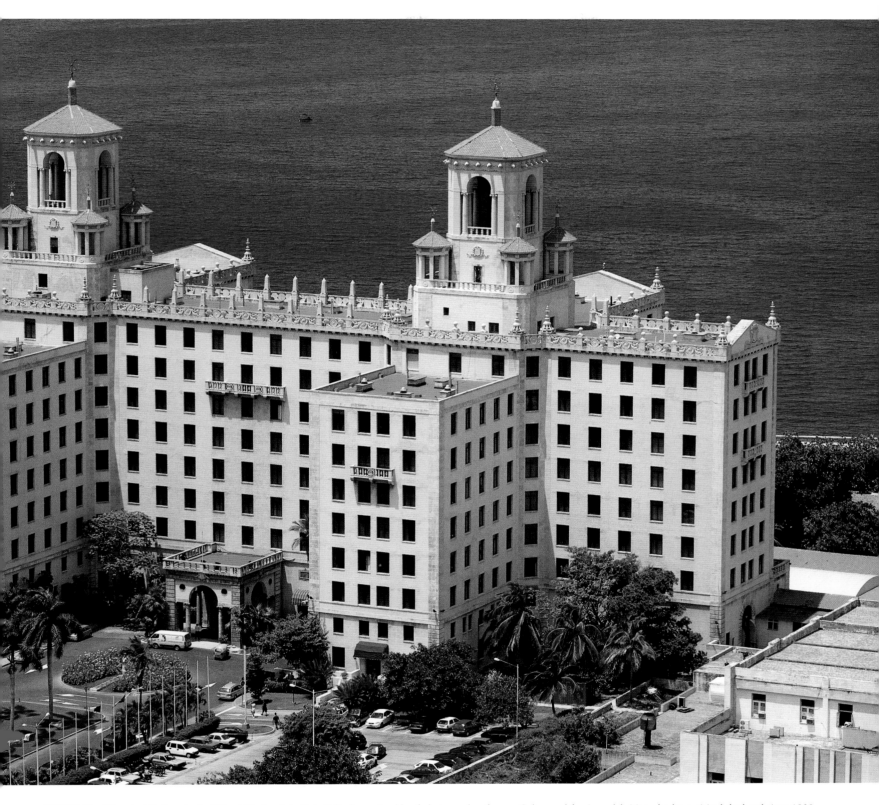

※ **ABOVE LEFT** The Historical Gallery in the "Hotel Nacional de Cuba" displays a jumble of photographs of many Cuban and foreign celebrities who have visited the hotel since 1930. **LEFT** One of the "classic" automobiles that forms part of the hotel's rental vehicle fleet. **ABOVE** The privileged location of the "Hotel Nacional de Cuba", in a central area of the capital city, provides outstanding views of both the sea and the city. **FOLLOWING PAGES** The main entrance to the hotel's vestibule is framed by colorful wainscoting made of tiles from Seville. * The giant poster behind a scale model of the hotel, features Raúl Capablanca, Fred Astaire, Gary Cooper, Rita Hayworth, Errol Flynn, Robert De Niro, Sara Montiel, Ava Gardner, Nat "King" Cole and Geraldine Chaplin. ※ **OBEN LINKS** Die »Galería Histórica« im »Hotel Nacional de Cuba« vereint Fotos von kubanischen und ausländischen Berühmtheiten, die diese Einrichtung seit ihrer Eröffnung, 1930 besucht haben. **LINKS** Einer der »klassischen« Wagen, die zum Mietfuhrpark des Hotels gehören. **OBEN** Der privilegierte Standort des »Hotel Nacional de Cuba« im Zentrum der Hauptstadt bietet ausgezeichnete Aussichten auf das Meer und die Stadt. **FOLGENDE DOPPELSEITE** Der Haupteingang des Hotels wird von einem großen Sockel aus sevillanischen Fliesen umrahmt. * Hinter einer Nachbildung des Hotels hängt ein großes Plakat, auf dem Raúl Capablanca, Fred Astaire, Gary Cooper, Rita Hayworth, Errol Flynn, Robert De Niro, Sara Montiel, Ava Gardner, Nat »King« Cole und Geraldine Chaplin zu sehen sind. ※ **PAGE DE GAUCHE, EN HAUT** La galerie historique est décorée de nombreuses photographies des célébrités cubaines et étrangères qui ont séjourné dans l'hôtel depuis son inauguration, 1930. **A GAUCHE** Une des automobiles « classiques » faisant partie du parc de véhicules de location de l'hôtel. **CI-DESSUS** Le site privilégié de « l'Hotel Nacional de Cuba », au cœur de la capitale, offre d'excellentes vues sur la mer et la ville. **DOUBLE PAGE SUIVANTE** L'entrée principale est bordée d'une grande frise en azulejos sévillans. * Sur l'affiche géante derrière une maquette de l'hôtel, on reconnaît Raúl Capablanca, Fred Astaire, Gary Cooper, Rita Hayworth, Errol Flynn, Robert de Niro, Sara Montiel, Ava Gardner, Nat « King » Cole et Géraldine Chaplin.

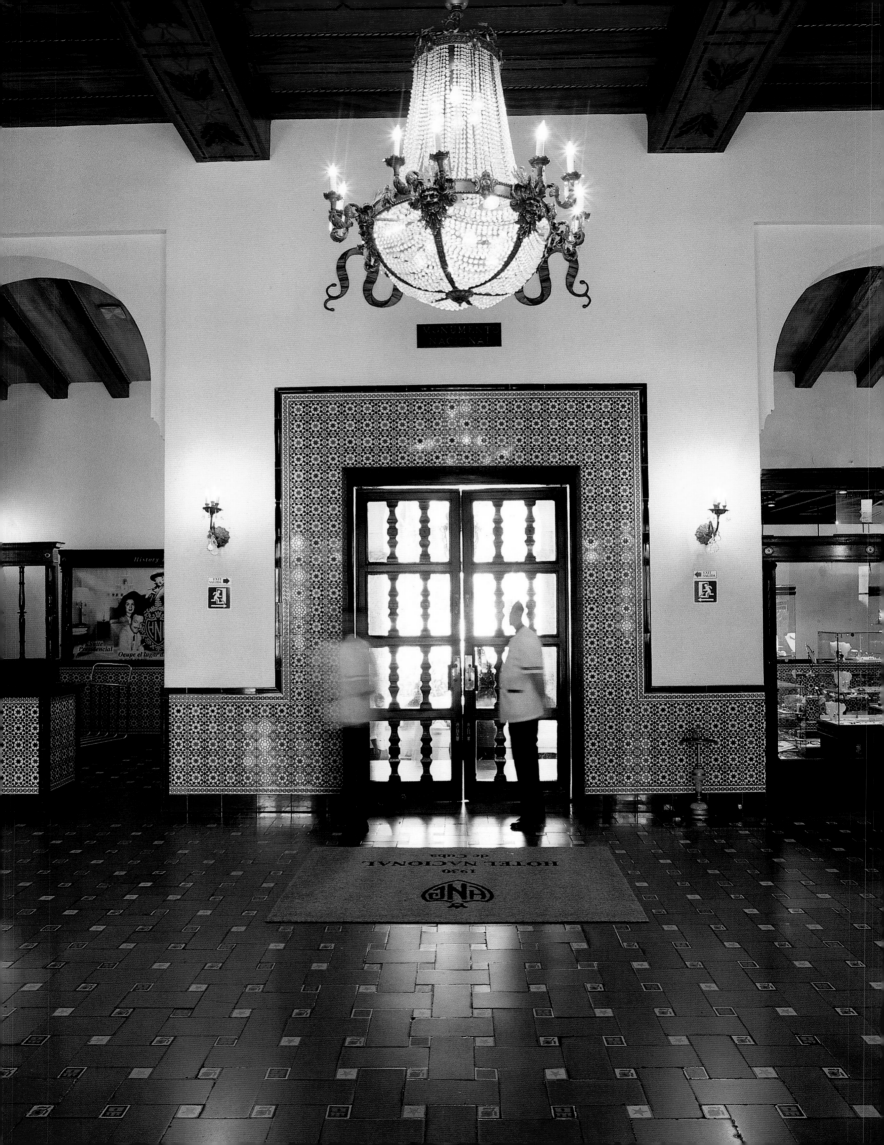

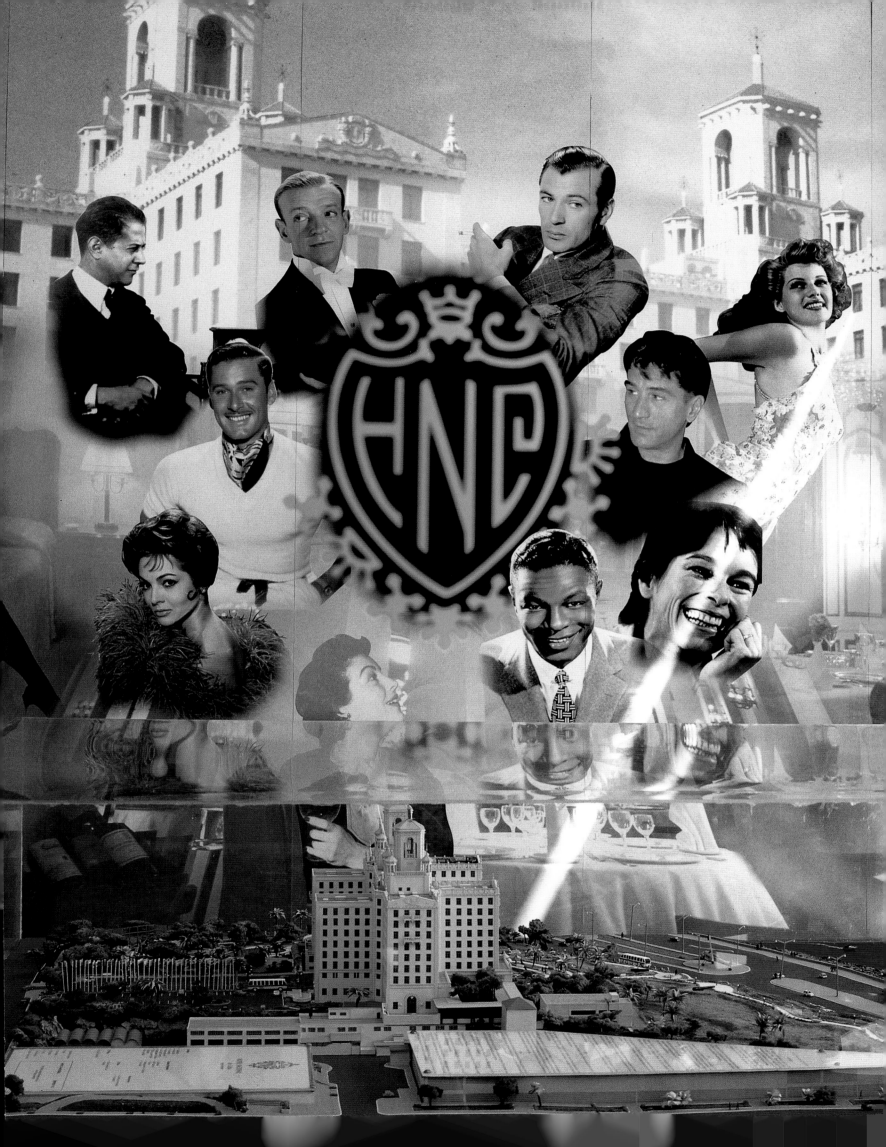

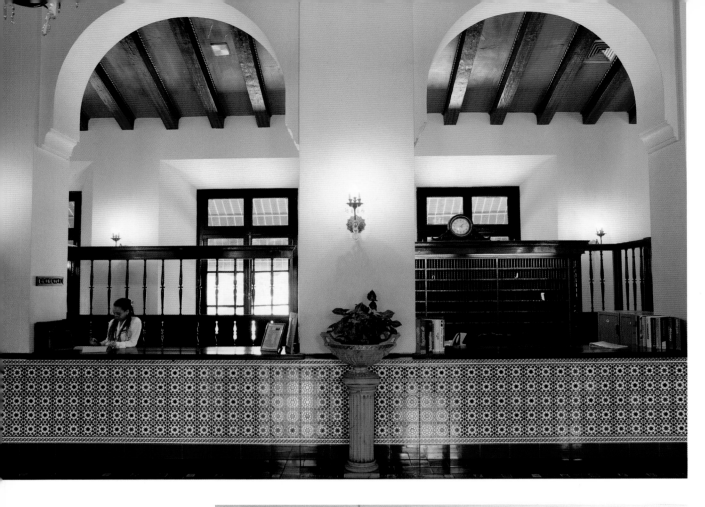

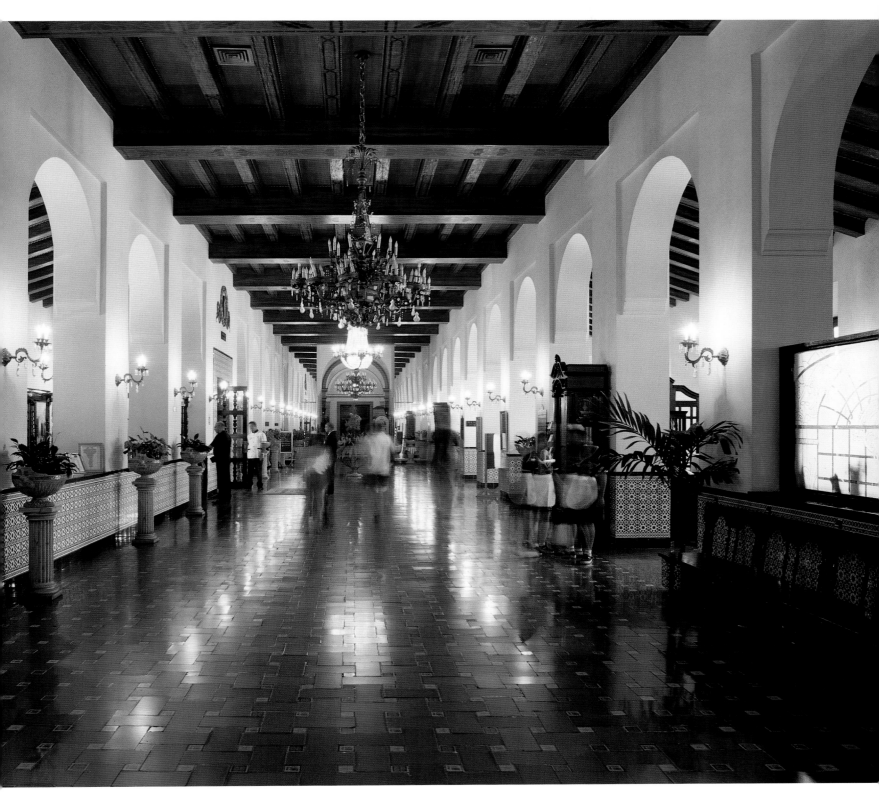

❋ **ABOVE LEFT** In the vestibule near the entrance, the reception desk of the "Hotel Nacional de Cuba" with its wood counter clad in tiles from Seville. **LEFT** Another huge poster in the hotel's Historical Gallery displays yet another group of famous personalities: Buster Keaton, Tom Mix, Rita Montaner, Johnny Weissmuller, Ernesto Lecuona, Jack Dempsey, the Dukes of Windsor, and the mobsters Meyer Lansky and Charles "Lucky" Luciano. **ABOVE** The lovely, welcoming vestibule of the "Hotel Nacional de Cuba" with its beautiful wainscoting made of ceramic tiles from Seville and its ceiling with decorative wooden beams. In the background, the Cabaret Parisién, where some members of the Buena Vista Social Club perform. ❋ **OBEN LINKS** Im Vestibül befindet sich in der Nähe des Eingangs die Rezeption des »Hotel Nacional de Cuba« mit einem Tresen aus Holz und sevillanischen Fliesen. **LINKS** Ein anderes großes Plakat der »Galería Histórica« zeigt eine weitere Gruppe von Berühmtheiten: Buster Keaton, Tom Mix, Rita Montaner, Johnny Weissmuller, Ernesto Lecuona, Jack Dempsey, die Herzoge von Windsor sowie die Mafiosi Meyer Lansky und Charles »Lucky« Luciano. **OBEN** Der prachtvolle, einladende Eingangsbereich des »Hotel Nacional de Cuba« mit seinen wunderschönen Sockeln aus sevillanischen Fliesen und der mit Holzbalken dekorierten Decke. Im Hintergrund sieht man das »Cabaret Parisién«, in dem Mitglieder des Buena Vista Social Club auftreten. ❋ **PAGE DE GAUCHE, EN HAUT** Dans le hall, près de la porte d'entrée, la réception avec son comptoir en bois tapissé d'azulejos sévillans. **A GAUCHE** Un seconde grande affiche dans la galerie historique présente un autre groupe de célébrités : Buster Keaton, Tom Mix, Rita Montaner, Johnny Weissmuller, Ernesto Lecuona, Jack Dempsey, le duc et la duchesse de Windsor, les gangsters Meyer Lansky et Charles « Lucky » Luciano. **CI-DESSUS** Beau et chaleureux, le grand hall avec ses hautes frises en azulejos sévillans et son toit en poutres décorées. Au fond, le Cabaret parisien, où se produisent quelques-uns des musiciens du Buena Vista Social Club.

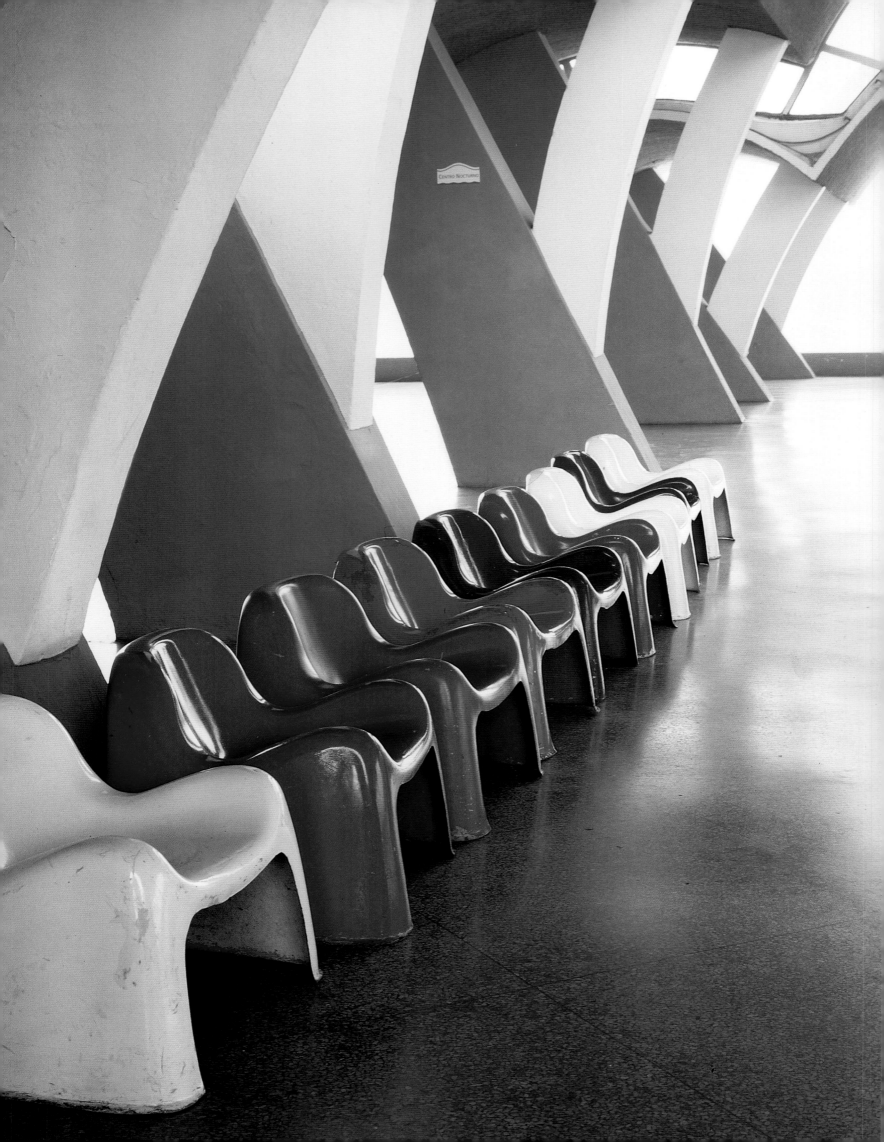

CLUB Náutico

An Oversized, Manmade Crustacean.

Both the shady interior and the bright exterior of the "Club Náutico" merge in this unusual organic form. Inside, you have the impression of being in a large, manmade crustacean; when looking at the colorful structure from the sea, the huge, undulating vaults make an explicit reference to the ocean waves as well as to underwater creatures. The seductive atmosphere achieved inside the building – the sense of openness and airiness, the interesting play of light, shadows, and reflections, and the telescopic effect of forced perspective towards both the sea and the entrance – was produced by tilting the central section of the thin vaulted shells upwards, which also allows natural light in from the skylights above. This intriguing and unique space was designed in 1953 by Cuban architect Max Borges Recio, who used the same idea in his successful project for the award-winning cabaret "Tropicana" two years earlier. In both of his masterpieces he accomplished great formal clarity by integrating simple natural forms with natural light. This original use of reinforced concrete vaults made it feasible to shelter large crowds of people dancing and relaxing in the tropical ambience.

Schatten und Licht verbinden sich im »Club Náutico« zu einem ungewöhnlichen, organischen Gebilde. Im Innern fühlt man sich wie in einem riesigen Schalentier. Das Gebäude erinnert in seiner Form an die Wellen des Ozeans und an irgendwelche Unterwasserwesen. Die dünnen, gewölbten Schalen des Daches wurden so ausgerichtet, dass der mittlere Teil nach oben ragt. Damit wird ein großzügiger und luftiger Effekt erzielt, der das interessante Spiel von Licht, Schatten und Reflexionen sowie die Perspektive zum Meer und zum Eingang hin verstärkt. Gleichzeitig kann das Sonnenlicht durch die Oberlichter ins Innere dringen. Dieses einzigartige, faszinierende Gebäude wurde vom kubanischen Architekten Max Borges Recio. 1953 entworfen, der bereits zwei Jahre zuvor die gleiche Idee bei dem preisgekrönten Kabarett »Tropicana« umgesetzt hatte. Die beiden Meisterwerke bestechen durch die formale Klarheit, die durch das Zusammenspiel von einfachen, organischen Formen und Sonnenlicht entsteht. Unter den verstärkten Betongewölben kann man in tropischem Ambiente tanzen und entspannen.

La forme organique originale du «Club Náutico» fait fusionner la fraîcheur des intérieurs et le soleil des terrasses. Dedans, on se croirait dans un grand crustacé modelé par la main de l'homme. Quand on regarde l'étrange bâtiment depuis la mer, ses immenses voûtes ondoyantes renvoient explicitement aux vagues de l'océan et à ses créatures sous-marines. La belle atmosphère qui règne à l'intérieur – l'impression d'ouverture et d'air, les intéressants jeux de lumière, d'ombres et de reflets, l'effet télescopique de la perspective vers la mer et l'entrée – est renforcée par la surélévation de la coque centrale, laissant la lumière s'engouffrer par de grandes verrières. Cet espace intrigant et unique a été conçu en 1953 par l'architecte cubain Max Borges Recio., qui a réutilisé l'idée de son projet pour le cabaret «Tropicana», primé deux ans plus tôt. Ses deux chefs-d'œuvre sont d'une grande clarté formelle, leurs lignes simples et fluides épousant la lumière naturelle. Le recours original aux voûtes en béton armé permet de créer des espaces capables d'accueillir de grandes foules venues danser ou se détendre dans une ambiance tropicale.

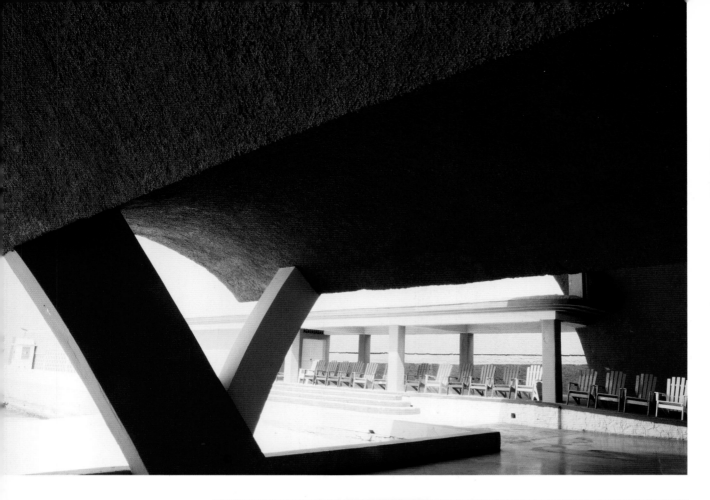

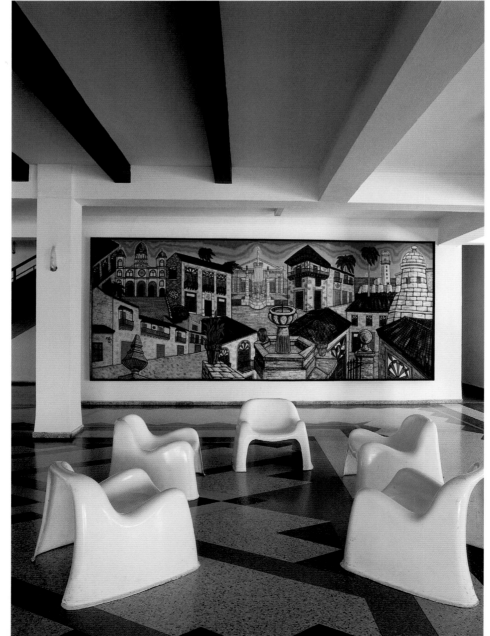

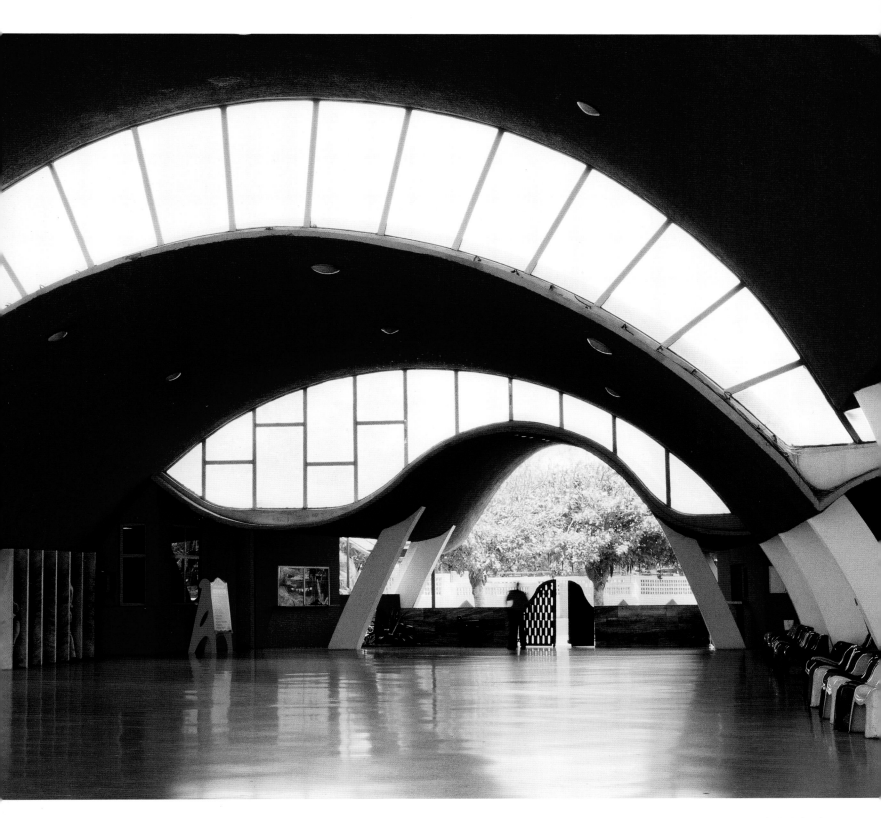

※ **ABOVE LEFT** The enlargement of the "Club Náutico" building, designed in 1953 by the Cuban architect Max Borges Recio who took care to create covered areas near the little beach that would hold a maximum number of people with a minimum number of architectural supports. **LEFT** Fiberglass chairs in one of the salons at the Club Náutico. The background mural depicts several colonial architectural monuments in Old Havana. **ABOVE** The sensual curves of the vast roof allude to the movement of the waves in the sea. **FOLLOWING DOUBLEPAGE** The interior space is open and transparent, with an interesting play of light, shadow and reflection. ※ **OBEN LINKS** Der Anbau des Gebäudes, in dem sich der »Club Náutico« befindet, wurde 1953 von dem kubanischen Architekten Max Borges Recio entworfen und beinhaltete große überdachte Bereiche in der Nähe des kleinen Strands, um mit wenigen Mitteln eine große Personenzahl aufnehmen zu können. **LINKS** Glasfaserstühle in einem der Aufenthaltsräume des »Club Náutico«. Das Wandbild im Hintergrund zeigt verschiedene Kolonialbauten des Viertels »Habana Vieja«. **OBEN** Die sinnlichen Kurven des großen Dachs sind eine Anspielung auf die Wellen des Meers. **FOLGENDE DOPPELSEITE** Der Innenraum ist offen und transparent und bietet ein interessantes Spiel von Lichtern, Schatten und Spiegelungen. ※ **PAGE DE GAUCHE, EN HAUT** L'extension du club nautique, construite en 1953 par l'architecte cubain Max Borges Recio inclut des zones couvertes proches de la petite plage et capables d'accueillir un grand nombre de personnes avec le minimum de moyens. **A GAUCHE** Des sièges en fibres de verre dans un des salons du club. La fresque du fond représente divers monuments coloniaux de la Vieille Havane. **CI-DESSUS** Les courbes sensuelles du grand toit évoquent le mouvement des vagues. **DOUBLE PAGE SUIVANTE** L'espace intérieur est ouvert et transparent, avec un intéressant jeu de lumières, d'ombres et de reflets.

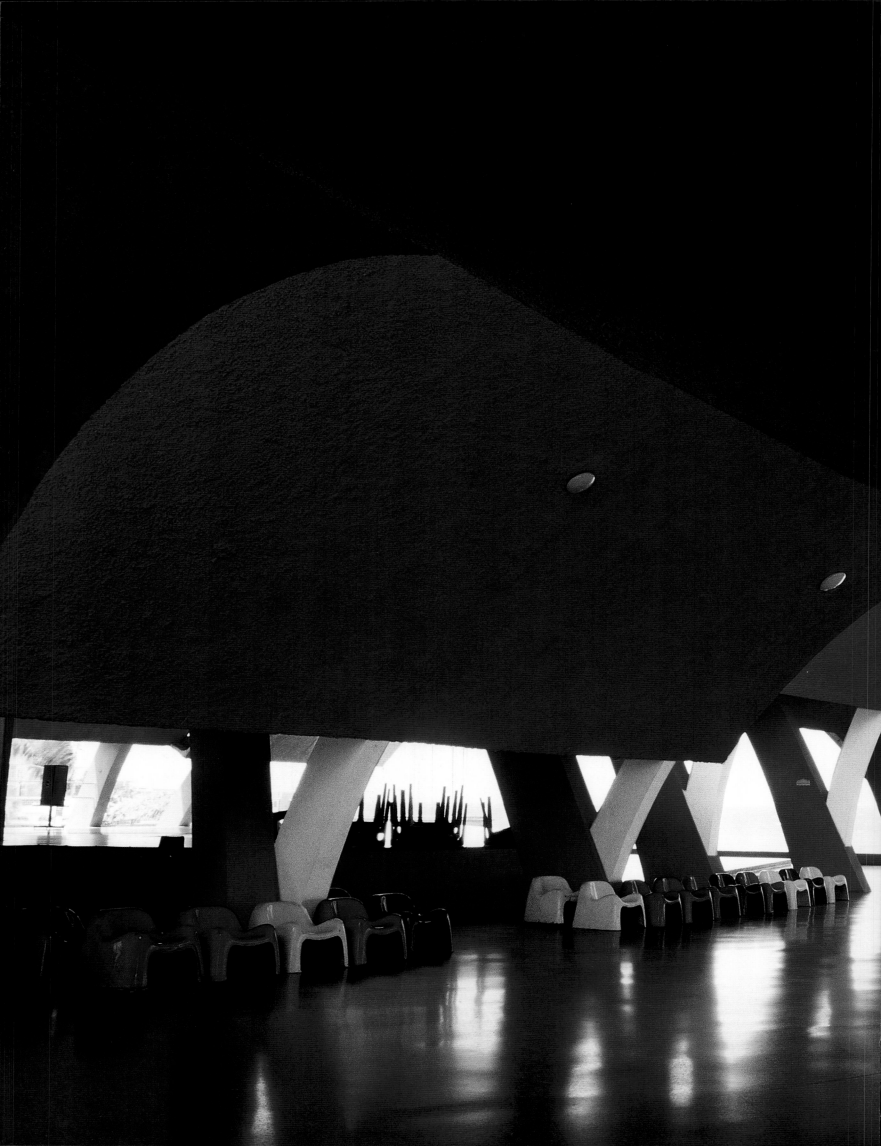

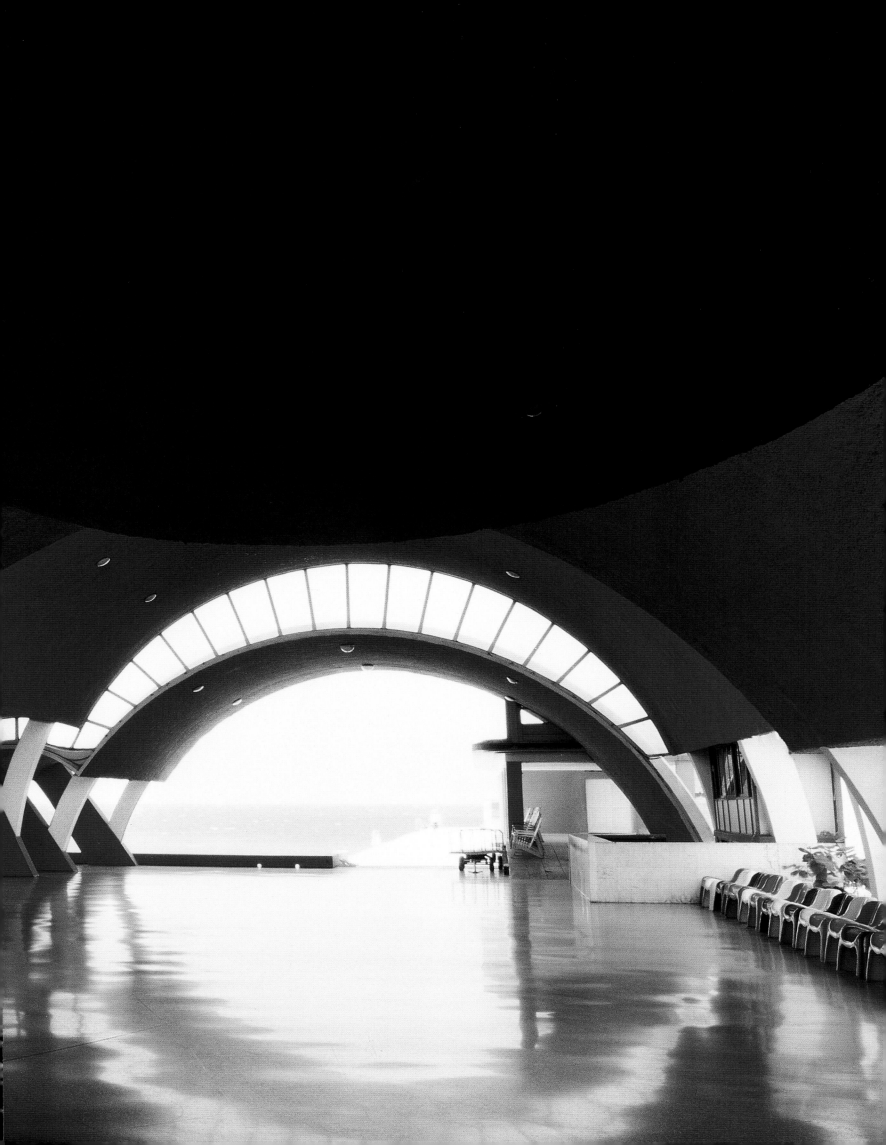

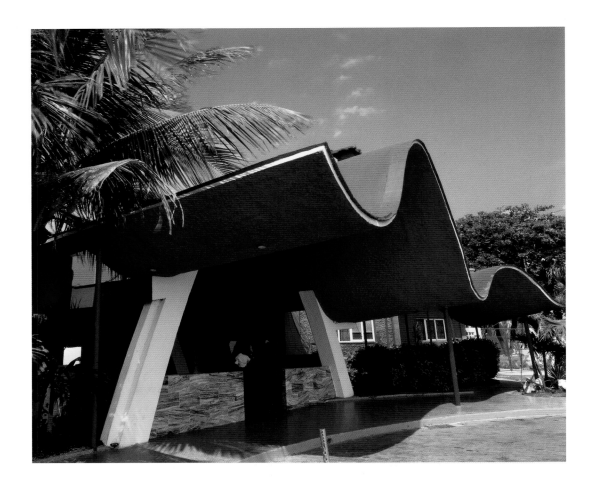

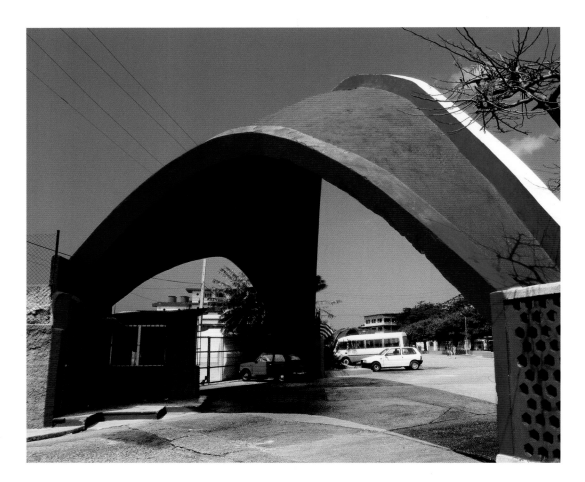

※ **TOP** The overhang of the undulating roof serves as an entrance marquee to the "Club Náutico" from both the street and the beach, where the building resembles a large crustacean. **BELOW** The reinforced concrete vaults are characteristic of the enlargement undertaken by the architect Borges, in contrast to the rectilinear lines of the pre-existing building, although attempts were made to integrate both parts through the use of color. **FOLLOWING DOUBLEPAGE** The attractive marine landscape invades the premises of the "Club Náutico": a symphony of blues begins with the immensity of the sea and extends throughout the building. ※ **OBEN** Die Auskragung des Wellendachs dient als Vordach des Eingang zum »Club Náutico« – sowohl an der Straße als auch am Sandstrand, von wo das Gebäude wie ein großes Krustentier wirkt. **UNTEN** Die Gewölbe aus Stahlbeton kennzeichnen den Ausbau durch den Architekten Borges. Dieser bildet einen Kontrast zur geradlinigen Gestaltung des bestehenden ursprünglichen Gebäudes, wenngleich mit der Farbgebung eine harmonische Verbindung beider

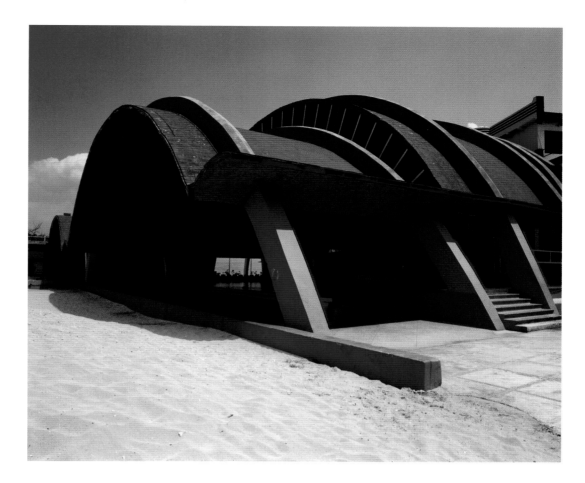

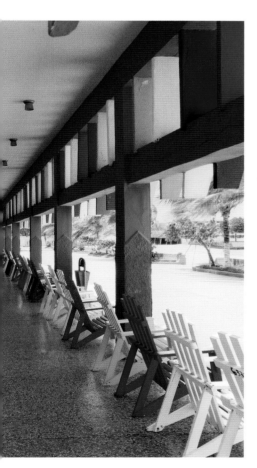

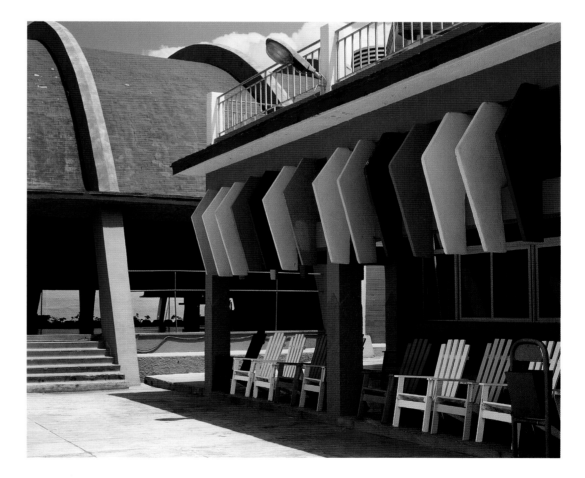

Elemente angestrebt wurde. **FOLGENDE DOPPELSEITE** Die reizvolle Wasserlandschaft verschmilzt mit der Architektur des »Club Náutico«: Eine Symphonie von Blautönen beginnt in der Weite des Meeres und wird mit dem Gebäude fortgesetzt. ※ **EN HAUT** La corniche ondoyante du toit forme un auvent au-dessus de l'entrée, tant côté rue que côté plage, donnant à la structure l'allure d'un grand crustacé. **EN BAS** Les voûtes en béton armé de l'extension réalisée par Borges contrastent avec les lignes droites du bâtiment initial, même si, dans les deux cas, on a tenté d'harmoniser l'ensemble à l'aide des couleurs. **DOUBLE PAGE SUIVANTE** Le beau paysage marin s'immisce jusque dans le club nautique. La symphonie de bleus commence avec l'immensité de la mer et se prolonge dans l'édifice.

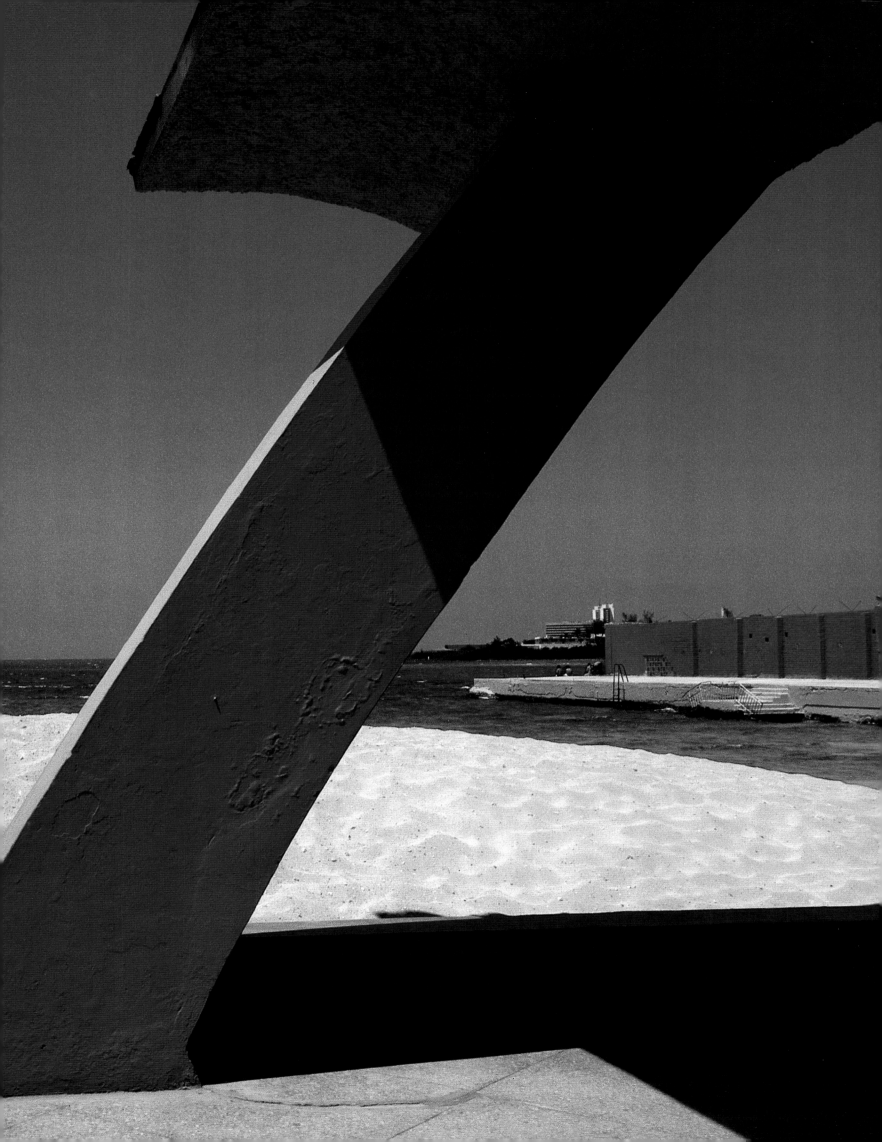

※ **TOP AND BOTTOM** The wooden beach chairs are lined up along the narrow wharf and in two rows at the game areas in order to enjoy the views of the sea. ※ **OBEN UND UNTEN** Die bunten hölzernen Strandstühle stehen aufgereiht entlang einer schmalen Mole und der Flure in den Spielbereichen, damit der Besucher den Meerblick genießen kann. ※ **EN HAUT ET EN BAS** Des fauteuils de plage en bois alignés le long d'un quai étroit et dans les allées de l'aire de jeux pour mieux profiter de la vue sur la mer.

※ **FOLLOWING DOUBLEPAGE** The fascinating interior atmosphere of the building benefits from the light and color of the natural setting which was assimilated by elevating the ceiling vaults.
※ **FOLGENDE DOPPELSEITE** Das faszinierende Ambiente im Innern des Gebäudes nutzt das Licht und die Farben der umliegenden Naturlandschaft, die dank der Höhenverschiebung der Gewölbe eingefangen werden. ※ **DOUBLE PAGE SUIANTE** La fascinante atmosphère à l'intérieur du bâtiment, où la lumière et les couleurs du milieu naturel se confondent avec l'exhaussement des voûtes du plafond.

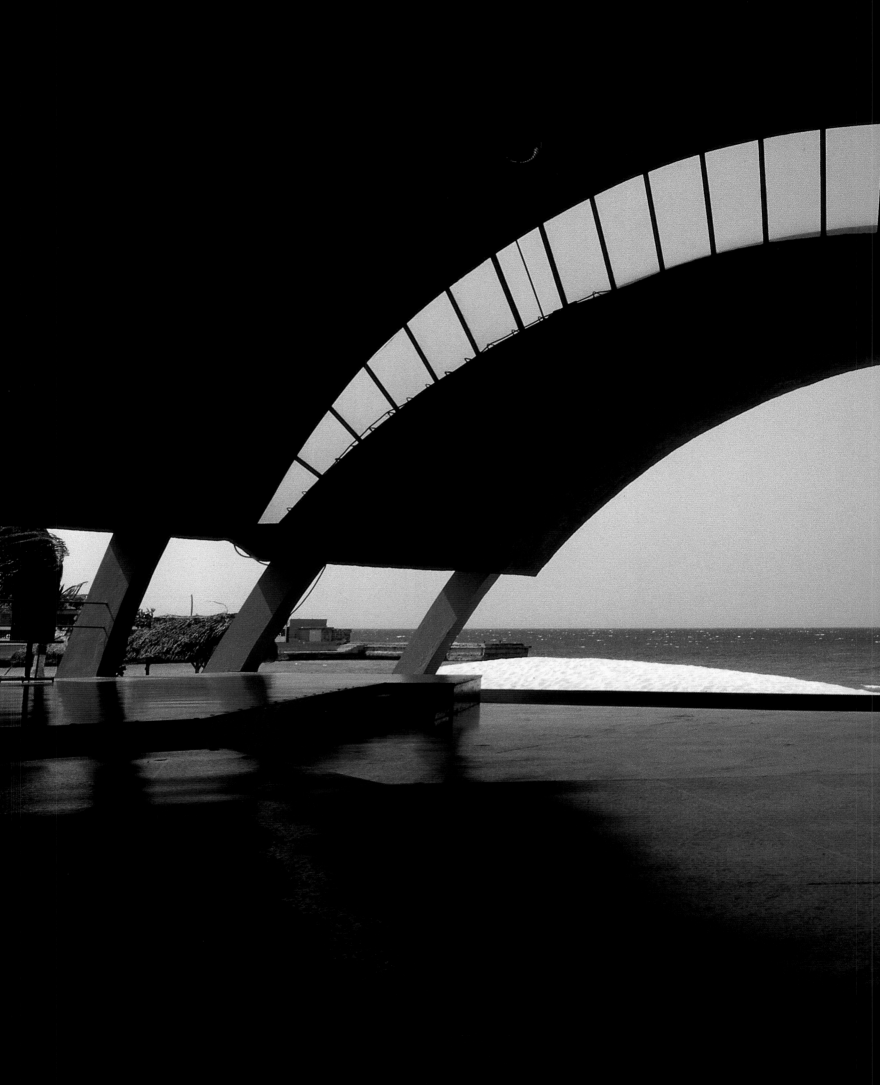

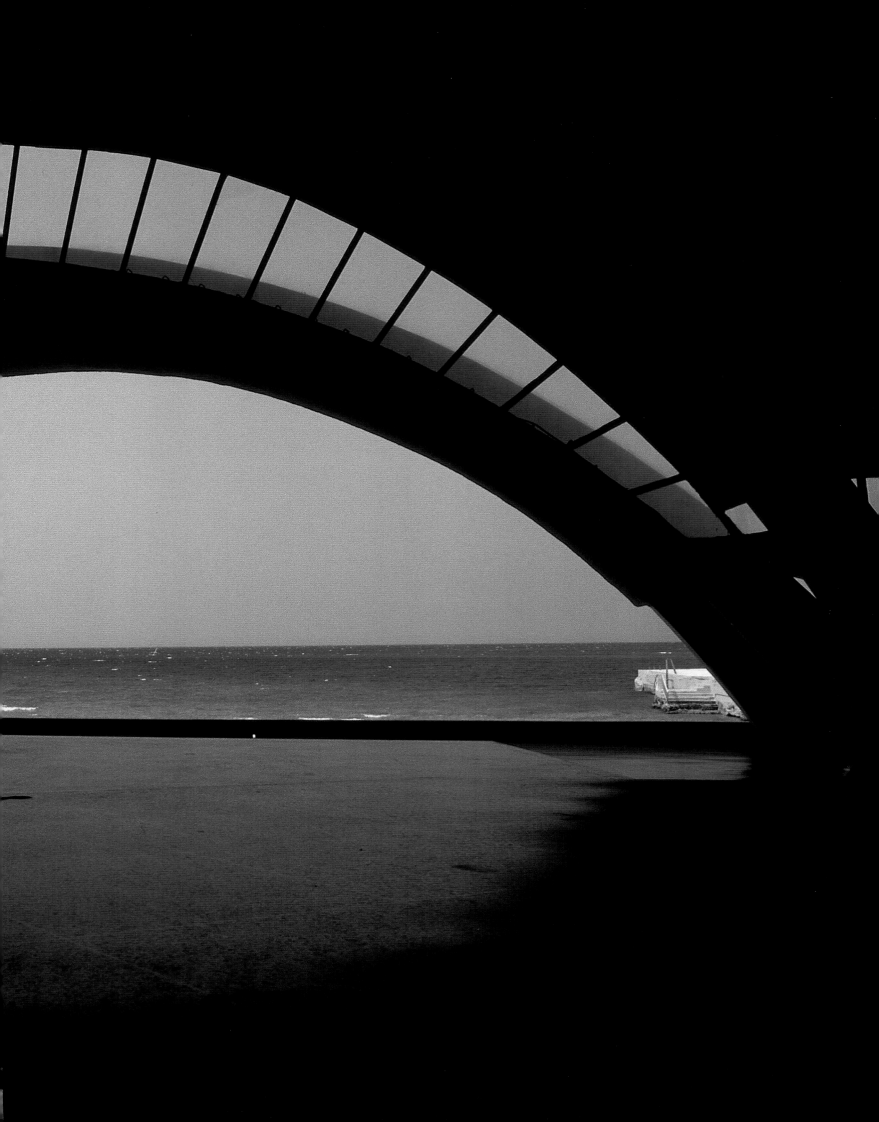

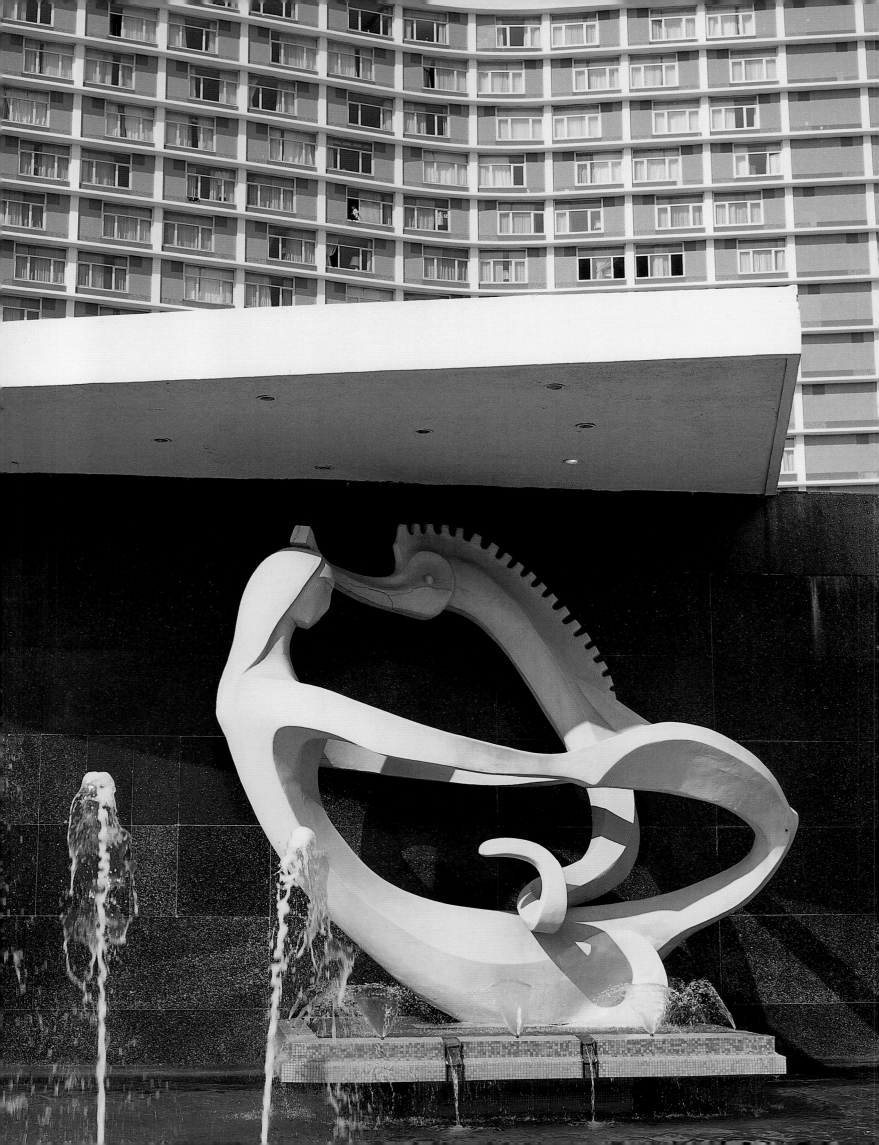

Hotel Habana Riviera

The Empire of the Mafia in Cuba.

The history of the "Hotel Habana Riviera" is intertwined with the presence of the US mafia in Cuba. Mobster Meyer Lansky – sometimes seen driving his cream-color Chevrolet convertible along the Malecón – was in charge of a powerful empire in the glamorous Havana of the 1950s. The first plans for the hotel were drawn up by New York architect Philip Johnson, who traveled from the US to present his design to the developers; the meeting went well until Johnson felt offended by one of the gangster's suggestions to include an overhead mural depicting gambling dice. Johnson withdrew, saying, "Gentlemen, let's not be vulgar." This disagreement with the investors at their first meeting made them hire the Miami firm of Polevitzky, Johnson and Associates, who freely borrowed from Morris Lapidus's "too much is never enough" ideology and spread it throughout the building. They even included an iconic "staircase leading nowhere," which Lapidus used in his Fontainebleau Hotel in Miami Beach. From the time it was built in 1957, the Riviera became one of the symbols of modern architecture in Havana, a landmark in the city thanks to its prominent 20-storey tower, the colorful ceramic-clad dome covering the casino, and its prime corner site close to the ocean.

Die Geschichte des »Hotel Habana Riviera« ist eng mit der der amerikanischen Mafia in Kuba verbunden. Meyer Lansky war der Boss eines mächtigen Mafia-Imperiums, und im eleganten Havanna der 1950er pflegte er mit einem cremefarbenen Chevrolet am Malecón entlang zu fahren. Die ersten Pläne für das Hotel stammten vom New Yorker Architekten Philip Johnson, der aus den USA anreiste, um sie den Bauherrn zu präsentieren. Alles lief gut, bis einer der Gangster vorschlug, ein Wandbild mit einem Spielwürfelmotiv zu gestalten. Johnson zog sich mit den Worten »Gentlemen, seien wir nicht vulgär« aus dem Projekt zurück. Daraufhin wurden die Architekten Polevitzky, Johnson and Associates aus Miami für den Bau des Hotels engagiert, die hemmungslos den Leitspruch »auch zu viel ist nie genug« des exzentrischen Architekten Morris Lapidus, der in den 1950ern den Hotelstil in Miami Beach prägte, im ganzen Gebäude umsetzten. Sie bauten eine Kopie von Lapidus' »Treppenhaus, das nirgends hinführt«, das er für das »Fontainebleau Hotel« in Miami Beach plante. Das »Riviera« wurde seit der Erstellung 1957 zu einem Wahrzeichen der modernen Architektur in Havanna. Das Hotel mit einem zwanzigstöckigen Turm, einem mit Kacheln verkleideten Dom über dem Kasino und der Lage am Ozean ist eine Sehenswürdigkeit geworden.

L'histoire de l'«Hôtel Habana Riviera» est indissociable de celle de la pègre nord-américaine à Cuba. Dans les années 1950, le gangster Meyer Lansky, que l'on voyait parfois remonter le Malecón au volant de sa Chevrolet décapotable beige, était à la tête d'un puissant empire à la Havane. L'architecte new-yorkais Philip Johnson dessina les premiers plans de l'hôtel et vint sur place présenter son projet aux promoteurs. La réunion tourna court quand un des gangsters suggéra de peindre au plafond une fresque représentant des dés. Offensé, Johnson se retira en déclarant : «Messieurs, ne sombrons pas dans la vulgarité.» Les investisseurs firent ensuite appel au cabinet de Miami, Polevitsky, Johnson and Associates, qui adopta la devise de Morris Lapidus «trop n'est jamais assez» et l'appliqua dans tout le bâtiment. Il reprit même l'idée de «l'escalier menant nulle part» que Lapidus, qui a marqué de son empreinte l'architecture hôtelière à Miami au cours des années 1950, avait conçu pour l'hôtel Fontainebleau de Miami. Depuis sa construction en 1957, le Riviera est devenu un des symboles de l'architecture moderne de la Havane, un véritable monument avec sa tour de vingt étages, le dôme en céramiques de son casino et son site privilégié au bord de l'océan.

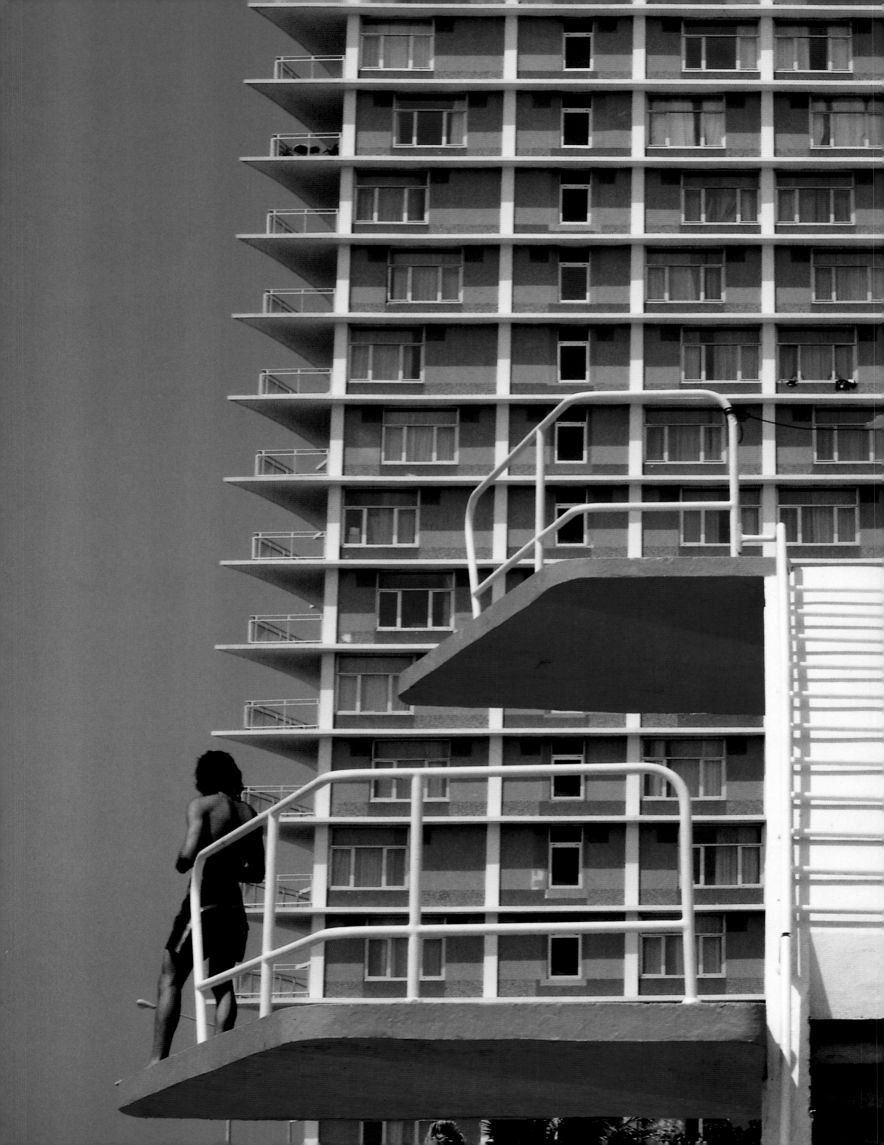

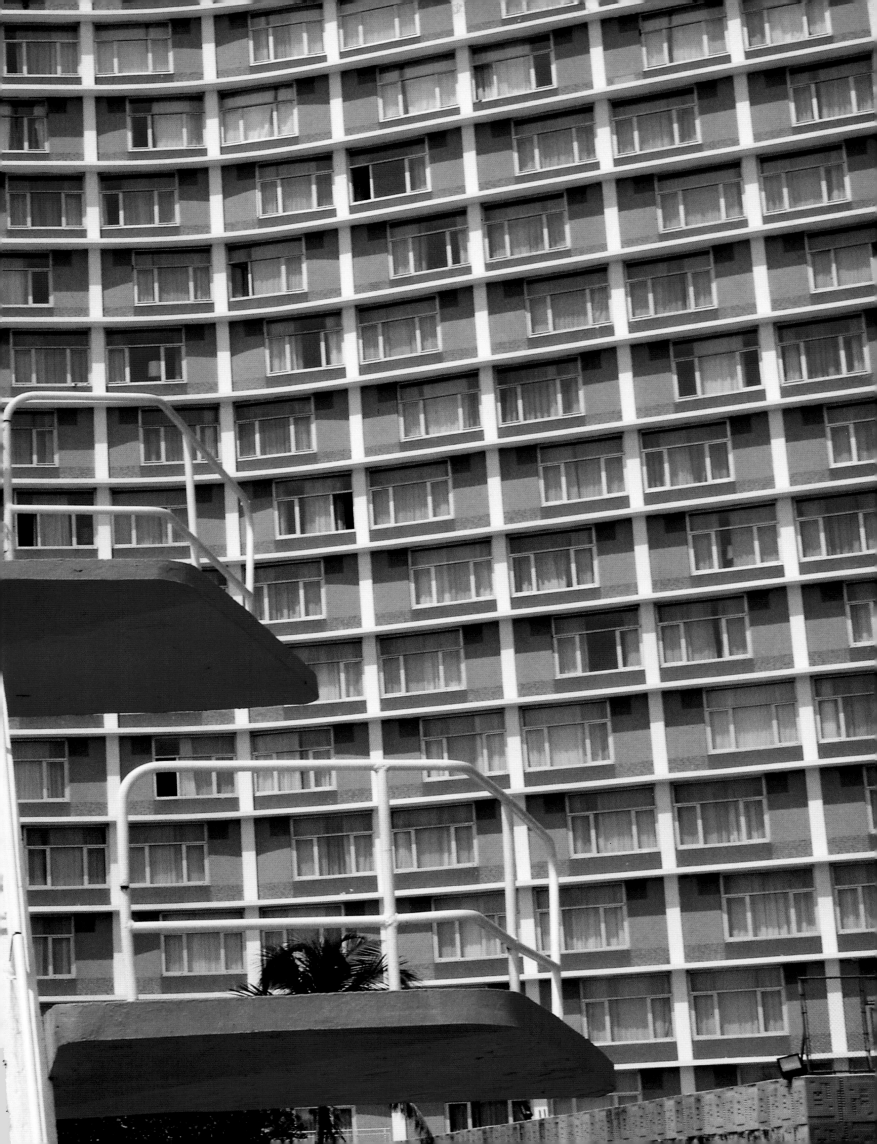

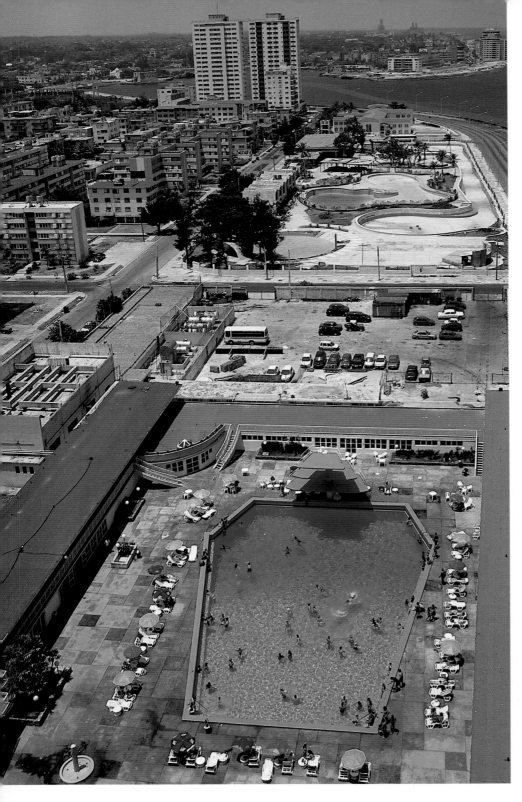

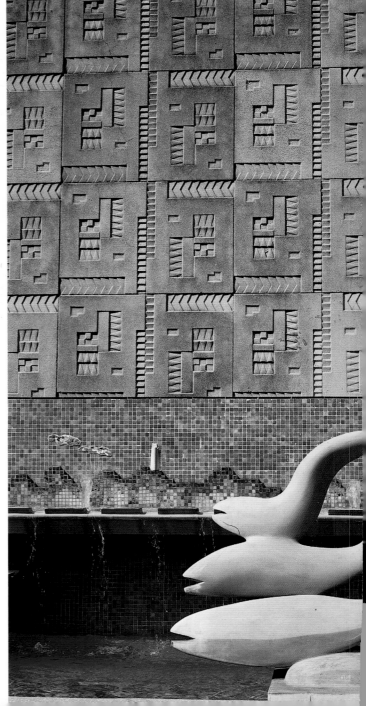

❋ **PREVIOUS DOUBLE PAGE** All 368 rooms at the "Hotel Habana Riviera" have views of the sea thanks to its exceptional city location next to Havana's Malecón. **ABOVE** A great deal of the Cuban capital can be glimpsed from the hotel. **RIGHT** The entrance to the hotel is accentuated by clusters of sculptures and fountains by the Cuban sculptor Florencio Gelabert. The wall's cement slabs are reminiscent of the façades of some of the California houses designed by the U.S. architect Frank Lloyd Wright. **FACING PAGE** The orientation of the hotel's west façade provides views of both the sea and the swimming pool.

❋ **VORHERGEHENDE DOPPELSEITE** Alle 368 Zimmer des »Hotel Habana Riviera« bieten dank des einzigartigen Standorts an Havannas Kai eine Aussicht aufs Meer. **OBEN** Vom Hotel aus überblickt man einen Großteil der kubanischen Hauptstadt. **RECHTS** Der Hoteleingang ist mit Skulpturgruppen und Brunnen des kubanischen Bildhauers Florencio Gelabert versehen. Die Betontfliesen der Mauer erinnern an die der Fassaden einiger kalifornische Bauten des Architekten Frank Lloyd Wright. **RECHTE SEITE** Die Westfassade des Hotels ist so ausgerichtet, dass man von dort einen Blick aufs Meer und auf den Swimmingpool hat.

❋ **DOUBLE PAGE PRECEDENTE** Grâce à l'emplacement exceptionnel de l'hôtel sur le boulevard qui longe la côte, ses 368 chambres ont une vue sur la mer. **CI-DESSUS** L'entrée de l'hôtel, avec un groupe de sculptures et de fontaines du sculpteur cubain Florencio Gelabert. **A DROITE** Les dalles en ciment du mur rappellent celles de certaines façades de maisons californiennes dessinées par l'architecte Frank Lloyd Wright. **PAGE DE DROITE** La façade ouest de l'hôtel est orientée de sorte à avoir une vue sur la mer et la piscine.

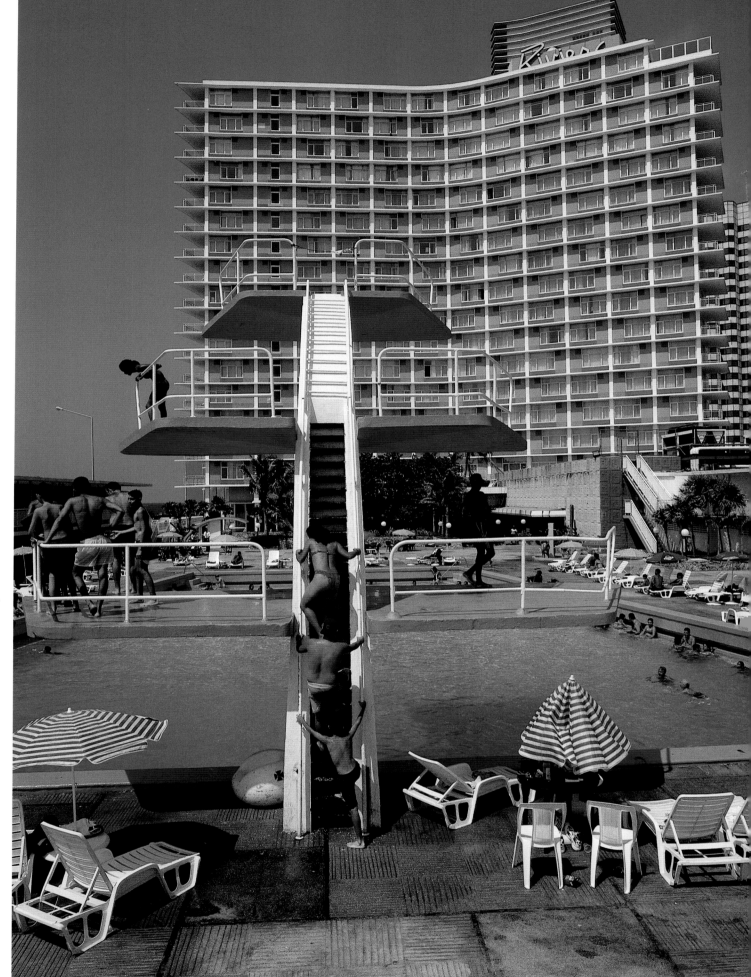

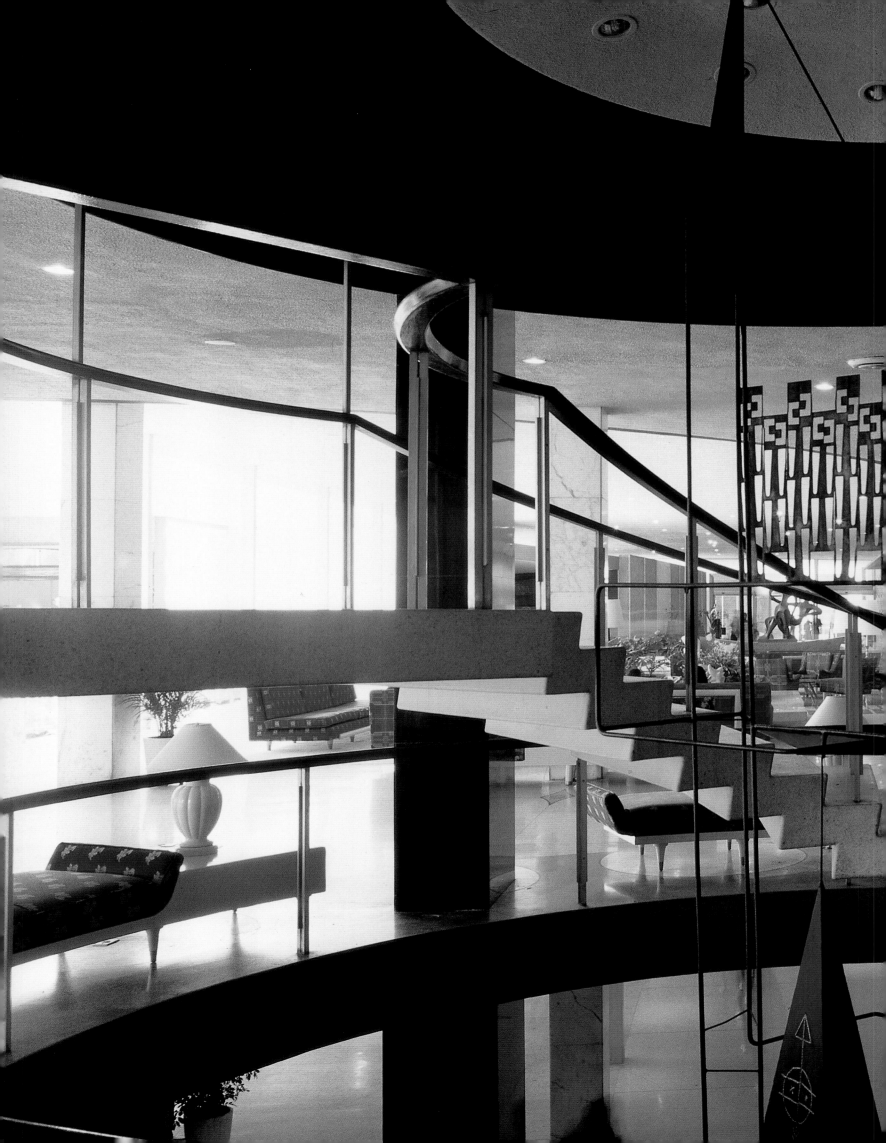

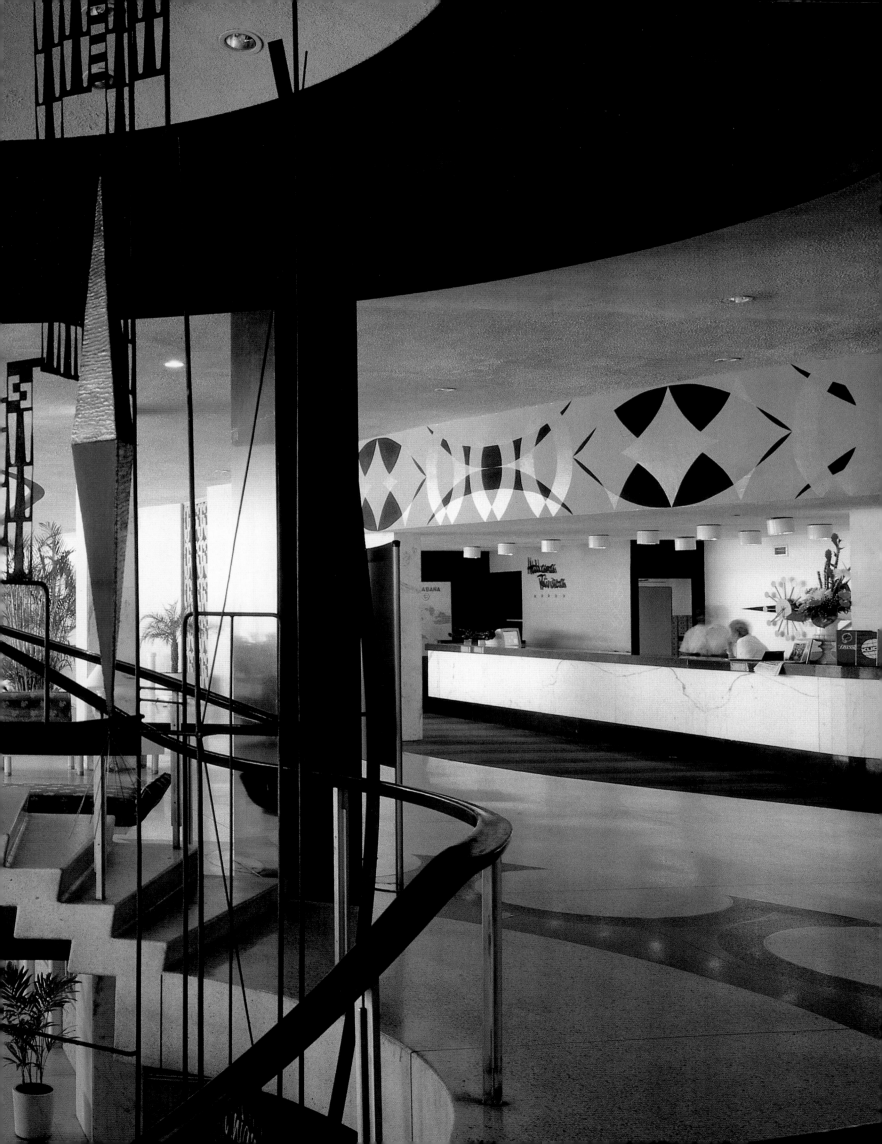

※ **PREVIOUS DOUBLE PAGE** A curious chime called "La Religión del Palo", the work of artist Rolando López Dirube, re-creates features of Cuban religious syncretism and is integrated into the lovely staircase made of solid terrazzo that closes the visual perspective of the elongated lobby. **BELOW** Circulation from both the hotel's entrances converges at the cut-off staircase which only leads to the basement. The design of the lovely marble floor in the vestibule resembles a rug. ※ **VORHERGEHENDE DOPPELSEITE** Eine sonderbares Mobile mit dem Titel »La Religión del Palo«, Werk des Künstlers Rolando López Dirube, zeigt Aspekte des kubanischen religiösen Synkretismus. Sie ist in die schöne Terrazzotreppe integriert, welche die Perspektive des länglichen Vestibüls abrundet. **UNTEN** Die Wege beider Hoteleingänge laufen an einer Stelle zusammen, an der sich die spiralförmige Treppe befindet, über die man aber lediglich in den Keller gelangt. Das Muster des wunderschönen Marmorbodens im Vestibül ähnelt einem Teppich. ※ **DOUBLE PAGE PRECEDENTE** Un étrange mobile baptisé « La Religion du Palo », œuvre de l'artiste cubain Rolando López Dirube qui reprend des aspects du syncrétisme cubain, orne le bel escalier en granit qui ferme la perspective du grand hall. **CI-DESSOUS** Les deux entrées de l'hôtel convergent vers ce hall où se trouve l'escalier spiralé qui ne mène qu'au sous-sol. Les motifs du beau dallage de marbre rappellent un tapis.

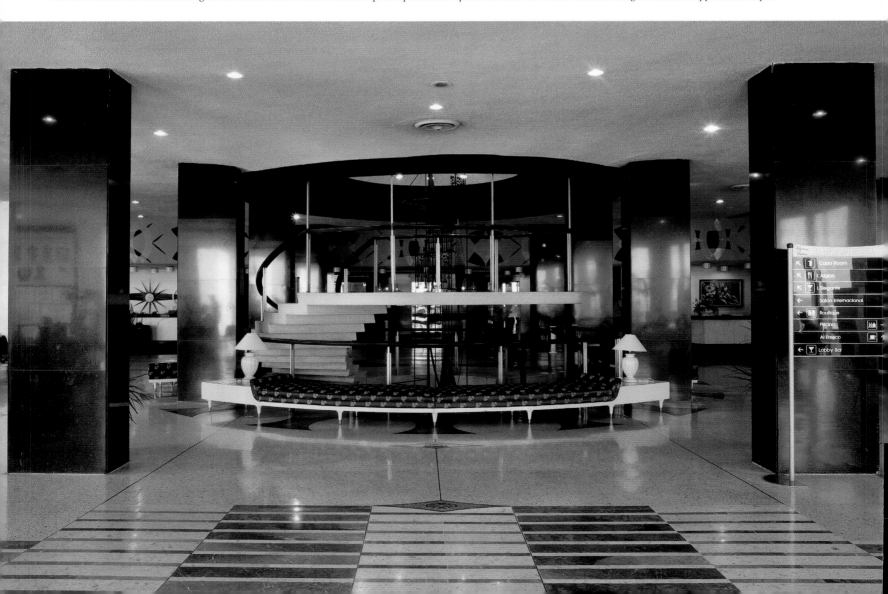

❄ **BELOW** The reception area of the "Hotel Habana Rivier" a has lower ceilings than the rest of the vestibule and is decorated with geometrical motifs. On the back wall, three different clocks display the time in different time zones. **FOLLOWING DOUBLE PAGES** The work entitled "Ritmo Cubano" by Cuban sculptor Florencio Gelabert, wrought in bronze, occupies a pre-eminent place in the decoration of the vestibule of the "Hotel Habana Riviera". * The staircase leading nowhere becomes a sculpture in the vestibule and is part of the spread of kitsch forms derived from the influence of works by U.S. architect Morris Lapidus. * The mural relief at the entrance to the former casino, created by the Cuban artist Rolando López Dirube, portrays mythical religious symbols of the secret society, "Abakuá", founded in Cuba in 1836 by the Black African Carabalis. ❄ **UNTEN** Der Rezeptionsbereich des »Hotel Habana Riviera« besitzt eine niedrigere Decke als das übrige Vestibül und ist mit geometrischen Motiven dekoriert. An der Rückwand zeigen drei verschiedene Uhren die Zeiten unterschiedlicher Längengrade an. **FOLGENDE DOPPELSEITEN** Das aus Bronze gefertigte Werk »Ritmo Cubano« des kubanischen Bildhauers Florencio Gelabert besitzt einen Ehrenplatz in der Lobby des »Hotel Habana Riviera«. * Das »Treppenhaus, das nirgends hinführt«, wirkt wie eine Skulptur im Vestibül und ist Teil der weitverbreiteten Kitsch-Sprache, die dem Einfluss der Architekten Morris Lapidus zuzuschreiben sind. * Das Wandrelief im Eingangsbereich des alten Kasinos stammt von dem kubanischen Künstler Rolando López Dirube und zeigt Symbole der religiösen Riten der Geheimgesellschaft »Abakuá«, die Schwarzafrikaner aus Carabalis 1836 in Kuba gründeten. ❄ **CI-DESSOUS** Le comptoir de réception de l'hôtel se distingue par son plafond plus bas et sa moquette. Cette partie est décorée de motifs géométriques. Sur le mur du fond, trois horloges donnent l'heure sous différentes latitudes. **DOUBLES PAGES SUIVANTES** Rythme cubain, une œuvre en bronze du sculpteur Florencio Gelabert, occupe une place de choix dans le hall de l'hôtel * Dans le hall, l'escalier qui ne mène nulle part devient une sculpture, s'intégrant dans l'ensemble de formes kitsch inspirées de l'œuvre de l'architecte américain Morris Lapidus. * La peinture murale qui orne l'entrée de l'ancien casino, réalisée par l'artiste cubain Rolando López Dirube, représente des symboles propres aux mythes religieux de la société secrète « Abakuá », fondée par les Africains des Caraïbes à Cuba en 1836.

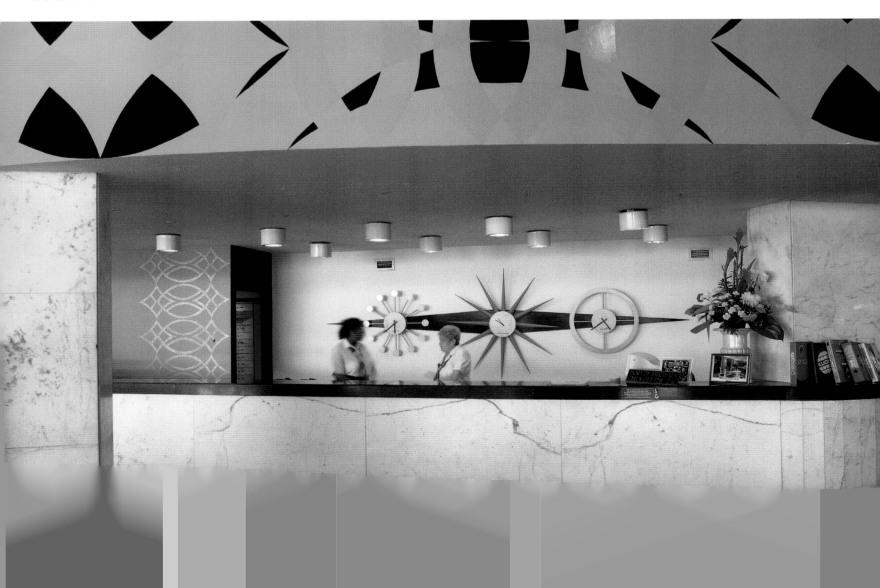

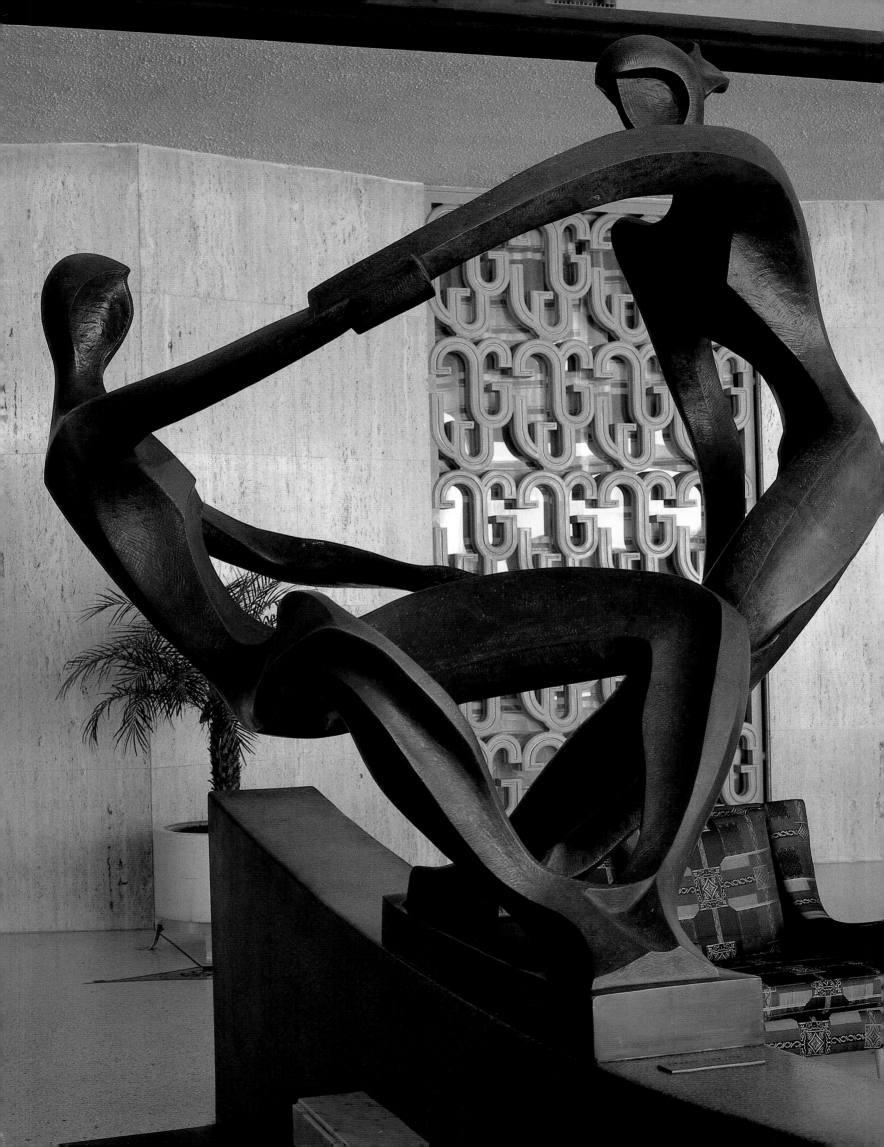

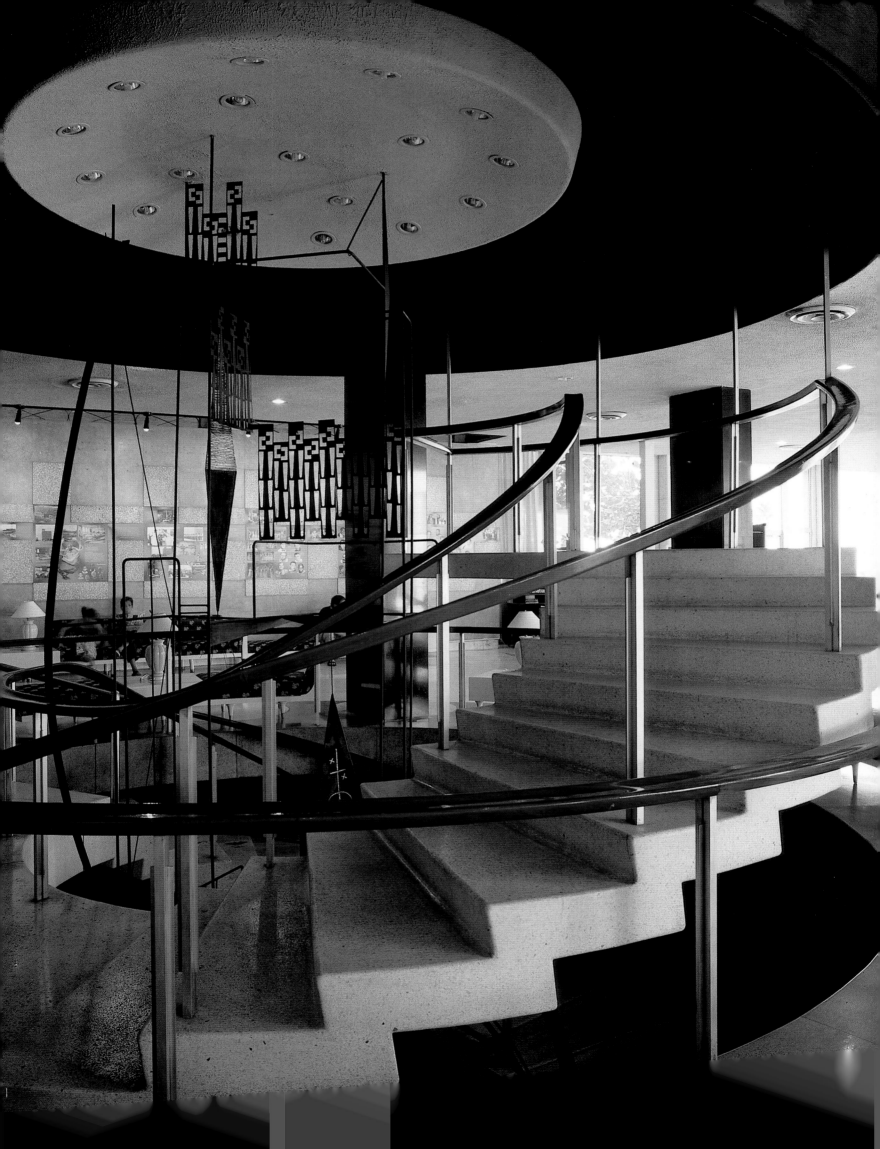

❋ **ABOVE** The walls of the swimming pool's café are decorated with marine motifs. **FACING PAGE** The "L'Aiglon" restaurant conserves the original design of its lamps, furnishings and mural decorations. The Spanish artist Hipólito Hidalgo de Caviedes blends scenes from Spanish theater with others from Cuban Mardi Gras in the mural on the back wall.
❋ **OBEN** Die Wanddekoration im Schwimmbadcafé besteht aus bunten Meeresmotiven. **RECHTS** Im Restaurant »L'Aiglon« sind die ursprünglichen Lampen, Möbel und Wanddekoration erhalten geblieben. In dem Wandgemälde kombinierte der spanische Künstler Hipólito Hidalgo de Caviedes Szenen des spanischen Theaters mit anderen des kubanischen Karnevals. ❋ **CI-DESSUS** Les peintures murales de la cafétéria de la piscine sont basées sur des thèmes marins. **PAGE DE DROITE** Le restaurant « L'Aiglon » conserve ses lampes, son mobilier et ses décorations murales d'origine. Sur la fresque du fond, l'artiste espagnol Hipólito Hidalgo de Caviedes a marié le théâtre espagnol et le carnaval cubain.

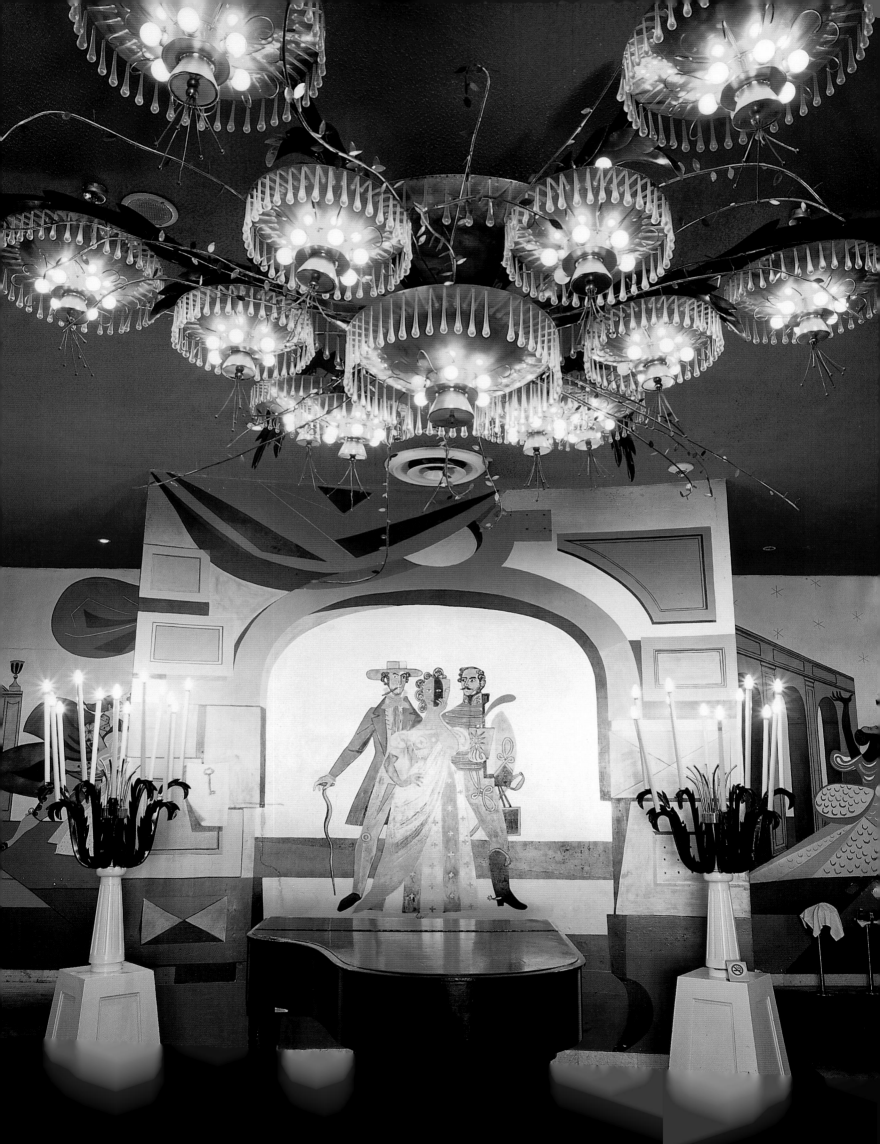

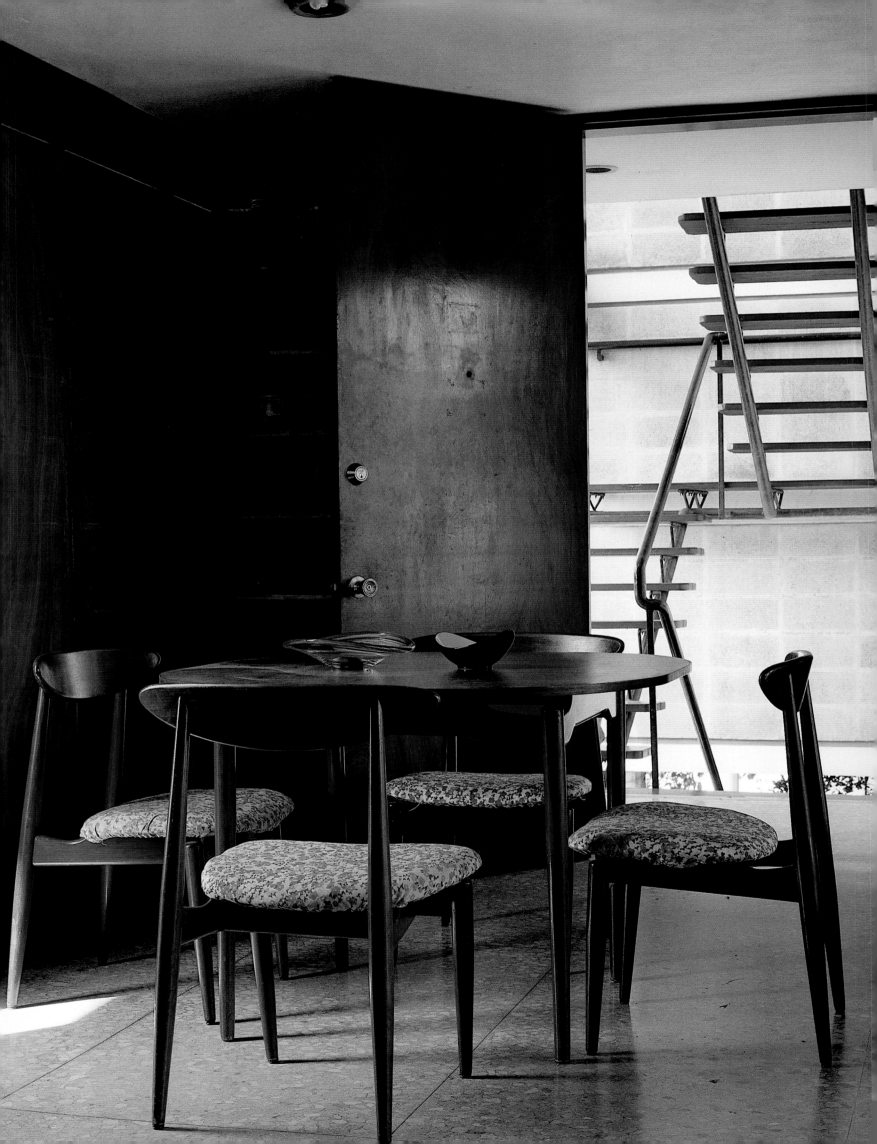

Pérez Farfante

The Three Ps.

Patios, porticoes and "persiennes" are the three major features of Cuba's architectural legacy, and the most suitable means of dealing with its tropical climate and idiosyncratic, extroverted way of life. In the 1950s these elements were creatively reinterpreted by Cuban architects. Frank Martínez achieved a synthesis between the international avant garde and Cuban tradition in creating an original, contemporary architectural language: his design for the Pérez Farfante family in Nuevo Vedado in 1955 successfully combined Corbusian syntax with traditional Cuban architecture. The clever layout separates the prismatic structure on stilts into two separate housing blocks by means of a central soaring space. The open ground floor becomes an extended porch set upon a clifftop. The floor-to-ceiling carpentry, which includes both louvers and panes of glass, reasserts the lines of the windows, which provide cross-ventilation as well as natural light. The two apartments are identical, with terrazzo floors, exposed concrete blocks and wood paneling to display works of art by contemporary Cuban artists such as Amelia Peláez. Martinez's approach to segregating the living spaces from the bedrooms by using traditional features shows that form *can* follow function, and it can also reaffirm cultural identity.

Die wichtigsten Merkmale der tradtionellen kubanischen Architektur sind die Innenhöfe, Säulengänge und Jalousien. Sie passen zum tropischen Klima und extrovertierten Lebenstil der Kubaner. In den 1950ern interpretieren Architekten diese Elemente neu. Frank Martínez' Synthese zwischen internationaler Avant-garde und kubanischer Tradition brachte eine originelle, zeitgemäße Architektursprache hervor. Sein Entwurf für das Haus der Familie Pérez Farfante in Nuevo Vedado von 1955 ist eine gelungene Synthese zwischen der Formensprache Le Corbusiers und traditioneller kubanischer Architektur. Das prismatische Gebäude steht auf Stelzen und wird von einem hohen Raum in der Mitte in zwei verschiedene Wohnblöcke getrennt. Das offene Erdgeschoss erweitert sich zu einer Veranda, die auf einem Felsen liegt. Deckenhohe Holzverkleidungen, Fensterwände mit integrierten Lamellenjalousien verleihen den Räumen Struktur. Beide Wohnblöcke sind identisch: Böden aus Terrazzo, Wände aus unbehandelten Betonblöcken und Holzpaneelen mit Kunstwerken zeitgenössischer kubanischer Künstler wie Amelia Peláez. Martinez' Werk zeigt, dass Form der Funktion folgen kann, ohne damit die kulturelle Identität zu verleugnen.

Patios, portiques et persiennes sont les trois grandes caractéristiques des vieilles maisons cubaines, étant parfaitement adaptées à son climat tropical et à son style de vie extraverti. Dans les années 50, ces éléments ont été réinterprétés par des architectes cubains. Frank Martínez a synthétisé l'avant-garde internationale et la tradition cubaine en créant un langage original et contemporain : la demeure qu'il a conçue pour les Pérez Farfante à Nuevo Vedado en 1955 marie avec succès la syntaxe le-corbusienne et l'architecture cubaine traditionnelle. Son plan ingénieux divise la structure sur pilotis en deux corps de bâtiments à l'aide d'un puits central. La charpenterie s'étend du sol au plafond, les persiennes et les baies vitrées soulignant la ligne de fenêtres tout en laissant passer l'air et la lumière naturelle. Les deux appartements jumeaux ont des sols en mosaïque, des murs de béton brut et des boiseries où sont accrochées des œuvres d'artistes cubain contemporains tels qu'Amelia Peláez. La séparation des espaces de séjour des chambres à coucher à l'aide d'éléments traditionnels prouve que la forme peut épouser la fonction tout en réaffirmant l'identité culturelle.

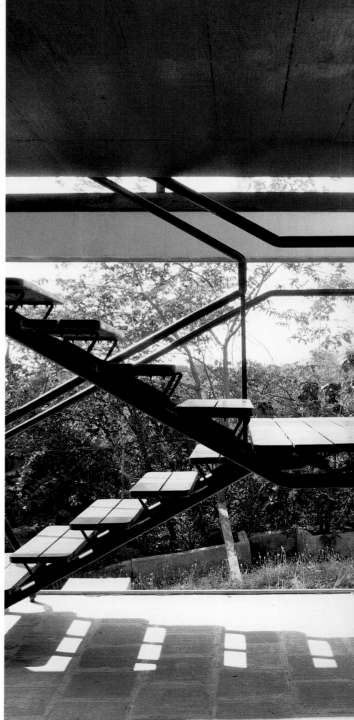

※ **ABOVE** A central space, which evokes the courtyard found in traditional architecture, functionally, spatially and volumetrically separates the bedroom block from the other one containing the living and dining rooms. The building is supported on stilts, following Corbusian postulates. **RIGHT AND FACING PAGE** The simple, minimalist conception of the tubular steel staircase with wooden steps, suspended from the mezzanine level, reinforces the building's transparency while leaving views of the landscape unhampered.

※ **OBEN** Ein zentraler Raum, der an den Innenhof der traditionellen Architektur erinnert, trennt den Schlafzimmerblock funktional, räumlich und volumetrisch von dem Bereich mit Wohn- und Esszimmer. Das Gebäude steht – den Postulaten des Architekten Le Corbusiers folgend – auf Stelzen. **RECHTS UND RECHTE SEITE** Das minimalistische Konzept der im Zwischengeschoss befestigten Treppe aus Stahlrohr und Holzstufen verstärkt die Transparenz des Gebäudes und gibt den Blick auf die Landschaft frei. ※ **CI-DESSUS** Un espace central évoquant le patio traditionnel sépare le bloc des chambres à coucher de celui du séjour et de la salle à manger. L'édifice repose sur des pilotis suivant les principes de Le Corbusier. **A DROITE ET PAGE DE DROITE** La conception simple et minimaliste de l'escalier tubulaire en acier avec des marches en bois, partant de l'entresol, renforce la transparence du bâtiment sans couper la vue sur le paysage.

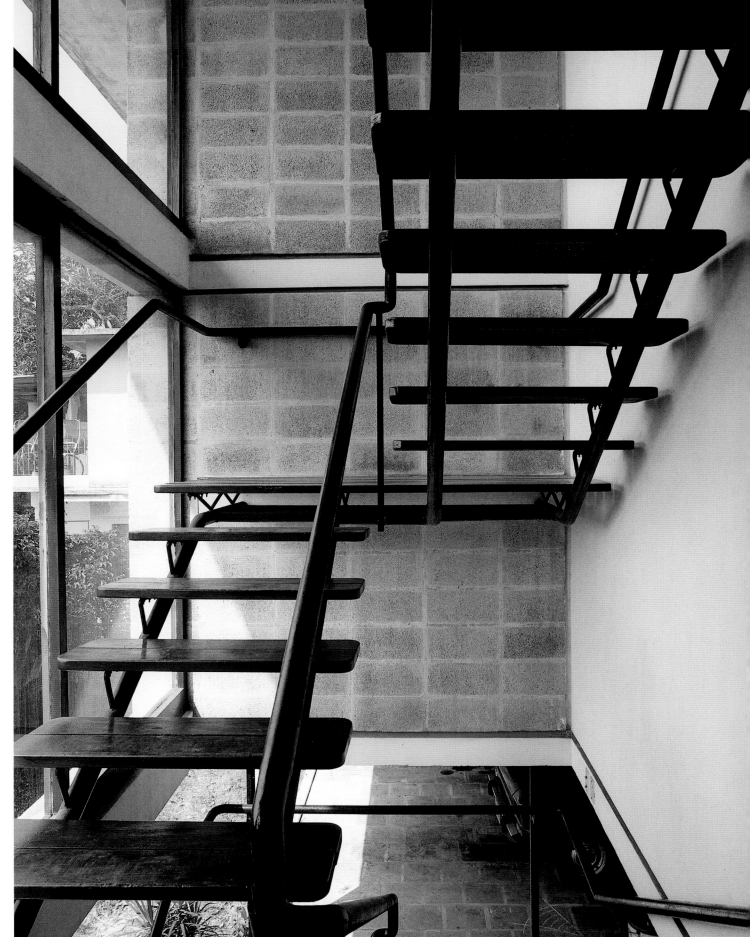

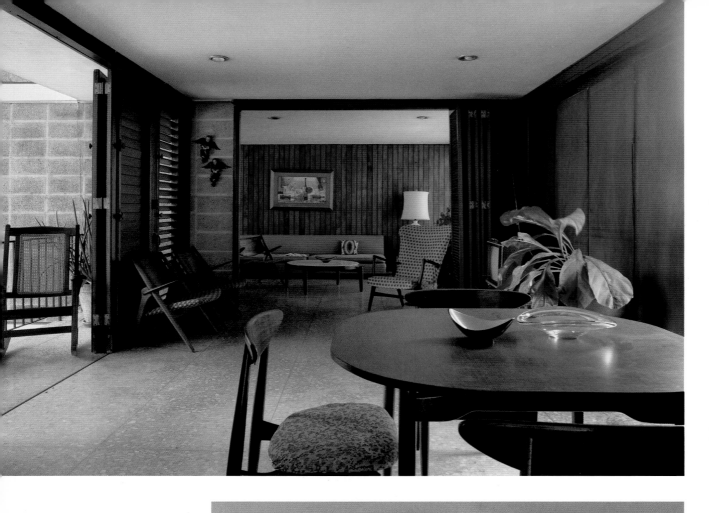

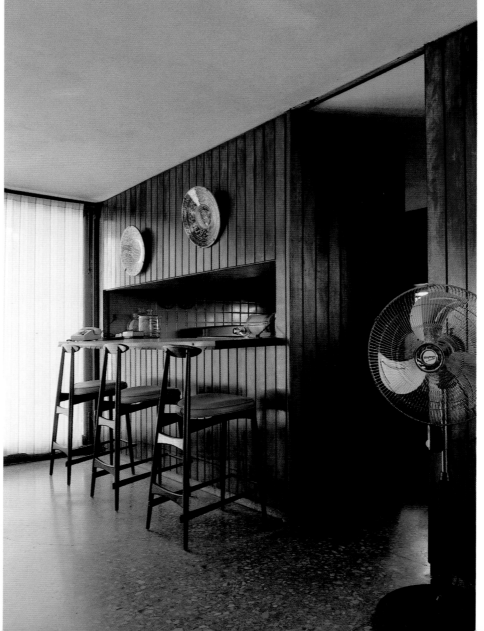

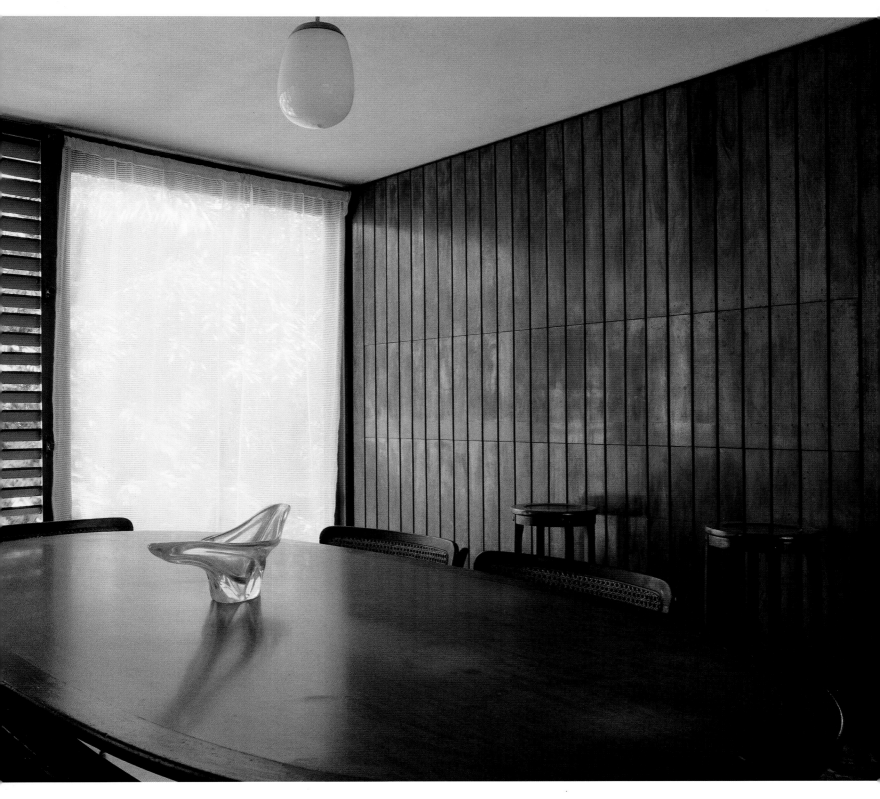

✳ **LEFT AND ABOVE** The spatial fluidity and integration of the different spaces, which may be opened and closed at will, are some of the most outstanding features of the modern concept of what a building should be. ✳ **LINKE SEITE UND OBEN** Der Raumfluss und das Ineinanderübergehen unterschiedlicher Wohnbereiche, die ganz nach Belieben geöffnet oder abgetrennt werden können, sind einige der herausragenden Eigenschaften dieses modernen Gebäudekonzepts. ✳ **PAGE DE GAUCHE ET CI-DESSUS** La fluidité spatiale et l'intégration des différents espaces qui peuvent s'ouvrir et se fermer à volonté font partie des caractéristiques les plus frappantes de cette architecture moderne.

FACING PAGE The study is illuminated by the large floor-to-ceiling windows. **RIGHT** One of the terraces with a gallery-type ceiling over the central entrance space that divides the building's two functional blocks. **BELOW** The living room and dining room areas are integrated into a single space near the kitchen. ❋ **LINKE SEITE** Das Arbeitszimmer der Appartements erhält sein Licht durch die großen Fenster, die sich vom Boden bis zur Decke erstrecken. **RECHTS** Eine der überdachten, galerieähnlichen Terrassen über dem zentralen Eingangsbereich, der die Funktionsblöcke des Gebäude unterteilt. **UNTEN** Wohn- und Esszimmer gehen ineinander über und befinden sich in der Nähe der Küche. ❋ **PAGE DE GAUCHE** Le bureau, éclairé par de grandes fenêtres qui vont du sol au plafond. **A DROITE** Une des terrasses couvertes telle une galerie au-dessus de l'entrée centrale qui divise les blocs fonctionnels du bâtiment. **CI-DESSOUS** Le séjour et la salle à manger sont intégrés dans un même espace jouxtant la cuisine.

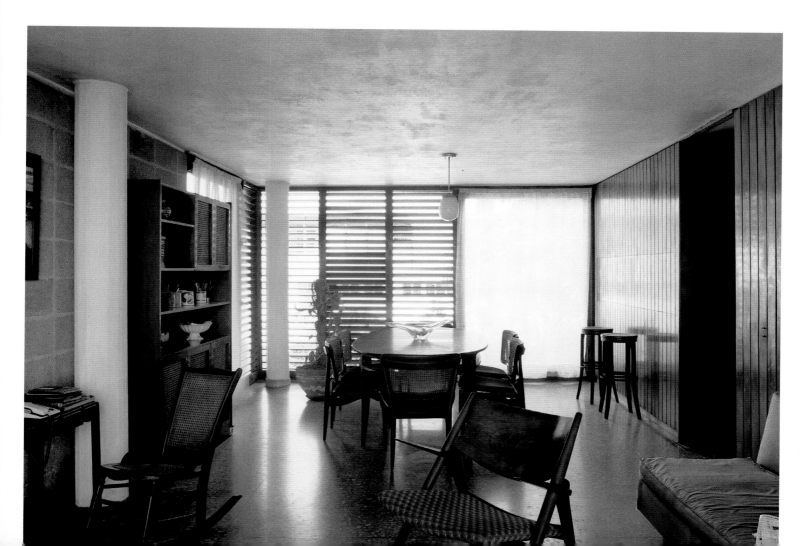

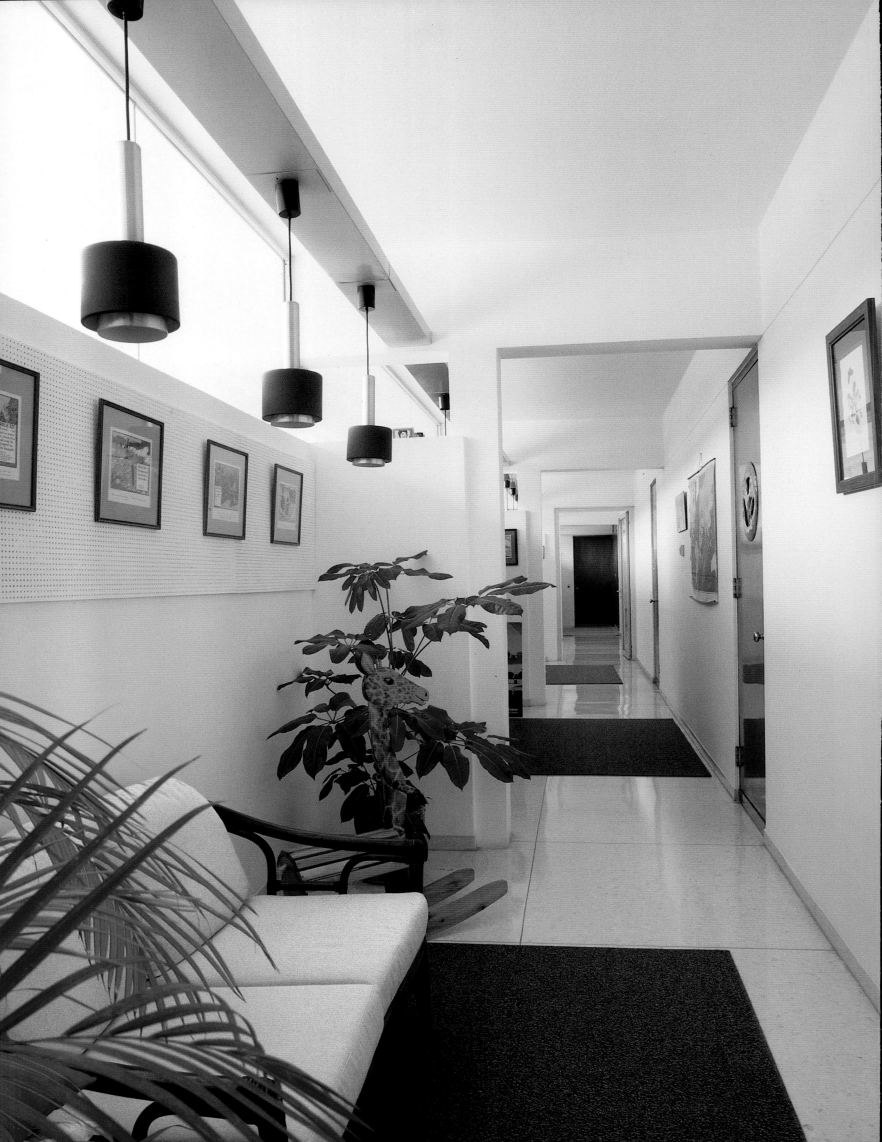

CASA DE SCHULTHESS

A Richard Neutra House in the Tropics.

When young architect Richard Neutra wrote in his diary in 1919 that he wished he could get to an idyllic tropical island, he hardly imagined that 35 years later he would design an award-winning house in Cuba for Swiss banker Alfred de Schulthess. Located on a huge site in the most exclusive suburb of the city, the house is today the residence of the Swiss Ambassador and is one of the best modern houses to have been built in Havana. It is a straight-edged, C-shaped house in a park-like setting, with steps down to a garden designed by Brazilian landscape designer Roberto Burle Marx. A pool mirrors the magical deep blue sky. The elongated two-storey block contains living spaces that open onto terraces sheltered by porches, which emphasize the horizontal aspect of the building and visually connect the interior with the exterior. The most spectacular feature is the home's interior, which confirms Neutra's mastery of light and space. The ground floor is a single spacious hall with extensive glass surfaces that convey a complete sense of openness and transparency. The varying ceiling heights, textures from different materials, and the hanging staircase that connects both levels give an extraordinary spatial richness to this great example of modern architecture.

Er war ein junger Architekt, als Richard Neutra 1919 in sein Tagebuch schrieb, er wünschte sich, auf eine tropische, idyllische Insel reisen zu können. Damals konnte er noch nicht ahnen, dass er 35 Jahre später in Kuba ein Haus für den Schweizer Bankier Alfred de Schulthess bauen würde. Die heutige Residenz des Schweizer Botschafters liegt auf einem riesigen Gelände im nobelsten Vorstadtviertel und ist eines der schönsten modernen Häuser, das in Havanna je gebaut wurden. Das Haus in der parkähnlichen Anlage hat die Form eines eckigen »C«, und ein paar Stufen führen hinunter in den Garten, der vom brasilianischen Landschaftsarchitekten Roberto Burle Marx entworfen wurde. Im Pool spiegelt sich das Dunkelblau des Himmels wider. Die Wohnräume des in die Länge gezogenen zweistöckigen Blocks öffnen sich auf Terrassen, die von kragenden Vordächern bedeckt sind. Dadurch verschmelzen Innen und Außen optisch zu einer Einheit. Die Inneneinrichtung zeugt von Neutras meisterhaftem Umgang mit Licht und Raum. Das Erdgeschoss besteht aus einem einzigen, offenen Raum mit großflächigen Fensterwänden. Verschieden hohe Decken, eine Vielfalt an Materialien und die hängende Treppe, die beide Stockwerke untereinander verbindet, verleihen diesem preisgekrönten modernen Haus räumliche Fülle.

Quand, en 1919, le jeune architecte Richard Neutra écrivit dans son journal qu'il rêvait d'une île tropicale idyllique il n'imaginait pas que, 35 ans plus tard, il serait primé pour sa villa construite à Cuba pour le banquier suisse Alfred de Schulthess. Située dans une banlieue sélecte de la ville, la résidence de l'ambassadeur suisse est l'une des plus belles maisons modernes de la Havane. Tout en lignes droites, la structure en U se dresse au milieu d'un parc et quelques marches mènent au jardin dessiné par le paysagiste brésilien Roberto Burle Marx. Une piscine reflète le ciel d'un bleu magique. Le corps de bâtiment d'un étage comporte des espaces de séjour s'ouvrant sur des terrasses protégées d'auvents en console, ce qui renforce l'horizontalité du bâtiment et relie visuellement l'intérieur et l'extérieur. L'intérieur est particulièrement spectaculaire, confirmant la maîtrise de la lumière et de l'espace de Neutra. Le rez-de-chaussée n'est qu'un grand espace dont les nombreuses surfaces en verre donnent une impression d'ouverture et de transparence. Les différentes hauteurs sous plafond, le mélange de matériaux et l'escalier suspendu confèrent une richesse spatiale extraordinaire à ce superbe exemple d'architecture moderne.

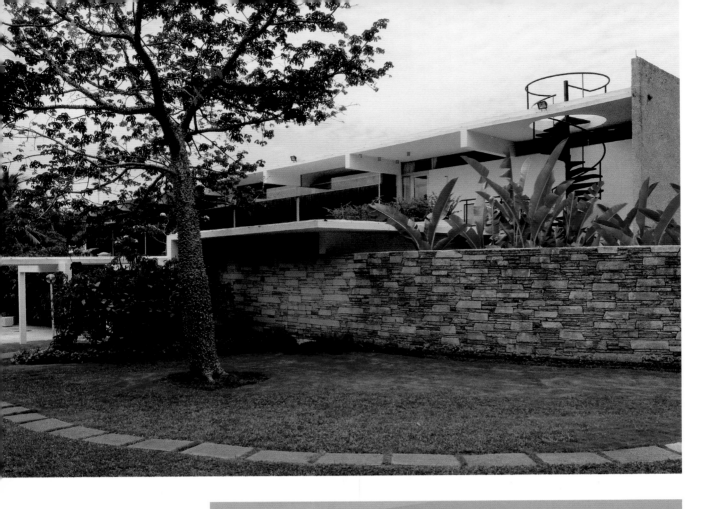

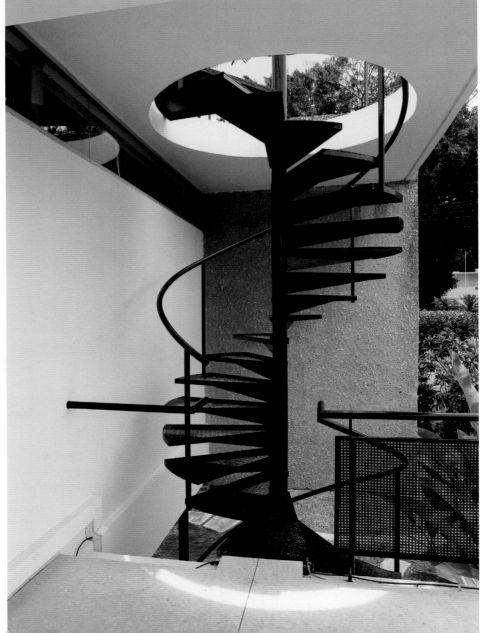

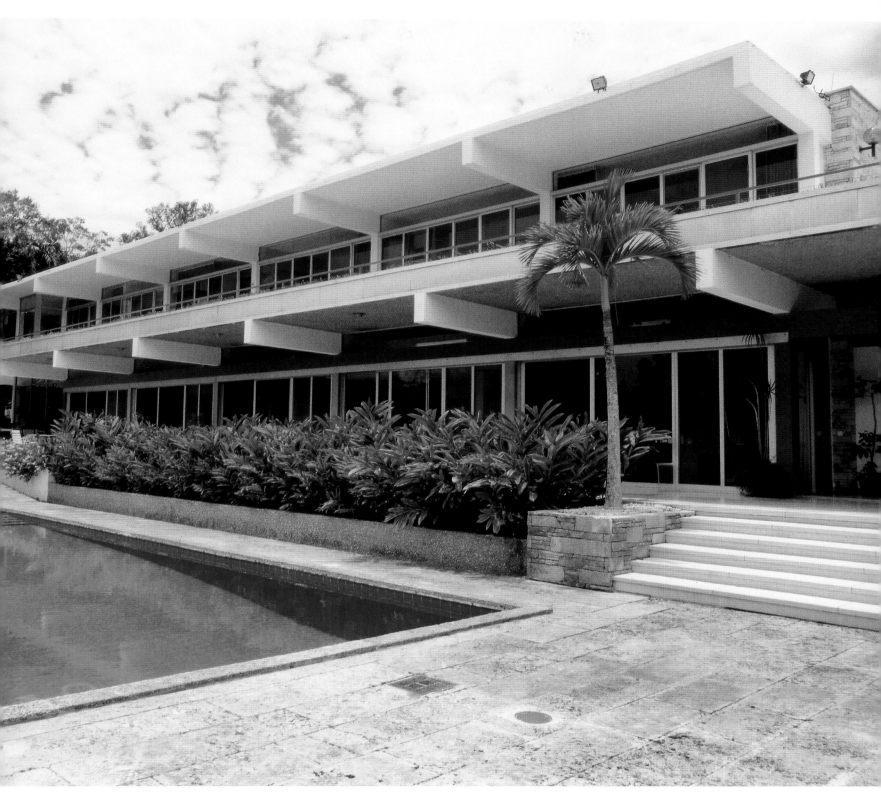

❋ **ABOVE LEFT** The well-tended garden at the entrance to the house, designed by the Brazilian landscape architect Roberto Burle Marx, encroaches into the guest area, protected by a curved stone wall. **LEFT** The curved lines of the metallic spiral staircase leading to the roof terrace contrasts with the building's straight lines. **ABOVE** View of the spacious terraces at the de Schulthess residence, Gold Medal winner from the National Architects' Association in 1958. **FOLLOWING DOUBLE PAGE** The main façade, made up of terraces with floor-to-ceiling glass walls, is oriented toward the house's gardens, the pond and the swimming pool. The geometrical flower beds contrast with the sinuousness of the general lines of the gardens.

❋ **OBEN LINKS** Der vom brasilianischen Landschaftsarchitekten Roberto Burle Marx entworfene Garten im Eingangsbereich dringt bis zum Gästebereich vor, der durch eine gekrümmte Steinmauer geschützt ist. **LINKS** Die metallene Wendeltreppe führt zur Sonnen- und Dachterrasse und bildet einen Kontrast zur Geradlinigkeit des Gebäudes. **OBEN** Die ausgedehnten Terrassen des Wohnhauses von de Schulthess, das im Jahr 1958 die Goldmedaille der Nationalen Architektenkammer erhielt, spiegeln sich im Swimmingpool des von erlesenen Grünanlagen umgebenen Gebäudes. **FOLGENDE DOPPELSEITE** Die Hauptfassade besteht aus Terrassen mit vom Boden bis zur Decke reichenden Glasfronten, mit Blick auf die Gärten, den Teich und den Swimmingpool. Die geometrischen Blumenbeete stehen im Kontrast zur allgemein bogenförmig gehaltenen Gartenanlage. ❋ **PAGE DE GAUCHE, EN HAUT** Le jardin soigné devant la maison, dessiné par l'architecte paysagiste brésilien Roberto Burle Marx, s'avance dans l'aile des invités, protégée par un mur arrondi. **A GAUCHE** Les courbes de l'escalier métallique en colimaçon qui mène au solarium et à la terrasse sur le toit contrastent avec les lignes droites du bâtiment. **CI-DESSUS** Les vastes terrasses de la résidence de Schulthess, médaille d'or du Collège National des Architectes en 1958, se reflètent dans la piscine entourée de jardins raffinés. **DOUBLE PAGE SUIVANTE** La façade principale, avec ses terrasses et ses baies vitrées du sol au plafond, est orientée vers les jardins, le bassin et la piscine. Les plates-bandes géométriques contrastent avec la sinuosité du tracé général des jardins.

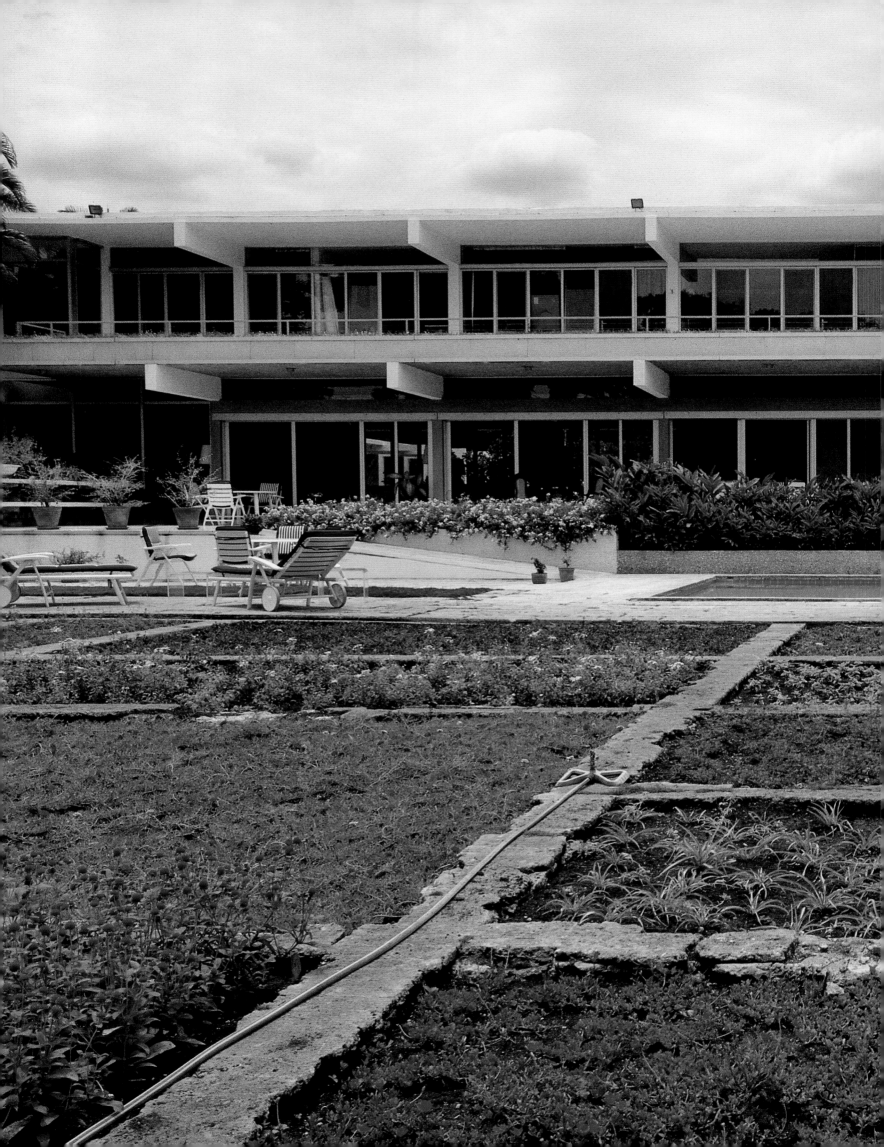

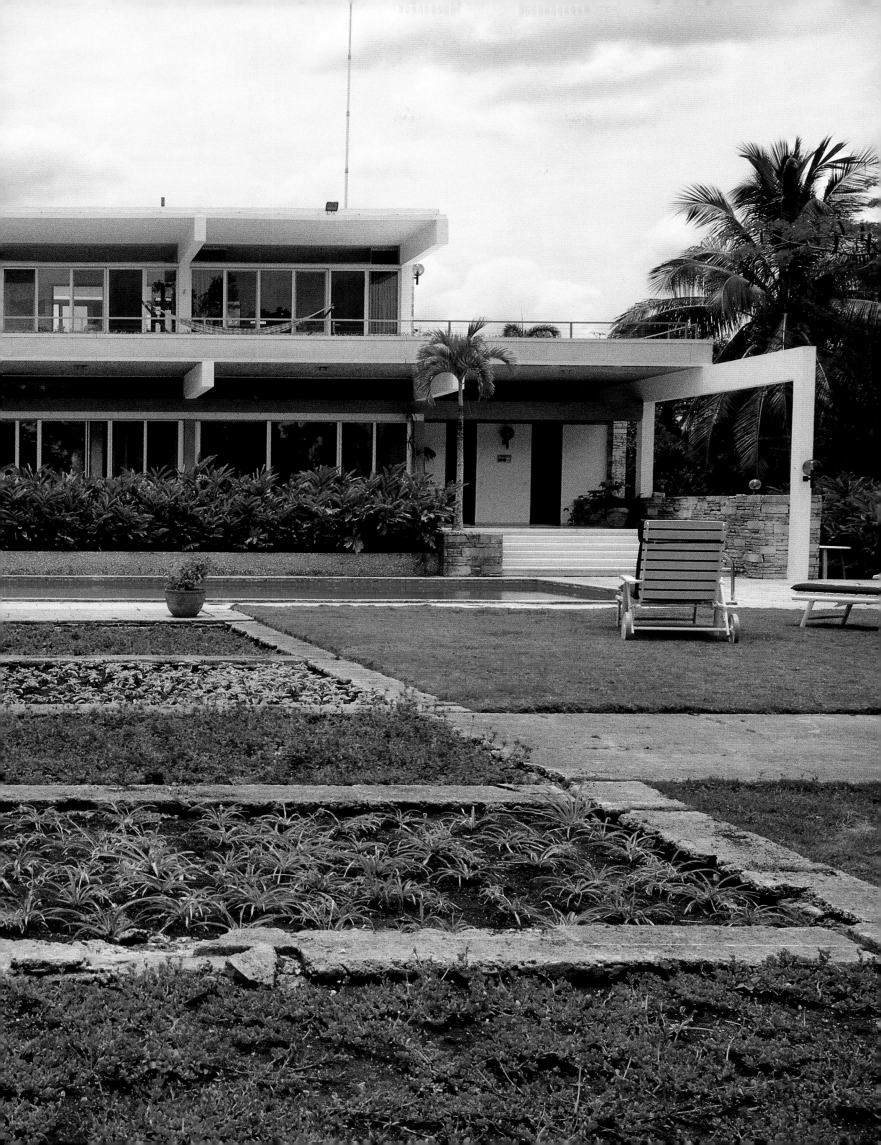

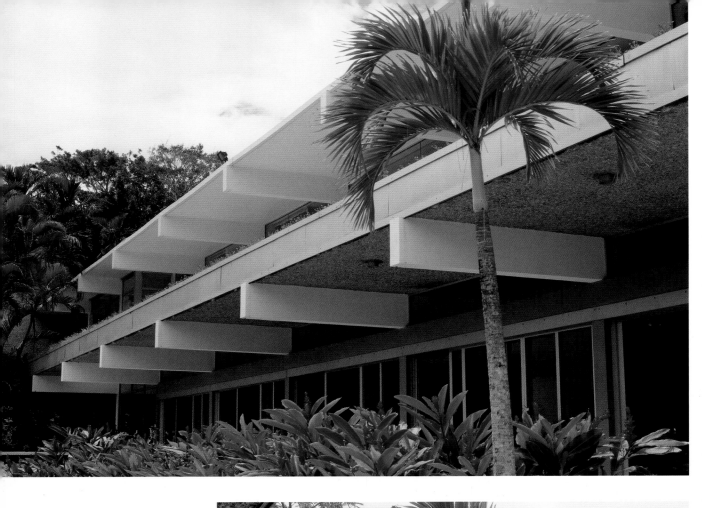

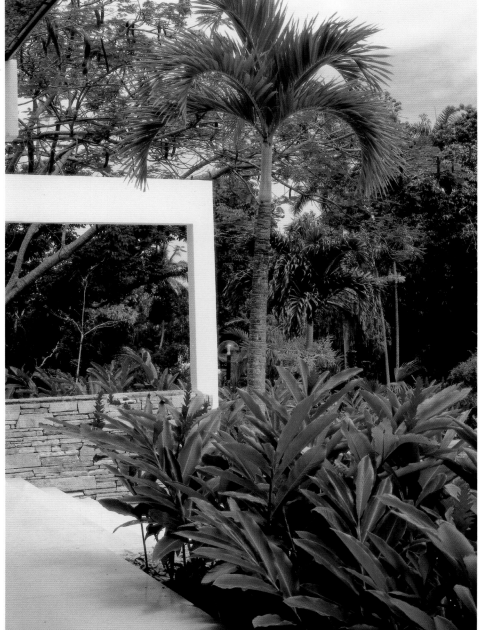

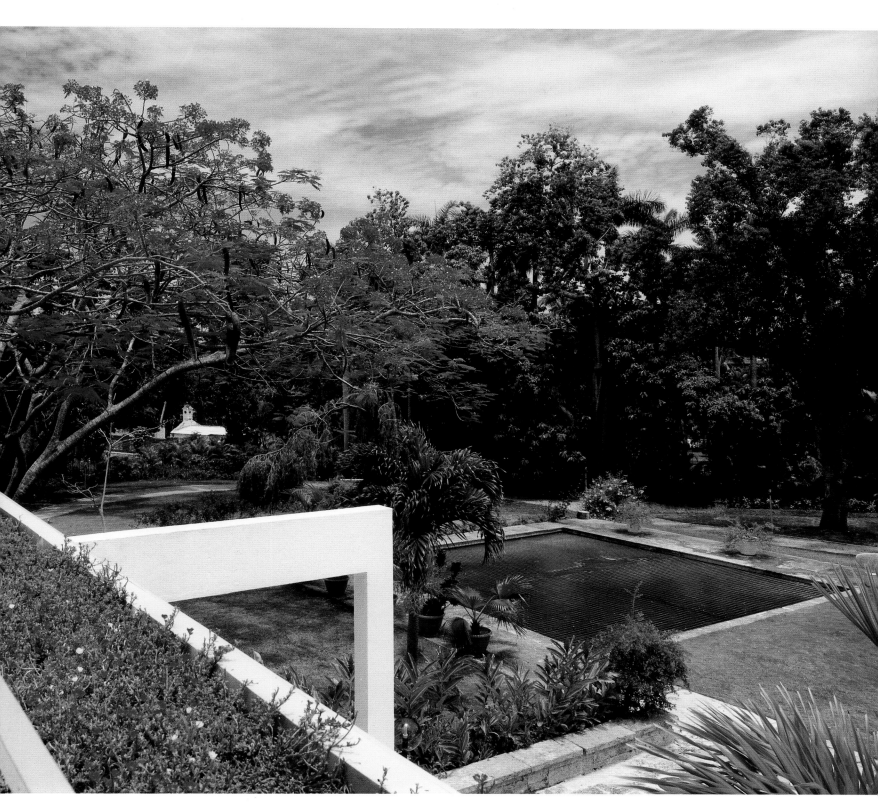

✳ **ABOVE LEFT** The striking horizontal expression of the building is emphasized by the broad eaves with jutting supports. **LEFT** A series of slender, inverted U-shaped porticoes resting directly on the grass hold up the marquee at the entrance to the house. **ABOVE** From the house's rooftop, one has views of the entire property. A black tile pond with a jet in the middle is surrounded by the lush garden designed by the famous Brazilian landscaper, Roberto Burle Marx. **FOLLOWING DOUBLE PAGE** The continuous, fluid and transparent space in the main living room with views of the private garden can be subdivided using sliding wooden panels. The furniture includes "Barcelona" chairs by Mies van der Rohe and a "Wassily" chair by Marcel Breuer. ✳ **OBEN LINKS** Die stark horizontale Gestaltung des Baus wird durch die großen Vordächer, gestützt von auskragenden Trägern, noch verstärkt. **LINKS** Eine Reihe schlanker Portiken in umgekehrter U-Form sind im Rasen verankert und tragen den Sonnenschutz des Hauseingangs. **OBEN** Von der Dachterrasse des Gebäudes aus hat man einen guten Blick über das gesamte Grundstück. Ein mit schwarzen Fliesen ausgekleideter Teich mit zentraler Fontäne liegt umgeben von einem üppigen Garten, der auf den Entwurf des berühmten brasilianischen Landschaftsarchitekten Roberto Burle Marx zurückgeht. **FOLGENDE DOPPELSEITE** Das offen, fließend und transparent gestaltete große Wohnzimmer mit Gartenblick lässt sich anhand von verschiebbaren Holzpaneelen unterteilen. Die Einrichtung beinhaltet Stühle der Modelle »Barcelona« von Mies van der Rohe und »Wassily« von Marcel Breuer. ✳ **PAGE DE GAUCHE, EN HAUT** L'horizontalité de l'édifice est encore accentuée par les vastes balcons soutenus par des solives en saillie. **A GAUCHE** Une série de portiques élancés en U inversé et plantés dans la pelouse soutiennent la marquise de l'entrée. **CI-DESSUS** Depuis le toit, on peut contempler l'ensemble de la propriété. Un bassin en carrelages noirs, avec un jet d'eau au centre, est bordé de l'exubérant jardin dessiné par le célèbre paysagiste brésilien Roberto Burle Marx. **DOUBLE PAGE SUIVANTE** L'espace continu, fluide et transparent du grand salon avec vue sur le jardin privé, peut se subdiviser grâce à des panneaux coulissants en bois. Le mobilier inclut des fauteuils « Barcelona » de Mies van der Rohe et « Wassily » de Marcel Breuer.

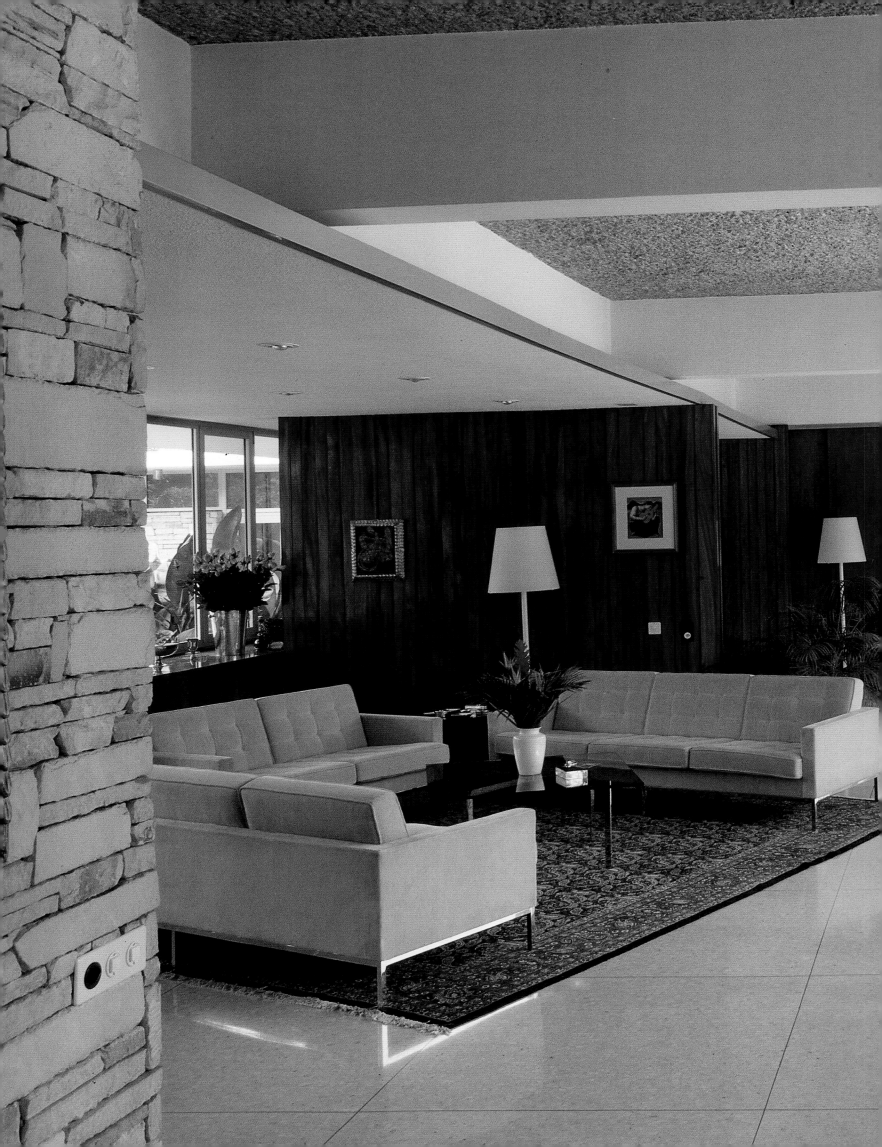

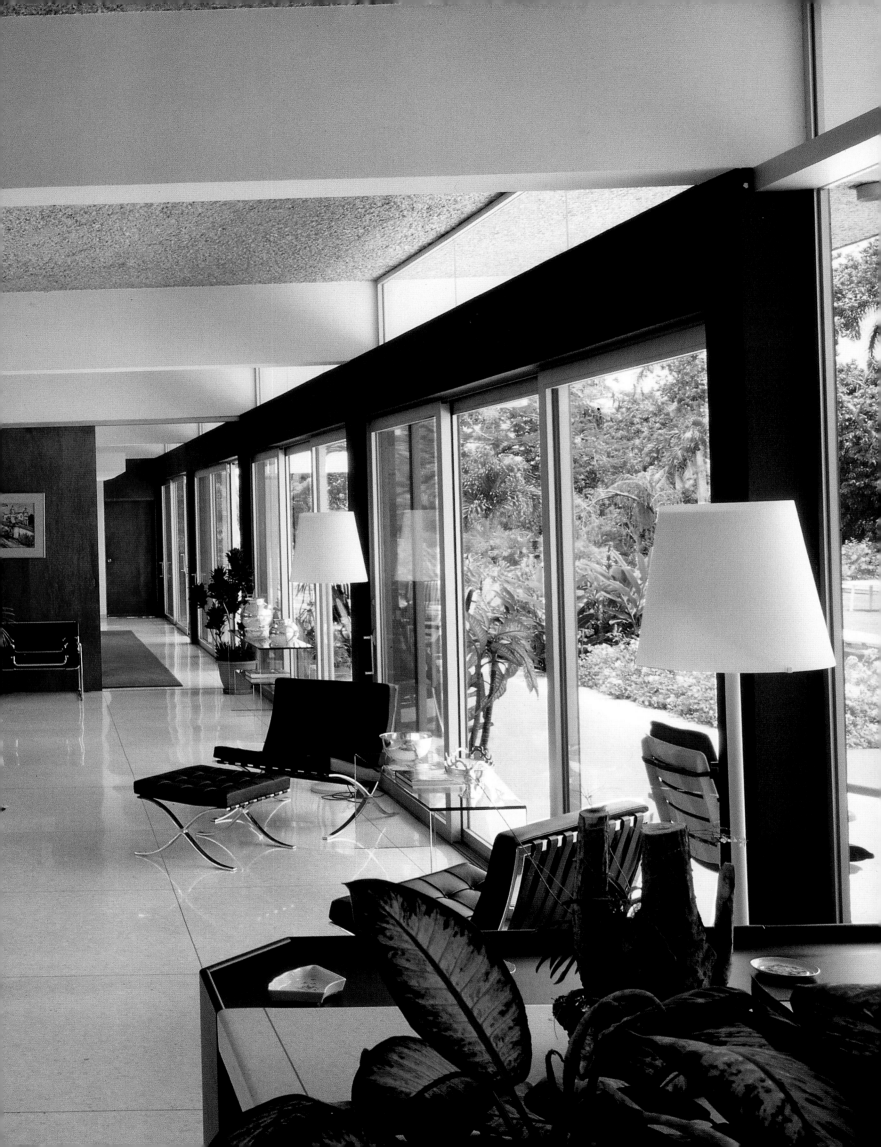

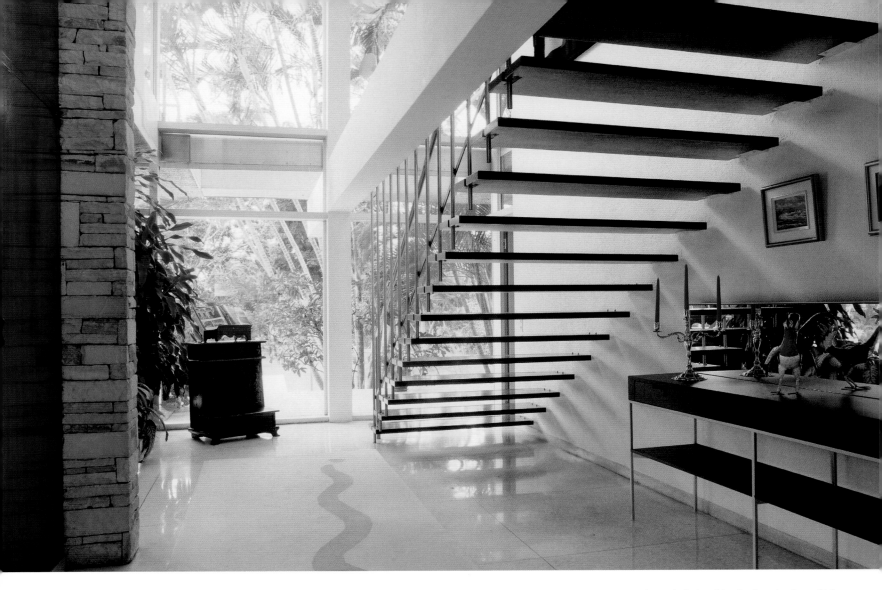

❈ **ABOVE** The airy semi-transparent staircase suspended from a beam in the entrance hall of the de Schulthess house, a mature avant-garde work designed by the Austrian-born, U.S. architect Richard Neutra in conjunction with the Cuban architects Álvarez and Gutiérrez. **BELOW** The different atmospheres in the residence are skillfully separated through changes in floor and ceiling levels and by the use of different materials and textures. ❈ **OBEN** Die grazile und transparente Treppe ist an einem Träger im Eingangsbereich der »Casa de Schulthess« befestigt. Sie ist ein spätavantgardistisches Werk des nordamerikanischen Architekten Richard Neutra, österreichichen Ursprungs, in Zusammenarbeit mit den kubanischen Architekten Álvarez und Gutiérrez. **UNTEN** Die verschiedenartigen Räumlichkeiten der Wohnung sind gekonnt anhand unterschiedlicher Boden- und Deckenhöhen sowie der Verwendung unterschiedlicher Materialien und Texturen getrennt. ❈ **CI-DESSUS** Dans le vestibule, un escalier léger et transparent suspendu à une poutre, une œuvre avant-gardiste d'une belle maturité, réalisée par l'architecte américain Richard Neutra originaire d'Autriche, en collaboration avec les Cubains Álvarez et Gutiérrez. **CI-DESSOUS** Les différents espaces de la maison sont savamment séparés par des différences de niveaux du sol et de la hauteur sous plafond, ainsi que par le recours à différents matériaux et textures.

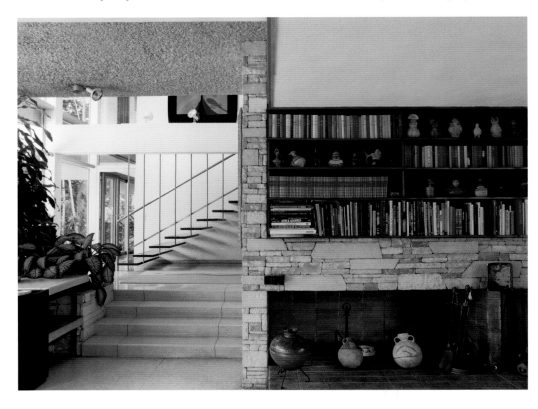

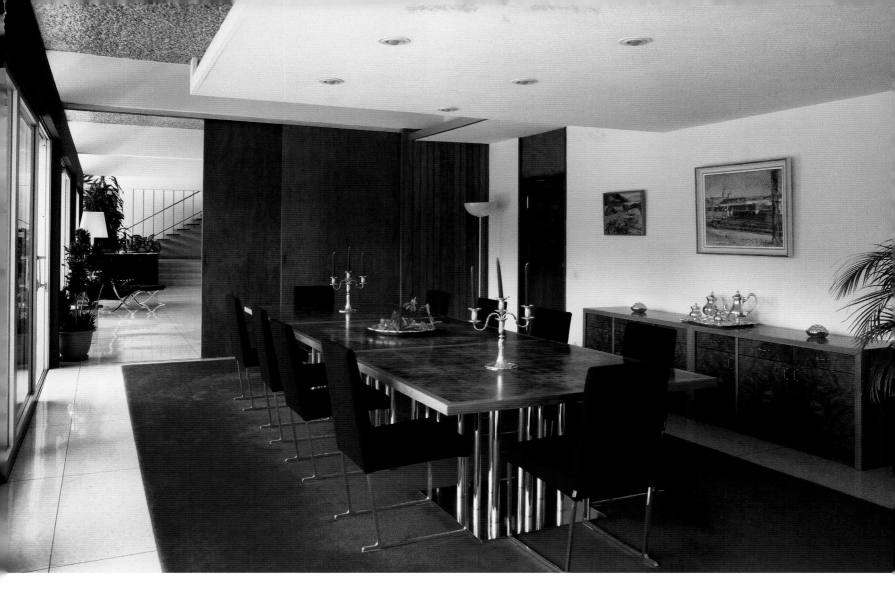

❋ **ABOVE** The dining room, located just off the living room, also enjoys unhampered views of the garden and the swimming pool. **BELOW** A lounge chair, model B306, designed in 1928 by Le Corbusier in one of the corners of the living room, next to the library. ❋ **OBEN** Das Esszimmer liegt im Anschluss an das Wohnzimmer und bietet ebenfalls einen umfassenden Blick auf Garten und Swimmingpool. **UNTEN** Ein Liegestuhl, Modell B306 aus dem Jahr 1928, nach einem Entwurf von Le Corbusier steht in einer Ecke des Wohnzimmers neben dem Bücherregal. ❋ **CI-DESSUS** La salle à manger, située dans le prolongement du séjour, bénéficie elle aussi de belles vues sur le jardin et la piscine. **CI-DESSOUS** Dans un coin du séjour, près de la bibliothèque, une chaise longue, modèle B306, dessinée par Le Corbusier en 1928.

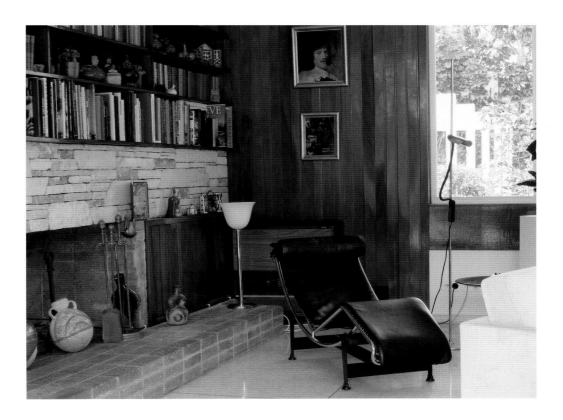

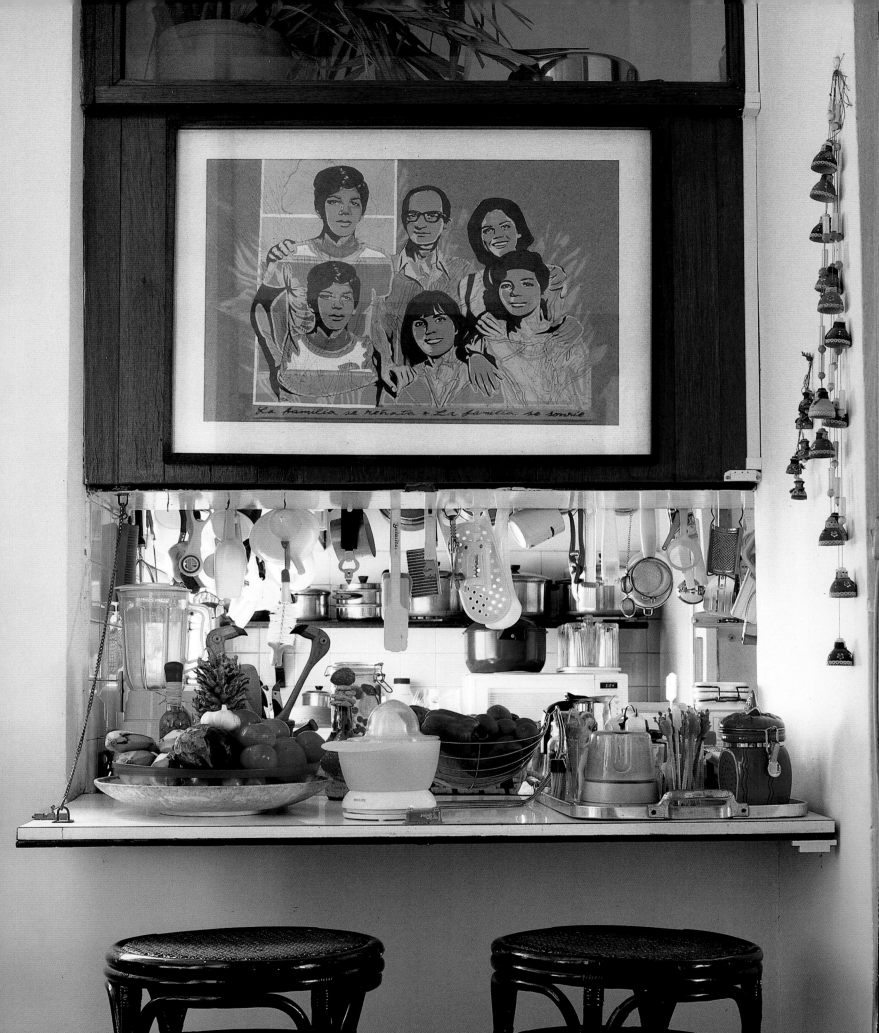

Apartamento Fofi-Lan

A Cuban House in the Tradition of Japanese Architecture.

Cuban architect Mario Romañach's interest in integrating contemporary and traditional architecture encouraged him to use elements from the Japanese architectural tradition, particularly "shoin-zukuri," in some of his work. The 1958 Fofi-Lan apartment building is an example of this kind of modernism. Its reinforced concrete structure references a post and lintel skeleton frame, based on the use of the "ken" module – a unit related to the human scale. The ground floor of this building is devoted to parking, so access to the apartments is via a staircase that opens into a small transitional space. It is defined by intricate wooden latticework and clay-tile jalousies that filter sunlight. The living rooms have "tatami"-like floors and shallow display alcoves, or "tokonoma." The almost hermetic main façade with small windows reveals its introverted purpose – to shut out the noise of the street – and alternating forms (which are closets) that protrude out of the façade create a dialogue between order and diversity. Light, shadow, geometry, and detailing contribute to Romañach's reinterpretation of the modern Cuban house while simultaneously instilling a spiritual content into modern architecture.

Der kubanische Architekt Mario Romañach hatte ein Faible dafür, zeitgenössische Elemente in traditionelle Architektur einfließen zu lassen. Es scheint deshalb naheliegend, dass er Teile der alten japanischen Architekturtradition »Shoin-Zukuri« in seine Werke übernahm. Die »Fofi-Lan«-Wohnung von 1958 zeigt, was Romañach unter Moderne verstand. Das verstärkte Betongebäude ist auf dem »ken«-Modul aufgebaut, dessen Gerüst sich an menschlichen Maßen orientiert. Das Erdgeschoss dient als Parkplatz, und über ein Treppenhaus und einen schmalen Durchgangsraum mit aufwändigem Gitterwerk aus Holz und Lehmziegel-Jalousien, gelangt man in die Wohnungen. Die Wohnräume haben »tatami«-ähnliche Böden und schmale »tokonoma«-Alkoven. Die fast hermetisch geschlossene Hauptfassade mit schmalen Fenstern soll den Straßenlärm draußen halten. Einbuchtungen in den Wänden dienen als Schränke und sind von außen zu sehen. Sie erzeugen dadurch einen Dialog zwischen Ordnung und Vielfalt. Romañachs Neuinterpretation des modernen kubanischen Hauses zeigt sich im Spiel von Licht und Schatten und seiner Liebe zur Geometrie und zum Detail. Gleichzeitig verleiht er der modernen Architektur ein Stück Spiritualität.

Cherchant à conjuguer le contemporain et le traditionnel, le Cubain Mario Romañach s'est inspiré de l'architecture japonaise, notamment le «shoin-zukuri». L'appartement Fofi-Lan, datant de 1958, illustre ce modernisme. Sa structure en béton armé repose sur une carcasse en poutres et linteaux, utilisant le module «ken», une unité basée sur l'échelle humaine. Le rez-de-chaussée abrite un parking. On accède aux appartements par un escalier qui débouche sur un petit espace de transition, défini par un fin treillage en bois et des jalousies en tuiles d'argile qui filtrent le soleil. Les séjours ont des sols en «tatami» et des alcôves peu profondes ou «tokonoma». La façade principale quasi hermétique percée de petites fenêtres révèle sa nature introvertie (cherchant à se protéger des bruits de la rue). Les formes saillantes (en fait des placards) créent un dialogue entre l'ordre et la diversité. La lumière, les ombres, la géométrie et les détails contribuent à la réinterprétation que Romañach offre de la maison cubaine tout en instillant un contenu spirituel dans l'architecture moderne.

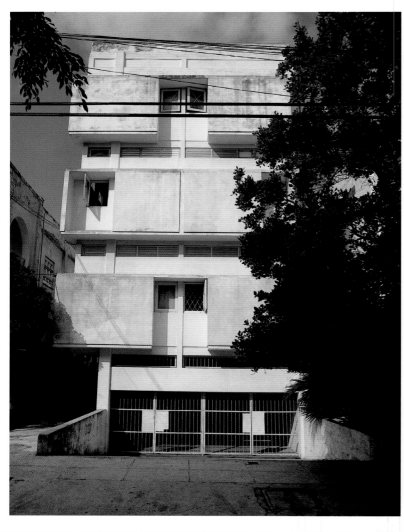
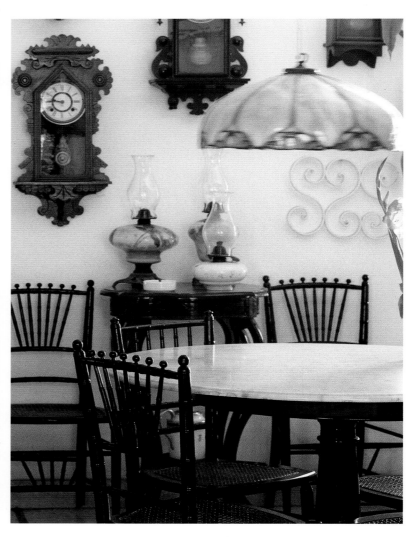
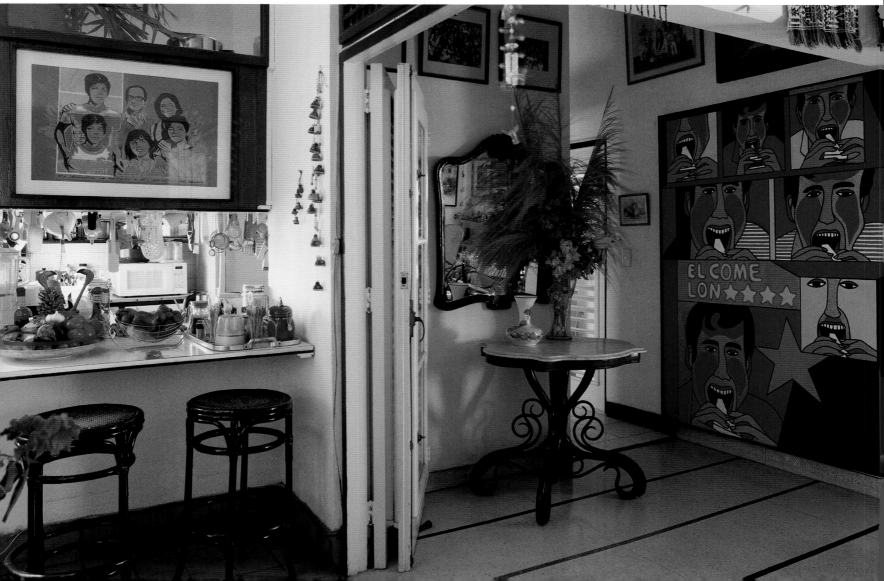

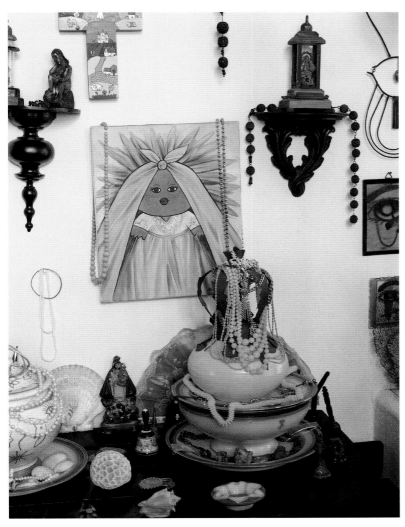

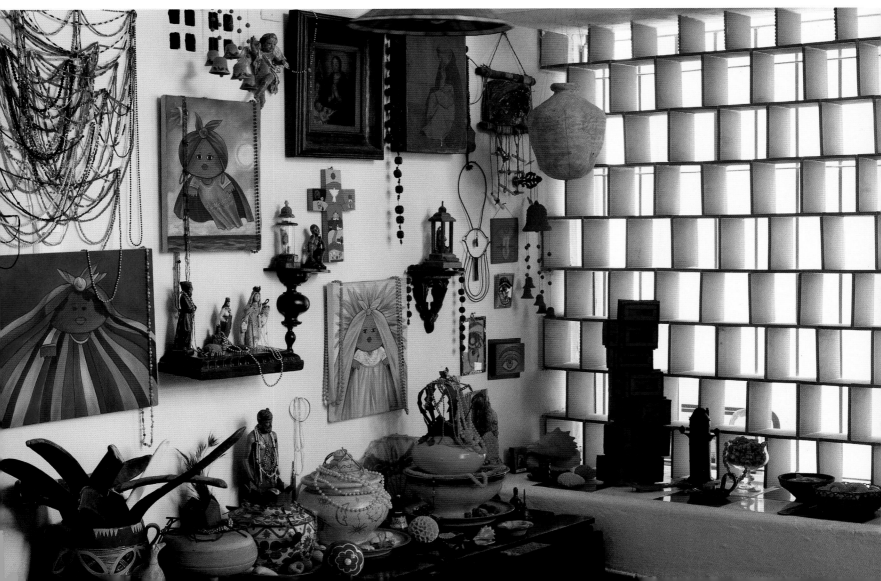

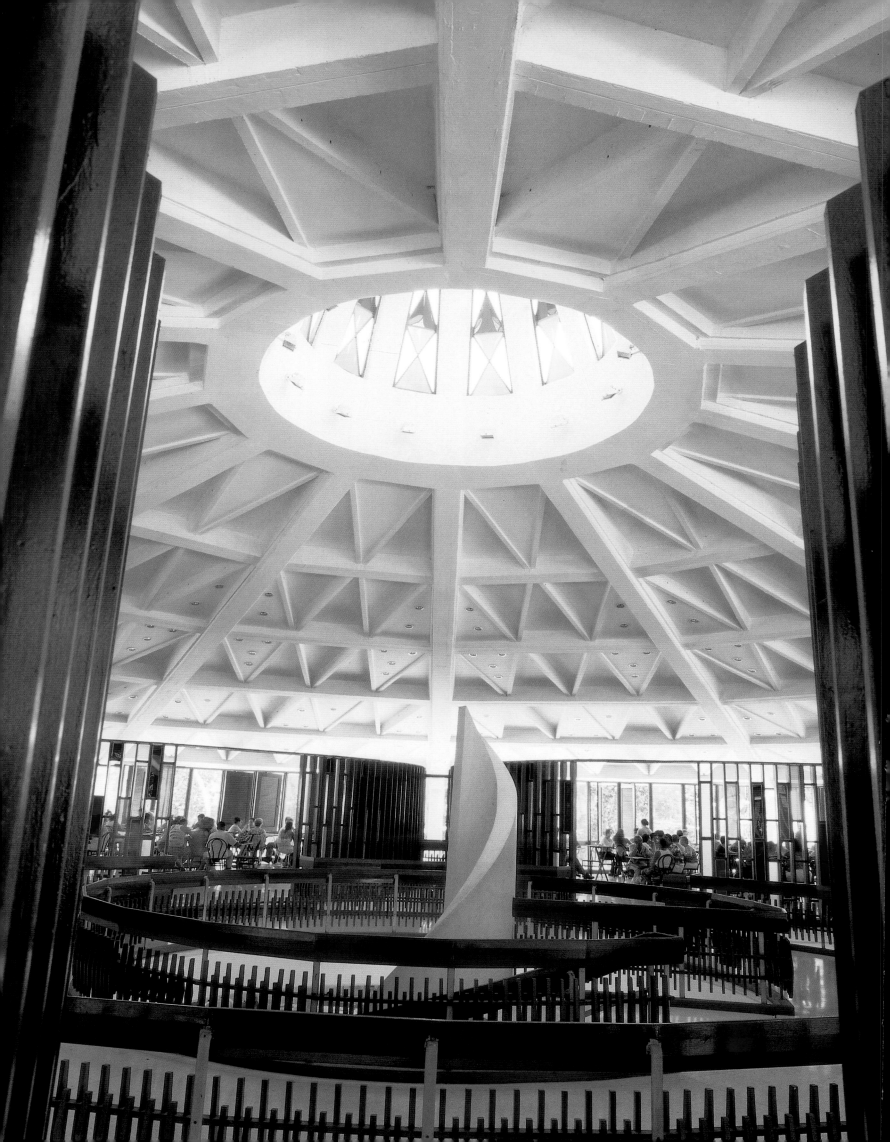

HELADERÍA
COPPELIA

The Hottest Spot in Town for Cuban Ice Cream.

"Coppelia" is not only the name of a beautiful ballet, it is also a brand of famous, internationally acclaimed Cuban ice cream. It is the only rival in Cuba for the hedonistic trio of cigars, rum and coffee, and its quality has been compared to that of Italian "gelato." "Heladería Coppelia" is a landmark in the heart of La Rampa, in Vedado. Since it was built in 1966, it has been the most popular spot in town, a unique gathering place where youngsters hang out, lovers date, and students and friends meet. It was the backdrop for the first scene of the Oscar-nominated 1995 Cuban film "Fresa y chocolate." Designed by Cuban architect Mario Girona, it was conceived as a huge, lightweight concrete structure surrounded by gardens in the center of a city block. The design consists of two structures connected by a bridge: the secondary one is a service block, and the main one is a circular structure covered by a single slab and crowned with a truncated cone; this ring has a tinted-glass clerestory and anchors the exposed concrete girders that cover six drum-like dining halls subdivided by wood and glass partitions on the upper floor. The whole ambience is open and very Cuban.

Zigarren, Rum und Kaffee – diese Genüsse aus Kuba haben Weltruhm erlangt. Weniger bekannt ist Kuba für sein leckeres Eis, das von Kennern mit dem italienischen »gelato« verglichen wird. »Coppelia« steht nicht nur für das fantastische Ballett, sondern auch für das beste Eis in Kuba. Die »Heladería Coppelia« wurde 1966 eröffnet und liegt auf der La Rampa von Vedado. Sie ist eine Attraktion und einer der beliebtesten Treffpunkte der Jugend, Liebespaare und Studenten. Hier wurde auch die erste Szene des Oscar-nominierten kubanischen Films »Erdbeer und Schokolade« aus dem Jahr 1995 gedreht. Mario Girona, der kubanische Architekt, entwarf das Gebäude. Es ist eine riesige und dennoch leicht wirkende Betonkonstruktion, die aus zwei Gebäuden, die mit einer Brücke miteinander verbunden sind, in einer Gartenanlage besteht. Eines dient als Betriebsgebäude. Das runde Haupthaus ist von einer einzigen Betonplatte abgedeckt, auf der ein abgebrochener Kegel mit Buntglasoberlichter steht. Er verankert die nach außen gestellten Betonträger, die sechs Zylinder zusammenhalten. Die Speisesäle im oberen Stockwerk sind mit Holz- und Glaspaneelen voneinander abgetrennt. All dies wirkt durch und durch kubanisch.

«Coppelia» n'est pas qu'un beau ballet classique, c'est aussi une marque de crèmes glacées cubaines de renommée internationale. D'une qualité comparable aux «gelato» italiens, elles rivalisent avec le trio hédoniste : cigare, rhum et café. Depuis son ouverture en 1966 au cœur de la Rampa, à Vedado, le glacier «Coppelia» est l'établissement le plus populaire de la ville, le rendez-vous des adolescents, des amoureux, des étudiants et des amis. Il a servi de décor à la scène d'ouverture de «Fresa y chocolate», le film cubain nominé aux Oscars en 1995. Conçu par l'architecte Mario Girona, c'est une immense structure en béton léger entourée de jardins occupant tout un pâté de maisons. Deux bâtiments sont reliés par une passerelle, le premier abrite les services, le second, circulaire, est recouvert d'une seule dalle couronnée d'un cône tronqué. Il comporte un étage protégé de vitres teintées. Les piliers en béton cachent six tambours. Les salles de restaurant à l'étage sont divisées par des cloisons en bois et verre, créant une ambiance ouverte et très cubaine.

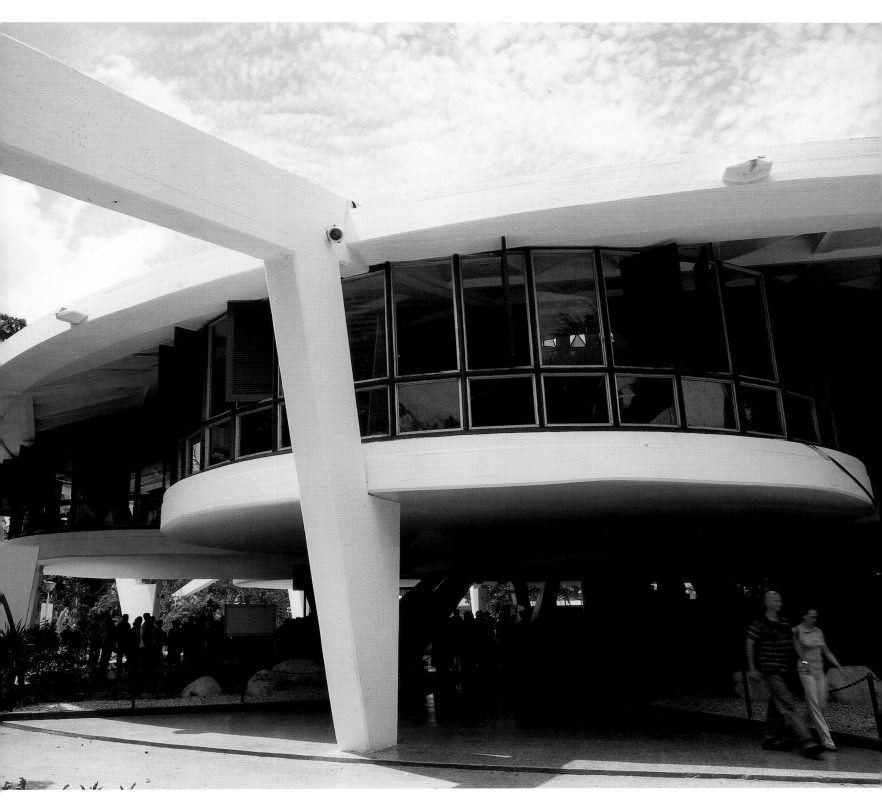

✻ **ABOVE LEFT** The "Coppelia" ice cream parlor, surrounded by gardens, is located in the middle of a city block right in the heart of Havana. The radial reinforced concrete girders, support by V-shaped columns, converge in the middle of the building. **LEFT** A bridge joins the two volumes of the building, establishing a clear formal, spatial and volumetric separation between the different functional areas. An orthopolygonal staircase leads to the administrative area. **ABOVE** The transparent, open atmosphere in the building encourages communication and impersonal mingling, part of the charm of a place that skillfully assimilates Cuban idiosyncrasies. **FOLLOWING PAGES** The exposed reinforced concrete structure and the solid terrazzo floors, with a design based on freeform curves, encompass a spacious, open, well-ventilated public area. ✻ **OBEN LINKS** Das Eiscafé »Coppelia« liegt umringt von Grünanlagen inmitten eines Blocks im Zentrum Havannas. Die strahlenförmigen Stahlbetonträger lehnen an V-förmigen Stützen und laufen in der Mitte des Gebäudes zusammen. **LINKS** Eine Brücke verbindet die beiden Gebäudeteile und erzielt gleichzeitig eine formale, räumliche und volumetrische Trennung der verschiedenen Funktionsbereiche. Eine rechtwinklig-polygonale Treppe bietet Zugang zur Verwaltung. **OBEN** Das transparente Gefüge des Gebäudes begünstigt die Kommunikation und die menschliche Begegnung und ist mitverantwortlich für den Zauber dieses Treffpunkts, der den kubanischen Charakter einfängt. **FOLGENDE DOPPELSEITE** Die unverhüllte Stahlbetonstruktur und der Terrazzoboden mit seinem wellenförmigen Design bilden einen großen, offenen und gut durchlüfteten Raum. ✻ **PAGE DE GAUCHE, EN HAUT** Le glacier « Coppelia », entouré de jardins, se dresse en plein cœur de la Havane. Les poutres radiales en béton armé, prenant appui sur des colonnes en V, convergent vers le centre du bâtiment. **À GAUCHE** Une passerelle relie les deux volumes du bâtiment, établissant une séparation claire, formelle, spatiale et volumétrique entre les différentes zones fonctionnelles. Un escalier orthopolygonal mène à la partie administrative. **CI-DESSUS** L'atmosphère du bâtiment favorise la communication et les contacts humains, ce qui fait partie du charme de ce lieu typiquement cubain. **DOUBLE PAGE SUIVANTE** La structure en béton armé brut et les sols en granit décorés de motifs aux courbes libres accueillent une vaste salle publique ouverte et bien aérée.

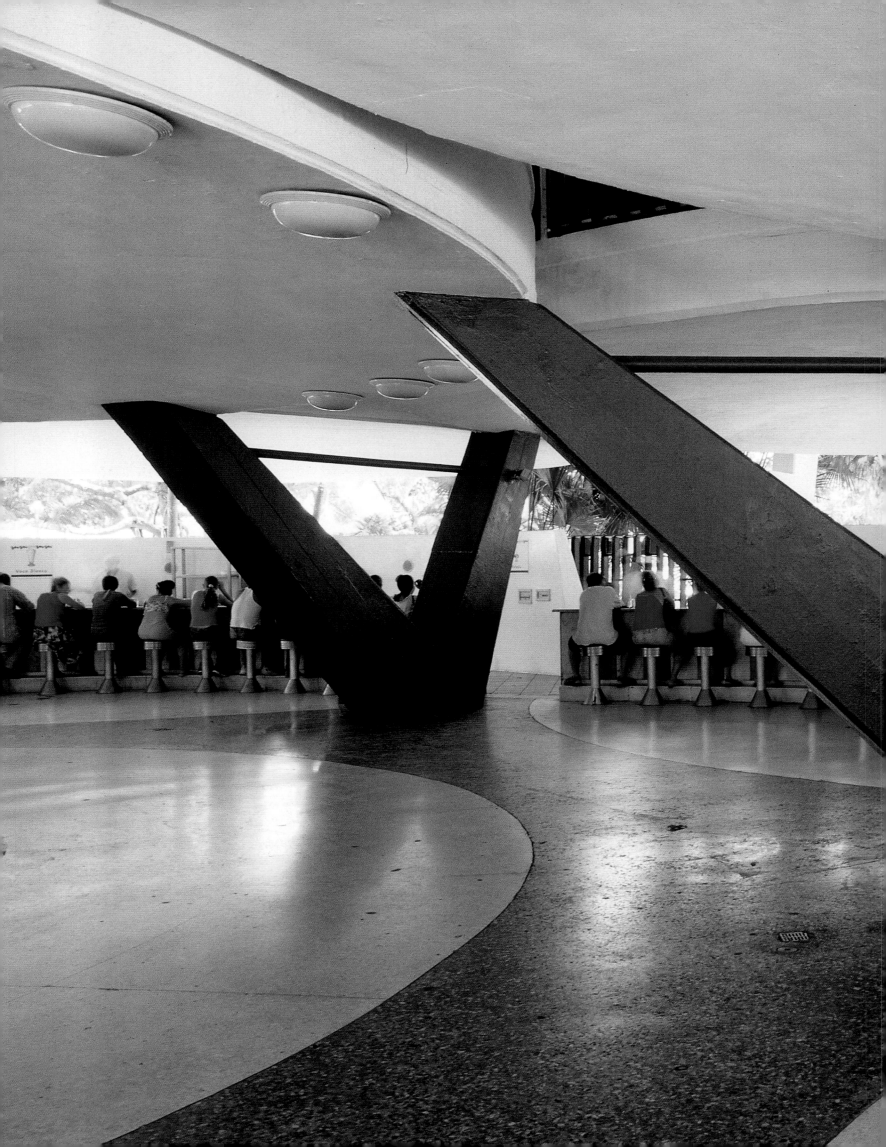

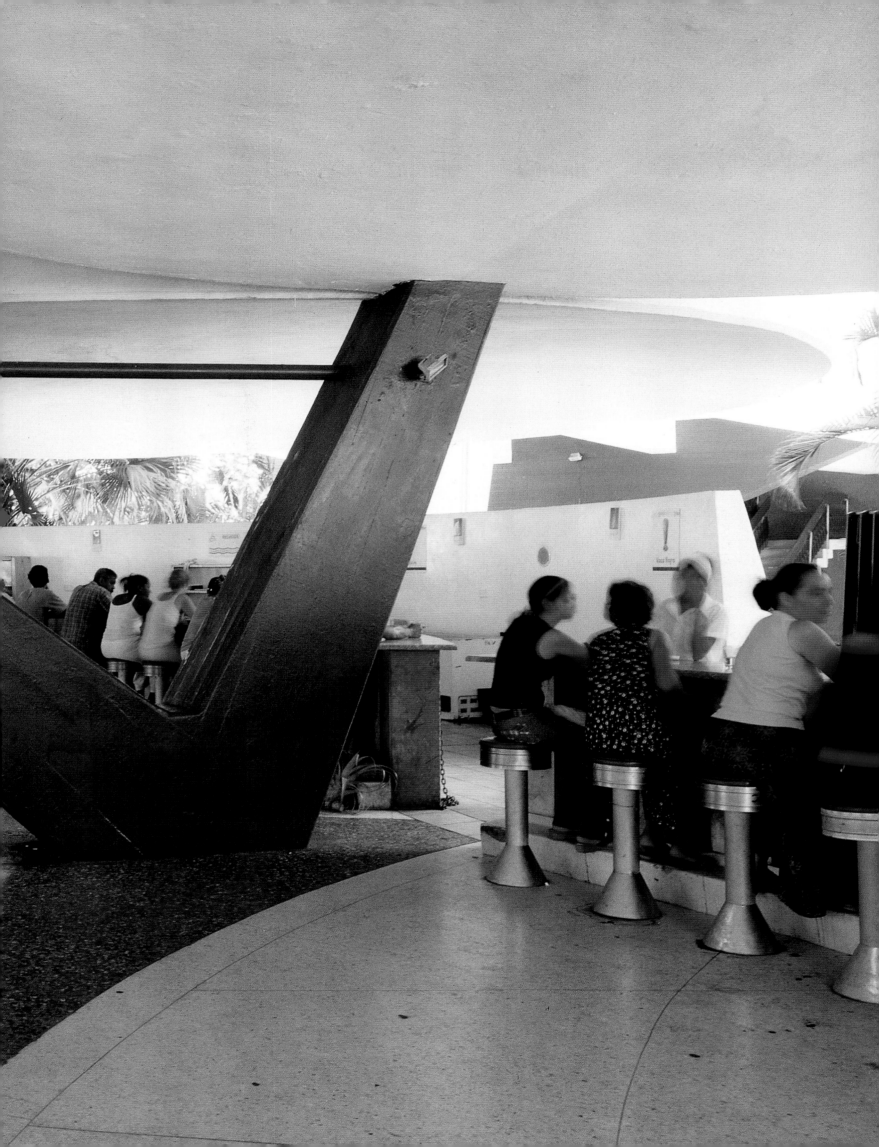

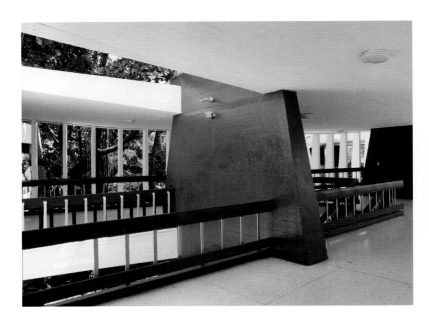 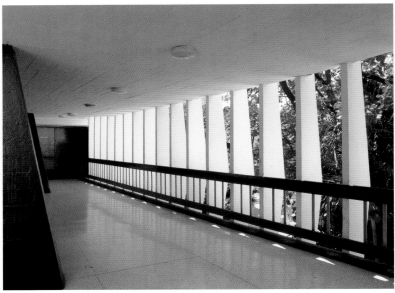

❋ **ROW ABOVE** The reinforced concrete bridge connecting the two volumes is covered by vertical concrete sun breaks whose rhythm reinforces the linear nature of the space. The wooden jalousies and the skylight provide a great deal of color and rhythm to the site. ❋ **OBERE REIHE** Die Stahlbetonbrücke zwischen den beiden Gebäudeteilen wird von vertikalen Betonstreben als Sonnenschutz verschlossen, was den linearen Raumaufbau verstärkt. Die Holzgitter und das Buntglasfenster verleihen dem Bau Farbenpracht und Rhythmus. ❋ **LINIE EN HAUT** La passerelle en béton armé qui relie les deux volumes est fermée par des pare-soleil verticaux en ciment qui accentuent le caractère linéaire de l'espace. Les jalousies en bois et vitraux projettent une belle lumière colorée et rythment l'espace.

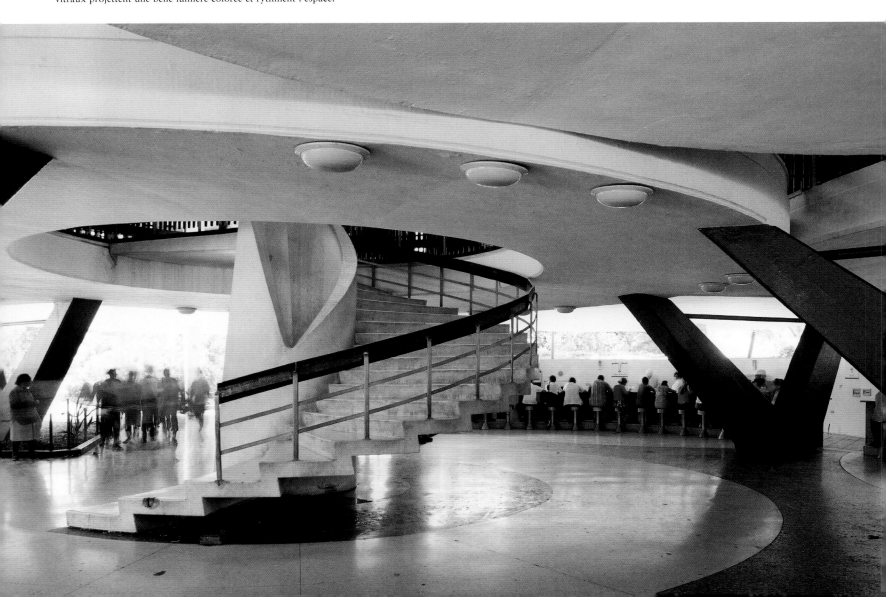

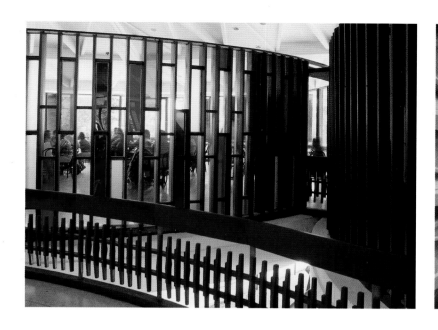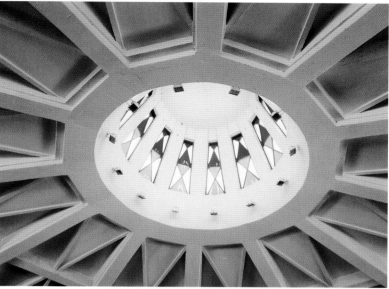

❋ **BOTH BELOW** The staircase made of solid terrazzo is the center of the building's spatial composition and joins both floors. On the lower storey, the walls delimiting the service area do not reach the mezzanine in order to ease ventilation. **FOLLOWING DOUBLE PAGE** The spatial fluidity of the interior is ensured by the enormous light on the roof which has no intermediate supports. The interior space of the upper floor is solely delimited by airy partitions. ❋ **UNTEN, LINKE UND RECHTE SEITE** Die spiralförmige Terrazzotreppe steht im Mittelpunkt des räumlichen Gebäudegefüges und verknüpft die beiden Stockwerke. Im Erdgeschoss wurden die Mauern im Servicebereich nicht bis zum Zwischenbereich aufgezogen, um die Belüftung zu gewähr- leisten. **FOLGENDE DOPPELSEITE** Die fließende Struktur des Innenraums wird durch den starken Lichteinfall gewährleistet, welcher auf der Decke ohne Zwischenstützen beruht. Das Innere des Obergeschosses ist nur mit grazilen Raumtrennern unterteilt. ❋ **CI-DESSOUS, PAGE A GAUCHE ET PAGE A DROITE** L'escalier en granit se trouve au centre de la composition spatiale du bâtiment. Au rez-de-chaussée, les murs délimitant la partie des services n'atteignent pas la hauteur de l'entresol afin de faciliter la ventilation. **DOUBLE PAGE SUIVANTE** À l'intérieur, la grande quantité de lumière qui filtre sous la coupole surélevée créé une atmosphère fluide. Dans la grande salle à l'étage, seules de légères cloisons délimitent les espaces.

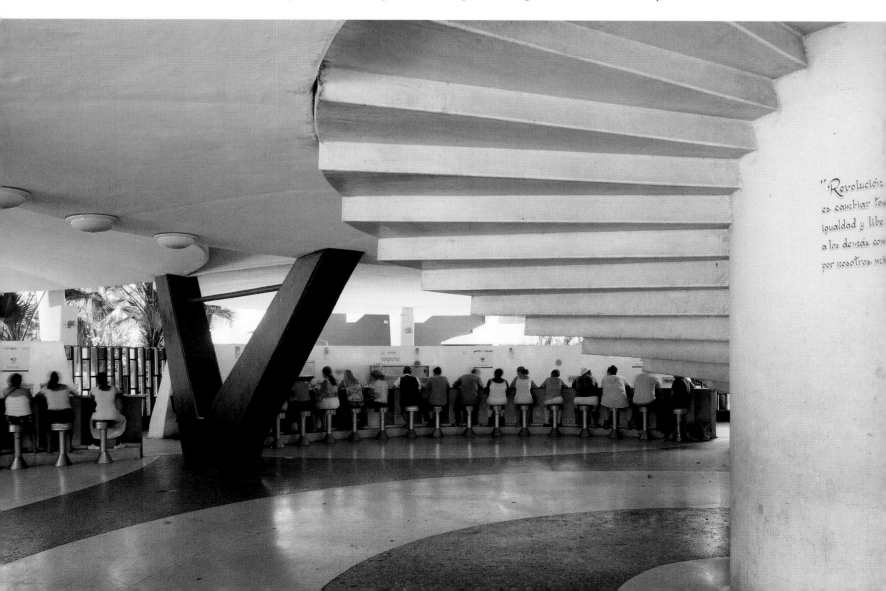

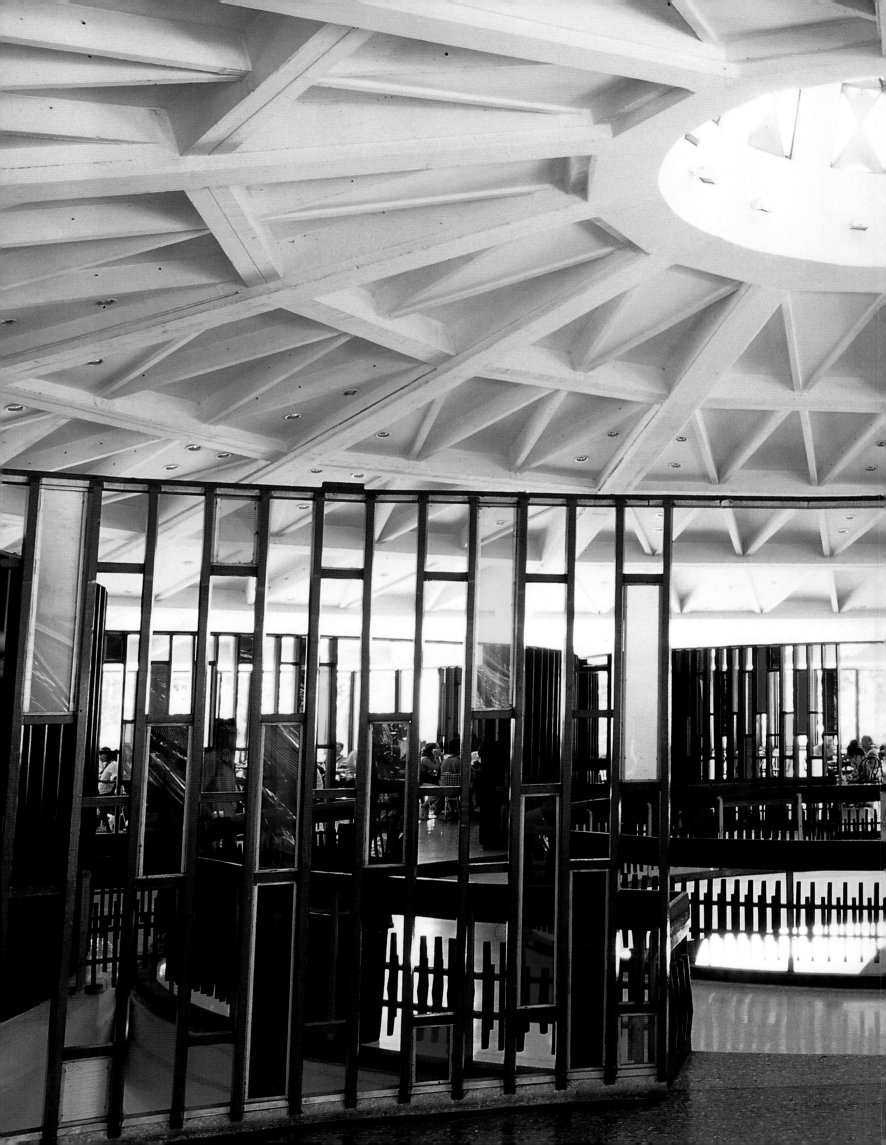

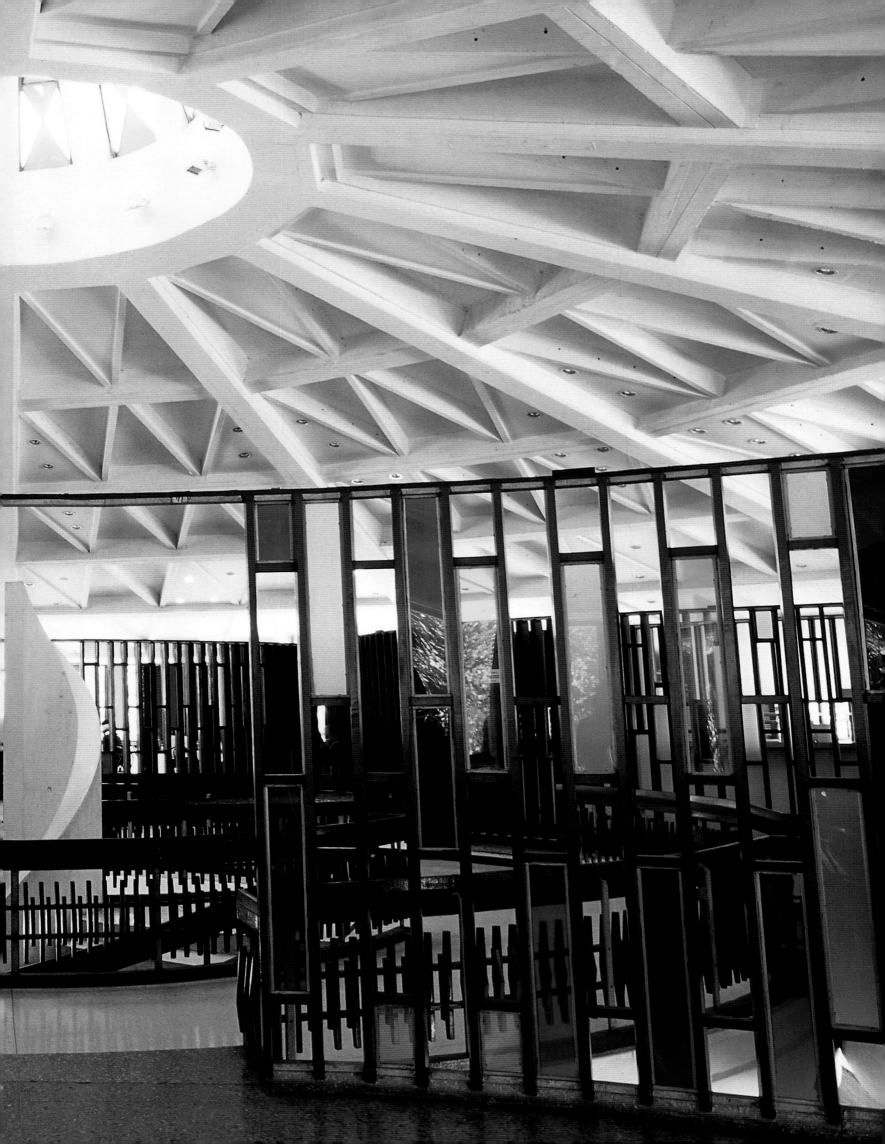

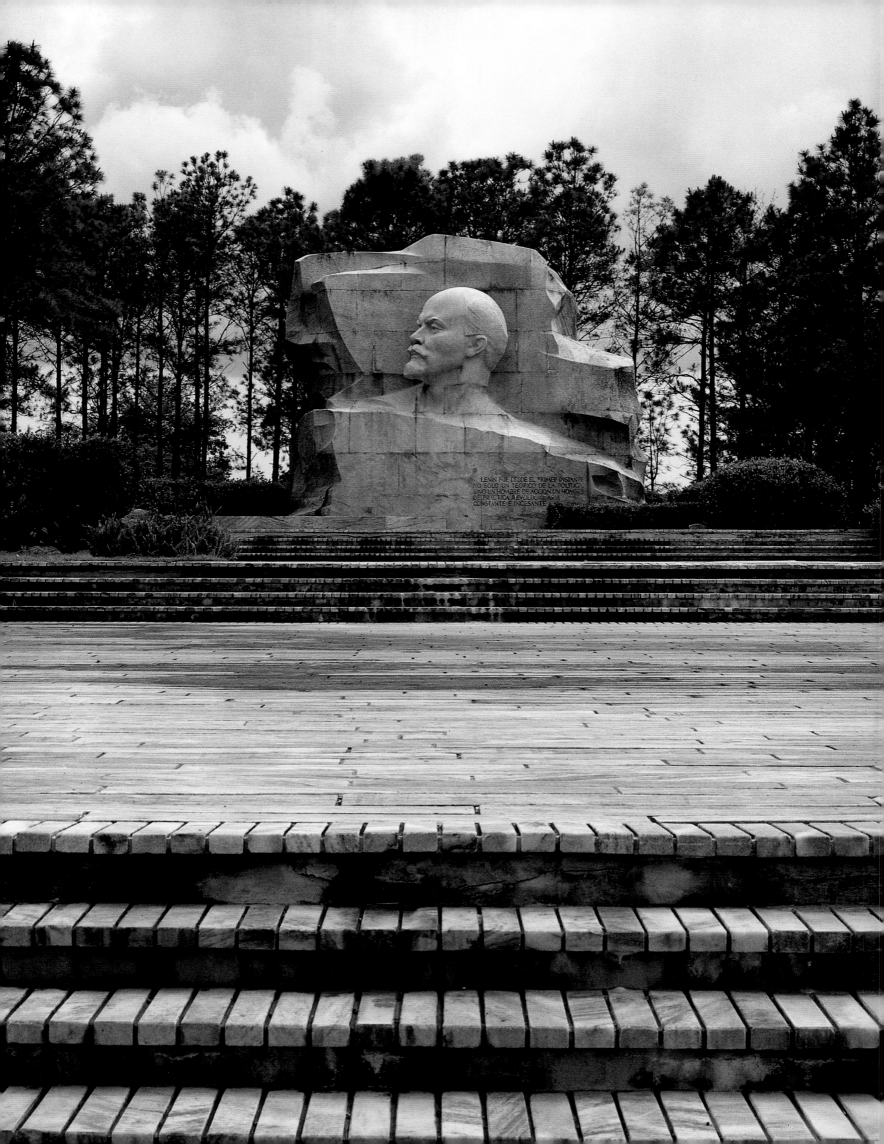

Parque Lenin

One of the Paradigms
of Modern Cuban Architecture.

In the early 1970s, Parque Lenin was planned in an effort to increase the percentage of green land per citizen while protecting the Vento basin, Havana's main source of water. A team of architects led by Antonio Quintana transformed a wasteland into an idyllic forest of bamboos, palms and pines, punctuated with kiosks, cafeterias, restaurants, and even an amphitheater. Cuban architect Joaquín Galván designed one of the paradigms of modern Cuban architecture, "Las Ruinas". An orthogonal white concrete structure wraps around the stone ruins of a 19th century farm, creating a highly original setting for a restaurant. The cantilevered beams stretch into the landscape, framing views of the park and establishing a delightful transition between indoors and out. The free-flowing interior space is formed by changes of floor level and a variety of textures. A staircase bridges the two-storey vestibule with the mezzanine dining area, where one can see a freestanding stained-glass mural by Cuban artist René Portocarrero. This addition of vibrant color adds to the sublime experience of being in "Las Ruinas".

Der Parque Lenin wurde in den frühen 1970ern angelegt, um die Grünfläche in der Stadt zu vergrößern. Gleichzeitig konnte damit die Hauptwasserversorgung Havannas aus dem Vento-Becken geschützt werden. Ein Architektenteam unter der Leitung von Antonio Quintana verwandelte das einstige Ödland in einen idyllischen Wald aus Bambus, Palmen und Pinien mit Kiosken, Cafés, Restaurants und einem Amphitheater. Zu einem Standardwerk der modernen kubanischen Architektur wurde das Restaurant »Las Ruinas«, das der Architekt Joaquín Galván entworfen hatte. Das weiße rechtwinklige Betongebäude wurde um Steinruinen eines Bauernhofes aus dem 19. Jahrhundert angelegt. Ausladene Betonträger erstrecken sich nach außen und rahmen die Sicht auf den Park ein. Dadurch ergibt sich ein harmonischer Übergang zwischen Innen und Außen. Der schwebende Innenraum wird durch Treppen auf ungleichen Ebenen und mannigfaltigen Strukturen bestimmt, und das Treppenhaus verbindet ein zweistöckiges Vestibül, dessen Mezzanin als Essraum dient. Von hier aus sieht man auf ein freistehende Wand aus einem Buntglasfenster, das der kubanische Künstlers René Portocarrero gestaltet hat und dem Besuch von »Las Ruinas« etwas Erhabenes verleiht.

Le Parque Lenin fut planté au début des années 1970 afin d'augmenter le pourcentage d'espaces verts par habitant tout en protégeant le bassin du Vento, principale source d'eau de la Havane. Sous la direction d'Antonio Quintana, une équipe d'architectes a transformé un terrain vague en forêt idyllique de bambous, de palmiers et de pins, parsemée de kiosques, de cafés, de restaurants et même d'un amphithéâtre. «Las Ruinas», un des fleurons de l'architecture moderne cubaine, a été dessinée par le Cubain Joaquín Galván. Cette structure octogonale blanche en béton s'enroule autour des ruines en pierres d'une ferme du 19e siècle, créant un décor très original pour un restaurant. Les poutres en console s'étirent dans le paysage, encadrant des vues du parc et établissant une belle transition entre le dedans et le dehors. À l'intérieur, l'espace ouvert se distingue par ses différents niveaux et une variété de matières. Un escalier relie le haut vestibule à la salle de restaurant en mezzanine. Celle-ci est ornée d'un vitrail sur pied signé de l'artiste cubain René Portocarrero, une touche de couleur qui ajoute encore à la sublime expérience de dîner à «Las Ruias».

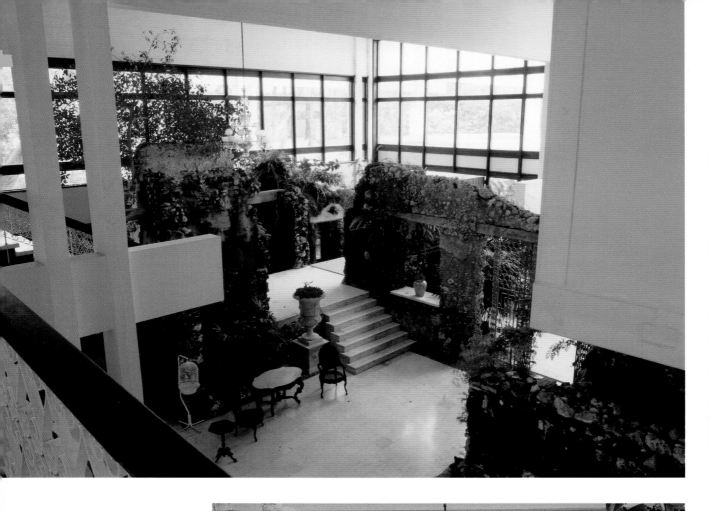

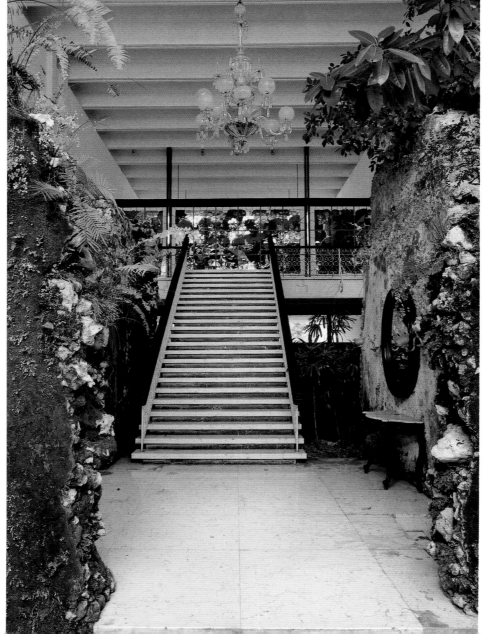

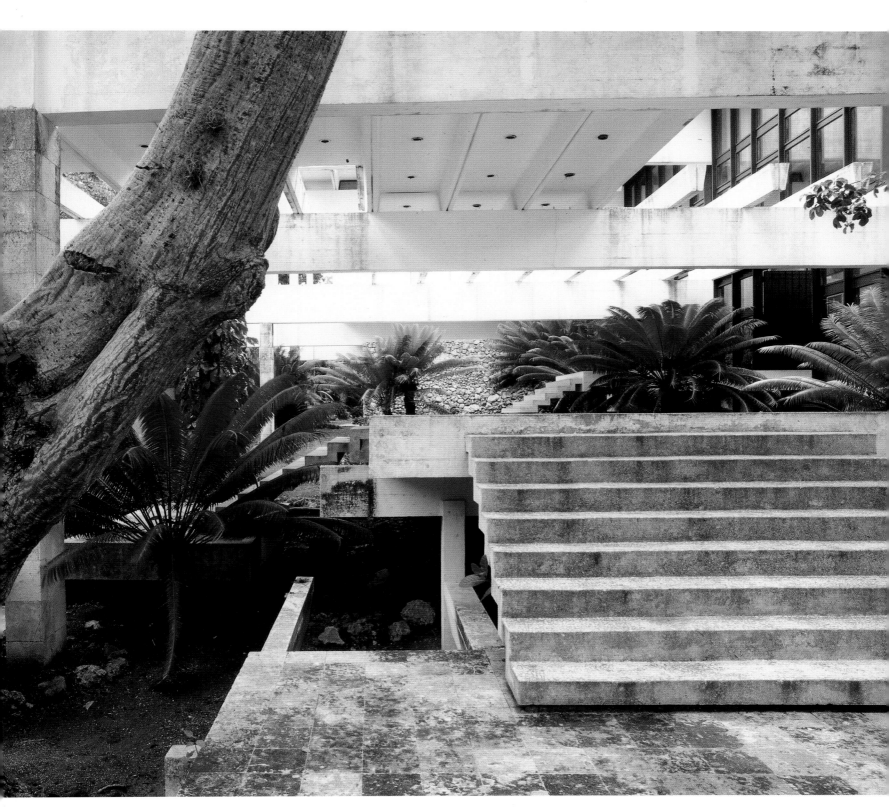

❋ **ABOUT LEFT** A melding of new and old. The Cartesian structure of columns and reinforced concrete beams envelops the remains of an old building belonging to a 19th century coffee plantation and creates an exceptional ambiance inside the building. **LEFT** An integration of avant-garde art and architecture. A beautiful, enormous stained glass window with floral motifs by the famous Cuban artist René Portocarrero is located at the entrance to the restaurant on the upper floor. **ABOVE** The main entrance to the restaurant, "Las Ruinas", is made up of a series of terraces and staircases that resolve the different levels of the terrain where the building is located. ❋ **OBEN LINKS** Alt und neu vereint. Die kartesianische Struktur aus Stahlbetonsäulen und -trägern umschließt Reste eines alten Gebäudes, das im 19. Jahrhundert zu einer Kaffeeplantage gehörte. Diese Verbindung erzeugt im Innern des Baus ein einzigartiges Ambiente. **LINKS** Künstlerische Avantgarde verschmilzt mit Architektur. Ein herrliches Buntglasfenster mit Blumenmotiven aus der Hand des berühmten kubanischen Künstlers René Portocarrero schmückt den Eingang des Restaurants im Obergeschoss. **OBEN** Der Haupteingang des Restaurants »Las Ruinas« besteht aus einer Reihe von Terrassen und Treppen, welche die Höhenunterschiede des Geländes überbrücken. ❋ **PAGE DE GAUCHE, EN HAUT** L'intégration du nouveau et de l'ancien. La structure cartésienne avec colonnes et poutres en béton armé entoure les vestiges d'une ancienne plantation de café du 19e siècle, créant une atmosphère exceptionnelle à l'intérieur de l'édifice. **A GAUCHE** L'avant-garde artistique intégrée dans l'architecture. À l'entrée du restaurant situé à l'étage, un beau vitrail aux motifs floraux, œuvre du célèbre artiste cubain René Portocarrero. **CI-DESSUS** Le bâtiment étant construit sur un terrain pentu, on accède au restaurant « Las Ruinas » par une série de terrasses et d'escaliers.

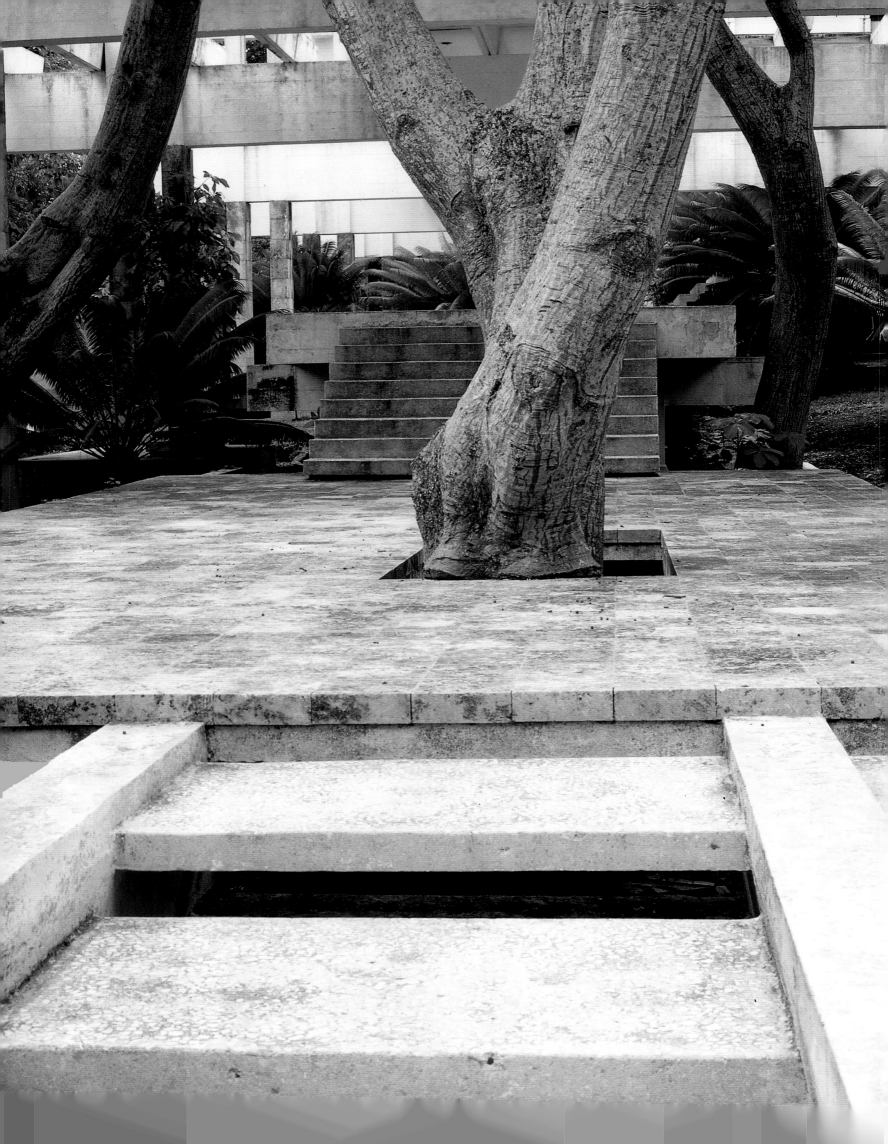

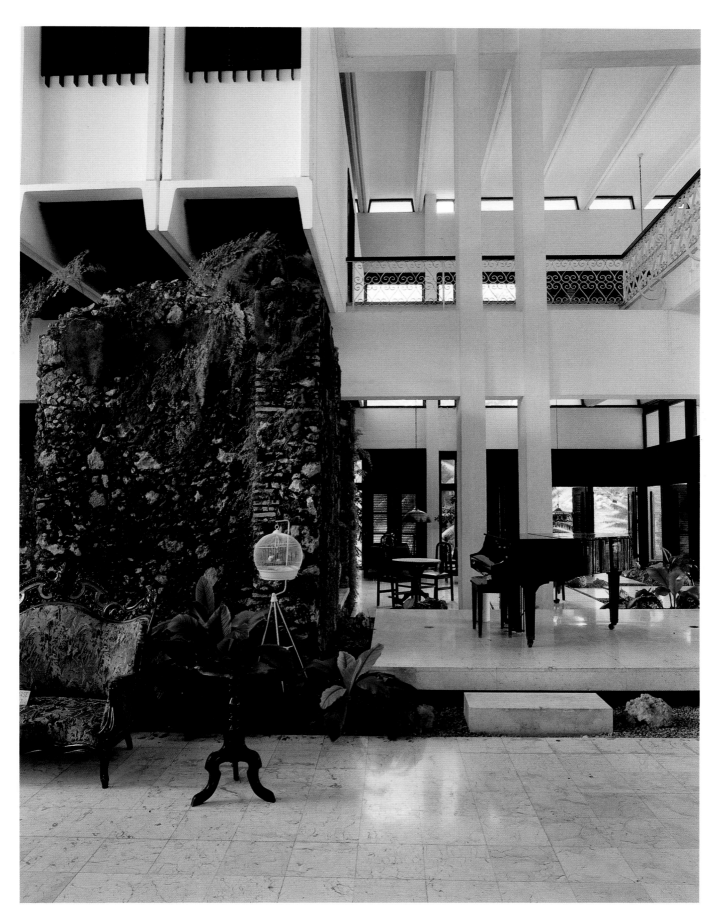

※ **FACING PAGE** The trees on the site were left intact and made an integral part of the new building. **ABOVE** The refined interior is the result of a skillful manipulation of the space and the interplay of volume, light and shadow which together with the different levels of Cuban marble floors and the play of different ceiling heights, creates an intriguing atmosphere.
※ **LINKE SEITE** Die Bäume wurden erhalten und in den Bau integriert. **OBEN** Das elegante Ambiente im Innern ist das Ergebnis einer feinsinnigen Verarbeitung des Raums und der Kombinationen von Volumina, Lichtern und Schatten. So wird zusammen mit den unterschiedlich hohen Böden aus kubanischem Marmor und den verschiedenen Deckenhöhen eine faszinierende Atmosphäre erzeugt. ※ **PAGE DE GAUCHE** Les arbres du site ont été respectés et inclus dans le nouveau bâtiment. **CI-DESSUS** L'intérieur raffiné est le fruit d'une savante manipulation de l'espace, des volumes, des lumières et des ombres associée aux différents niveaux des sols en marbres cubains et aux jeux des lignes verticales.

CASA ELEJALDE

In the Mode of Yin and Yang.

"If space is halfway between cosmos and chaos, and we human beings are the play of light and shadow traveling in time and occupying a space, then the architect's task is to create spaces for man to dwell." Cuban architects Julio César Pérez and Esteban Martínez made this statement in 2000 in their proposal for a friend's low-budget home in Míramar, an elegant district west of Havana. The design combined a rational approach, based on geometry and form, with a philosophical one involving the notion of voids and solids, expressed in the use of varying ceiling heights. Set back from the street in the middle of a block, and leaving room from adjacent properties to allow for privacy, cross-ventilation, and natural light, the two-storey façade is framed by a lofty portico supported by concrete columns and steel beams that imply urban dignity and a certain monumentality. The entrance leads to a series of rooms defined by changes in the floor levels and materials: a grand two-storey space with a dining room and rock garden is bisected by a metal bridge. The upstairs bedrooms at the back overlook the central core, and a minimalist staircase anchors the bridge, and in doing so becomes a piece of sculpture.

»Die Aufgabe des Architekten ist es, Raum zu bauen, um dem Menschen Schutz zu gewähren« sagten die kubanischen Architekten Julio César Pérez und Esteban Martínez zu einem Freund, als sie ihm im Jahr 2000 einen Entwurf für ein Billighaus im eleganten Viertel Míramar im Westen von Havanna unterbreiteten. Der Entwurf ist genau so rational wie philosophisch. Geometrische Formen treffen auf ein Spiel zwischen Leerflächen und Festkörpern, das durch den Einsatz verschieden hoher Decken entsteht. Das zweistöckige Haus liegt etwas zurückversetzt in einem Straßenblock in einigem Abstand zu den Nachbarhäusern. So kann die Luft zirkulieren, genügend Tageslicht einfallen, und man bleibt ungestört. Rund ums Haus liegt ein luftiger Säulengang, der von Betonpfeilern gestützt und mit Stahlbalken verstärkt wird. Das Haus wirkt dadurch monumental und fast erhaben. Im Innern sind die unterschiedlichen Zimmer durch verschieden hohe Niveaus und jeweils andere Materialien definiert. Eine Metallbrücke unterteilt den großen zweistöckigen Wohnraum und das Esszimmer mit einem Steingarten, ein schlichtes Treppenhaus verankert die Brücke, die damit zur Skulptur wird. Im oberen Stockwerk gehen die Schlafzimmer nach hinten hinaus.

« Si l'espace se situe à mi-chemin entre le cosmos et le chaos et si les êtres humains ne sont que des jeux d'ombre et de lumière voyageant dans le temps et occupant un espace, alors la tâche de l'architecte est de créer des espaces où l'homme peut s'arrêter ». Cette déclaration figurait dans le projet des architectes cubains Julio César Pérez et Esteban Martínez auxquels, en 2000, un ami sans beaucoup de moyens avait commandé une maison à Míramar, quartier élégant à l'ouest de la Havane. Leur plan est à la fois rationnel, basé sur la géométrie et la forme, et philosophique, reposant sur les notions du solide et du vide, se traduisant par diverses hauteurs sous plafond. Située en retrait de la rue au milieu d'un pâté de maisons, espacée des voisins pour plus d'intimité, la façade est dominée par un haut portique en colonnes de béton et poutres d'acier dont la distinction urbaine n'est pas dépourvue de monumentalité. L'entrée donne sur une série de pièces définies par des différences de niveau et de matériaux. Un haut espace accueillant la salle à manger et un jardin de pierres est traversé par une passerelle en métal. On y accède par un escalier minimaliste, sculpture à part entière. Les chambres à l'étage, situées à l'arrière de la maison, donnent sur le puits central.

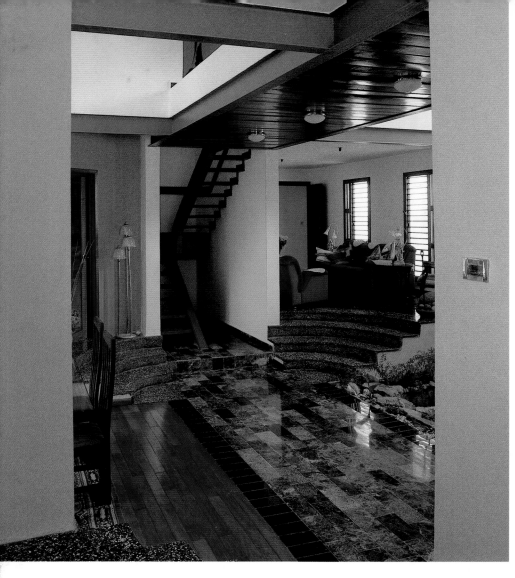

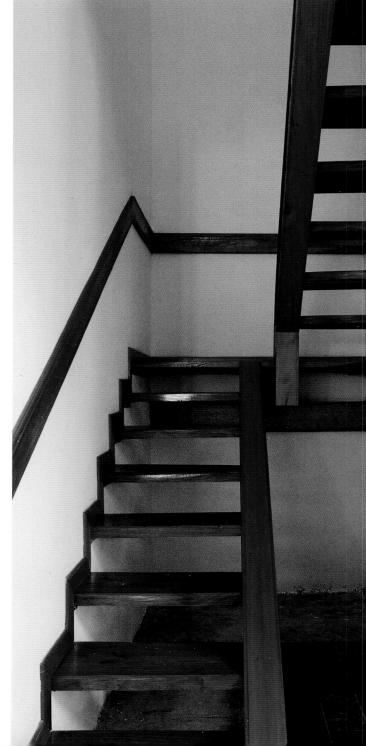

❋ **ABOVE** The core of the home is an atmosphere characterized by great spatial richness, with floor coverings of different materials and textures to distinguish the different functional areas. The color of the steel structure contrasts with the carpentry and the walls. **RIGHT** A minimalist staircase with a steel frame and varnished wood steps links both floors of the house. The columns in the middle frame the walk-in entrance to the house. **FACING PAGE** A steel-framed bridge divides the centrally-located double-height core of the house, where there is a rock garden and the dining room, and which leads to the private bedroom area at the back of the upper storey. ❋ **OBEN** Das Herzstück des Hauses ist das großräumige Erdgeschoss mit Böden aus unterschiedlichen Materialien und Texturen, welche die einzelnen Funktionsbereiche definieren. Die Farbe der Stahlstruktur steht im Kontrast zum Holz und zu den Farben der Wände. **RECHTS** Eine minimalistisch gestaltete Treppe mit gebeizten Holzstufen verbindet die beiden Etagen des Hauses. **RECHTE SEITE** Eine Brücke aus Stahlrahmen unterteilt den doppelstöckigen Raum, der einen Steingarten und das Esszimmer enthält. Diese Brücke führt zum Privatbereich am Ende des Obergeschosses, wo die Schlafzimmer liegen. ❋ **CI-DESSUS** Le cœur de la maison est d'une grande richesse spatiale avec des sols dont les matériaux et textures varient selon les aires fonctionnelles. La couleur de la structure en acier contraste avec celle de la charpente et des murs. **A DROITE** L'escalier minimaliste avec des marches en bois vernis. **PAGE DE DROITE** L'espace central, d'une double hauteur sous plafond, accueille un jardin de pierres et la salle à manger. À l'étage, une passerelle en acier mène aux chambres situées à l'arrière de la maison.

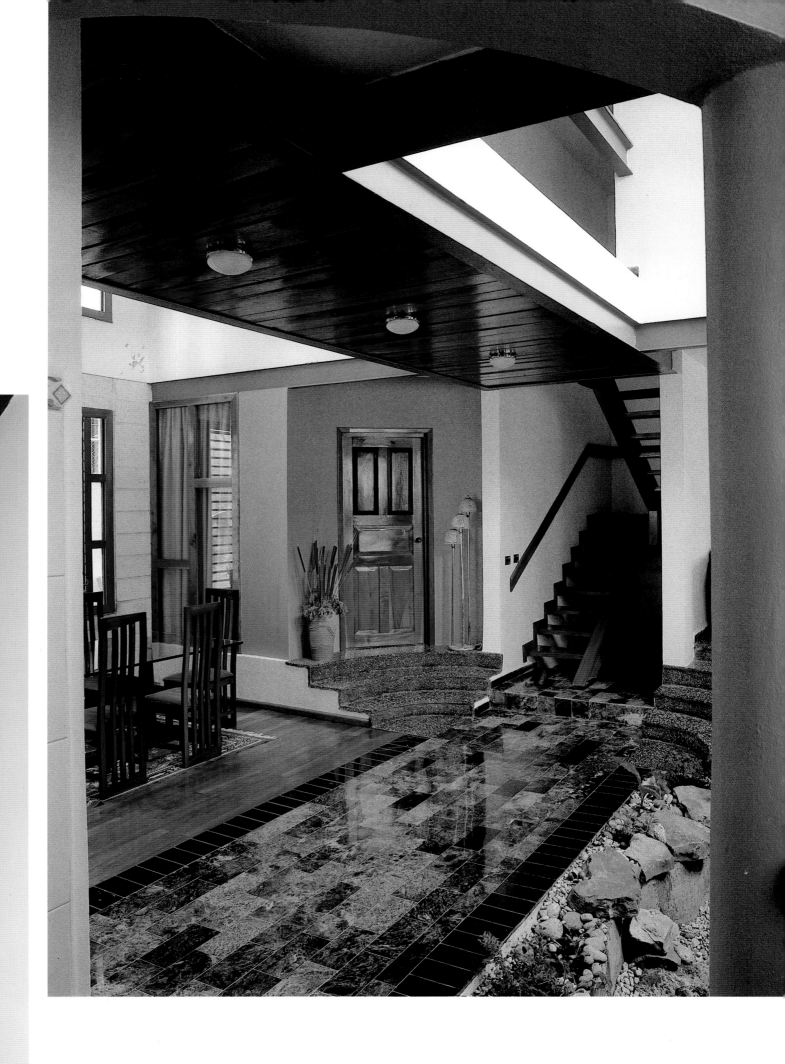

Addresses

Havana
Museums/Interesting Places

CASA DE LA OBRA PÍA
Obrapía # 158
La Habana Vieja 10100
fon: +53 7 861 30 97

PALACIO DE LOS CAPITANES GENERALES
Museo de la Ciudad de la Habana
Calle Tacón # 1 between Obispo and O'Reilly
La Habana Vieja 10100
fon: +53 7 861 28 76 or +53 7 863 99 81

HOTEL AMBOS MUNDOS
Hemingways Hotel Room No 511
Calle Obispo # 153 corner Mercaderes
La Habana Vieja 10100
fon: +53 7 860 95 29
fax: +53 7 866 95 32
e-mail: comercial@habaguanexhamundos.co.cu

REAL FÁBRICA DE TABACOS PARTAGÁS
Calle Industria # 520 between Dragones y Barcelona
Centro Habana
fon: +53 7 863 57 66
e-mail: otabaco@catec.co.cu

TEMPLO YORUBA
Calle Concordia # 655 between Oquendo y Soledad
Centro Habana
fon: +53 7 878 36 07

CLUB NÁUTICO
Calle 152 y Mar, Reparto Náutico
Playa
fon: +53 7 208 76 94
fax: +53 7 208 06 84
e-mail: cso.fe@cubacatering.avianet.cu

PARQUE LENIN
Calle 100 and Cortina de la Presa Empedrado # 207
Arroyo Naranjo, Miramar 11300
Ciudad de La Habana
fon: +53 7 44 27 22

Bars/Cafés/Restaurants

LA BODEGUITA DEL MEDIO
Calle Empedrado # 207 off Plaza de la Catedral
La Habana Vieja 10100
fon: +53 7 867 13 74/75
e-mail: comercial@bdelm.gca.tur.cu

EL FLORIDITA
Calle Obispo # 557 corner Monserrate
La Habana Vieja 10100
fon: +53 7 867 13 00
e-mail: director@flori.gca.tur.cu

PALADAR LA GUARIDA
(FILM "FRESA Y CHOCOLATE")
Calle Concordia # 418 between Gervasio y Escobar
Centro Habana
Ciudad de La Habana
fon: +53 7 866 67 41
fon: +53 7 863 73 51
e-mail: Enrique@laguarida.com

HELADERÍA COPPELIA
Calle 23 corner Calle L
Plaza de la Revolución
El Vedado 10400
fon: +53 7 202 22 20
e-mail: comercial@coppelia.cu

LAS RUINAS
Calle 100 corner Cortina de la Presa
Empedrado # 207
Parque Lenin
Arroyo Naranjo, Miramar 11300
fon: +53 7 57 82 86

Hotels

AMBOS MUNDOS
Calle Obispo # 152 corner Mercaderes
Habana Vieja, 10100
fon: +53 7 860 95 29
fax: +53 7 866 95 32

HOTEL NACIONAL DE CUBA
Calle 21 y O
Vedado, 10400
fon: +53 7 33 35 64/67 (switch board)
fon: +53 7 55 02 94 (reservation)
fax: +53 7 873 51 71 (reservation)
e-mail: reserva@hotelnacionaldecuba.com
www.hotelnacionaldecuba.com

HOTEL HABANA RIVIERA
Paseo y Malecón
Vedado, 10400
fon: +53 7 33 40 51
fax: +53 7 33 37 39
e-mail: reserva@gcrivie.gca.tur.cu